Digital Wedding Photography

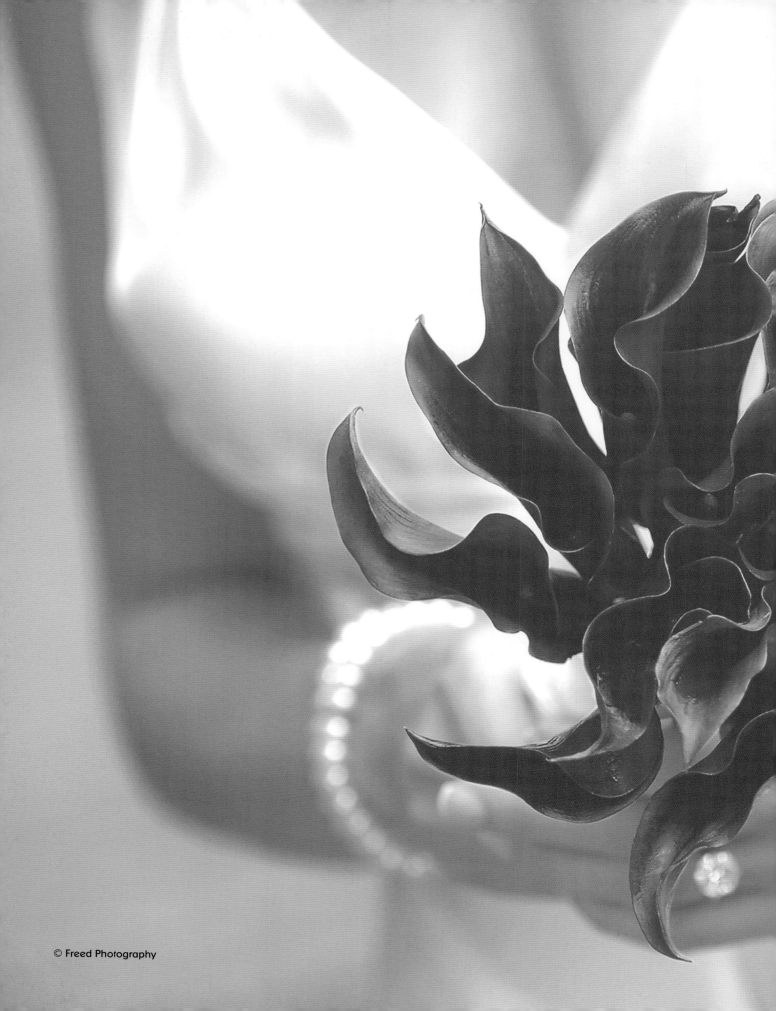

© Freed Photography

Digital Wedding Photography

Art, Business & Style

Steve Sint

An Imprint of Sterling Publishing Co., Inc.
New York

Editor: Haley Steinhardt
Book Design: Tom Metcalf Design
Cover Design: Thom Gaines

Library of Congress Cataloging-in-Publication Data

Sint, Steve, 1947-
 Digital wedding photography : art, business & style / Steve Sint.
 p. cm.
 ISBN 978-1-60059-565-3
 1. Wedding photography. 2. Photography--Digital techniques. I. Title.
 TR819.S558 2011
 778.9'939522--dc22
 2010047446

10 9 8 7 6 5 4 3 2

Published by Lark Photography, An Imprint of
Sterling Publishing Co., Inc.
387 Park Avenue South, New York, N.Y. 10016

Text © 2011 Steve Sint
Photography © 2011 Steve Sint unless otherwise specified
Illustrations by Sandy Knight, © 2011 Lark Photography
Cover Photos:
 Front cover © Russell Caron
 Front cover flap, top © Freed Photography, Inc.
 Front cover flap, bottom © Sara Wilmot
 Spine © Michael Brook
 Back cover, top left © Russell Caron
 Back cover, top middle © Botticelli Studios
 Back cover, top right © Sara Wilmot
 Back cover, bottom © Michael Brook

Distributed in Canada by Sterling Publishing,
c/o Canadian Manda Group, 165 Dufferin Street
Toronto, Ontario, Canada M6K 3H6

Distributed in the United Kingdom by GMC Distribution Services,
Castle Place, 166 High Street, Lewes, East Sussex, England BN7 1XU

Distributed in Australia by Capricorn Link (Australia) Pty Ltd.,
P.O. Box 704, Windsor, NSW 2756 Australia

If you have questions or comments about this book, please contact:
Lark Photography
67 Broadway
Asheville, NC 28801
(828) 253-0467

Manufactured in China

ISBN 13: 978-1-60059-565-3

For information about custom editions, special sales, premium and corporate purchases, please contact Sterling Special Sales Department at 800-805-5489 or specialsales@sterlingpub.com.

For information about desk and examination copies available to college and university professors, requests must be submitted to academic@larkbooks.com. Our complete policy can be found at www.larkcrafts.com. For more about digital photography, visit www.pixiq.com.

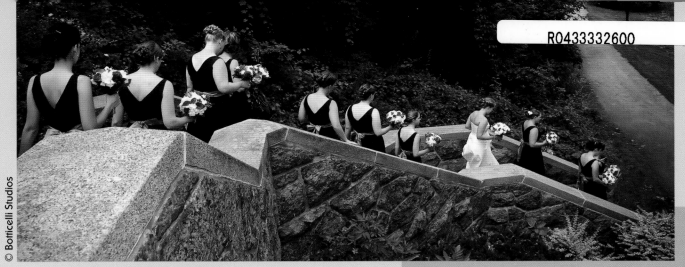

© Botticelli Studios

For three Js, an M, and a K...
...and, although she'll never read it, for Olga.

Acknowledgements

There's an old saying among successful photographers: You're only as good as your Rolodex. Thankfully for me, my Rolodex has grown quite fat over the years, and my hope is that this book will help the same become true for you.

It takes a lot of support and a lot of images to put a book like this together—not only my own, but from many other sources, as well. Of the photographers and studios represented on these pages, many are my clients, some have assisted me, some have been my students at the Maine Media Workshops, some represent a second generation of photographers whose parents are photographers I know, some are supporters, some are my suppliers, and all of them, I am proud to say, are my friends. So, I offer a special thanks to all of them. This book would not have been possible without their help. And a special thanks to Radek for always making sure there's a fresh card in my camera, and for a whole lot more!

Botticelli Portraits & Weddings
www.botticelliportraits.com – (631) 470-1358

Chantal Gauvreau
www.gauvreauphotos.com – (514) 432-5095

ePixel Photo Lab
www.epixel.com – (516) 354-6000

Franklin Square Photographers
www.fsphoto.com – (516) 437-1055

Freed Photography
www.freedphoto.com – (301) 652-5452

Glenmar Photographers
www.glenmarphotographers.com – (973) 546-3636

Great Expectations : A Dance Center
www.dancegr8exp.com – (718) 447-8377

Herman Brothers Productions, LLC
www.hermanbrothers.tv – (516) 791-7014

In-Sync Photography, Ltd.
www.insyncphotography.com – (908) 522-1801

Jerry Meyer Studio
www.jerrymeyerstudio.com – (516) 688-7722

Marcia Mauskoff
www.marciaphoto.com – (480) 366-4476

Megan Jones Photography
www.meganjones.com – (978) 376-5334

Michael Brook
www.michaelbrookphotography.com – (857) 272-1385

Photography Elite, Inc.
www.photoeliteinc.com – (718) 491-4655

Russell Caron Photography
www.wed-pix.com – (207) 233-4050

Salzman & Ashley Photography
www.salzmansshley.com– (516) 349-9500

Sara Wilmot
www.sarawilmot.com– (207) 807-0936

Steve Sint
www.stevesint.com– (516) 328-7617

Three Star Photography
www.threestarphotography.com – (718) 376-1922

contents

Foreword ●

The first version of this book, *Wedding Photography: Art, Business & Style*, was published in 1998, but the thinking about exactly what to write—followed by actually writing, organizing, picture gathering, and picture selecting—took almost three years. Because of the book's popularity, a second edition was published in 2005 and, thanks to the groundwork done in the first edition, that book had a gestation period of only one year. The book you are holding in your hands right now is a complete reworking of the previous edition, created to focus on the now prominent role of digital imaging in the wedding photography business. I started working on this newest version in late 2008 and, with a close eye on the ever-evolving trends of the industry, revised the material herein for nearly two years, resulting in the refined publication you see here.

A lot has happened to photography in the 15 years since this project first started! While the first edition was published at a time when professional wedding photographers used roll film cameras almost exclusively, the second edition was written during the transition between film and digital image capture. It is now safe to say that wedding photography, and in fact all professional photography, has changed almost completely to digital imaging.

Although the bedrock principles of photography still apply, as *this* book's title— *Digital Wedding Photography: Art, Business & Style*—suggests, it is directed at the new generation of digital photographers who bravely go out with their digital SLRs (aka DSLRs) each weekend to create a bountiful bunch of beautiful wedding photographs to satisfy a never-ending stream of brides and grooms! This book's goal is to show you how to exploit the advantages of using a DSLR for wedding photography, as well as to provide you with a starting point for growing a successful business in professional wedding photography. So slip a card into your DSLR and let's go!

© Michael Brook

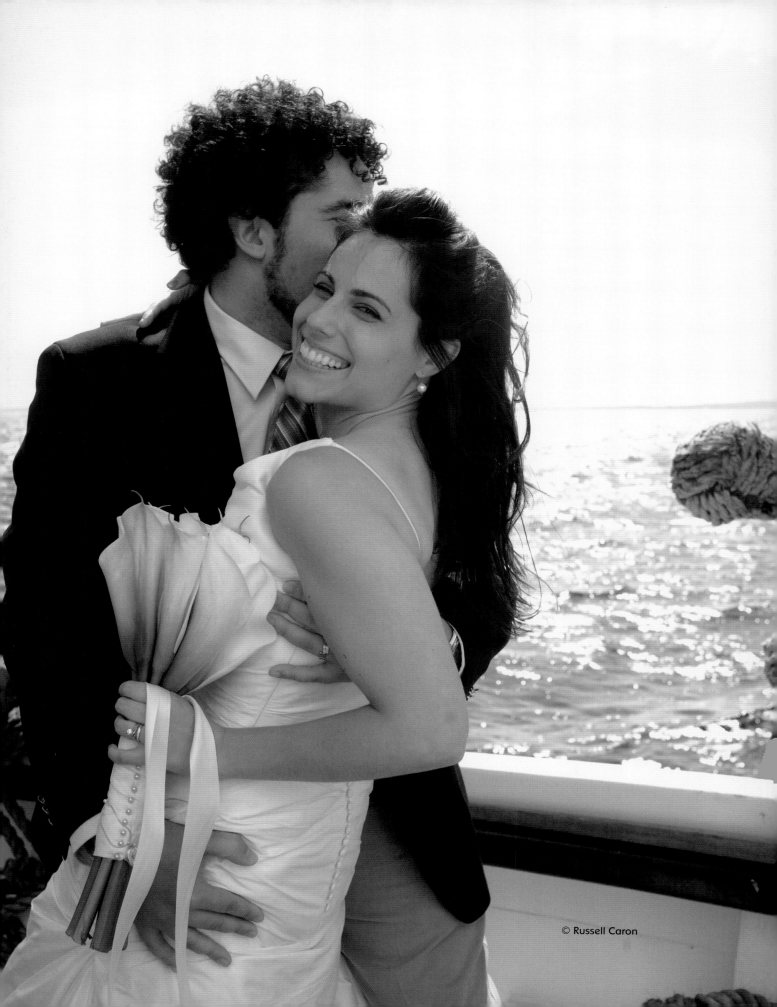

© Russell Caron

Introduction ●

This truth should be self-evident: If you want to shoot wedding pictures, whether for fun or profit, then you'd better like people. You have to like people at their best, people at their worst, people with expectations of perfection, people with no expectations at all, happy people, sad people, excited people, exasperating people, controlling people, serene people, argumentative people, dull people, and even people who are just plain nuts! The point is that you have to like all kinds of people if you choose wedding photography as your profession.

Taken a step further, to be happy and content with yourself and to have the ability to satisfy all the customers who will be paying you, it helps to like all styles of wedding pictures. There are cheesy grin pictures, corny pictures, creative pictures, dramatic pictures, digitally manipulated pictures, light-hearted pictures, modern pictures, old-fashioned pictures, photojournalistic pictures, posed pictures, and non-posed pictures, to name but a few... and there are dozens (maybe hundreds) more if you care to parse it even further. Without reservation, I can honestly say that I like every style of wedding picture out there. As a matter of fact, I try to cover as many as I can on every assignment I shoot. Sure, there are some I like more than others, but even if I don't love a particular type of picture, my client might, and as a professional, my primary goal is to satisfy my client. I'll commonly shoot a dozen photojournalistic images in a row and then ask those same subjects to turn, look my way, and smile. Shooting these differently styled pictures together can take less than ten seconds, and any one of them might be the photograph my client thinks is the best. Plus, shooting a variety of styles provides an opportunity to learn new things that you can then apply to your next assignment.

Some of my readers might think that I am purely a traditionalist, and although I like all the traditions associated with weddings (and I'll admit this is partly motivated by profit), those readers are wrong! I'm not locked into doing only traditional wedding pictures or any other type of wedding picture. Remember, I like them all! The best tool you can bring to any photo assignment is an open mind... and the computer between your ears.

I have studied the images of Henri Cartier Bresson with intense interest because I appreciate his concept of the "decisive moment." Being there at exactly the right moment in time and space with your camera working and set correctly is no small feat! In contrast, I have also studied the carefully contrived, illustrative images of Annie Leibovitz with equal intensity, and marveled at how Arnold Newman places a subject within the boundaries of his frame to reveal more about it than any traditional framing might. All of these wildly divergent styles excite and intrigue me because each has a beauty all its own, and the distinct styles I have learned by studying these artists, and many more, are something I can take with me on every shoot.

Since I don't believe there is one "best" style of wedding photography, I was faced with an interesting problem when writing this book: Which style of photography should I write about? The conclusion was simple: I chose to offer readers different style options for photographing a given subject whenever possible. Take note, however, that when I offer up four ways to do something, you need not immediately conclude that the first way I mention is the best. There is no "best" way! Further, don't assume that if I don't cover a certain technique it isn't worthy of examination.

For any photographic situation you face at a wedding, there are always multiple ways to make that particular photograph, and all are valid! Keep this thought in mind and don't let yourself become pigeonholed into one type of photograph because that is the real recipe for boring pictures. I believe that the old saying "variety is the spice of life" is true, and variety can turn your wedding photography into a profitable career that can keep you interested and fresh for a lifetime.

What Type of Wedding Photographer Are You?

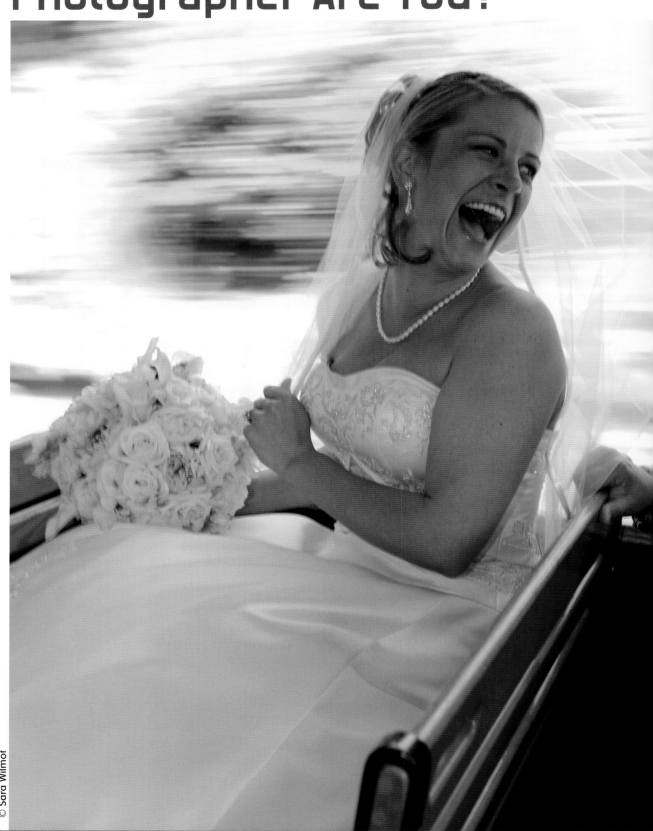

It was an August Thursday "singles" night in a New York City, and sometime before midnight I found myself at a favorite bar in Greenwich Village—The Riviera Café. Try as I could, I struck out with every woman I approached. I ended up back in my apartment alone, without even a single new phone number! By the following Sunday night, for six photographers who covered New York's hotel weddings, it had been an exhausting weekend. As we always did on Sunday night, Fred, Peter, Neil, Jim, Loretta, and I converged on The Riviera Café—this time with the excuse that we were celebrating our survival of the sweltering, humid weekend. Fred and Peter had shot a wedding at the Plaza, Neil and Jim had been at the Essex House, and Loretta and I had covered one at the Waldorf. Loretta in a knee-length black dress and the rest of us in tuxedos, we strode into "The Riv" like we owned the world, giving a wave to our friend the bartender and hello hugs to our two favorite waitresses (we were all big tippers) as we took command of a big round table.

Feeling at home, Fred immediately took off his shoes because his feet hurt—he sometimes did this even while shooting! Neil took off his jacket (probably because he had broad, muscled shoulders) and I pulled at the end of my bow tie. I let the loose ends dangle because I thought it made me look like Frank Sinatra. Drinks came as we each tried to top the other with the stories of our weekend exploits. I too told my tales of the weekend until I noticed that the girl at the bar was the one of the ladies who had brushed me off four nights earlier. With my tie still doing its Frank Sinatra impersonation, I left our table and walked up to the girl at the bar. Instead of looking at my shoes while politely asking if maybe, possibly, could I ask her name, I stared her right in the eye and said: "Hi, you look great, can I buy you a drink?" She looked me up and down, smiled, and said, "Sure, my name is Karen, a bone dry martini with two olives. Are you a musician?" I put on my best smile and answered: "No, better—I'm a photographer." As we talked and laughed the thought crossed my mind that in my wedding photographer disguise and mindset, I was invincible!

Many people consider wedding photography an art, but I disagree. Although there are moments when it may be elevated to an art form, I prefer to call it a craft. Once learned, the skills of a craft are ones you will always possess. In fact, it can be argued that an accomplished wedding photographer can go to any major city in the world and, with a case of equipment and a nice suit of clothes, make a living.

There are three different scenarios in which you can pursue being a wedding photographer. We'll cover each one in detail here because they are all worth considering. Deciding between them really comes down to personal preference—how you like to work, whether you want to do this full- or part-time, and how much money (and profit) you want to generate from your wedding photography. Normally, a book like this might start out with the basics of techniques and equipment one needs to be successful, but I would wager that you picked up this book because you want to know how to make a profit, and possibly a living, from wedding photography. That being the case, I think it makes sense to first identify what type of wedding photographer you'd like to be so that you can be thinking along those lines as you read the rest of this book.

Open a Wedding Studio

The first way to make money at the wedding game is to open your own wedding studio and contract with couples to produce their wedding photos. While this may seem the most obvious way to proceed, it can be a very laborious process. First, you need to find a way to get customers—that is, engaged couples planning their wedding—be it through advertising or word of mouth. Then, you need to show samples of your work to the couple (and often to their parents), draw up and sign a contract with them, and collect a deposit. You will then need to shoot the job, process the files, have proofs made, edit the proofs, deliver the proofs, go over the proofs with the customer, take the order, work on the files in an

© Russell Caron

imaging program (correcting and/or retouching), order the prints, examine and check the prints, send the finished prints to a bindery (or design the album yourself), place extra prints in folders, check the job over, deliver the finished product and, finally, collect the money. As you can see, there are many more steps in the process than just shooting the assignment. In fact, many successful wedding studios say that shooting the assignment is probably one of the easiest parts of the whole process!

Selling photographs is the name of the game in the studio business. While it is very important to sell the couple on the idea that you are the best person to shoot their wedding from a stylistic standpoint, stiff competition in many regions demands that a studio offer its customers a competitive rate that builds only a small profit into the price for the actual photography services. For a studio to be successful with this business model, selling as many extra prints as possible to the customers is key. These include extra prints for the albums, loose prints for family and friends, album style upgrades, or even frames and plaques for displaying the pictures. The key to success is selling the extras, both before you've been hired and after the proofs have been delivered.

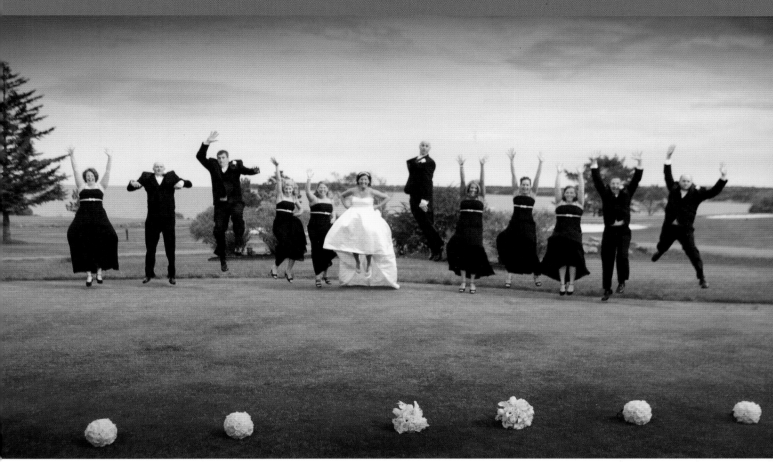

Many wedding studios offer a basic package for budget-minded customers. For example, a simple package might include:

- One 8 x 10-inch (A4) bridal album that holds 24 to 50 photographs

- Two 5 x 7-inch (A5) parent albums with 12 to 24 photographs each

- An 11 x 14-inch (A3) portrait

- A dozen wallet-sized photos

- 50 to 100 photo thank-you cards

While this package might not yield a lot of money up front, the hope is that, by offering a budget-priced option, the studio can get clients in the door and then up-sell them on more prints after the wedding is over and they see how good the proofs look. While it's important to offer lower-priced options that make you accessible to a range of clients, consider your time carefully, because up-selling the client is obviously not guaranteed. If you are going to offer an inexpensive starter package, be aware that you might be locking yourself into an assignment on that particular day that may not be as profitable as another wedding in which the customers might order a larger package. It pays to consider this if a couple wants to book you at your minimum rate for a Saturday night in June, which is prime wedding season in many regions of the country.

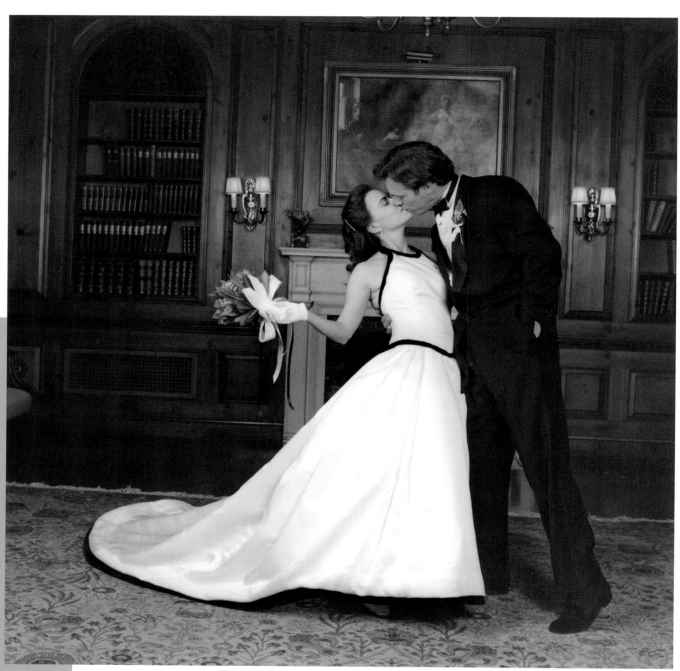

Making these decisions will, of course, vary with how well your business is established. If you have the luxury of waiting for higher-paying customers, more power to you. But if you are just getting started, you will certainly want to offer budget packages as a way of getting new customers through your door. After all, it's better to be working for the budget package price on that Saturday night in June than not working at all.

Selling your work as a package, whether large or small, has its advantages and pitfalls. On the positive side, it gets your customers to commit to a package and a price (and hopefully extras beyond the basic wedding album) from the beginning. This lets you make economical choices right from the start. For example, if a couple contracts for a 70-photograph bridal album instead of your

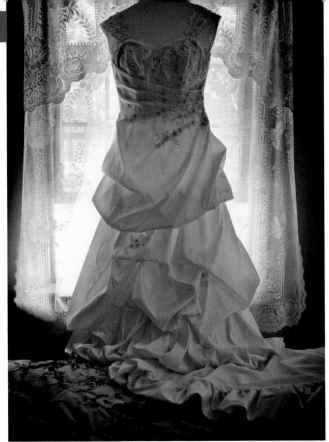

© Sara Wilmot

minimum of 24 prints, you can afford to take more photographs because the profit built into the higher package price will pay for the extra time and expenses incurred. (Check out the sidebar on page 20 to learn more.) On the negative side, expensive starting packages can often make customers resistant to purchasing extras, and building the order up during the proof-viewing session may be more difficult. So, larger, more elaborate starter packages can often mean fewer, if any, spur-of-the-moment additions later on.

© Botticelli Studios

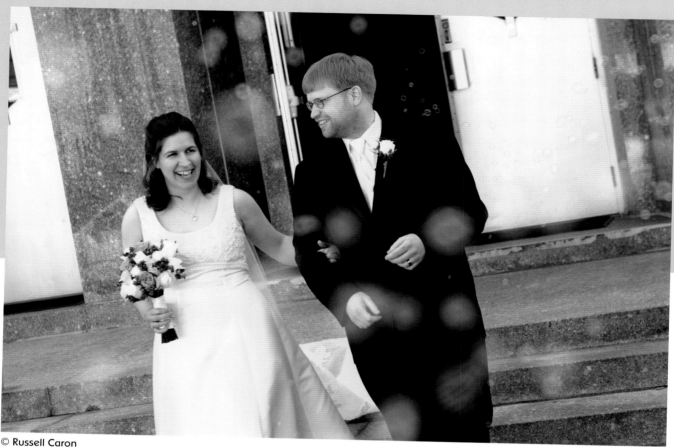

© Russell Caron

Some studios don't offer wedding packages at all. These operations usually serve a high-end clientele where the customer is less encumbered by budgetary considerations. These studios often start with a minimum order, which by most standards can be quite high. They then sell their customers all the extras (from parent albums to portraits) on an à-la-carte basis. These studios cater to the wishes of their affluent customers, and their next assignment is often obtained because of whose wedding they shot previously. While this business model is simple in many ways because it gets rid of the tiered packages and assures a decent amount of pay upfront, a studio must be well-established before it will appeal to customers of this type. There are also wedding studios that specialize in shooting for a specific ethnic group or religious community, and they often get their next assignment from referrals within that community. This can be very lucrative and, if the community is large (or affluent) enough, there may be work within this specialized area to keep a studio going for generations.

While opening a full-service wedding studio with an actual brick and mortar location is one way to milk the most profit from each individual assignment, it is also the most expensive in terms of the monthly overhead you must carry. Rent, staff, décor, advertising, insurance, utilities, and phone service (amongst many other things) must be paid regularly, and these expenses can become a huge drain compared to the income you can generate in the dire straits of February!

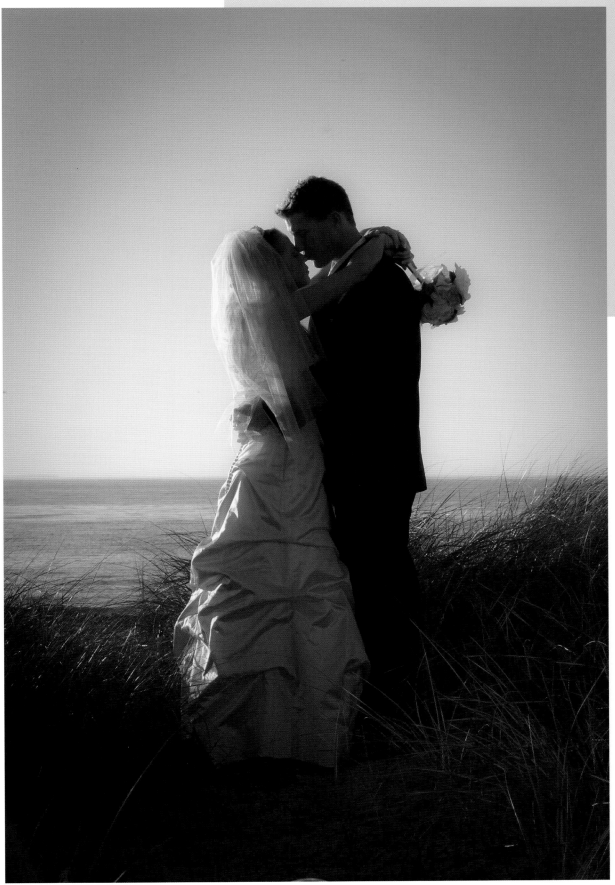

© Botticelli Studios

A Myth-Busting Moment

© Botticelli Studios

If a client opts for a more expensive package upfront, you can afford to take more photographs thanks to the profit that is built into the higher package price, which enables you to pay for the extra time and expenses incurred. No doubt, many of you may now be wondering, "What extra time and expenses? With digital, there aren't any film and processing costs!" Although I hate to burst anyone's bubble, let's take a look at the time and expenses that actually go into shooting a wedding digitally.

Over the course of the last 11 years, I have bought and filled eight external 1TB (1 terabyte) drives, used and replaced two different desktop computers, gone through five different CD and/or DVD burners, three card readers, four different versions of the memory card brand I use, and three different DSLRs. All of these hardware expenses don't include the cost of my laptop computer, software and software updates, dozens of connector cables, USB and FireWire hubs, or the various other computer doodads that I have needed to purchase to optimize my workflow and protect my work.

Now, here's the important point: If I were to shoot 2,000 images during an assignment instead of 1,000 images, the expense of all my storage and backup requirements (i.e., cards, hard drives, and DVDs) would double. Furthermore, instead of me wearing out a camera's shutter mechanism in, say, 24 months, that same shutter would need to be replaced in 12 months!

Next, let's consider the time it takes to download all the images, burn the DVDs needed for my offsite storage system, and to copy all the files to two external hard drives. Currently, using the fastest downloading bus, DVD burner, and external drives available, it takes me approximately 20 to 25 minutes to download a 4GB card, burn a DVD of the images, and copy the images to two external backup drives. At 900 to 1,100 images per wedding, my downloading

and backup workflow requires about 90 minutes of my time. If I were to double the amount of images taken at each wedding, my downloading regimen would be 180 minutes of my time. That's an extra hour and a half of work for every assignment before your client sees a single picture!

Before digital, a photographer simply dropped his or her film off at the lab and picked up finished proofs and processed negatives at a later date. Today's digital workflow has added the extra time required to get the digital files out of the camera, saved, and digitally processed into a medium ready for making prints. This time can become very sizeable, and must always be considered when it comes down to the question of overall profitability. So, while we can argue all day about one workflow and backup regimen versus another, one can't blithely say that shooting more images will not result in more time and expense simply because you are shooting digitally.

A full-service wedding studio requires constant thought, planning, and monitoring to be successful. So, while this type of operation can generate the most profit, it also requires the highest amount of both business skills and bookings to sustain. One thing photographers who are just starting out often forget to consider is the concept of keeping their overhead as low as possible to insure success. Therefore, if this scenario sounds like something you desire, remember that it almost always requires much more selling and standard business time investment than actual assignment shooting.

Lastly, since so many photographers hate the selling side of professional photography and don't have the ability to do it well, one last possibility for this scenario is to find a business partner (or employee) whose strengths in selling complement your strengths in photography. A great salesman can often do as much for the success of a growing wedding studio as a great photographer can. I know of multiple studios in my area that have become extremely successful due in large part to a symbiotic relationship between a great salesman and a great photographer. In almost every case, the salesperson doesn't know the difference between an f/stop and a bus stop, and he or she doesn't need to because most potential clients fall into the same general category!

If you want to explore this partnership arrangement, make sure there is a written agreement describing exactly how to dissolve the symbiotic relationship if the need or desire arises to do so. And be cautious to ensure that the good salesperson you are negotiating with doesn't sell you on a deal that is more beneficial to him (or her) than it is to you. If the thought of this type of agreement scares you, then you may want to consider one of the other two scenarios outlined in the following pages of this chapter.

Shoot and Turn Over the Images

Many photographers absolutely hate the production and selling work that comes before and after shooting a wedding assignment—they just want to shoot the assignment and move on to the next one. For photographers of this ilk, there is an option for simplifying the whole process and doing away with all of the complexities and costs of the studio business model. In this scenario, a photographer contracts with the bride and groom to shoot the wedding and deliver the digital image files on a DVD, leaving it up to the couple to get their own prints and albums. And with that, they end their involvement with the couple. There's no selling of prints or packages; there's just the two tasks of booking and shooting the wedding. There may be many of you who, upon reading this second scenario, are smiling broadly and saying, "That's the road for me!" What could be better? You get the excitement and fun of shooting, and you are unencumbered with all the tedious selling and production work. But before you bite at this idea, let's look at it in greater detail.

Although this scenario may seem like the perfect solution, from a profitability point of view it can be a recipe for disaster. One of the main reasons for this is because many new photographers have hung out a shingle (or put up a website) and declared themselves professional wedding photographers. Since the digital revolution, it has simply gotten easier to become a "pro" photographer because of equipment automation, a lowering of equipment prices, and the ease of reaching potential customers through the Internet. However, this has also resulted in a glut of photography school students graduating and looking at this scenario as the way to go. This increased competition has, in general, caused a lowering of prices and less wedding

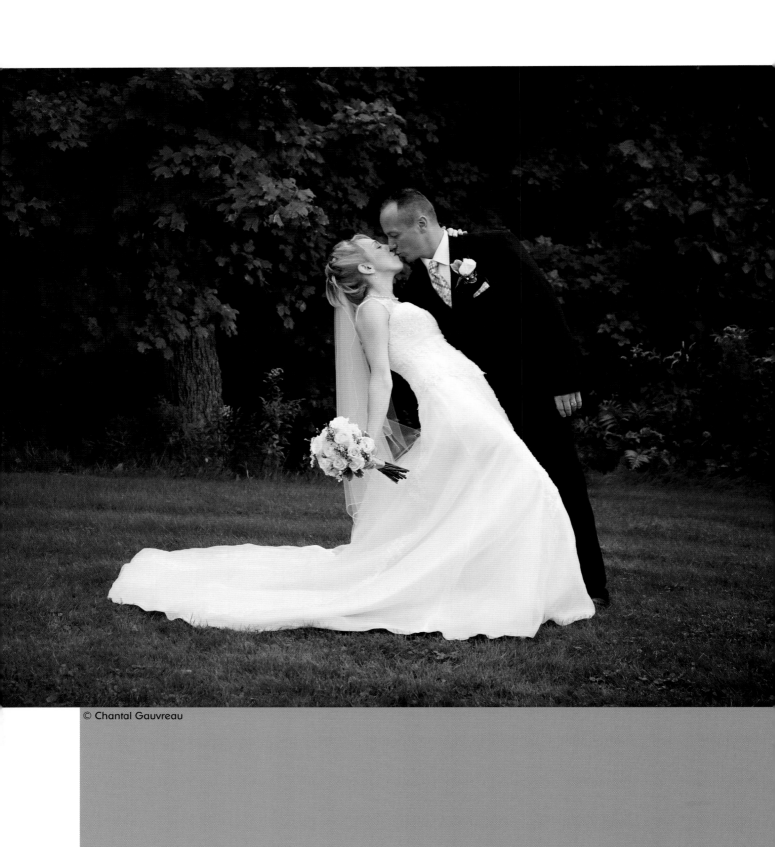

© Chantal Gauvreau

assignments to go around per photographer. Therefore, this is not a good scenario for success. To paraphrase an apt realization from one of my workshop students, if you just shoot the assignment and turn over a DVD of the images, it takes adding up the profits from five weddings just to buy a $400 backup flash unit. At some point, as prices and profit margins shrink, you're better off driving a cab or working in a fast food restaurant!

Another point to consider about this scenario is that there is no "gravy." What does gravy have to do with wedding photography, you ask? Here's the point: As competition increases and prices have to be adjusted downward, at some point, the profit becomes not gravy but "thin water" instead. For most established studios, the bulk of their profit comes from selling the extras that the brides and grooms invariably want. In this shoot-and-turn-over-the-images scenario, however, the gravy of extra profit from sales simply doesn't exist! And if you think this extra profit is mere pennies, you are very much mistaken. In my area, an extra 8 x 10 (20.32 x 25.4 cm) print sells for between $20 and $30, while a professional level color lab will produce them for you at $2.50 to $3.00. Ten of these prints will put an extra $170 in your pocket, and that's not pennies! Many established studios also offer framing and matting services—add-ons that can become another great way to profit from print sales. Sadly, none of these additional profit streams are available to the photographer who just shoots the pictures and hands over the image files.

This scenario is a recipe that, while seemingly "cool," ends with the photographer being an eternal part-timer with little chance of ever growing a self-sufficient business. In my opinion, it's a dead-end, part-time reality that will always require the photographer to maintain another job while cutting every corner when actually doing the assignment in order to make a paltry few bucks when all is said and done. The only way it can be considered "professional" is by charging a high fee for your shooting time but, as you might guess, people who can afford to pay a high fee almost always contract with an established, full-service wedding studio; the clients who are looking to buy the shoot-and-hand-over type of wedding photography are the ones looking for the least-expensive option. I am not saying that this shooting scenario can't be fun, but it is worth noting that it almost always comes at the expense of the photographer.

The Altruistic Approach

Some photographers—especially those with a secure full-time job—who run their wedding photography business on the side, rationalize their low earnings by saying they just love to shoot and don't really care about the dirty, mercenary profit at all. But, you are not just working for nothing; you are working for a loss! A negative! Don't believe me? What about the cost of your equipment, your backup equipment, repairing your equipment, your computer system, updating your photography and computer equipment, the extra wear and tear on your car, insurance on your camera equipment, buying a tux or some type of working outfit, or cleaning it? Oh, and let's not forget liability insurance. Sure, that's not necessary... until someone sues you! The list of business expenses is almost endless and, when you finally reach its end, you still have to consider that you are giving up some of the nicest weekend days of the year to shoot other people having a good time, when you could be spending that time with family and friends of your own. Is that really something that you want to give up for little or no money?

Become a Candidman

In medium to large metropolitan areas, there is another way to make money photographing weddings. If you have your own camera and lighting equipment, you can sell your services to wedding studios on a per-job basis as a candidman. This scenario is different than the other two because the bridal couple is not your client—the wedding studio is. In this instance, the trick is to be sure not to only shoot what you want to shoot, but rather shoot in the style of the wedding studio that is your client. The primary advantage to this scenario is that you have no contact with the bride and groom other than when you are actually shooting pictures of them, which cuts out a whole category of potential stresses.

The term "candidman" started in the late 1940s (soon after World War II) with the advent of flash bulbs, the precursor to portable electronic flash units. Before portable flashes and cameras were invented, couples went to a photographic studio to have their wedding portrait made. More than one portrait would only be taken if the couple could entice the rest of the family to come along, so the sale of multiple portraits was never guaranteed.

Once portable lighting joined forces with smaller, more portable cameras (like the venerable Speed Graphic), a new type of wedding photography—candid wedding coverage—was born. This new style brought on a boom in the photography business. Simply put, photographers could sell a lot more pictures by filling an album with images from a day of shooting than by filling a single picture frame with the results of a portrait session. Thus, a new breed of photographer emerged, aptly named "the candidman." And to this day, good candidmen are in high-demand in densely populated areas.

So let's jump back into the pros and cons of this working model. Just as with the other two scenarios we've discussed, shooting weddings as a candidman has both advantages and disadvantages. First off,

the pros: While wedding studios must do all the work involved in selling and producing the final product, a candidman just has to show up on the day of the wedding, shoot the event as specified by the contracting studio, and deliver the images to the studio after the job is complete. It's simple, really: Get the information about the job from the studio, shoot in the studio's style, return with the images, and get paid.

Compensation varies with location, with better pay available in affluent regions or major urban areas. Depending on the size, length, and importance of the job, as well as the level of expertise required, a good candidman can earn from $50 an hour all the way up to $150 per hour, ranging from around $300 to $1200 per assignment. Some studios are so large that they can keep a candidman's schedule totally full, offering their best shooters a contract that specifies a specific number of assignments per year (usually anywhere from 50 to 125 jobs). In such a case, the photographer crosses over from being a candidman to being a contract shooter. Just remember, getting to the top is not an easy proposition. You have to compete with guys like me! Being a top candidman requires commitment and a solid reputation for reliability that can only be built over time.

Good candidmen often shoot for more than one studio without ever encountering a conflict of interest, especially in large cities. Many candidmen (myself included) change their style so that their photos match the samples the studio has shown to the customer. Some studios show very formal portraits to prospective customers, while others present photos shot in a more photojournalistic, relaxed style. A good candidman can switch from style to style to satisfy a wedding studio's needs and that of its customers.

© Botticelli Studios

Being a Candidman and a Studio Owner

For some photographers, the first step towards opening their own wedding studio is to become a candidman. Established studios (especially in larger cities) have many assignments that a good candidman can pick up while building a sufficient reputation to support his or her own studio. And, many small wedding studio owners switch hats and shoot as candidmen to supplement their studio's income. While this supplemental income can be helpful, many established studios are wary of hiring a candidman who is also a studio owner. Plainly put, an established wedding studio is not in business to further the reputation of one of its freelance employees' studios. Why should they help their competition? With this thought in mind, it is easy to understand that it is a big "no-no" to give out business cards for one's own studio while shooting as a candidman for another. Photographers who do this usually find that assignments from other wedding studios will be few and far between.

However, in densely populated areas, it is possible for a studio owner to have his or her own clientele and shoot as a candidman for studios that cover an entirely different segment of the population. Examples of this can be found most readily in areas where there is a great deal of ethnic diversity. For example, if your studio mostly handles Protestant weddings, you can shoot as a candidman for studios that cater to a Jewish (or Greek, or Italian) clientele with little chance of running into a conflict of interest. Or, if your studio is on Long Island, you could also shoot as a candidman for a studio in suburban New Jersey with little chance that the two studios' clientele will overlap. Again, this scenario is really only possible in large, densely populated metropolitan areas.

While the life of a candidman may seem perfect because there is no selling or album-producing involved in the job, and the money is better than that in the shoot-and-hand-over wedding photography model, it does have one main disadvantage: Candidmen don't build a clientele the way a wedding studio does. In fact, they help build someone else's reputation with their hard work. So at the end of a career, candidmen have no tangible business to sell or pass on to a second generation. The candidman's eyes, hands, voice, and equipment are the only assets of the business, and they are assets that can't be sold to fund a comfortable retirement.

© Russell Caron

Building a Business

Regardless of which path you choose from the scenarios I have outlined here, there are some standard rules of the game and equipment needs that are helpful to know about. First, success in wedding photography, like in real estate, is a matter of location, location, location! Smaller cities and towns with only one photo studio and one catering hall limit your possibilities. Big cities, on the other hand, offer a variety of options and opportunities.

Second, it pays to be able to shoot in many styles. Just because you fancy yourself a photojournalist doesn't mean your clients aren't going to want a mix of posed shots and photojournalistic-style images! Believe me, if you're not willing to change up your style to give the client everything they want, they will easily find someone who will. Every photographer is replaceable, whether we like to admit it or not!

So, what's next? Now that you've got some idea where you fit into the world of wedding photography, let's look at who and what you might want to photograph. In the next chapter we'll go beyond the making money aspect of the business and get down to the task of shooting an assignment.

Wedding Photographer Necessities

Here's what I think you'll need (in order of importance) to play at the top of the game (i.e., elegant, big-contract weddings) in any big city:

- An easygoing, engaging personality

- Good communication skills

- Passion—an intense desire to treat any assignment as if you were shooting a spread for a national magazine

- The ability to keep your cool—and your wits— about you

- Good to very good (notice I didn't say "great") photographic skills

- A complete digital camera system with at least two camera bodies and backups of all other major gear (meters, sync cords, lenses, memory cards, etc.)

- At least two battery-powered flash units (three or four would be better for a big-contract wedding) with battery charger(s), brackets, light-activated slaves, radio slaves, and plenty of extra batteries

- At least two (three would be better) AC-powered flash packs with three to four strobe heads, or two to four self-contained AC-powered flash units

- Light stands and lighting accessories (barndoors, clips, umbrellas, bank lights, boom arm, etc.)

- A tuxedo or equivalent formal attire and a neat, clean appearance

- A reliable car

- Liability and theft insurance

- A date book or calendar program for keeping organized

- A desktop or laptop computer

While some may think the equipment required is too costly, acquisition of these items can be spread over a long period of time. Also, please note that I list photographic skills as fifth in importance. Your friendly personality and a passion for the work are more noteworthy assets.

Preparing for the Shoot

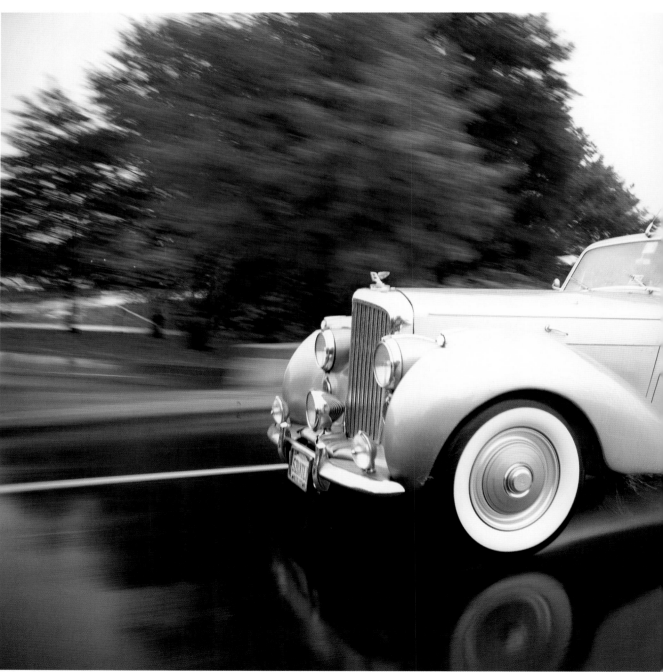

© Freed Photography

I once shot a wedding for one of America's great families. I worked all day, into the night, shooting around 500 pictures. Within a week, I received a check for the entire amount called for in my contract. But when the proofs were returned, the customer wanted only three 8 x 10-inch (A4) portraits. I called to find out what was wrong with the rest of the pictures and was told (by a secretary) that my clients loved the pictures, but they needed only one print for the bride and groom and one print for each set of parents. Even considering yesteryear's prices, I had sold three prints for $1,000 each! Years later, as I toured the summer estates of America's aristocracy in Newport, Rhode Island, I realized what had happened. For people with a mansion in New York, a villa on the Riviera, and a horse farm in Kentucky... people with a second (or third) home on the Seine and a chauffeur on the house staff... for these beautiful people, a wedding is just one more nice day in a life filled with nice days.

However, for every one of these people, there are millions of others for whom a wedding is a most special event, hopefully a once-in-a-lifetime occurrence. To these people, every nuance of the traditional wedding is something to be savored and remembered—and photographed. A repertoire, as used in the context of this book, is a list of all the photo opportunities (both real and staged) that record those nuances and traditions.

Building Your Own Repertoire

Granting that there are probably as many different kinds and sizes of weddings as there are people getting married, there are still a remarkable number of similarities when you start to compare them. First off, weddings are a coming together of people to celebrate. There is also some sort of officiant to recognize and certify the couple's commitment in the eyes of a deity and/or the government. But, after that, everything else is an extra frill. The cathedral, the caterer, the florist, the photographer, the multi-tiered wedding cake, the open bar, the live orchestra, the DJ—all these extra things are just that: extras. And, regardless of these extras, the dedication, commitment, and love expressed by the bridal couple towards each other is not dependent upon the number of guests, what's on the dinner menu, the type of entertainment at the reception, or how the event is recorded.

The wedding repertoire I present in this book is a basic shot list, a standard to compare against when you are planning what you might want to shoot on a typical wedding assignment. Remember, though, that every wedding is different, so please take into account that the list included here must be pruned or built upon to suit all the little things that make each wedding unique. What I am offering is a basic framework that you should feel free to expand upon or contract as the individual case demands.

© Botticelli Studios

© Russell Caron

© Russell Caron

On any wedding assignment, my main goal is to produce a set of photographs (and, eventually, a wedding album) that will tell a story about the day. If you go through my repertoire carefully, you'll notice that, although all the shots are listed, exactly how they are produced is not always mentioned. This is where your individual creativity and style come into play.

A repertoire is a living, breathing thing. You can use mine as a starting point, but the best repertoires are filled with individuality. So, the real idea here is to use my list as the basis for creating your own. Feel free to add, subtract, and combine it with your ideas and those of other photographers, and always remember: The best repertoire for you is YOURS!

A Great Starting Point

For the novice, having a repertoire is essential. Very often when new "wedding warriors" go on their first assignments, they draw a blank when it comes time to start taking pictures. By having a list of pictures and going down that list, you always have something to fall back on. This is not to say that you shouldn't be constantly trying to build and improve your repertoire to keep

© Russell Caron

assignments fresh over a long period of time, but if a new wedding photographer can capture 95% of the photographs on this list, he or she will be able to produce a wedding album that both tells a story and has great sales potential.

Looking at wedding photography through the eyes of a pro by enlisting the help of a tried and true repertoire can be enlightening. Every wedding (from ceremony to reception) has specific events that occur. Realistically, after you've shot 100 or so weddings in your area, you should start to see which events happen with the most regularity. As your experience grows, you'll find that brides and grooms are constantly explaining to you how unique their wedding will be, while in reality you've seen the same flaming bridal cake in the shape of a volcano at the local catering hall a dozen times. No matter what, do not diminish or deflate the excitement they show. Delight in their enthusiasm because it will sell photographs. Just smile to yourself and remember that the volcano cake shot is paying for your new car.

Photojournalistic vs. Posed Photography

Wedding photographs can be categorized into to very broad styles: posed and photojournalistic. The biggest difference between these two styles lies in the presence or absence of photographer intervention and/or direction. Regardless of which style a photographer prefers, in order to shoot an assignment competently—any kind of assignment—a pro must have some idea of what he or she is going to shoot. Whether you call it a shot list or a repertoire doesn't matter. Having a solid approach in mind is a good idea, even for shooters who think that photojournalism is all the rage. The list of photographs that I'm proposing should still get covered, even if the photographs are casual and done with an absolute minimum of photographer direction.

Personally, I don't subscribe to a singular style of wedding photography; I like both photojournalistic and posed shots, and I feel that each is more appropriate at different times during most wedding assignments. I like a mixed-bag approach, with posed portraits of certain people

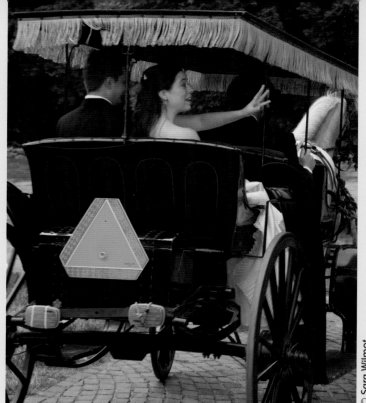

© Sara Wilmot

©Russell Caron

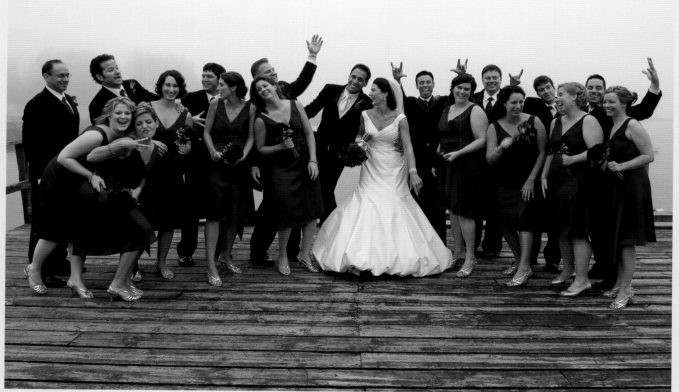

© Sara Wilmot

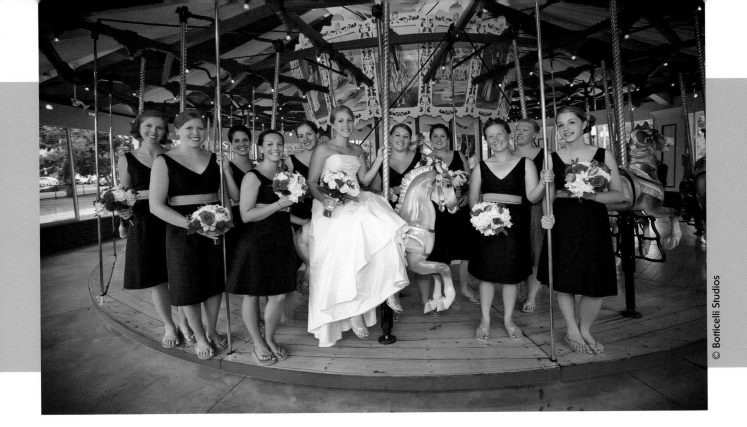

at certain times during the day combined with a completely unobtrusive style for situations where I am just an observer (though not a casual one!).

Some photographers who lay claim to the photojournalistic style might feel that even the thought of shooting to a repertoire is disingenuous, and the very antithesis of what they try to do. Without casting aspersions, I can safely say I have never done an assignment as a professional photographer in which I wasn't made aware of who the principles I was shooting were, what they would be doing, and what the point of my assignment was. This information is not given to limit my shooting, but merely to ensure that, at a minimum, I capture the most important players and events. This requires some planning, and though I do shoot plenty of photojournalistic-style images on a given wedding assignment, I do not forgo my essential checklist of must-have shots in favor of capturing everything on the fly—nor do I recommend that course of action!

Keeping to this train of thought for a moment, let's say that you are a strong advocate of photo-journalistic style and, on your first wedding shoot, you see the bride's dress hanging serenely on a doorframe, awaiting its moment in the sun. You take a picture of it that the bride loves. Now, let's

say that at the next ten weddings you shoot you also see the bride's dress hanging on a doorframe, and each time, you take essentially the same photograph of the hanging dress for each of the ten brides. All the brides love the photograph of the hanging dress, each includes it in her wedding album, and to each, it creates a special memory. Is the picture of the dress you take for the tenth bride any less unique or less meaningful than the one you took for the first bride? I think not. Each bride got a picture of her unique dress taken on her unique wedding day. Like it or not, whether you're more on the side of a being photojournalist or a traditionalist, the shot of the wedding dress hanging in the doorframe has become part of your repertoire, and there might even come a day when the dress is draped over an armchair when you arrive, so you hang it on the doorframe and take your picture of it.

Furthermore, while some think that shooting exclusively photojournalistic images is where it's at, it pays to remember that weddings, by their very nature, are steeped in tradition and custom. Weddings are a time when families and friends dress up and come together. A large majority of couples getting married revel in the traditions and, good news for us, they want pictures of them.

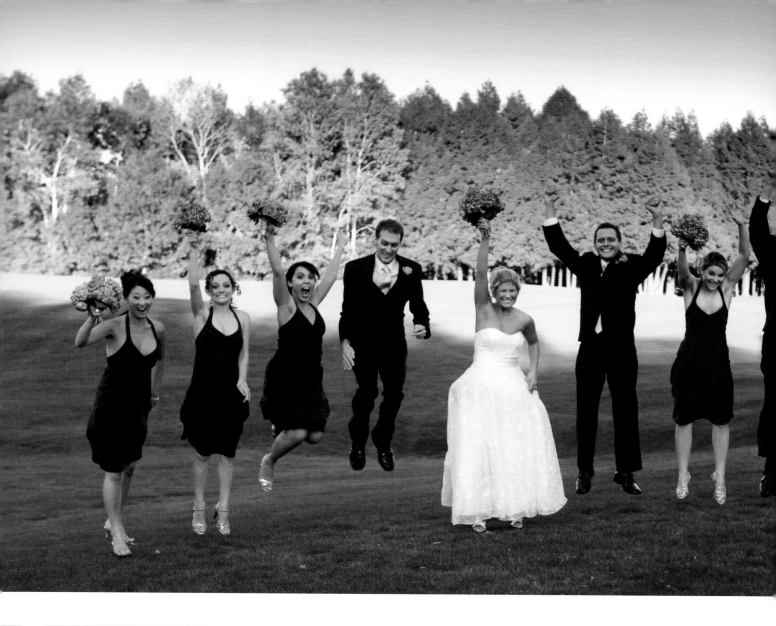

Plan Ahead

A repertoire is based on the first pro axiom: Plan ahead. Bear in mind, though, that you should still be prepared for the unexpected. You may go to an assignment knowing that you want to do a formal portrait of the bride and her sister because it's in your repertoire. You want formal, but they want to throw their arms around each other and hug. The photographers with the best people skills can get both shots, but even if you only get the hugging shot, having a plan you deviated from is still better than having no plan at all.

The repertoire I offer in this book is certainly not engraved in stone. You may pull out your camera and suggest where to start, and the bride might make a face signifying she doesn't like the idea. At that moment, it's time to modify your repertoire (or at least that section of it). Other times, you may take a photograph during one of the five basic segments of coverage (the bride's home, ceremony, formals, family pictures, or reception) and discover it fits somewhere different than the place it would fall in the normal scheme of things. That's okay! There are no hard-and-fast rules dictating the order in which you must take

©Russell Caron

the pictures. A specific example of this might be when you plan to take a photo of the bride and all her siblings before the ceremony (at the bride's house) only to discover that three of her brothers aren't there because they are at the church acting as ushers. That's okay; you can always pick up that picture later in the day. You still want that picture, even if it doesn't happen at the bride's house as you originally planned it would.

However, there is safety in working with a plan. Not only do you not want to lose a sale, but you also don't want to be responsible for missing a memory. Having a plan in-hand can help you avoid both

pitfalls. In addition, by having a specific idea of what you're going to shoot, you can manage your time better. Knowing that you have a dozen full-length photos, a dozen bust-length shots, and a dozen close-up photos of the bride on your camera's memory card frees you up to concentrate on getting photographs of other important people at the wedding (like the groom, primary family members, and the couple's friends). As you can see, this type of information is very important; in order to be the "harbinger of happiness" to the bridal couple—and have a profitable business—you have to cover the assignment.

Another advantage of shooting to a repertoire if you are a studio owner is that you can book more than one job on a beautiful Saturday in June, sending additional photographers to shoot your repertoire in your style on other assignments. Your repertoire can serve as a blueprint to teach other photographers whom you hire how to capture the kind of images clients expect from your studio.

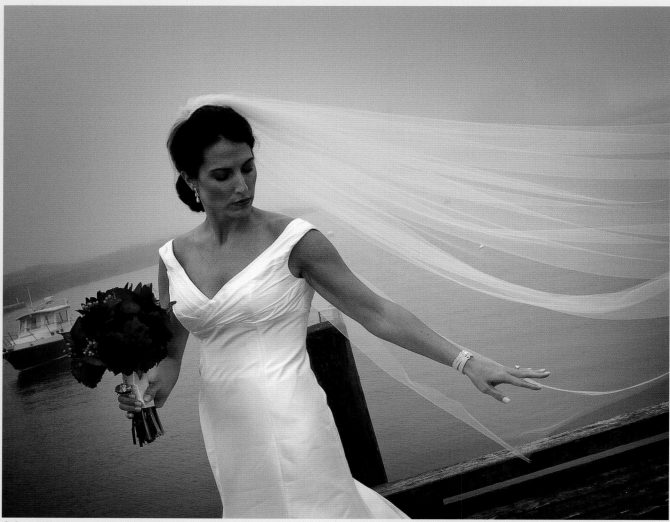

© Sara Wilmot

Be Flexible

To follow my wedding repertoire, you should arrive at the place where the bride will be getting dressed an hour and a half before the ceremony. After checking out the locale, spend at least one hour working with the bride, her parents, her siblings, and the bridal attendants. Some feel that an hour shooting in the bride's home shortchanges the groom's side, but many consider a wedding to be the bride's day. From a photographer's point of view, more can be done with a beautiful gown, headpiece, and bouquet than with a tuxedo. Also, brides are often more interested in wedding photographs than their grooms are. Therefore, it makes sense to take

more time to photograph the bride. (So much for equality of the sexes!)

If a customer insists on pictures of the groom's preparations, this would be a perfect time to sell them on the idea of hiring a second photographer from your staff (if you are a studio owner). The photographers can start at the two principals' homes, shoot parallel pictures, and meet at the church. (If that is the game plan, note that the order of the repertoire changes with regard to when you shoot the groom's family pictures.) Like many extras in the wedding photo game, this can be a situation that allows you to make additional profit.

Maximize Your Time

Between the ceremony and the reception, you will have one to two hours in which to take formal and family photographs. This time can be spent at a park (weather permitting), in a backyard, at the altar (if another wedding isn't booked during that time), or even at the photo studio or reception hall. In any event, if your time becomes limited, either because the subjects are not ready or because of how long it takes to travel from one location to another, you must start to prune the repertoire. In that case it's best to concentrate on photos of the bride and groom, the parents, and larger groups. A picture of the bride with each of her six sisters will take six times as long to shoot as one with all the sisters together.

A well-planned repertoire can really maximize your shooting time and ease the transitions from one shot to the next. You can plan to create a group picture in such a way that you keep adding people to a pose, shooting as you build the scene. For example, you can start with the bride and groom, picking a pose for them that can serve as a foundation for a larger group shot, such as the bride facing the groom and their rear shoulders touching. Then add a set of parents, with the mother facing the bride's back and the father behind the groom. After taking that picture, you can add the siblings and shoot an immediate family photograph, then add the grandparents and shoot again. After that, instead of letting the pose dissolve, you can remove the parents and grandparents and be left with a pose of all the siblings together—a perfect picture for the album or, better yet, the parents' living room.

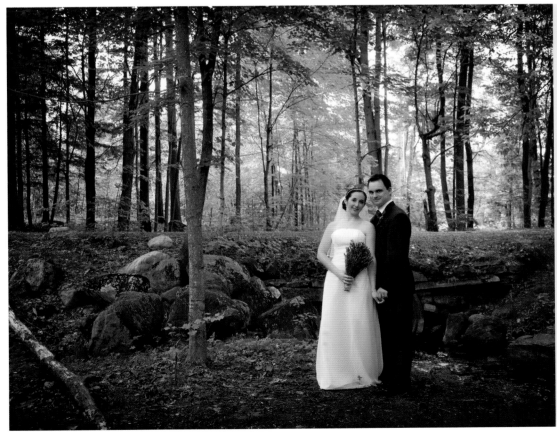

© Chantal Gauvreau

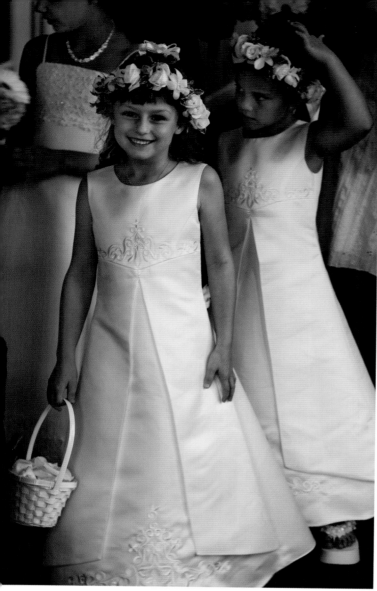

© Sara Wilmot

Become an Insider

The photographer is the first in a long line of people who will help the couple through their wedding day. The priest or minister will tell them where to stand, the maître d' or caterer will tell them when to eat, the band leader will tell them when to dance, and you will pose them, even if only by suggestion. While these other "helpers" may supply directives, the smart photographer will use a softer voice and offer suggestions instead.

You have a terrific opportunity in being the first of these authority figures to see the bride on her special day: You can use your first-in-line position to your advantage. While I can (and do) make 50 – 100 different pictures in one hour at the bride's home (shooting many of them multiple times), I also use this time to become an insider—a friend.

Insiders have privileges. Their counsel is heeded. This is just what you need in order to do the best job possible and generate recommendations. During my first hour with a bride, I ask questions. Even these questions could be considered a repertoire of sorts by themselves because, at every wedding, I'm interested in the same sort of information. It is always helpful to know such things as: How long has she known the groom? Who is her maid of honor? How close is she to her sisters and brothers?

If the bride confides in me that, for example, she's close to her sister or doesn't like her future mother-in-law, I'm on my way to being an insider. Every question I ask, every bit of information I get, is absorbed for later use. Where are they going on their honeymoon? This can be used some time later when the groom has a hard time smiling. I can say, "Think of you and (bride's name) on the beach in Malibu (or wherever)."

I ask questions about the ceremony: How well do they know the officiant? Is the person performing the ceremony a friend of the family? If so, a picture of him (or her) with the couple is in order.

As important as it is to ask questions, it is even more important to listen to the answers. This takes a high state of concentration. Even if you are a new photographer and you know your first subjects intimately (because they're probably friends), it still pays to ask questions and pay attention to the answers.

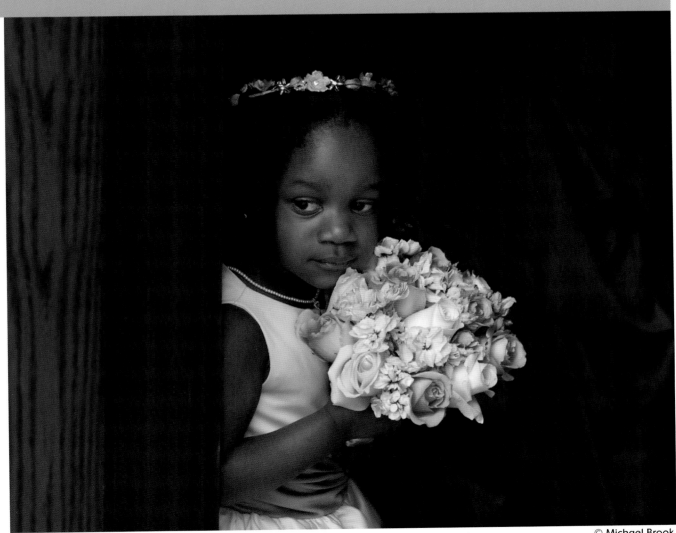

© Michael Brook

Equipment Concerns

Logistically, once you get to the bride's house, it's smart to create a base of operations—a safe place where you can put your equipment. I often choose the kitchen table, but what you need is any flat surface that's away from the areas where you'll be shooting. I usually lay out a zoom with a moderate normal range, a portrait lens, a wide-angle zoom, some specialty filters I like, and so on. I also test-fire my flash equipment a few times. I might even go

so far as to shoot a few test images in areas where I might be photographing, checking my LCD monitor to be sure I'm in the ball park exposure-wise.

Finally, after my camera and flash equipment, the most important accessory I carry is my tripod. Sometimes, up to half the pictures I shoot at a wedding are taken with my camera mounted on a tripod. In fact, anytime my shutter speed drops below 1/60 second, I use a tripod religiously.

There are times when a tripod may be impossible to use, such as during a processional at a church, or on the reception hall dance floor. Generally, though, my tripod is my constant companion. Not only will it sharpen available-light pictures and free my hands for holding filters in front of the lens, but it also adds a certain presence to your camera that smacks of professionalism. Lastly, it offers the possibility of adding movement to a still photograph by capturing some subject movement during a long exposure.

How Many Pictures Should You Shoot?

During the process of editing and laying out this book, my editor called and asked if I could note how many images I take of each pose, setup, or situation that presents itself at the average wedding. She felt that it would help the reader (you!) get a handle on why I decide to shoot 10 images of one picture but only two of the next. As I thought about this, I realized that there were a number of different things I take into consideration when deciding how many times I push the shutter button each time I lift my camera to my eye. Each consideration is different, so I want to spend a few moments identifying them individually.

In the days of film, every single image— including film, processing, and proofing— cost between $.75 and $1. For every pro looking to maximize profit, this was a sobering thought that tempered the button pushing of successful wedding photographers. Digital imaging has changed that formula. Even so, every pro who shoots digital must always be aware that shooting insanely high numbers of images magnifies the amount of post production time, and that time greatly cuts into your profitability. It has been said that the most expensive commodity a professional photographer has is his or her time, and I, too, believe this is true. So, keep this thought in mind before you take 25 pictures of a single pose.

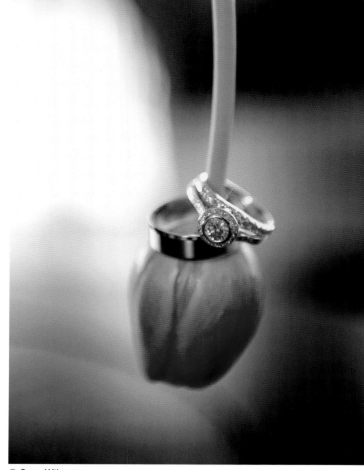

© Sara Wilmot

Single Pose vs. Full Portrait Workup

Consider the difference between a pose and a full portrait workup. While a pose is a single shot regardless of how many times you shoot it, a full portrait workup includes full-lengths, bust-lengths, and close-ups, and you might even get to throw in some environmental renditions, such as of the bride featured as a smaller part of a huge scene. Plus, a full portrait workup allows you to capture detail shots of the bride's gown and accessories.

What accessories, you might ask? Obviously, the bridal bouquet, but also consider these items, if her wedding attire features them: a big bow, a laced-

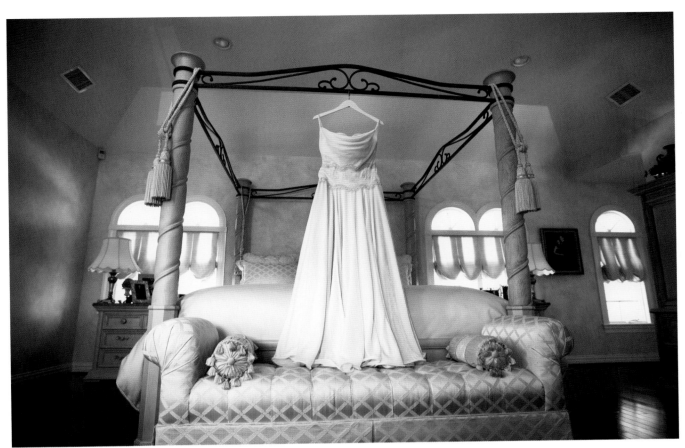

© Botticelli Studios

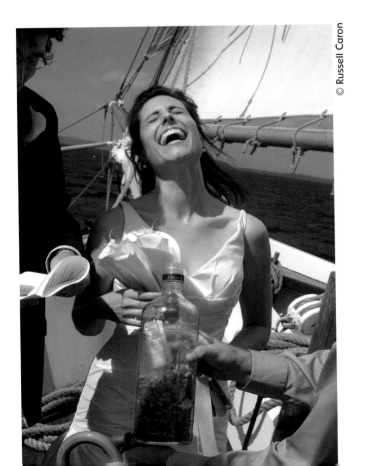

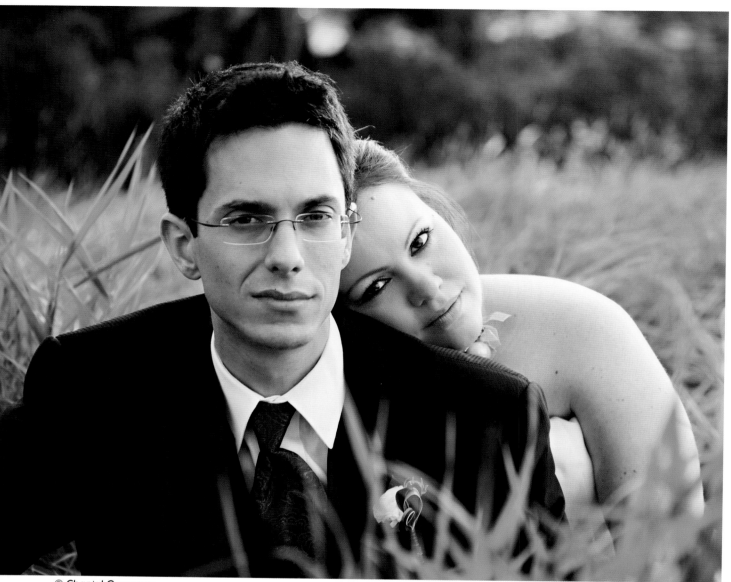

© Chantal Gauvreau

corset-type bodice (shoot the laces!), lace or satin gloves, a great manicure, a headpiece, her shoes, a fabulous earring or other piece of jewelry, a garter, or any other unusual or beautiful element. All of these are potential detail shots of bridal accessories.

If you pose a bride and then shoot 25 images of her in that exact pose, the result is complete overkill. Photographers who like to set their camera's advance rate to high-speed continuous shooting should remember that a bride is not a racecar! Slow down your shooting and be conscious of how many shots you take so that you will waste less time later wading through images. No bride is going to choose more than one image of a specific pose.

In instances when I am shooting one or two posed subjects, especially if my camera is tripod-mounted (which allows me to view my subject with my naked eye during the moment of exposure), four to five images of a single pose are more than enough. Importantly, though, this rule is somewhat different for the bridal couple. For them, I usually shoot anywhere from 6 – 15 poses of each of them individually, then 6 – 15 more of the couple. This means that I end up with anywhere from about 25 to 75 formal portraits for the bride and groom to select from.

Different Rules for the Stars of the Show

The stars of the show get more poses and more pictures of each pose than other subjects do. The supporting cast members (listed in probable order of importance) are the couple's parents, siblings, grandparents, nieces and nephews, and the bridal party. The actual order of importance will vary from bridal couple to bridal couple. However, all these supporting cast members get preferential treatment as compared to any other people attending the wedding celebration events.

The one exception to the rule of the bridal couple getting the most photographs per pose comes when shooting large groups. As a general rule, as the number of subjects in the photograph increases, so does the number of images I take of each pose. So, a family group of five or six subjects who fit into the "star" category might get 10 images per pose and two or three poses to choose from; a 40-person extended family photograph might only get 15 to 20 images of a single pose. Sometimes—just so my subjects don't get bored while I crank off the 15 to 20 images—after I take the first 10, I suggest we take a second photograph "just in case," and make a minor change in the arrangement. This trick is not so much for me, but rather so that the group accepts the idea of having to take five to ten more photographs!

Minimally Posed and Photojournalistic-Style Shots

Aside from formally posed pictures, there are two other loose categories of images I shoot regularly at weddings: groups posed casually on the dance floor or around a table (I say something like: "Hi, could you two [or three, etc.] get closer and look this way?"), and photojournalistic images in which I offer no input to the subject(s). For the casually posed shots, how many images I take depends upon whose idea it is to take the picture. If I suggest the picture, I rarely take more than two; if one of the "stars" suggests it, I usually grab three or four images.

Importantly, and as previously mentioned, if this type of picture contains more than two or three subjects, then the number of images I take balloons up to six or eight images. To make this more palatable to my subjects, I often shoot three or four images of this type of group and then say something like: "Wait a minute. You're all friends (or "you're family")—hug each other!" As they hug, I shoot another three or four images, and that means I have two variations of an important grouping (remember, a "star" asked for the picture!).

When it comes to the purely photojournalistic shots in which I have no input other than to record the moment, for years I would shoot a single image in this type of situation and then walk away. But, I have realized that sometimes what I thought was "the perfect moment" gets even better if I wait a few seconds more. So today, when I'm in photojournalism mode, whenever I shoot a picture, I wait to see what unfolds next with my subjects, and a single image often turns into five or six images.

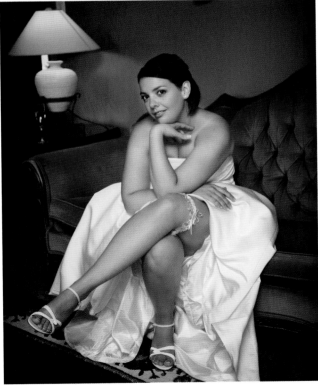

© Chantal Gauvreau

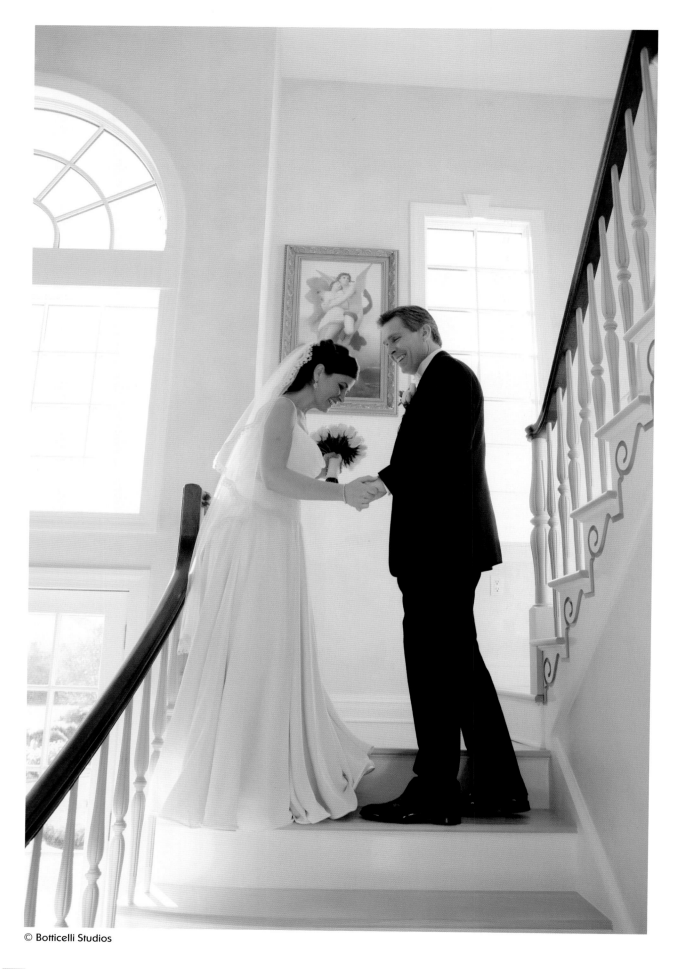

Concluding Remarks

While I just explained how many images I take in a specific situation depending upon who the subjects are, how many subjects are in the picture, or what type of picture it is (formal portrait, casually posed, or photojournalistic), you must take the information I offer here with a grain of salt. In other words, you have to season it to your own tastes because, in a way, this is all a bunch of hooey! Do I shoot five or six images of a single pose, photo opportunity, or portrait situation then just turn around and walk away? Almost never! My goal is to get at least one great image from every situation I shoot while still working within the time constraints of the assignment... and that should be your goal too! The immediate feedback provided by the camera's LCD screen means that I can be sure that I have a reasonably good portrait before I give up and try a different approach or another pose. So, when I mention a specific number of photos to take of a specific situation, please remember that the number is only a guideline—nothing more, nothing less. When trying to satisfy a client, the best wedding photographers (those who take great images and generate tons of recommendations) stay loose. I'm always willing to change my approach at the drop of a hat, and in my opinion, you should be, too.

Finally, to put everything into perspective, I will tell you that for the average wedding assignment I cover, I shoot between 750 and 1500 images. The actual number of images depends upon how long I'm hired for (I have a 6-hour minimum), how big the families are, how big the bridal party is, and how active and involved the guests at the reception are. Further, because I shoot as a candidman at large, big-city weddings, there is usually a second photographer and an assistant crew (both from the same studio that hired me) and, in those cases, the number of images balloons to about 2000 broken down into a 1500/500 or 1000/1000 mix depending on which of the crews is covering what.

What you've just read deals with getting your head in gear before you start shooting a wedding. It involves you thinking about, and making, some sort of plan while being willing to deviate from at a moment's notice as the situation changes or the client provides you with more input. Now, you're finally ready to make pictures, so let's proceed to the bones of the business: a working wedding repertoire.

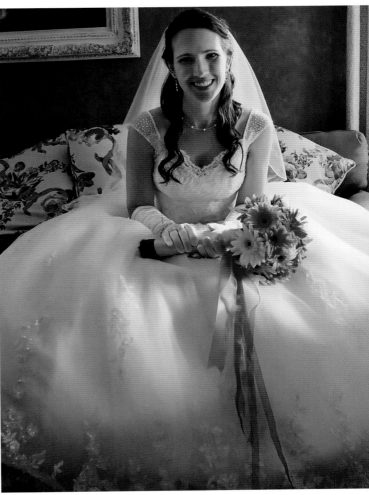

© Michael Brook

My Wedding Repertoire

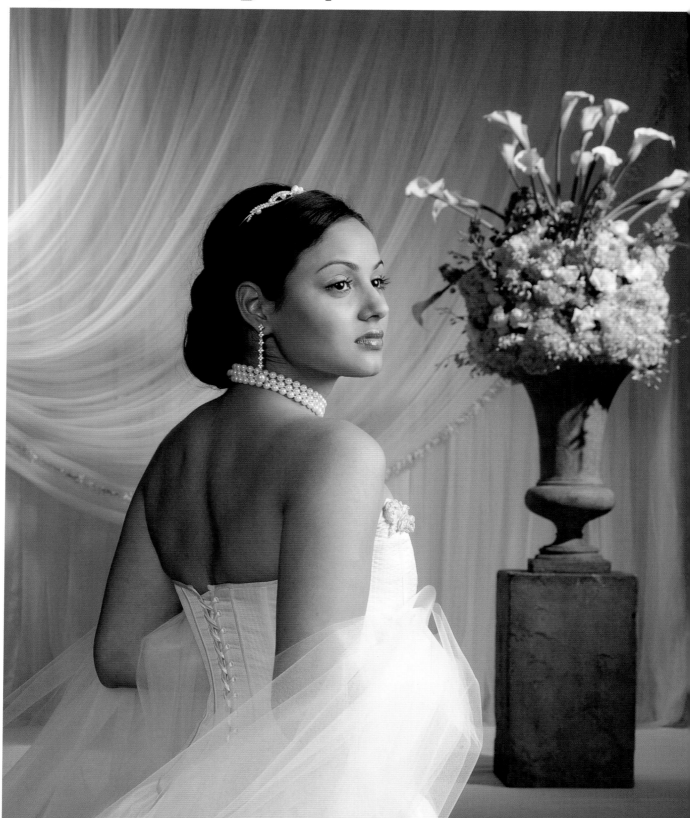

It was a beautiful Saturday afternoon for an outdoor wedding reception set on a rolling lawn behind a mansion. The guests waltzed on the portable wood dance floor under the tent as I watched two young boys, maybe 5 and 7, staring in awe at the three-tier wedding cake on a front table. I could tell by their expressions it was the largest, most sugary cake they had ever seen. Using a long lens, I took a few images from afar so as not to interrupt the kids' fantasy.

As I watched, I decided that this fantasy had, no doubt, progressed to how great it would be to actually taste the cake! With that in mind, I put a wide-angle lens on my camera, walked over to the little guys, and said, "You should take a finger-full of the icing and taste it right now!" The expression on the older boy's face was one of incredulity as he whispered, "We can do that?" I smiled and said, "Absolutely!" I pointed to a spot on the a back part of the cake and said, "Do it right here, and if anyone yells at you, just tell them the photographer told you to do it!" As I stepped backwards to about five feet (1.5 meters) away, the boys looked at me, then at each other, and the older one reached out and swiped a finger-full of icing off the cake and stuck it in his mouth. I shot my picture. Then, a second later, the younger one did the exact same thing. I was ready and shot a second picture, then both kids ran away smiling and laughing.

A few seconds later, the bride's mom came over to me and told me she had just watched what had transpired between the boys and myself. Feeling caught, I just smiled while trying to think up something to say. But before I could respond, she smiled and said, "Those two pictures you just took… they were the most precious pictures I have ever seen!" My response was immediate: "Don't blame the kids, I told them to do it." She said, "Blame them? I loved it!" With that she smiled once again and walked off.

The very next day, another wedding rolled around, and there were two other little kids staring at the wedding cake. What can I say? So much for photojournalism!

This repertoire has been designed to include most of the basic photo combinations you should consider covering at a typical wedding. What do I mean? Well, I guess some definitions are in order. I think of people placed together in wedding photographs as combinations. Furthermore, I refer to a one-person picture as a single or a one-up, a two-person picture as a two-up, a three-person picture as a three-up, etc. And when I mention a workup, I am referring to a group of photos (i.e., "the groom's family workup" refers to the group of pictures of the groom's family).

Finally, although this repertoire is pretty complete, it should not be considered anything more than a framework of ideas around which to build your own repertoire. Your repertoire should be yours as my repertoire is mine. Feel free to add to it or prune it as you see fit. In truth, I do that to mine all the time! So, without further ado, here is my current wedding repertoire, with annotations.

NOTE: For the smaller repertoire sections that come later in the Other Special Family Occasions chapter, I broke each section up into a separate shot list specific to that topic. For the shots outlined in this chapter, however, I have used continuous numbering. This is to help you get a sense of the overall number of different shots and poses you are looking at as you head into a wedding assignment.

While it is true that many of the same things happen at almost every wedding, it is equally true that each wedding is unique. Part of a wedding photographer's job is to cater to that uniqueness. To that end, an important trait worth developing is learning to shift gears at a moment's notice. In my opinion, if you doggedly cling to the idea that changing your repertoire on the fly is a huge hassle instead of a creative opportunity, you are running down a dead end that will only make your job more difficult. If, instead, you look at the change in plans as just another opportunity to create something that's fun and exciting, you'll have a much more fulfilling career and a happier, easier time doing your job, which is a good thing because the feelings you project will also rub off on your subjects.

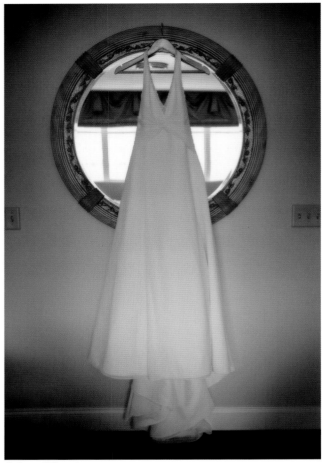
© Sara Wilmot

The Bride's Home

Although I call this section "The Bride's Home," please don't take that too literally. In reality, this set of photographs will occur wherever the bride is dressing. I have photographed thousands of brides at their parent's homes, and I have also photographed a bride dressing in her and her fiancé's apartment, in hotel honeymoon suites, at bed and breakfasts, seaside resorts, boat and pool houses, country clubs, friend's houses, catering hall dressing rooms, church meeting rooms, spare room's at synagogues, rabbi's libraries, and even large bathrooms at restaurants! It doesn't matter where it happens; wherever the bride is getting ready, that's where you will make your images.

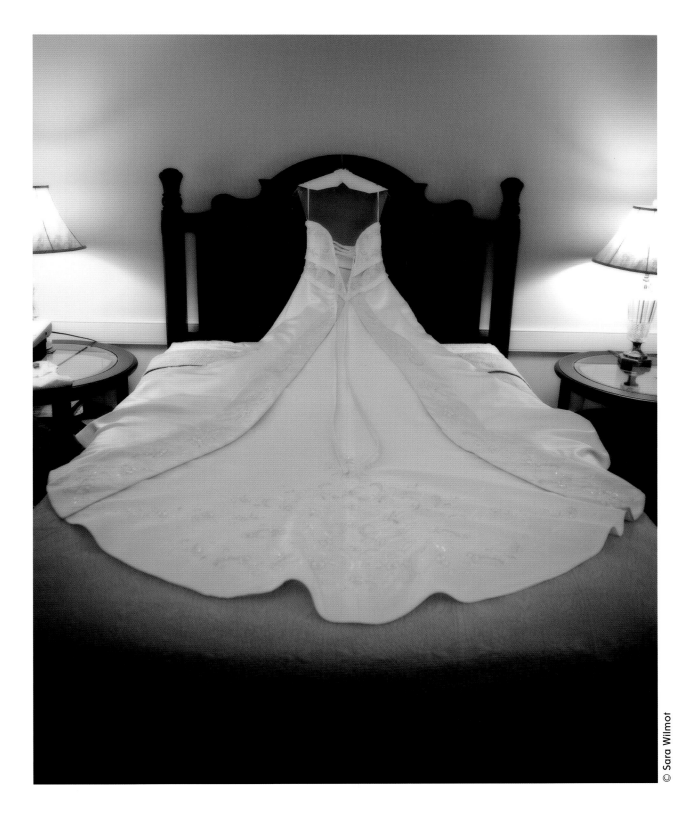

© Sara Wilmot

1. The Dress – *1 shot*

Depending on when you arrive, you may be able to get a picture of the wedding dress awaiting its occupant. You only need one shot because the dress isn't going to blink or make a weird expression, but you might want to make a few bracketed exposures of this one shot so you don't blow out a lace overlay by overexposing it. There is also the possibility (depending upon the bride, of course) that you can get a few photographs of the bride putting on her dress. Discuss this with the bride upon your arrival to see what her comfort level and interest are in this type of shot.

Hang on to the invitation and shoot it again later for a chance at capturing another great shot of it in a different setting.

2. The Invitation with Wedding Accoutrements – *1 shot*

Many times, the bride is already in her dress when I arrive. If that's the case, I will usually start off with a shot of the invitation. On a technical note, remember that it is important to have a lens with close-focusing capability in your arsenal to take shots such as this one. Look for key wedding accessories to compliment your photograph of the invitation, such as the ring bearer's pillow, the bride's engagement ring, and/or her garter (if she's wearing one). Bridal props are all around you on the wedding day. Don't overlook shoes, rings, champagne glasses, parasols, beaded gloves, sun hats, and bouquets as possible props.

Capturing the details matters because they tell part of the story of the day. And, while I just suggested that many of these things might be used as props, these same things are often worthy of being elevated to the status of stand-alone subjects, themselves. One thing I often do (if possible, and with permission) is to strip a rose of its petals, sprinkle the rose's petals on the bride's train, and place the invitation on top of my newly made mini backdrop. If you want to make this image a signature shot of yours, look into buying an in-expensive box of artificial rose petals at a party goods store. There are very realistic artificial petals available at party and bridal shops in both red and white.

A photo of the invitation is very important for two reasons. First, it is a great beginning to the wedding album so, even if you don't shoot it here, shoot it sometime during the day. Second, after you shoot the invitation, pick it up and put it in your camera case so that you are sure of the address and name of the church! While you may laugh at this (what kind of photographer doesn't know where the church is?), if you're in an unfamiliar neighborhood, or you lose the limousines you're trying to follow, the invitation, complete with the church's name and address printed on it, can be your salvation! And since you'll have it on hand, you might even consider investing the time required for another few shots and capture the invitation propped on the wedding cake, or beside two champagne glasses later on.

3. Mirror Photos – *4-10 poses, 2-3 shots each*

Doing pictures of the bride's reflection in the mirror over the dresser in the master bedroom might seem a bit old-fashioned... and it is. However, this is one of those pictures that the bride may remember seeing in her mom's wedding album, so it is often worth taking. Remember, traditions are a big part of weddings! Almost as importantly, reflection shots can give you a few moments alone with the bride, which can help you establish a rapport with her.

To get some privacy, you can always point out to onlookers that you can see their reflection in the mirror (you usually can). They will ordinarily scatter. Notice exactly what the reflections in the mirror reveal. It isn't attractive to shoot a beautiful bride and her bouquet in the mirror if the reflection also includes a pair of dirty socks lying next to the bed! Also, remember to straighten up what's visible on top of the bureau. And you can consider decorating the scene by laying the bridal bouquet (and possibly the bridesmaids' bouquets) at the base of the mirror.

If you're doing these photographs in the traditional candidman style with on-camera flash, you might consider using bounce flash to even out the illumination between the bride and her reflection. If you use direct flash, you'll find that the bride is much closer to the camera than the reflected image is, and she will therefore be hopelessly overexposed compared to her reflection. The flash unit may only be one and a half to two feet (.5 to .6 meters) from the bride herself, but to illuminate her reflection, the light has to travel from the flash to the mirror and then back to her face—a total distance of about 6 to 8 feet (1.8 to 2.4 meters) in this example.

Using bounce flash with your mirror portraits will give you salable images. If the dressing room has a dark ceiling, however, bounce flash won't work. In that case, try to shoot only the bride's reflection to avoid the problem of lighting both the subject and reflection. Make sure to position yourself so you do not see your own reflection in the mirror! (For more details on using bounce flash in your wedding photography, reference pages 202 – 203.)

Now that you have a sense of what to be aware of on the technical side of things, here are some suggestions for what to shoot:

- Bride using comb or brush
- Bride with compact
- Bride applying lipstick
- Bride's hands holding parents' wedding photo, with her reflection in the mirror behind

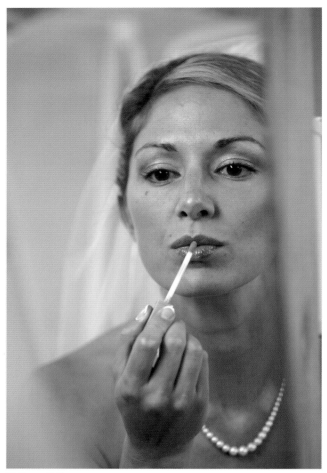

© Russell Caron

Bride and her reflection together (only if the bride can position her body very close to, or actually touching, the mirror)

This last pose is an especially convenient one to stage in catering halls with mirrored walls and, although it is a simple picture, the results look special. Remember this shot when you're up against the (mirrored) wall! Try shooting the bride's face and reflection, either with her looking at her ring, or at the bouquet, or even looking at your camera in the mirror. As an aside, if you are going to see the bride's hand in the image, remember to try and include her left hand (instead of her right) to show off her shiny engagement ring.

The first three photos listed above are modifications of the more traditional mirror poses, and they make use of the reflection in the mirror and a foreground item in front of the reflection. They're interesting, and different than the run-of-the-mill dressing room photos, so it's worth taking one or two. In addition, if you include one of the parents' wedding photos, you can often sell the image twice—one for the bride's album and one for the parents'.

These next photo suggestions are not really traditional dressing room photos, and can be done anywhere with a mirror:

Bride's hands holding invitation, with her reflection in the mirror behind

Bride's hand holding her engagement ring between her thumb and pointer finger, with her reflection in the mirror behind

Another version of the ring photo would be to place the ring (or rings) into a flower on the bride's bouquet. To successfully capture this kind of image, however, you will need to have a lens with excellent close-focusing capabilities.

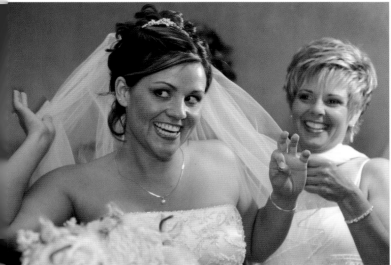

© Russell Caron

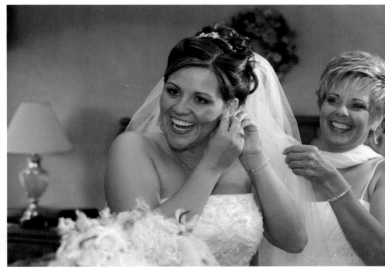

© Russell Caron

4. Mom Adjusting Bride's Veil – *1 pose*

Don't think of this shot as being limited to the act of the bride's mother adjusting her veil. What you really want is anything that captures the bride and her mom interacting in a meaningful way. Anything! It's the interaction between the two subjects that makes it different from a "both-of-you-look-at-the-camera" portrait. You could have them looking at one of mom's wedding photos (often there's a framed one on a bureau), mom adjusting one of the bride's earrings or putting a necklace on her, or even the bride and her mom clinking champagne flutes as they look at each other. Regardless of which photo you take, it's the interaction between the two subjects that's the important point.

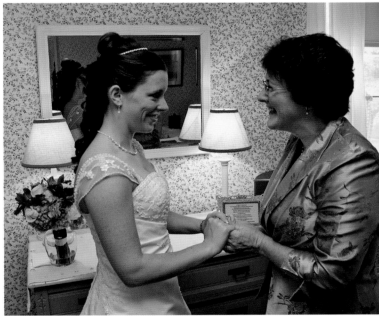

© Sara Wilmot

5. Bride and Maid of Honor – *1 pose*

For this picture, you might want to do something really corny with the maid of honor, such as having her adjust the bride's garter. If you decide to go this route, consider including the flower girl covering her eyes as the bride lifts her dress to reveal her garter. If you're going to get corny, you might as well go all the way!

The Living Room or Yard

When I first arrive at the bride's home, I spend a few minutes looking for backgrounds and deciding which sections of my repertoire I'll shoot where. It's time well spent. Don't overlook little nooks and crannies that might be good for single or two-up portraits. A porch or a corner of the yard might be great for a one-, two-, or three-subject portrait. Equally true, look for stairs and banisters that might help arrange larger groups in an interesting composition.

NOTE: When it comes to staircases and banisters, you can sometimes get a more effective photograph by reversing the normal positioning and shooting from the top of the staircase looking down at your subjects. One easy way to eliminate double chins is to shoot from above and have the subject(s) looking up at you.

In colder climates, bad weather, or houses without beautiful yards, you'll find yourself taking photographs of the bride, her family, and her attendants in the living room or family room. If the room has a white ceiling, bounce lighting is the way to go. (For bounce lighting suggestions, see pages 202 – 203.) Shooting indoors does have its limitations, though. Photos of groups require a wide-angle lens, and between changing lenses and putting down your camera and flash to arrange each picture, things proceed more slowly than they do outdoors. Quite simply, shooting outdoors usually takes less time, especially if your camera is tripod-mounted and you're shooting under natural light.

If you decide on the outdoor route, let me offer a few hints. First, look for open shade so you don't have to use fill flash. Open shade makes complexions look smooth, which is just the effect you're after. Second, when you're searching for a portrait location in open shade, imagine what the backgrounds will look like. Further, when looking for open shade, don't be limited to just the shade from trees; covered porches or a shaded side of the house, can be equally effective. If the backgrounds are lit by direct sunlight and your subject is in open shade, you'll find that the backgrounds in your

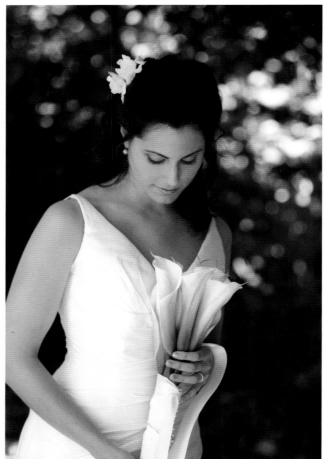

© Russell Caron

images will be overexposed, which will generally detract from your primary subject. As with all rules, though, this one begs to be broken. But if you decide to break it, do so only occasionally.

I find that some of the best backgrounds are out-of-focus green smudges created by such things as high shrubs or low trees. While the smudged background really isolates the subject, shooting with greenery in the background is another rule ripe for breaking. Even the bride's house can be an effective, if busy, background. Some might say that if you can include the place where the bride grew up in the background, so much the better. Sometimes, you'll have an embarrassment of riches, and both the front and back yards will be photogenic. In this instance, try to use both locations, as the variety of backgrounds can increase your sales.

6. Bride and Dad: Formal – *1-2 poses*

A formal portrait of the bride and her dad can be done just about anywhere. If you don't get it at the bride's house, you can pick it up later in the day at the catering hall. Regardless of when you get it, don't forget it!

7. Bride and Dad: Semi-Casual – *1-2 poses*

For this shot, have the bride kiss dad on the cheek or give him a hug. This picture may appear to be a relaxed version of the previous "Bride and Dad" shot, but you can have two possible sales if you change the background and the pose enough to make the photos different. Often, I'll sit the dad down (or let the bride stand on a step) and place her behind her dad with her face next to his and her arms wrapped around his shoulders. Another thought, while old fashioned, is to have the bride adjust her dad's tie or boutonniere, which can even be done as a very tight close-up.

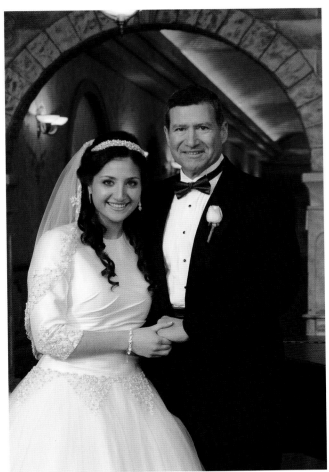

I use my camera's manual white balance option for my photography (see pages 160 – 163) so that I can exactly match the color temperature of the primary light source that is lighting my subjects. Here, the primary light falling on the bride and her dad is a mixture of flash and window light, so I set my Kelvin temperature accordingly (to about 5600K), but doing so meant the low wattage tungsten background lights would appear orange in the final image. I don't find this effect objectionable in this case.

8. Bride and Parents – *shoot a few*

You'll notice that I call for this and some other photos to be shot a few times. That's because this photo is a "bread-and-butter" picture that's in every album. It would be a pity to have one of the three principal subjects blink during the only time you shot that image. In addition to taking a few shots, you would also be wise to check your LCD monitor to make sure you have the image you want. Sometimes, after getting my formal portrait I ask the three subjects to squish together which makes the picture appear more relaxed while still keeping it looking formal.

9. Bride and Parents: Selective Focus – *1 pose*

The idea behind this shot is to focus on the bride with her parents in the background, slightly out-of-focus. This different approach to a bride-with-parents photograph is a perfect candidate for creating and selling a two-page spread, but to pull it off, you must shoot the same picture later with the groom and his parents (see page 96).

To take this album spread idea one step further, reverse the pose for the groom-and-parents photograph. In other words, put the bride on the right side of a horizontal composition; then, when you shoot the other half of the spread with the groom, place the him on the left side of the frame. That way, when the images are viewed as a two-page spread in the album, they will fit together better and it will make selling the idea easier.

10. Bride's Parents Alone – *shoot a few*

Once again, this picture is a sure-seller for the bride's album, and it might even find its way into her parents' album, or a frame. This is a must-have image, so it's worth taking a few shots of it.

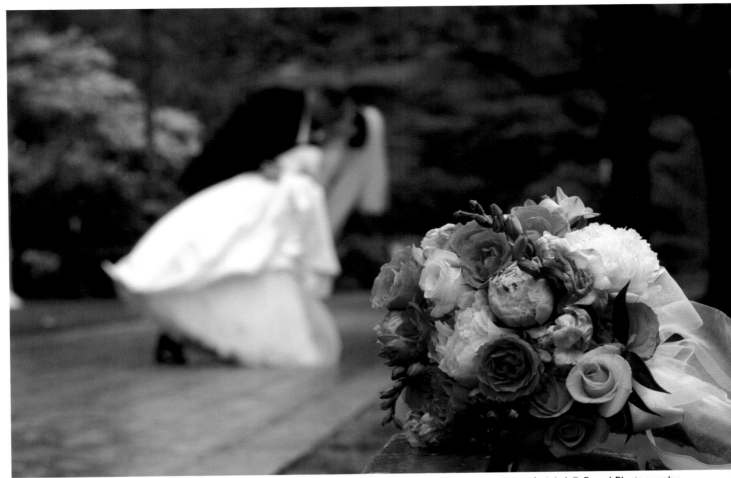

Selective focus can be used in a variety of situations, and is a very important tool to have in your bag of tricks! © Freed Photography

11. Bride and Mom: Regular and Soft Focus – *1-2 poses*

The relationship between the bride and her mom can be particularly close. Your photograph of the two of them should show that bond. I try to make this a special picture, and I almost always shoot more than one.

A popular variation is of the two women together taken with a soft focus or diffusion filter over the lens. Almost any time your photograph includes a mature woman in this kind of stylized atmosphere, it pays to shoot a photo or two with a diffusion filter. My case has four different diffusion filters, so I have a selection to choose from. (See pages 167 – 168 for more about diffusion filters.)

NOTE: Even though I can create a soft-focus effect using software, I find it an easier sell if the customer can see the result when they first look at the image at the proof stage. This would not be possible if I applied the effect later during image processing, as I do not process every photo that I take; I only spend that kind of time on images that my clients definitely want in the album.

12. Three Generations: Bride's Side – *1 pose*

Capturing three generations in one photograph is something special. If the bride's maternal grandmother is present at the house, a picture of the three women together will almost always make the album. I don't know if the three-generation picture was the invention of some enterprising photographer, but regardless of whose idea it was, the picture has become a standard. If the bride has a sister who has a daughter that is there, then you have a four-generations picture. Once the picture has ballooned to five subjects (Grandma, Mom, the bride, the bride's sister, and the sister's daughter), you might decide to add in any other sisters of the bride for one, grand, multi-generational extravaganza!

13. Bride and Her Siblings – *1 pose with all or 1 pose with each*

This group of images can create a sticky dilemma. If you shoot the bride and all her siblings together, chances are good that you won't sell pictures of the bride with each individual sibling. Why should she buy two (or more) photographs when she can have all the same people in just one? This is also a double-edged sword because one photograph of all the siblings together usually finds its way into a parent album, and is often the type of photograph her parents might display in their home. Additionally, you might be able to sell a photograph of the bride with her sisters, and one with the bride and her brothers.

If you decide to shoot the bride and each sibling individually, you must get all of them if you expect the pictures to sell. A bride won't include photos of just four of her five siblings in the album. It can become political. Realizing this, if you can't get each sibling alone with the bride, you may decide to shoot all the siblings together. If so, it pays to remember that, often, the youngest sibling has a special place in the family (and perhaps especially so if he or she is noticeably younger than the rest). It is usually worth taking a single image of the youngest sibling, both alone and with the bride. Further, if the bride (or groom) is half of a pair of twins, a separate image of them together is worthwhile because of the special bond between them, and how the family perceives them. Finally, if any siblings are married, you can leave their spouses out of the sibling shot, but be sure to do a few special pictures of the married siblings and their spouses together with the bride and groom later in the day.

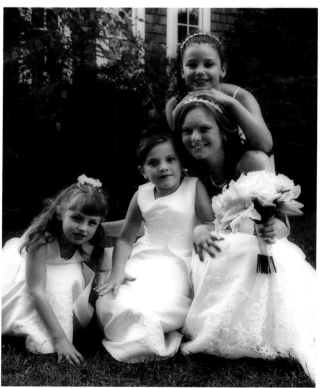

© Sara Wilmot

14. Bride and Bridesmaids – *1-2 poses*

The bride with all her bridesmaids and the maid of honor (and the matrons of honor, the junior bridesmaids, the flower girls, etc.) is a must-get picture. If the bride's house is tiny or the yard is not photogenic, pick up this group picture while the formals are taken after the church ceremony (see page 89).

Shooting a series of the bride with each maid individually is also an interesting option because of its sales potential. Although it won't produce photographs for the album, it will give the bride a nice memento to give to bridal party members. If you go this route, you'll have to produce the same set of pictures for the groom with his ushers. You might even try to get photos of couples within the bridal party for more sales possibilities. In the same vein, with an eye to future assignments, if there are any bridesmaids and ushers who are engaged, they are definitely worth a separate portrait. Keep in mind, though, that since these pictures aren't specifically for the wedding album, they should be eliminated from your repertoire if you are pressed for time.

15. Bride and Flower Girl Alone – *1 pose*

Like the extra photo of the bride with her youngest sibling (see page 60), this picture is also a stellar seller because dressed-up little kids are so cute! You can make this kind of photograph into a real Norman Rockwell affair. Don't be afraid to ask them to touch noses or something else equally as sweet.

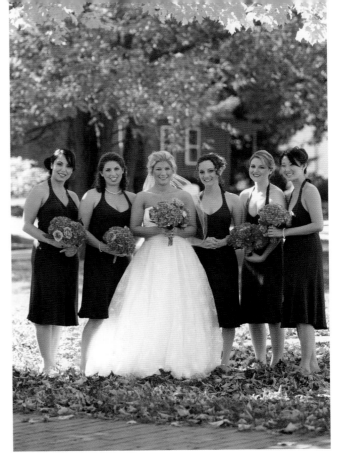

© Russell Caron

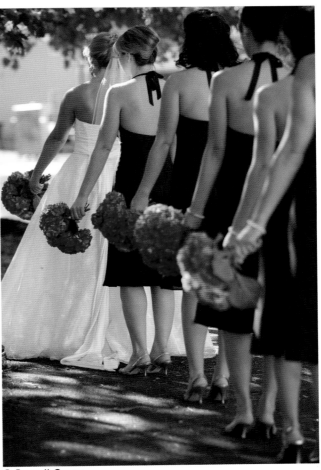

© Russell Caron

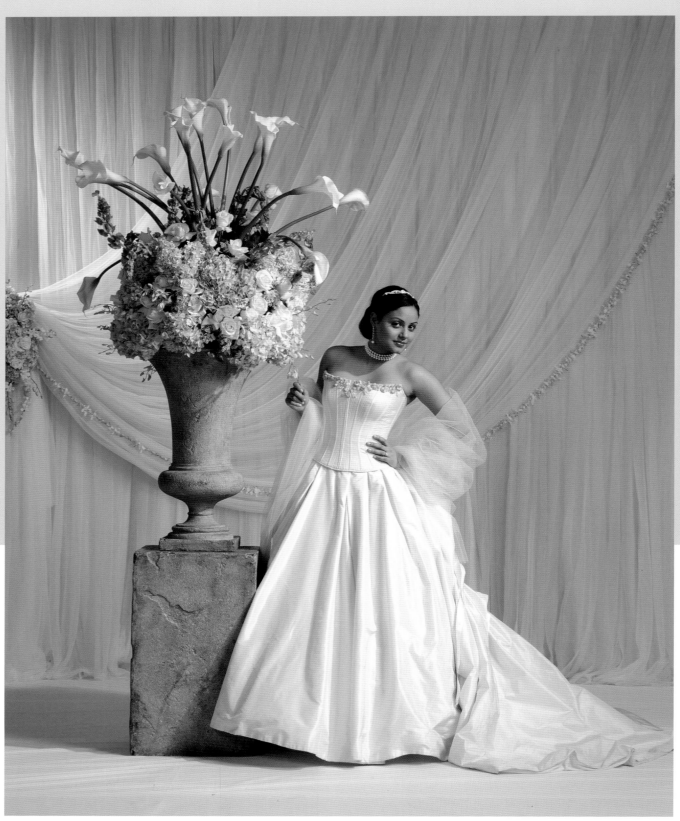

Sometimes, the bride's house just doesn't have an ideal portrait background and the weather doesn't permit you to work outside. If this is the case, you can always do these photos later, before the reception. But, you should at least try to get some of the bride's formal portraits at the house because you don't really know what the future will hold and these are shots that you cannot complete the assignment without. Better to have portraits with less-than-perfect backgrounds than to have none at all!

16. Bride Alone – *3 to 4 close-ups, 3 to 4 full-lengths*

Formals of the bride alone are often the centerpiece of the entire day, so it pays to invest some extra effort here. Every misplaced flower petal or lock of hair will be proudly displayed for decades to come by the bride and her family! Considering the importance of the bridal formals, sometimes I'll even reshoot a few pose ideas after the ceremony because the bride is more relaxed then.

To ensure as much sales potential as possible, vary the framing and poses as you shoot. Traditional bridal close-ups are often framed from the bottom of the bouquet to right above the top of the bride's head, but if she's holding a long, trailing bouquet, you can do some poses that don't include the floral trail. Investigate both formal and relaxed poses and change the background frequently for variety. A few tight close-ups of the bride's face shot with a longish lens are also great to add to the mix. Also, remember to use your diffusion filter for some of the shots.

Don't be afraid to try unique poses. Some of my most successful formal bridal close-ups were created by shooting from behind a couch with the bride leaning over the back, facing towards me, or with the bride lying on a bed among rose bouquets. The picture you take will probably be in someone's wallet for a long time. Even better, it will be pulled out of that wallet and shown to many people who are all potential customers. If you can make every bride look like a supermodel, your future's assured!

Like the close-up shots, the full-length portraits of the bride are also in the "they've-got-to-be-good" category. Once again, variety is key. Show off the line of the dress by placing the train behind your subject. Make the train stand out by posing the bride facing away from you and having her swivel at the hips so she's looking back over her shoulder at the camera. Then try a frontal pose, but pull the train around from behind her and drape it in front of the gown. Every bridal album and bridal magazine you see can be a source of new full-length poses of a bride in a gown. Buy a few copies of *Brides Magazine* or *Modern Bride* for fresh full-length ideas.

17. Bride Alone by Window Light – *shoot a few*

Many of you are going to think that because I say you should shoot this picture a few times, it is a "must-have" image. While the resulting picture is attractive and different, the real reason you should shoot it a few times is because the relatively long shutter speeds required mean that any motion created by the subject or camera might ruin one of the images. The real trick in window-light photography is to have the lens axis parallel to the window. In other words, the window isn't in front of or behind you, but next to you.

The bride must also be carefully placed. If she is right next to the window, you will end up with lighting that will split her face down the middle—not an attractive effect. If, because of the physical layout of the room, the bride must be next to the window, you can snatch victory from the jaws of disaster by turning the bride's face toward the window's light. In a perfect world, if you have the space and you pose the bride just past the window's frame, the window light becomes a 45° frontal light, which is quite beautiful.

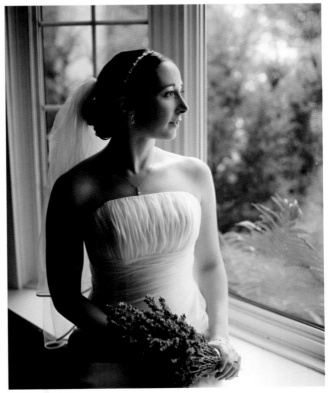

© Chantal Gauvreau

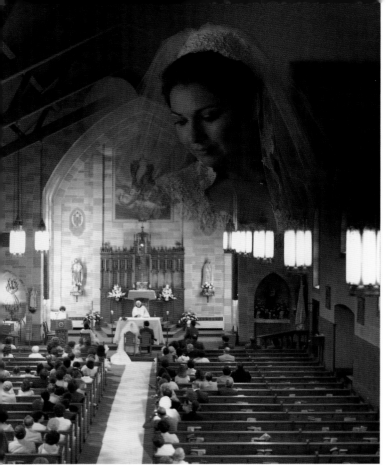

© Glenmar Photographers

18. Bride Alone: First Half of a Double Exposure – *at least one*

This special-effect photograph will really end up being comprised of two shots in one. Although some DSLR cameras offer the ability to do double (or an even greater number of) exposures in-camera, this can also be easily accomplished in post-processing. If your equipment enables you to go for this type of effect in-camera and you want to attempt it, make sure that the shots you wish to combine are both on the same memory card.

It really helps to use a tripod in situations such as this where critical framing is of utmost importance. In the first half of the double exposure, I photograph the bride's face in an upper corner of the frame while blocking off the remaining three-quarters of the composition. For this masking, I use my either my hand or a black card I carry with me (the black card works better!) to block off part of the frame, creating a soft edge so that the two images

will eventually blend with ease. By stopping the lens down to the taking aperture using the camera's depth of field preview button, the edge of the mask comes into focus, allowing me to see exactly what I'm blocking out and what I'm including. I position the bride's face within the frame so that she is looking down at the opposite (lower) corner of the composition. When I do the second half of my double exposure, I use a small piece of black cardboard to block off the quarter of the frame where the bride's face will fit in.

In the days of shooting film one of the most frustrating things was having half of a double exposure ruined by a funny expression, a blink, or camera movement. Adding insult to injury, you never saw this until after the film came back from the lab. In today's digital environment, whether you put the images together in the computer of combine them in your DSLR, you are no longer limited to one exposure for each half of the image. Because of this, I suggest taking two or three shots of each element you wish to include in your final image.

Many digital photographers know that combining two images in the computer is little more than a mouse click away, but be sure that you actually follow through with combining the exposures into one image before trying to sell the idea to the bride or her family. Be it on a CD or on traditional paper, I have found that it is much easier to sell a double (or multiple) exposure if the couple and their families can see the resulting image. If you show a bride an image of her looking down in one picture and the ceremony in another, she might not be able to visualize how the two will look together. This fact hasn't been lost on some digital camera manufacturers. Some models have multiple exposure capabilities built right into them.

Leaving the House

Congratulations! You have just finished covering the first quarter of this wedding repertoire. The next section covers the ceremony (followed by a portrait session and the reception). Get ready to leave the bride's house (or where ever she got dressed) and head for the ceremony site.

19. Bride, Parents, and Bridesmaids in Front of House – *1 pose*

This photograph gets all the principals and the bride's homestead in one photograph. It can be argued that, if you're late to the bride's home (a flat tire, a car accident, your pet goldfish died, you had another wedding just before this one, etc.), this is the one picture you must get at the bride's home. All the other photographs that you would have taken at the bride's house can be picked up later in the day. From mirror shots at the catering hall to formal bridals at the park after the ceremony, everything else can be patched in as the day progresses, but once you leave the bride's home for the ceremony, you won't be returning there for the rest of the day.

20. Dad Helping Bride into Limousine – *1 pose*

One night, I was watching a very good wedding video cameraman. He was doing a slow pan of a Viennese dessert table, followed by shots of individual displays of desserts to be used for wipes and dissolves. I asked him how he chose which ones to shoot, and he said, "If it costs extra money, I shoot it."

Limousines cost extra money. Couples spend even more money on top of that for specialty rides. Antique cars, white Rolls Royces, horse-drawn buggies, and other unique vehicles often spend their weekends hauling around bridal parties. If the couple went to the trouble of hiring a limo, or an even more unique vehicle, I include it in the pictures. After all, it costs extra money.

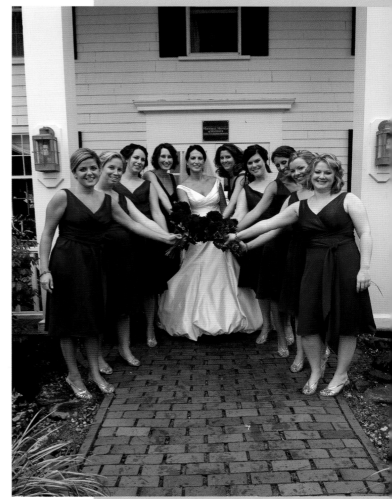

© Sara Wilmot

Arriving at the Venue

I always take a few shots of the bride's family arriving at the ceremony site. Usually I feature the bride and her dad in this part of the repertoire, but I also mix it up from time to time with other variations. Keep in mind that the arrival shots must happen quickly. You can't waste a lot of time because you need to meet the officiant and the groom before the ceremony starts.

21. Dad Helping Bride out of Limousine (or Variations) – *1 pose*

This picture doesn't really have to be of the bride being helped out of the car or limo by her dad; it could be of the bridal party arriving, or the bride and her mom standing together. Whatever I shoot, I try to include the ceremony venue in the background of this photograph. If it is especially beautiful, this type of photo can set the scene for the ceremony section of the album.

22. Dad and Bride Entering Venue – *1-2 poses*

If the ceremony site's exterior isn't photogenic (or the weather is crummy), I forget the limo shot and try to catch a photo of the bride and her dad in the venue vestibule. This totally candid moment between the bride and father is often filled with emotion. Sometimes, you can ask the bride to kiss her dad on the cheek, or ask him to kiss his daughter on the forehead. Mom will cry for sure... and they'll buy the photo!

Although I am a business-minded professional, I try to remember that the reason for the entire wedding day—from flowers to fancy limos—is the ceremony. Without it, there would be no bride, groom, or party to shoot in the first place. On a pragmatic level, your respect for the institution will

© Sara Wilmot

also make your dealings with religious officiants much easier. In the scenario I paint in this repertoire, once you arrive at the ceremony site you have two important contacts to make: the person performing the ceremony, and the groom.

Before I seek out the officiant and the groom, I stash my tripod somewhere handy—like under a rear pew bench if I'm shooting at a church—so it's available quickly when the time comes. Then, I drop my small camera bag filled with shooting essentials up close to the altar area, like in a front pew on the side of the church. Now I'm ready to go meet the officiant (priest, minister, etc.), groom, the best man, and the other guys.

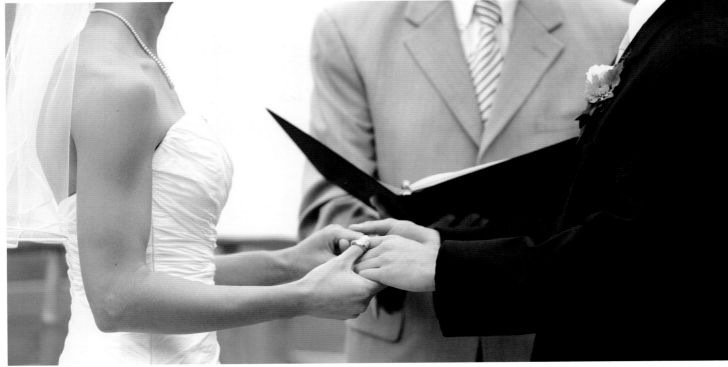

© Russell Caron

Meeting the Officiant

Many weddings take place in a house of religion, and once you walk into that church (or temple, mosque, etc.), you are on God's playing field, and the officiant (whether pastor, priest, imam, rabbi, or monk) is the referee. Clergy have specific ideas about where, when, and how to take pictures in their place of worship and during the ceremony, and in their house, they make the rules. Because of this, I usually seek out the officiant first before meeting the groom.

In a small community, it is good business to be friends with the local clergy. The longer you are in the wedding photography business, the more familiar you will become with the clergy in your area. There have been times, on a busy weekend, that I have seen the same priest in the same church four times! As you can imagine, cultivating a good working relationship with such a person will serve your reputation well.

Just as I do when I meet the bride in her home, I have a few agendas when I introduce myself. To start with, once again, I want to become an insider. After all, it never hurts to have God's right-hand man (or woman) on your side!

Usually, the first words out of my mouth after saying hello are, "What rules would you like me to observe?" This question accomplishes several things. One, I get information not only about the ceremony but, more importantly, about how rigid the officiant is. If I'm presented with a laundry list of "don'ts," my first response is to say, "I wouldn't do that!" If the officiant tells me he or she has seen too many photographers who have broken the rules, I usually say, "I don't know what other photographers do, but I know that I won't." Actually, I'm being very sincere, as I really don't want to do anything to spoil the couple's day. On the other hand, if the officiant tells me, "Anything goes as long as you don't climb up on my shoulders," then I know that the situation is more relaxed.

Some members of the clergy do not allow flash during the ceremony; others don't care. Some will re-pose for the important pictures after the ceremony if they do not allow photographs during the ceremony, and if there is time available. And even though I know there is no eleventh commandment that says "Thou Shalt Not Use Flash," I go along with the clergy's requests. Remember, it's their playing field.

After reading the officiant's personality, I ask questions about the ceremony. Is it possible for the bride and groom to face each other during the exchange of rings? How about during the exchange of vows? Is the couple making any presentations or coming away from the altar to greet their parents? Are they lighting a candle? Where will the candle be? When will it happen? Absorb, absorb, absorb.

My last question is conspiratorial. I ask if another ceremony is being performed in the church after this one. This helps me know how to pace myself. For instance, it can help me determine if I should rush my photographs after the receiving line. This question is usually the clincher, because it tells clergy that I am thinking about their schedule as well as my own. This puts us on the same team! This two-minute investment usually leaves me satisfied with our relationship, and it will then be time to move on to meet the groom.

At this point I must sadly say, however, there will come a time (I can promise you) that you will meet a priest who is having a bad day, and no matter what you say or do, he or she will be peeved with you. There is nothing you can do about it. Weird as it may sound to neophyte shooters, there are some people who just do not like photographers—not just you, but all photographers! And, you will also find other people who make your job more difficult: a florist with an attitude, a maître'd who thinks he's a prison commandant, or a bandleader who assumes his microphone makes him the appointed leader (which, incidentally, it does). When you meet one of these "special" people, always try to be polite. But remember, you still have a job to do, regardless of anyone else's attitude. You cannot let them affect how you feel about your work and about the bride

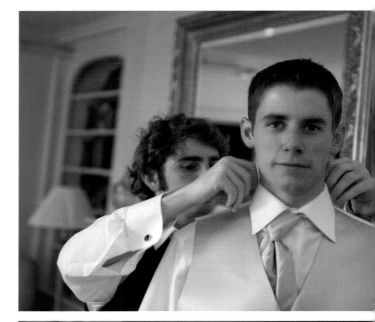

Photos © Sara Wilmot

and groom, who probably feel just as frustrated by a sourpuss as you do. No matter what happens, never, ever lose your temper or your self-control. Happily, I can tell you that, as your people skills improve, you may find it both interesting and challenging to try and turn such a cantankerous person into a friend. Some of these individuals have turned out to be real friends of mine. Since you're going to be running into them anyway because both of you work the wedding world, your efforts at diplomacy can be very fruitful.

Meeting the Groom

Meeting the groom is just like meeting the bride except that, when you meet the bride at her house, it is an hour or two before the ceremony. When you meet the groom, the wedding ceremony (probably the most significant life change he's ever experienced) is staring him right in the face. I have met many grooms in this situation and, while there are some who are cool and relaxed, in my experience, the vast majority are tighter than a drum.

This is the first time you will be seeing the groom on his wedding day, and if you're shooting the wedding as a candidman, this will probably be the very first time you have ever met the groom. Since you're going to be photographing this person for the next five to seven hours, first impressions are important. While the bride hadn't yet reached a precipice of panic when you met her, by the time you meet the groom, he will almost definitely be there! And although you had an hour to build a rapport with the bride, you've got just 30 seconds (literally) to make the groom comfortable with you. That is one tough act! So, right after my hello and handshake, I usually start by telling the groom that his bride is not only gorgeous, but is a really nice person to boot (whether I truly think so or not; after all, he is in love with her, so who am I to say otherwise?). If he seems a little nervous, I offer that she's a bit nervous, too. Misery loves company.

I choose my words and responses to the groom based on his body language and demeanor. I've met grooms who are so languid they looked like they were about to fall asleep. On the other hand, there are others who bounce around like a jack-in-the-box. In the end, I try to shoot an unobtrusive, easy photograph of the groom and best man together, shaking hands or maybe hugging, with some wedding or religious paraphernalia in the background.

Sooner or later, you are sure to meet a surly groom. For whatever reason, he just doesn't like photographers (or any authority figure, for that matter). Who knows? Maybe he started celebrating early. (Some people become more aggressive once they've hit the sauce!) Or maybe he's paying for the photography even though he had no input in choosing the photographer or the size of the picture order. Despite the amount of time you will spend with an irritable groom, never lose your temper or your self-control! Consider yourself as "human Valium" and, regardless of what the groom throws your way, remain easygoing. Never let anyone stop you from doing your job. When the proofs are delivered, the groom won't remember his own attitude, but neither the bride nor the groom will understand or be happy with whatever your problem was that day.

23. Groom and Best Man – *shoot a few*

A straightforward photograph of the groom and best man can be a simple affair, but sometimes a corny gag shot can also be fun. Some photographers hate corny gag pictures, while others do them at every wedding. I don't get involved with making value judgments about a single type of picture. Remembering that it's only one in a thousand, I will say that if I decide to go corny I will happily go all the way. I've seen pictures of the best man holding onto the groom's coattails as he tries to bolt for the door, or the best man pointing to his wristwatch as the groom tries to stretch his shirt collar with a fingertip.

Although I personally find some gag images tasteless, they do offer a variation on the typical groom-and-best-man-shaking-hands shot. Other ideas on the more straightforward side include the best man adjusting the groom's tie or boutonniere. And, in certain instances when the groom seems especially close to the person performing the ceremony, I've included him or her in a photograph with the groom and best man.

Stay sharp and make time to capture any unique details of the ceremony, such as these notes written on the groom's palm. © Marcia Mauskopf

The Ceremony

Before you even think about what you are going to shoot on the aisle, check the amount of exposures left on your memory card. If there is even the slightest possibility that it will fill up before the processional is over, change it now! This is especially important if you are using a low-capacity card in your camera, which I do not recommend.

Next up, consider if you want to frame your aisle photographs as vertical or horizontal images. While both are acceptable there are advantages to shooting all your aisle shots horizontally, as I do. A horizontal aisle shot will include guests in the pews to the right and the left of the primary subjects walking down the aisle. While I can crop out the guests from a horizontal image and end up with a vertical image of just the primary subjects. However, if I choose to shoot the images vertically I only have the option of featuring the primary subjects. Why limit yourself

when you can shoot horizontally and go with either framing later on? (Read more about horizontal and vertical framing on pages 116 – 119.)

It is worth noting that, if your DSLR's resolution is high enough, you can crop an 8 x 10-inch (A4) vertical composition out of a horizontal shot, but there are usually not enough pixels to crop a horizontal composition out of a vertical one unless you expand the digital file by interpolation—a technique with which I have never been totally satisfied. Without delving into this too deeply, I like to have approximately 300 pixels per inch of final print size. Today's 12-megapixel cameras usually have close to 3000 pixels in the vertical dimension when the camera is held in horizontal shooting position. This pixel count is why I can comfortably crop a vertical print out of a horizontal composition.

If your DSLR has a resolution of 6 megapixels or less, you might be better off shooting your aisle pictures in the vertical format (or getting a new camera!), but if your camera has a higher resolution, you might just settle on shooting your aisle photographs horizontally to give the bride and groom their choice of whether they want horizontal or vertical aisle pictures.

Focusing on a Moving Target

For many, the bride being escorted down the aisle by her dad is the most important photograph of the day. The problem is that many photographers go weak in the knees when it comes time to shoot pictures of people walking straight at them. They think they can't possibly focus and shoot simultaneously as the subjects are walking towards them.

While it is true that focusing on a moving target can be difficult, there is an easy way to avoid pitfalls. One trick is to pre-focus on a stationary point through which your subjects will pass. In a church or synagogue setting, for example, pre-focusing on a specific pew can be a great help. Set your DSLR's focus lock feature (I set mine to lock at a partial press of the shutter release button) and, when the subject is one step away from the pre-focus point, frame the people you want to photograph, and take the shot. By the time you frame them, they will have walked into the pre-focused spot!

There is another way to pre-focus, but it requires a bit of practice. With this technique, you must learn to judge distance accurately. Once you have that skill, all you need to do is preset your focusing scale to a specific distance, say 10 – 12 feet (3 - 3.7 meters). Then, the last step (which will give many new photographers the willies) is to turn off your camera's autofocus and use the manual focus setting. After all the practice I've had, I've learned how large the subjects look in my viewfinder with a given lens when they are the correct distance away from my camera. My brain (twisted as it is) is even able to take into account the different heights of different subjects in order to ensure sharp focus.

I can hear many of you saying (out of fear) that this pre-focus mumbo jumbo doesn't apply because you have an autofocus camera. However, I believe that the photograph of the bride and her dad on the aisle is not always the place to put your trust in an autofocus system. I know you've all seen photographers at pro football games shooting with autofocus without a second thought. But football stadiums are lit for TV cameras. Church interiors are dim, and you are trying to capture a great image of a man in a black tuxedo walking with a woman wearing a sail-like expanse of pure white! Even I might be willing to trust autofocus in a candle lit church if the bride and her dad were wearing orange jerseys with giant white numbers sewn to them.

Every summer, I teach a wedding photography course at the Maine Photographic Workshops, and my class goes to a church where we try to photograph two models (resplendent in tuxedo and wedding gown) as they walk down the aisle. The students come to the course equipped with their autofocus cameras, and on our little field trip, they all get set to do the aisle shoot in autofocus mode. Unbeknownst to them, I instruct the models not to pause as they walk down the aisle. Invariably, most of the students freak out when their autofocus cameras start to hunt in the dim church as they try to lock onto the featureless subjects! The bridal couple glides by and the students never get off a shot. If you believe, as I do, that the bride and her dad on the aisle is a must-get photo, then I implore you to forsake autofocus and go with a preset manual focus technique in this situation. There are no "do-overs" on the aisle! Finally, if you really insist on using autofocus on the aisle, try the first pre-focus technique I mentioned at the beginning of this section as an alternative to manual focus.

24. Mothers of the Bride and Groom Being Escorted – *1-2 shots*

These two photographs are important, not only because we are talking about the mothers of the bride and groom, but also because, many times, a mother is escorted down the aisle by one of her sons. As I side note, as soon as the groom's mother is seated, I always take a quick moment to introduce myself (if I haven't already). There isn't a lot of time, as the ceremony is about to start, but I can usually say, "Hello, I'm Steve. Congratulations. We'll talk after the ceremony." While our after-the-ceremony "talk" will probably be limited to "Congratulations," my simple introduction lets her know that I know who she is and it helps break the ice for shooting the groom's family pictures later.

25. Each Bridesmaid – *1-2 shots*

Some feel that a picture of each bridesmaid walking down the aisle is a waste of effort. To a certain extent they are right. These pictures are used infrequently in an album. They are competing with those taken of the bride and her maids at home. However, the bride and groom's sisters walking down the aisle are definitely worth a photo each. Even if they don't make the bridal album, they may be used in a parent book.

26. Maid of Honor – *1-2 shots*

A picture of the maid of honor walking down the aisle often makes it into the album, but even if it doesn't, the bride may present a print to her as a memento. What about the best man, you ask? In my experience, the best man usually stands at the foot of the aisle with the groom after they enter together from the side of the altar. But, every wedding is different. You may encounter an opportunity to snap a shot of the best man coming down the aisle, and if so, take it!

27. Flower Girls and Ring Bearers – *1-2 shots*

Pictures of little kids always seem to be purchased by someone. Many times, the children are the couple's nieces, nephews, or cousins. Even in the unlikely event that these photographs don't make it into the main album, someone else in the family will buy prints of them.

Although all the other aisle photos should be taken from an identical distance, these shots require that you wait for the subjects to take one extra step closer to the camera so that they fill the frame. You must change the focus setting (see page 71), but the results are worth it. You will also need to quickly reset the focus for the bride and her father walking down the aisle because they are next and that is the most important shot!

28. Bride and Her Dad – *shoot a bunch*

Remember, this is the shot to get. Every album I have ever seen (which number in the thousands) has a picture of the bride walking down the aisle. While, for many of your other subjects, only one good shot is required, in this instance, you should splurge and shoot at least a few. Without this picture, you have not completed the assignment, no matter how nice everything else looks. You can produce a beautiful 80-photograph album, but if you miss this photo, your "great wedding photographer" reputation will be tarnished... at least in the eyes of these families!

With many (though not all) DSLRs, the mirror flips up and blocks the viewfinder at the moment of exposure. It's amazing how many brides and dads glance at people along the aisle at that same moment, or they choose that moment to blink. If your camera has a live view mode, now would be the time to use it—but only if you have practice shooting in this mode and know that it doesn't slow your camera's operating speed. If not, with a little practice, you can lock the camera in position and

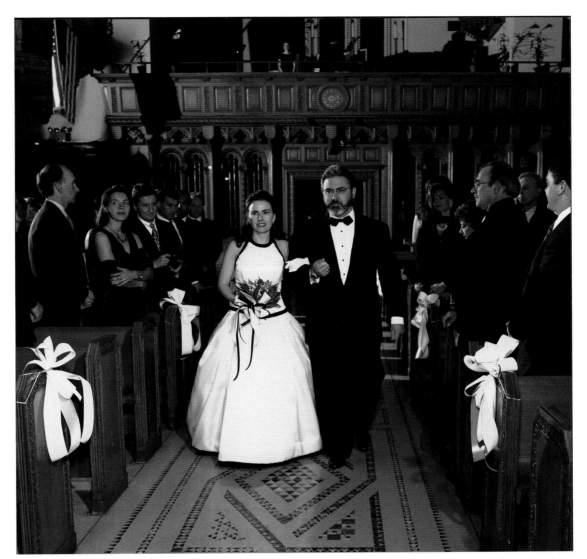

The shot of the bride being escorted down the aisle by her father is one of the most important of the day. In this example, the room lights illuminate the background and guests with a little help from an AC-powered light strategically placed to light the back of the church. The two main subjects are lit by two battery-powered frontal lights. ©In-Sync Ltd.

then move your head so you are looking at the actual subjects instead of at that blackened viewfinder during the exposure. That way, you can see exactly where the subjects are looking at the moment you press the shutter release. This is a technique that's well worth practicing if live view is not an option, and perhaps even if it is.

Lastly, for me at least, my adrenaline ramps up before the processional. I get tight. If that happens to you, remind yourself to breathe!

29. Dad's Kiss Goodbye – *shoot what you can!*

This scene is always viewed through tearful eyes, but you, as the photographer, can't afford to enjoy the precious moment. You have to record it. If you back up into the altar area, getting this picture can be tricky; you run the risk of people blocking your shot. That's because the area where the father is kissing his daughter goodbye is also the space where the groom, the officiant, the best man, the maid of honor, the attendants, and the assorted ring and flower little people are. Not only are all the big folk craning to get a better view of the bride and her dad,

but as you try to position yourself, you have to avoid the kids, who may or may not be moving! For all these reasons, photographing the father kissing the bride from the altar side can sometimes leave you feeling like a pinball in an arcade game.

By doing some fancy footwork, you can avoid the altar-side trap. Right after I shoot my last photograph of the father escorting the bride down the aisle, I stop back-pedaling and step forward, towards them. As I move forward, I step to the bride's father's side of the aisle. I then step up against a pew as the bride and her father pass by. Right after they glide past, I reenter the aisle behind them, being especially careful to avoid stepping on the bride's train. I take one more step back up the aisle, away from them, and when I turn around to face the altar the father is kissing his daughter goodbye right before my eyes. All of the "problem people" in the altar-side scenario are now background onlookers who are helping my picture instead of potentially ruining it! And, as an added benefit, I'm approximately the same distance away from the subjects as I was when I shot them coming down the aisle (but now I'm facing the opposite direction), so without changing my camera's settings I can literally lift it to my eye, frame the shot, and push the button if my picture is rushed. Given a few extra seconds, I can also choose to reset the camera and move a step or two closer to the bride and her dad.

The Dance of the Wedding Photographer

Although the fancy footwork I use to get in a good position to shoot the father of the bride kissing his daughter goodbye generally works well, here are some important rules worth remembering:

Always step to the father's side of the aisle as you're moving forward. That way, when you reenter the aisle, you have less chance of stepping on the bride's train, which is a definite no-no.

If the aisle is very narrow (or very short), you might not be able to get by the bride's father. Your only recourse in such a case is the dreaded altar-side shot. The officiant may ask you to stay in one position during the processional and, once again, this lands you with the altar-side shot of the kiss. Whenever I'm faced with having to shoot from the altar side for the kiss goodbye, I consider it a challenge as opposed to a problem. It's a harder photograph than the aisle-side shot, but hey—it makes life more interesting.

30. Readings and Music – *1 pose each*

During the readings or special musical entertainment, you must work as candidly as possible if you decide to photograph them at all. I have already left my camera bag somewhere safe near the front of the site (often in a front pew) so it is readily accessible. I change to a longer lens and try to shoot the readings or musical performances from a side aisle. My goal is to get these shots early so I can then leave the front of the venue and go to the back, where I stashed my tripod, for the next few shots.

31. Second Half of the Double Exposure – *1 pose*

Remember back at the bride's house when we did the first half of a double exposure (see page 64)? If you are planning to combine the exposures in-camera, now is the time to find that DSLR body you last used at the house and remount it to the tripod. I use a small piece of black mat board to block off the area where the bride's image is and arrange my composition so that the bride appears to be looking down at her own ceremony. (Be sure to blacken the

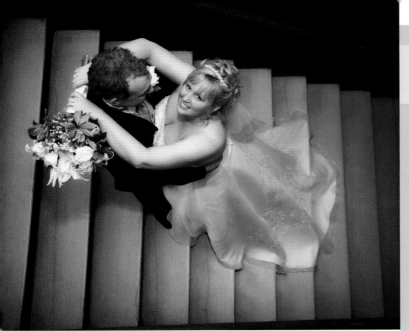

© Chantal Gauvreau

Take the High Ground

One thing you can do to make your pictures noticeably different from all the guests' snapshots is to shoot from a variety of perspectives. Look for unique, vantage points, such as choir lofts in the church, balconies in catering halls and hotel ballrooms, staircases, and even little outdoor hillocks that lend themselves to this idea. And if you opt to use a staircase as your backdrop for a photograph, don't rely too heavily on the typical shot that includes subjects set up on the ascending steps while you shoot from the stairway's base. Although this is certainly a worthwhile image, it can be more flattering to shoot your subjects from above, and it is a unique take on a traditionally successful shot.

edges of the mat board with a sharpie if they are not black already.) Although I used my hand to create a soft edge on the first half of the image, the hard-edged black mat board will suffice now because the soft edge of the first image is enough to create a nice blend. Don't forget to take enough shots to ensure you've got a good one!

You may be nervous the first time you do this, but after a while these simple types of double exposures will become the proverbial piece of cake. Since these types of photos sell, keep your eyes out for other double-exposure possibilities besides the one I have already suggested. If there are great stained-glass windows in the church, for example, you might try shooting the couple at the altar while blocking off the top of the frame. You can then make a second exposure of the stained glass. Sometimes I'll go outside and photograph the facade of the church while blocking off the area where the church doors are. Then, for the second half of the double exposure, I shoot a view of the altar positioned in the frame where the church doors would have been in the first half. During the second exposure, I mask the parts of the frame that overlap my exterior view. The resulting double exposure is of the ceremony floating on the church facade where the doors would be. It's very effective.

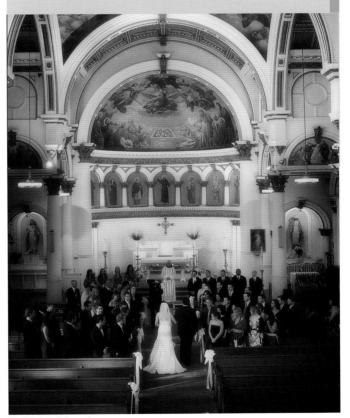

© Michael Brook

32. Long Exposures – *shoot a few*

After I've checked the double exposure off my list, it's time for a different look at the scene—namely, shots taken from a distance with long exposures. Slower shutter speeds are often necessary with these long views in order to achieve a good exposure. Don't worry too much about motion blur during these shots; even if someone moves, they will probably be too small in the frame to have it be noticeable.

Back in the film days, a photographer once told me that he always shot his long exposures of the ceremony with a one-second exposure at f/4 on ISO 160 color negative film. In general, I hate sharing exposure information because of the variables involved in every situation, but after shooting 3,500 or so weddings, I can tell you that one second at f/4 using ISO 160 is usually just about right, as long as the sun isn't streaming through the windows!

Consider doing things to add variety to these photographs, increasing your potential sales opportunities. Place a star or soft-focus filter over your lens to create an interesting, romantic effect. Look for a unique angle, such as a choir loft that will let you get a bird's-eye view of the ceremony. Or, you might take your camera off the tripod and lay it on the floor for a worm's-eye view. If you go this route, slip your pocket calendar or wallet under your lens hood to raise the front of the camera a bit. You might also consider taking a few shots of the ceremony from way back with a wide-angle lens, then switch to a short telephoto for even more possibilities.

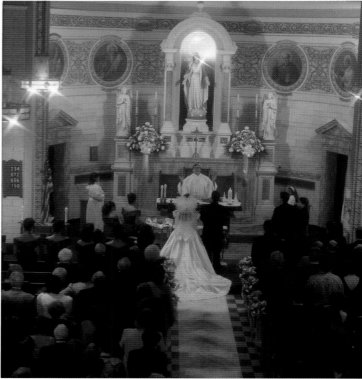

Shooting from a high vantage point, such as a choir loft, will give your long exposures a look that is distinctly different from the aisle shots you took from the floor. © Glenmar Photographers

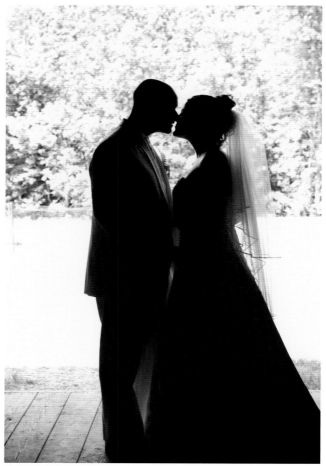

© Russell Caron

A Word About White Balance

One of the great advantages of shooting digitally is that you can easily set white balance to match the color temperature of the scene. This means that images taken without flash in venues lit with incandescent lights won't appear as orange as they would if you were limited to using daylight balanced film. But, just because your camera is capable of accurate color rendition doesn't mean you can't experiment with other white balance settings for a different look. If your camera allows you to enter specific Kelvin temperature settings, you can try both 2400K (the approximate color temperature of low wattage incandescent bulbs) and 3200K (which is the color temperature of quartz halogen bulbs). The 2400K will probably be most accurate, but the 3200K will be slightly warmer (though not as orangey as using a daylight setting of 5600K). This warm look could add desirable ambience to your images, and may be more to your liking than a more accurate color rendering. Regardless of your choice, you absolutely must remember to reset your camera's white balance back to the flash setting when you go back to using flash or you may be shooting images of a blue bride and groom! Finally, it is worth noting that, if your camera allows for simultaneous RAW+JPEG capture, this is one way to help ensure against ruined pictures due to incorrect white balance selections in-camera. However, the tradeoff is that you are using more than double the card memory as you shoot, so be prepared with a high-capacity memory card in the camera and a backup or two close at hand.

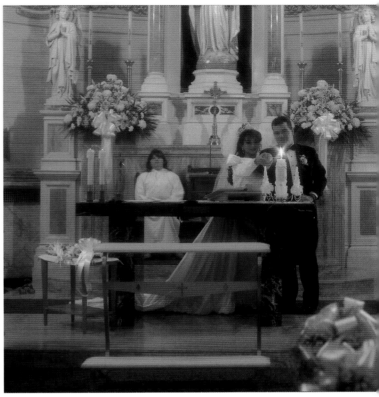

Candle lightings can make for truly beautiful images, especially if you are prepared for them and don't end up having to use flash just to grab the moment. Checking with the officiant before the ceremony to see if a candle lighting will take place is a good preparatory step. © Glenmar Photographers

33. Candle Lighting – *1-2 poses*

Very often, today's couples light a candle during the ceremony. Because my camera is not on a tripod when this happens, I try to shoot a handheld exposure just by candlelight, and if I can throw on a star filter, so much the better. Before I gamble on my steadiness however, I try to grab a quick shot with flash. While the flash picture isn't as unique, it is cheap insurance if my steadiness isn't up to snuff. If I can't get an available-light exposure of this moment, it can sometimes be posed after the ceremony, but even then it's usually rushed.

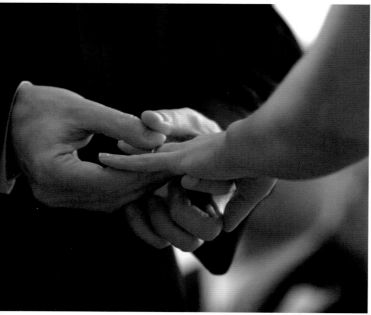

© Michael Brook

I can get a picture of the bride's face as the ring is placed on her finger. Sometimes I even have time to zoom in and get a close-up of their hands and the ring. The second I have my shot (or shots), I walk swiftly across to the same position on the other side of the aisle so I can be ready for the groom receiving his ring.

There are always a few moments between the two ring exchanges to cross the aisle. That said, don't dawdle, but don't run either! I never run because that can become a huge distraction to the guests. Finally—and this is kind of a drag—it is sometimes not possible to get your shot without blocking someone's view. It's a fact of wedding-photography life. When this is the case, I take my shot and move away the moment I've gotten it.

35. First Kiss as Husband and Wife – *shoot what you can!*

Sometimes the cleric has the bride and groom kiss at the end of the ceremony, and sometimes not! Be ready! If for any reason they don't kiss on the altar, or you miss it, look to get a kiss picture during the recessional.

34. The Exchange of Rings – *1-2 shots for each ring*

Most ceremonies today include the exchange of two rings, and that's worth considering when you plan the album. It is a very easy sale to suggest placing both ring shots on facing pages. If it's only a single-ring ceremony you lose out, but that one shot is still a keeper for the album.

When I meet the officiant, after he or she is done telling me about any ground rules they have for photography during the ceremony, I ask if they can please do me a favor and have the bride and groom face each other during the exchange of the rings. (Remember to say please!) I have never had anyone deny me this favor. Right before the ring exchange, I position myself about four steps away from the aisle's center on the groom's side of the church (because the bride's ring is always first). From that position, I don't block anyone's view and

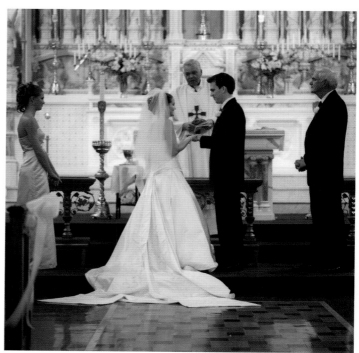

© Megan Jones

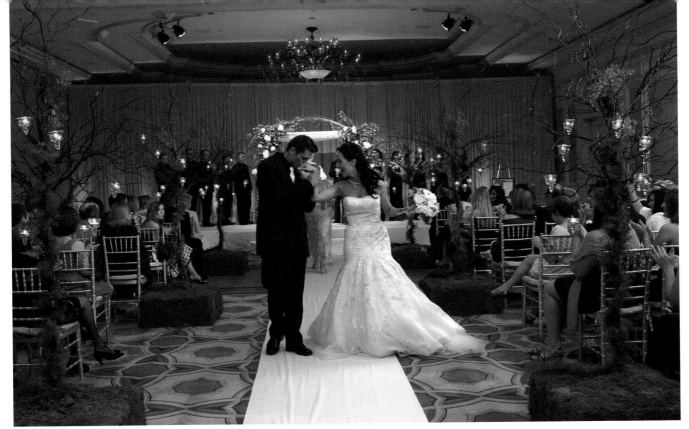

© Freed Photography

The Recessional

This can turn into a bit of a footrace, so you have to be on your toes. Like the processional, it is a time for pre-focusing so that you don't have to worry about focusing on the subject as you backpedal up the aisle. This is a quickly breaking situation and the worst thing you can do is stop mid aisle and let the people pass you because doing so only gives you one bite at the apple. After I get one or two of the couple as I backpedal, I very quickly turn and walk back to the rear of the aisle and continue shooting. Doing this lets me step to the side, behind the last pew, so I can shoot the parents and the bridal party as they file past me. I can tell you that, even after shooting a gazillion weddings, my adrenaline still ramps up during the processional and the recessional!

36. Bride and Groom – *shoot a few*

If you've been relating well to the bride and groom up until now (which, as mentioned earlier, is an important part of the game), it should be easy to catch their eyes for a quick photo of them looking at the camera. Before you try that, though, watch to see if they stop by their parents or grandparents on their way back up the aisle. And keep in mind that a shot of the recessional with the couple smiling at friends as they pass by is often as interesting as a shot of them looking at you.

37. A Parting Kiss – *1 pose*

When the couple reaches the very end of the aisle, I usually ask them to stop and kiss each other. I wait for them to get to me and then say to the groom, "Stop here and give her a kiss." Be warned, though, if you can't get this shot quickly, things are going to get crowded very fast because other bridal party members are coming up right behind the couple. It is imperative to take this picture using focus lock or by manually pre-focusing. There just isn't time to stop the couple, backpedal, and fumble with a focusing ring—and stopping the couple and backpedaling aren't optional!

As they lean in for the kiss, I quickly backpedal 6 – 7 feet (about 2 meters) away from them, which is where I've preset my camera's distance scale.

Then, I lift my camera to my eye and press the shutter button. As when shooting the processional, you must learn to estimate distances accurately. Thankfully, estimating distances between 5 and 15 feet (1.5 – 4.6 meters) is pretty easy. With shorter and longer distances, I find it harder to be accurate.

When I speak to the groom before the ceremony, I ask him to please do me a favor and tell him to stop at the back of the aisle and kiss his bride, or maybe even kiss her hand. It's sort of like a magician's trick where the magician has a willing accomplice that makes the trick possible. I tell him if he keeps it as a secret it will result in an unbelievable picture. Most grooms gladly accept my suggestion.

38. The Receiving Line – *shoot a bunch*

Try to concentrate on getting candids of parents, grandparents, siblings, and other bridal party members congratulating the bride and groom. This is also a great time to pick up expressions of joy, happiness, excitement, and surprise with a telephoto lens as the couple and their parents greet their guests.

Sometimes the receiving line is positioned outside of the venue. If this is the case and there are stairs leading up to the entrance, I put my camera on a tripod and work from the top of the stairs. (I'm always on the lookout for a different viewpoint.) Even though some might think candids are hard to shoot with a tripod, I find that a tripod allows my shots to have greater depth of field because I can use slower shutter speeds. Plus, it minimizes camera shake. I can pick up some great candids with a moderate telephoto lens.

As soon as I have captured a few great expressions from the bridal couple and their parents, I put my shoulder bag and tripod into my car because I want to travel light for the next group of pictures. All you'll need is your camera and flash. And, depending on the type of camera and the capacity of the card you are using, you might want to stuff an extra memory card and battery into your pocket as well.

Post-Ceremony Portraits

You don't have a lot of time to waste here. For one thing, especially in densely populated areas, there may be another wedding scheduled at the same ceremony site. Ideally, you know whether or not this is the case because you asked the officiant prior to the ceremony. Even if there is not another ceremony scheduled, you have an antsy crowd holding rice, confetti, flower petals, or birdseed just outside, so work fast!

39. Bride and Groom with Each Set of Parents – *1 pose each*

Once the receiving line is finished (with a big wedding it can take 30 – 40 minutes), I try to set up a quick shot of each set of parents with the bride and groom. I arrange the two women (the bride and a mom) in the center with both men (the groom and a dad) on the outside. I have the men shake hands with each other, and their outstretched arms form the bottom of my horizontal composition. While I usually get some candids of the parents and couple exchanging hugs, this posed picture is usually the one that makes the album because all four faces can be seen. It is also an easy two-picture sale because the couple won't slight either set of parents by leaving them out, and the two photos together make a great album spread.

40. Bride and Groom with Grandparents – *1 pose each*

Sometimes, elderly grandparents make it to the ceremony but don't go to the reception. If that's the case (and you'll only know if you ask), then you should get some photos of them after the ceremony.

41. Three-Generations – *1 pose each*

If the bride's mother's mother or the groom's father's father is in attendance, this is also a great opportunity to pick up a three-generation picture if it didn't happen at the bride's home and the grandparents aren't coming to the reception. This photograph is almost always included in one album or another, and having three generations of a family in one photograph—or even four, in some lucky cases—is a nice thing to have.

42. Semi-Silhouette in the Doorway – *1 pose*

One of the easiest shots that achieves special-effects-like ambience is a natural-light silhouette, and if the wedding venue happens to have an ornate doorway that allows you this opportunity, take it. I ask the bride and groom to stand in the doorway facing each other, and I have the groom place his hands on the bride's waist while she cups her hand under his chin. I turn off my flash unit and set my camera's f/stop and shutter speed for a correct exposure in the available light outside. Then, I stand inside, looking out towards the doorway that's framing the couple. The resulting picture silhouettes the couple in the doorway, and I have a winner... as long as I remembered to turn off my flash unit! (Hint, hint.)

43. The Bridal Party and Rice Throw – *1 pose each*

Trying to get a photograph of the bridal party outside the venue while controlling all the guests who are waiting to pelt the bride and groom with bushels of rice (or birdseed or rose petals) is an exercise in mob psychology. I usually line the bridal party up inside the church (women to one side, men to the other, in order of height, with the tallest closest to the maid of honor and best man) and the bride and groom in the middle flanked by the maid of honor and best man. I tell them to wait there for an instant while I go outside to talk to the crowd. The next part is tricky.

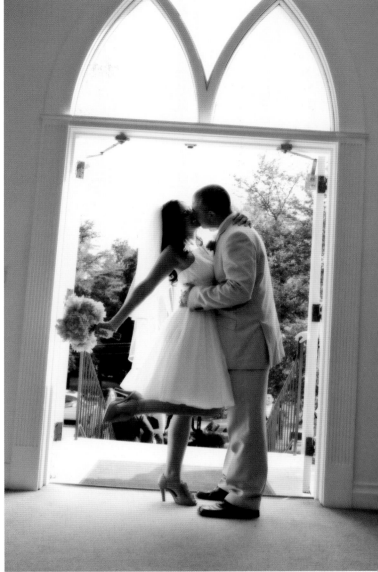

© Freed Photography

I walk out just past the doorway, and as I look at the crowd I say loudly (with a big smile on my face), "I heard some people here want to throw some rice at the bride and groom... and I want a picture of it!" Then, after the laughter and jeers die down I say, "Look, if we all wait until I count to three, we can pull this off together." By using the pronoun "we," I've made myself part of the mob. Next, I pick out some young person in the group, look him right in the eye (again with a smile on my face), and say loudly enough for everyone to hear, "Now

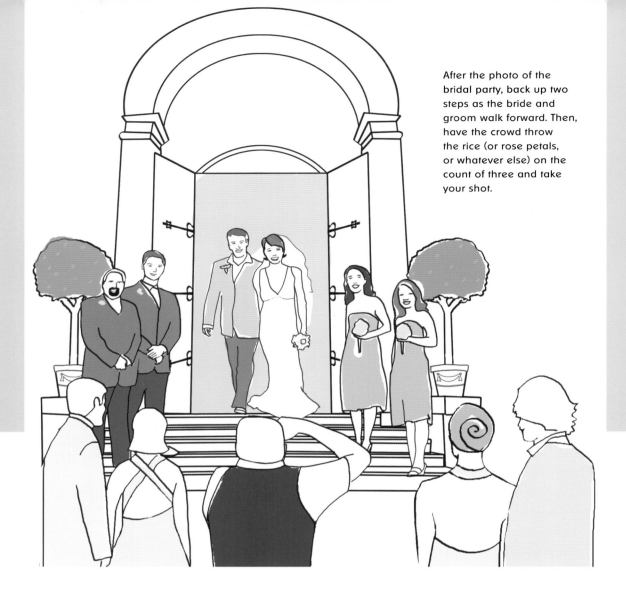

After the photo of the bridal party, back up two steps as the bride and groom walk forward. Then, have the crowd throw the rice (or rose petals, or whatever else) on the count of three and take your shot.

remember, wait 'til I count to three. No cheating!" It doesn't really matter whom I single out (although I try to single out someone I think could be trouble); it's just something I do to repeat the message for the crowd, and I always do it with a smile.

I then go back inside to the bridal party and tell the bride and groom (but directing my comment to the entire bridal party), "There are some people outside who want to throw stuff at you!" I then explain my plan to the bridal party. I ask all the ushers and bridesmaids to file out first and form a "V," then, at the last moment, the bride and groom will step through the doorway and stop in the center of the V.

As the bridal party is filing out, I move into the crowd, saying all along, "Remember now, wait until I count to three!" By the time I get into position, the bridal party is in place—including the bride and groom—and I grab my shot. This picture has

to be made quickly because my control of the crowd doesn't last long. The instant I get my picture, I immediately tell the bride and groom to start walking towards me, and I start to count loudly to three. The trick is to get to three when the couple is about 12 feet (3.7 meters) away from me because I've locked focus on some bridal party member midway up the leg of the V. As they cover the last couple feet and I shout, "Three!," the rice is in the air, I push my shutter button, and, usually, the bride and groom (and I) are rewarded with a scene that looks like a snowstorm! The downside is that I also get pelted with the rice and it gets into everything. By the end of a double-assignment day, my tuxedo is filled with it. It goes with the territory.

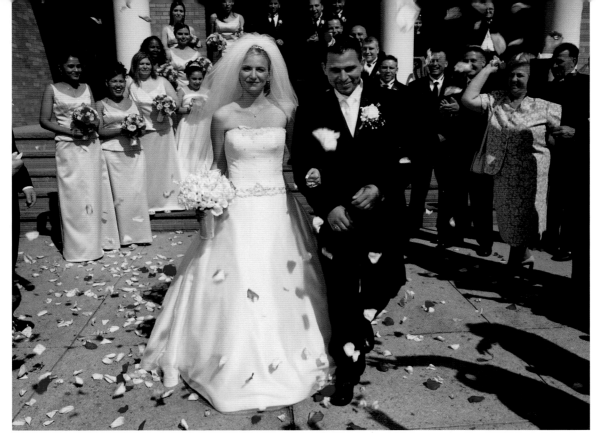

You will have a better chance of success in capturing a rice- or rose-throwing moment if you can get the crowd to time their throw to your count of three. There is always a chance that a big rose petal will be right in front of the bride's nose in the final capture, but hey, it's better than missing the moment! © Photography Elite Inc.

The Limo Shots

Limo pictures are special because the car itself is out-of-the-ordinary, and a photograph helps to further signify the extraordinary nature of the day itself. For some people, a ride in a limousine will happen only on their wedding day. Other people may hire other types of exotic or antique vehicles. Actually, I have done many a wedding where the bride and groom travel by horse-drawn carriage. I've seen Rolls Royce drivers in English chauffeur livery, rolled-out red carpets, champagne on ice in a silver bucket on an ornate stand outside the limo, twenties gangster cars complete with gangster-type drivers... I've even taken shots of a bride and groom laughing and hugging while they stood up through the sunroof of their VW Beetle. You can call it what you want, but to me, they're all "limo shots." The more unusual the vehicle is, the more I include it in the composition. As far as the album is concerned, limo shots taken before and after the church ceremony are great pictures that can be used to link the different parts of the day together.

44. Getting into the Limo – *1 pose*

The bride and groom usually enter the vehicle from the curb, so if you shoot from the street, you might be able to get the limo and the couple, with the wedding site in the background. If there's a "Just Married" sign on the car, get a shot of the couple in front of it now, too.

45. Shooting through the Far Door – *1 pose*

You can shoot through the limo's open street-side door as the bride and groom, standing on the curb, look at the camera through the open curbside door. If that's your plan, check the traffic before you open the door on your side of the vehicle, and again before you get down low to take the shot.

46. Couple Looking through the Window – *1 pose*

If you opt to photograph the couple through an open window, use your camera-mounted flash to "open up" the inside of the car, but make sure the door frame doesn't create a shadow across the bride and groom when flash fires. This is yet another situation where the ability to review your shot on the LCD monitor comes in quite handy.

47. Looking into the Backseat from the Front – *1 pose*

Try getting into the front seat of the limo and shooting over the seat into the back of the vehicle where the bride and groom are seated. Don't forget to check that the window between the front and rear seat is down if there is one. Don't laugh; I've seen it happen.

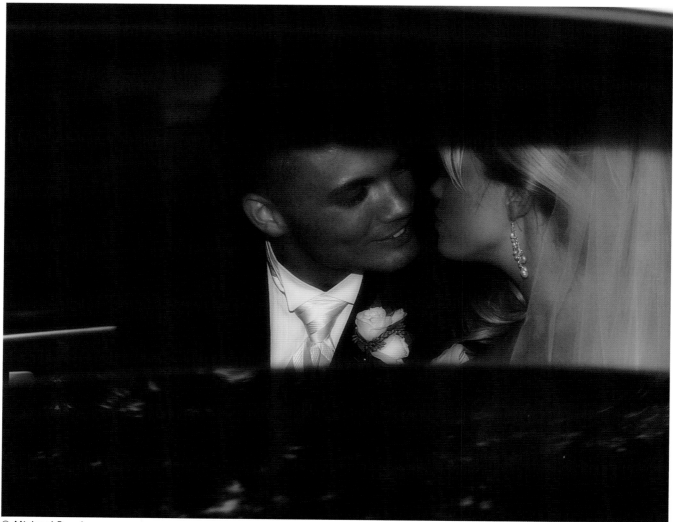

© Michael Brook

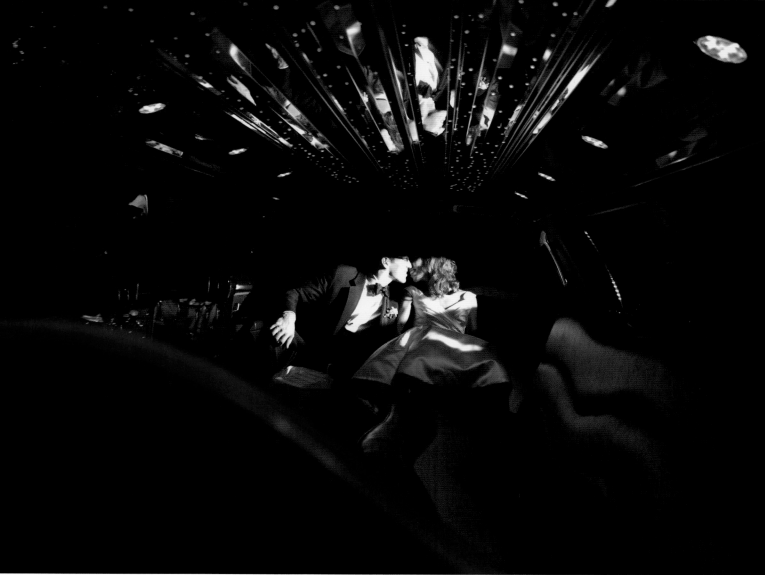

© Freed Photography

48. Limo Toast – *1 pose*

If the limo is equipped for a champagne toast, a picture is in order. Once again, the theory of "if it costs money, shoot it" applies.

49. Limo Kiss – *1 pose*

Round out your limo portrait session with a picture of the bride and groom sharing a kiss. And before you wave them off, don't forget to discuss where they would like to go for formal pictures. Then tell the limo driver two things: 1) where you plan to go, and 2) that you will be following him. That way you will all arrive at the same site together. Nothing is worse than losing the bride and groom as the limo speeds off! As an important side note, you should always have local area street maps in your car when you shoot a wedding.

Bridal Party Portraits

After the ceremony and before the reception is a perfect time to fit in the formal portraits of the couple and the bridal party. Also, if the couple's families are small, you may want to invite them along on this photo expedition. For the purposes of this repertoire, I am assuming that the family portraits will be taken at the reception hall (see pages 95 – 98 for details), but adjust your repertoire as needed on an assignment-by-assignment basis.

So, where to go? Very often, there is a park on the way to the reception hall. That is the easy solution, but there are many others. Some ceremony or reception sites have beautiful grounds, and that can be even more convenient than a nearby park. It might even be possible to go back to the bride's backyard—or the groom's—and shoot there.

On lovely days in the late spring, summer, and early fall, finding a suitable outdoor background for these portraits is a piece of cake, but finding a location on a rainy day, or in the dead of winter, can really test your creativity. Sometimes, catering halls have a large, separate bridal room that can double as a studio. If not, the lobby might be used, or you could seek out a drape in the reception area itself and use it to create a neutral background.

Other poor-weather possibilities include going back to your studio or, again, the bride's or groom's home if one of them has a nice living room area where the pictures might take place. (Truthfully, I've been in some living rooms that are nicer than any catering hall or club.) While many candidmen feel most comfortable working in front of a simple drape, a living room setting can really be beautiful. If that is the plan, remember to use staircases, chairs, couch arms, piano benches, and anything else that is handy for staging multiple subject levels. Try to stay away from lineups if at all possible. (See pages 114 – 135 for more detailed information about framing and posing.) And last, but not least, of my poor-weather-portrait solutions, for those days when I'm forced into working against bare, wood-paneled walls like those of a VFW hall, I carry a 10 x 20–foot (3 x 6.1-meter) gray, dappled, muslin background and support stands in a small case in the trunk of my car. It has often saved the day.

As a last resort, you can sometimes use the ceremony altar for a background. Check with the officiant beforehand to see if this is possible. If it is, here's a trick to help you limit the crowd of onlookers from climbing on your shoulders as you try to get your formal portraits done. Shoot the bridal party in front of the church, do the rice throw shot, do the limo shots, and then have the limo driver take the couple around the block and wait for five minutes before he drives the bridal party back to the ceremony site. While he's driving around, the crowd will disperse. By the time he gets back, you'll be there alone, ready to do some formals. Shooting the bridal party photos at the ceremony site is a popular alternative to going to a park in some areas. But, be sure that the bridal couple is well aware of your plans. The last thing you want is for them to go to the catering hall while you're left waiting at the church!

Getting the Shot: How well you relate to the bridal party is probably your most important asset when it comes to taking great formal pictures quickly. For instance, I always try to call everyone by name. Instead of saying, "Hey you," or "Could the usher on the end drop his hand to his side?," I prefer saying, "Janet, point your left toe towards me," or "Bob, drop your hand down a little."

Moving a large group of people around a park as a unit can be frustrating, but there are things you can do to smooth the situation and make it less of a burden on your subjects. For instance, smaller groups are easier to organize, so take the largest groups first. Then, send the bulk of them back to the limos where they can relax.

Now, before even looking at the list of photographs I recommend for this section of your wedding assignment, get it set in your mind that you should get more than one shot of every pose. And, as ever, the number of captures per pose should increase with the number of subjects in the picture. It is easy to watch for good facial expressions and avoid blinking eyes when shooting one or two subjects and, with practice, you can even catch these kinds of problems when shooting groups of three or

© Russell Caron

four. Once you get to larger groups of five or more people, however, it is impossible to watch everyone's face at once—especially during full-length captures where you are 15 – 20 feet (4.6 – 6 meters) away from them. So, with larger groups, I concentrate on making sure that the bridal couple and the little kids have a nice expression.

50. Entire Bridal Party – *shoot a few*

You can do this shot a couple different ways. One is to do a tight grouping, and the other would be to arrange the group by couples and spread them out on a lawn, hillside, or wide staircase. If you do the second shot with a wide-angle lens, place the bridal couple about 10 feet (3 meters) away and the rest of the couples about 15 feet (4.6 meters) or farther from the camera. This will give you an interesting composition, with the bride and groom appearing larger than their attendants. And remember to take at least six to eight shots of each arrangement to

be sure that you get one where everyone is looking at the camera and looking their best, especially the bride and groom.

51. Groom and Ushers – *1-3 poses*

While this photo is a pretty straightforward one to shoot, don't forget to keep the personalities you're photographing in mind when you go to create the poses. If you sense that the group would be up for a fun shot, give it a try! If they all have sunglasses handy, a "shades down" photo can be fun. Sometimes the groom can be laid across the usher's outstretched arms or a pyramid can be set up. Before you decide to try these ideas, though, get a read on your subjects' reactions. Look for hints as to how frisky these guys are to gauge how far you can push things. That said, if they go for one, they'll go for all of them. I've been at weddings where a friend of the groom brought the groom's Harley to the park. I've even shot photographs of a bridal party

© Russell Caron

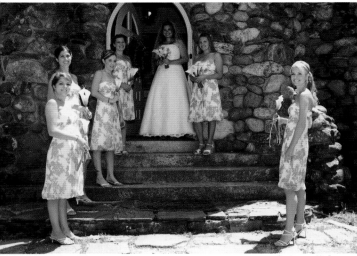

© Russell Caron

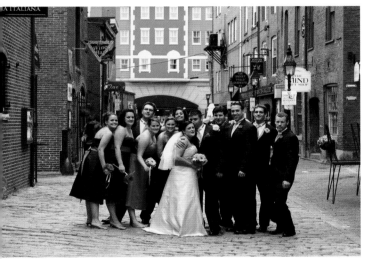

© Russell Caron

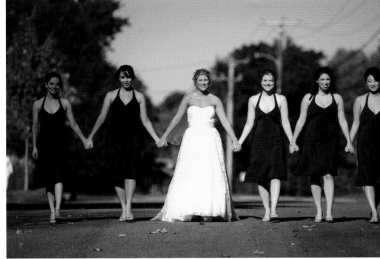

© Russell Caron

around a fire truck because the groom was a fireman. Also, remember that if you shot individual photos of the bride with each of her bridesmaids at the bride's home (see page 61), you should now shoot individual poses of the groom with each of his ushers.

52. Bride and Bridesmaids – *1-3 poses*

You already got this photograph at the bride's house (see page 61), but by shooting it now a second time, it will match the photograph of the groom and the ushers, and the two can be used as an album spread. And don't worry; the first shot of the bride with her bridesmaids before the ceremony wasn't necessarily wasted. The couple may still choose to include it at the front of the album.

53. Couple with Maid of Honor and Best Man – *1 pose*

Check out my framing and posing suggestions for four-person portraits on pages 116 – 118. You could go horizontal or vertical with this shot, or try some poses in both orientations.

54. Bride and Maid of Honor – *1 pose*

This is another shot that you may have gotten at the bride's house before the ceremony, but the pre- and post-ceremony shots will each have a different feel to them, and the couple just may select one of each for the album. If you have the time to take the shots, it may pay off in extra sales.

55. Groom and Best Man – *2 poses*

The same advice goes for this shot. You likely got a pose or two of the groom and his best man before the ceremony, but this is another opportunity to create a spread in the album of post-ceremony shots; match this portrait with the one of the bride and her maid of honor.

56. Groom Alone – *2-3 full-lengths, 2-3 bust-lengths or close-ups*

With all the hoopla surrounding the bride, it is sometimes easy to forget about the groom altogether. Don't do it! I once fell into this trap and shot a beautiful wedding but forgot to get a picture of the groom alone. I did it! I'm guilty! I saved the situation by shooting the groom on another day, but I ate the cost of his tuxedo rental and boutonniere and still had to throw in a few free prints. Still, considering my mistake, I got off cheaply. The couple was happy eventually, but it took some doing.

57. Bride and Groom – *shoot a bunch*

One of these pictures will be the most displayed picture of the wedding, and everyone who sees it will consider it to be representative of your work. Because of this, I like to get the bridal party pictures out of the way quickly so I can move on to concentrating closely on the couple. In terms of importance, these pictures rank up there with the bride and her father walking down the aisle.

Good coverage demands 4 – 6 full-length poses and at least as many close-ups. I try to get variety in both the posing and the background. No matter how

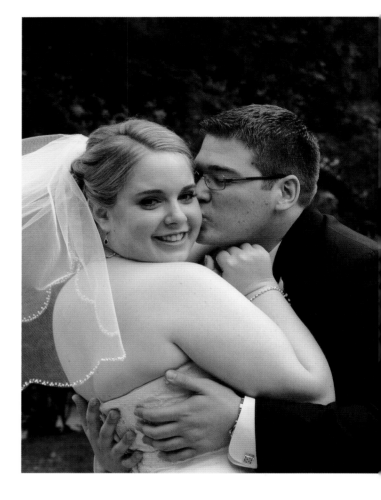

lazy you feel (it's hot, you're late, etc.), no excuses are allowed here. The only time that rushing these pictures is worth it is if the sun is going down and you're losing your light. You can't control the sun.

Bride and Groom Variations: Even though you are looking to produce a variety of basic bride and groom formals, you might try to tack on a few very different approaches for even greater sales potential. Most of the following don't fit into the classic definition of a bride and groom formal portrait, but each can add to the overall look of an album. In addition, they can make great beginning or ending shots for the album, and might even land you a large, specialty print sale.

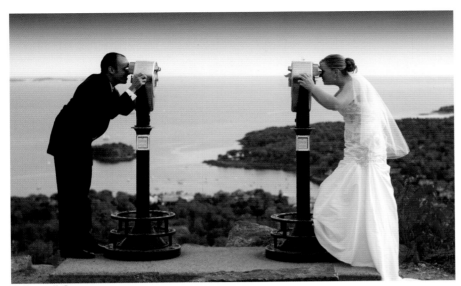

© Russell Caron

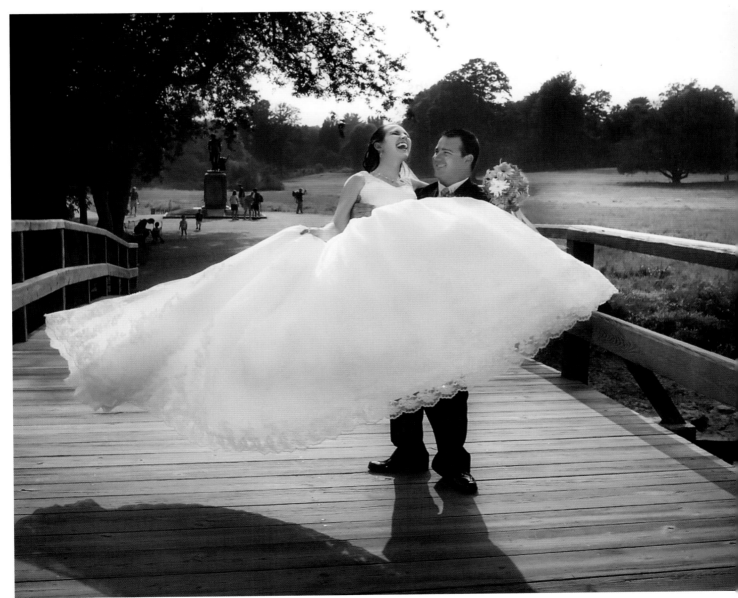

© Michael Brook

58. Close-Up of Rings on Hands – *1 pose*

For many couples, a photograph of their hands together wearing shiny, new wedding bands is a sentimental favorite. However, hands are not easy to photograph beautifully. In general, they look best when shown from the side and bent back slightly at the wrist, forming an "S" curve. Try to avoid showing the backs or palms of the hands in total. They will usually appear too large, and you run the risk of having them look like lobster claws.

For really top-notch hand positions, go to a local museum and study how some of yesteryear's painters handled them. After the museum trip, study your own hands by doing posing variations in front of a mirror. When positioned correctly, fingers can create repeating patterns that fit into classical rules of good composition, and that is what you should aim for.

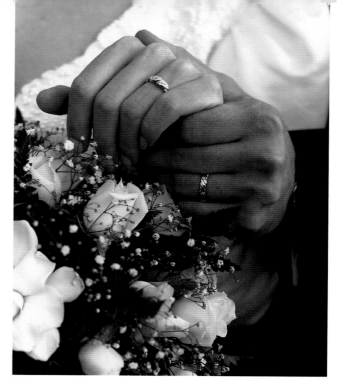

A close-up of the couple's hands displaying their shiny new rings is a worthwhile image to take. Keep in mind that, though the bride's hands may be beautifully manicured, that is not always the case for the groom. You can easily work around this, however, with careful posing. Be sure to use a lens setup that allows for close focusing to make this capture.

59. Close-Up of Couples Faces – *1-2 poses*

While you're considering close-ups of the rings, throw in a few really tight shots of the couple's faces. The vastness of the outdoors will let you turn the background into a beautiful blur, and the variety of these shots will make them stand out among the rest when your clients review the proofs.

60. A Scenic Image – *1-2 poses*

If you are shooting in a picturesque location, try backing up from the subjects so that the bride and groom are part of a larger scene. Architectural or natural elements can add variety and mood to the day's photographs. The couple could be sitting under a tree, by a lake, on a great lawn, or in a gazebo. Consider using soft-focus or graduated-color filters for these pictures to increase their romantic quality.

61. Bride and Groom: Selective Focus – *1-2 poses*

These shots offer a lot of room for creativity. For instance, you can arrange the bride in a bust-length pose and place the groom 5 feet (1.5 meters) farther away from the camera, but still within the frame. Focus your camera on the bride and you'll have a picture of her with the groom in the background, softly out of focus. Then reverse the pose, with the groom in the foreground and the bride farther from the camera.

Two selective-focus pictures of the couple can make a great two-page spread, but placement and posing are crucial to their success as a double sale. When you position the subjects, you must consider how the album pages will look together as a unit. To sell the double-page spread, the poses should be reversed entirely, placing the in-focus subject on the opposite side of the frame than the in-focus subject of the previous pose. This makes a big difference to the two images' final presentation.

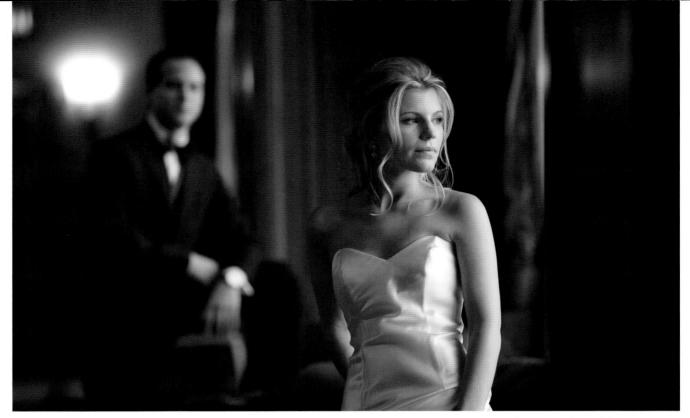

There will come a day in November or February when the formal pictures you might normally do outdoors on a beautiful summer day will have to be done inside. When this happens—and it will—cross your fingers that you'll be blessed with a beautiful venue and magnificent floral displays, but be prepared to get creative and make the absolute best out of what you've got. © Freed Photography

> **HINT:** Sometimes only one of the two selective focus images comes out great, or you run out of time you get distracted and forget to do the second image. If that's the case I can only say don't worry about it and try for both next time!

62. Extra Credit: Post-Ceremony Bride Alone – *3-4 full lengths, 3-4 bust lengths, 3-4 close-ups*

If there's time, and the light is particularly beautiful, catch a few additional full-lengths and close-ups of the bride even though you did a thorough work-up of her at home before the ceremony. You've got a different background to work with now, and because it's later in the day, the lighting may have a different quality. Further, now that the ceremony is over she's probably more relaxed and that usually means better pictures. If for any reason you didn't get some bridal formals at the house, you will need to take some extra time to get them now.

63. Bridal Party Wrap-Up – *1 pose each*

Ask the bride if there are any bridal party couples she would like photos of. If the answer is yes, pick those up at this point. If the groom has any siblings in the bridal party, catch him with them now. When you get to the reception, you're going to shoot his family pictures, and this will give you a head start on that list.

64. Final Bridal Party Group Shot – *1 pose*

End your park coverage with a relaxed group picture of the bridal party around the limos. Ask the drivers first, but try to seat bridesmaids and ushers on the fenders and bumpers, popping through open sunroofs, or anywhere else you can stick them that looks fun, with the bride and groom as your centerpiece, standing outside the limo, a little closer to the camera. Now, you're ready for the reception.

The Long Shot vs. The Tight Shot

Many of today's brides choose venues with beautiful gardens and interesting architectural details, so instead of always filling your frame with the bride, look for a picture that brings the beauty of the surroundings into your composition—a long shot. In addition to the standard picture taken at 15 feet (4.6 meters) with a normal lens, consider using a wide-angle lens and backing out to around 25 or 30 feet (7.6 or 9.1 meters). By making the bride (or couple) a small design element within a bigger picture, you can show off both the subject and the environment. This type of photo has the benefit of being different from what you would normally see in a wedding album and is also well-suited to be an extra-large and profitable print for the family to display. Use this technique judiciously, however, or you can be certain the bride will complain that there aren't enough photographs showing off her gorgeous gown.

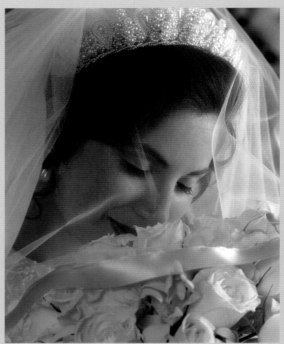

Tight shots can be done just about anywhere. Move in close to eliminate the background and fill the frame with your subject. This style of shooting does risk emphasizing facial blemishes, so consider using a soft-focus filter or, in the case of the bride, lowering her veil as I did in this example.

A tight shot involves using the opposite approach and taking very close-up photos of your subject to eliminate the background. The tight shot can be accomplished just about anywhere, as you will be eliminating the background altogether. You will need to use a longer than normal lens for this type of photograph so as not to accentuate any prominent facial features, as a normal or wide-angle lens would. You should also choose a lens with excellent close focusing abilities. And as with the long shot, don't overdo this type of photo. Both the long shot and the tight shot photos should considered in addition to more standard photographs. That said, they can quickly become an integral part of your portraiture bag of tricks. Variety in the pictures you shoot will make for happier brides and bigger print orders for you!

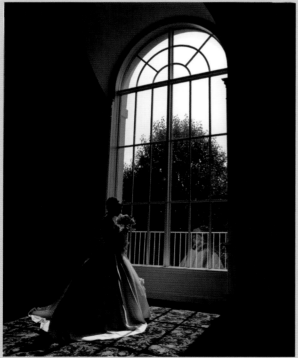

Wide-angle lenses make long shots possible, even indoors. In this case, I opted to create a semi-silhouette of the bride against the shadowy background and large window.

Family Portraits

As I mentioned in the section about formal portraits of the bridal party (see page 86), if the families of the bride and groom are small, you might consider inviting them to the park for pictures after the ceremony. If that's the case, take these pictures immediately after the ceremony, before you take photos of the bridal party. That way, you can photograph the parents first and they can be on their way to the reception. Nothing stifles creativity more than an anxious father wanting to get to the party.

If the families don't come to the park with you, these family photographs will have to be done at the reception hall. When they are scheduled to happen can vary. Often, at weddings I have covered, the bridal party has a cocktail hour separate from the other guests before the reception begins. If that's the case, I suggest you take the family pictures at that time. By then, however, the bride and groom are probably fed up with pictures (and with you). They want to relax and enjoy a drink, so broaching the subject of taking more pictures should be handled diplomatically.

There is an old saying that suggests it is not what you say, but how you say it that gets the response you want. Here's my approach. I go to the bride and groom and tell them two things: First, I thank them for helping me get beautiful pictures at the park; second, I tell them the only posed pictures we have left to do are a few family portraits. By mentioning that these are the last posed pictures to be taken, and that there are only a few left, I've made the idea more palatable to them. I also say that I would like to do these photographs now so that, once the reception starts, I won't have to bug them. Any of those words, "last," "few," or "won't bug," usually do the trick, and I then ask an usher and bridesmaid to go to the main cocktail hour to round up the people needed for the family pictures.

I have found that many people like to question everything, or are just contrary, but if I can give them a good, solid reason for doing something, they will usually cooperate. In this instance, the good, solid reason is an uninterrupted reception. It works. From a pictorial point of view, it is better to take the family pictures early because, as the reception progresses, people undo ties, remove jackets, get sweaty and flushed, hairdos fall, and generally subjects become less and less photogenic and less in the mood to be photographed.

The first several shots of the family group are the same set that you did at the bride's home with her family before the ceremony, only these are of the groom and his family. Look back at the notes about the bride and her family on pages 57 – 60 for reference. One would think that photographing the groom with his parents might be markedly different in some ways than shooting the bride with hers, but I have not found that to be true in most cases. But, if you want to test your limits, ask the groom's mom to give him a kiss on the cheek for one of your shots. Watch the groom's reaction as you shoot to gauge whether or not you can get away with as many touchy-felly photos with the groom's family as you did with the bride's!

65. Groom and His Dad – *2 poses*

Get at least one of them looking at the camera and one of them doing something—dad fixing the groom's tie (a bit hokey, but it works), or them hugging, leaning on a limo fender, shaking hands, checking their cell phones—anything where they are interacting with each other and not looking at you.

66. Groom and His Mom – *2 poses*

Just like with the groom and his dad, get at least one of them looking at the camera and one of them doing something. You might have the groom behind his mom with his arms around her shoulders, them hugging, her kissing him, or him kissing her—anything light and sweet will do.

67. Groom and His Parents, Add the Bride – *2 poses*

Get a straight, simple three-up and then ask them to get closer. To save a bit of time, you can easily add the bride to the picture for this second rendition. Just remember to do the straight shot first. Additionally, if you shot a photo of the bride and her parents using selective focus (see page 58), you should try to do the same with the groom and his parents.

68. Groom's Parents Alone – *shoot a few*

This shot can directly reference the instructions given for the bride's parents. Refer to page 58 for details.

69. Groom and His Siblings – *at least 1 pose each*

Refer to my suggestions on page 60 for photographing the bride and her siblings. Remember, if you opted to shoot the bride with each sibling individually, you will need to do the same for the groom and his siblings.

70. Three Generations: Groom's Side – *at least 1 pose*

This picture should include the groom, his father, and his father's father. These multiple-generation photos always sell, whether or not you were able to get a shot like this of both the bride's and the groom's side. Even if it doesn't make the album, it will most likely get you a couple of print sales.

71. Newlyweds with Groom's Family – *shoot a few*

How large this group is will, per usual, determine the number of shots you have to take to get one where everyone is looking at the camera with their eyes open. For sales potential, I recommend doing one rendition of this grouping with just the bride, the groom, and the groom's immediate family. Then, do another with the groom's grandparents added to the mix.

72. Newlyweds with Groom's Siblings – *1 pose*

This shot can be done a few different ways, again depending on the number of people in the photo. Pages 114–135 offer some important framing and posing considerations to keep in mind based on the number of subjects you're shooting. Keep in mind that, if you are running short on time, this is not a must-have image.

73. Newlyweds with Groom's Grandparents – *at least 1 pose each*

You might consider taking photos of the couple with each set of grandparents separately. The grandparents on either side of the groom's family will likely appreciate a portrait of themselves with the couple and, since each set of grandparents are in separate pictures, you might get portrait print sales out of this image too.

74. Newlyweds with Bride's Parents – *shoot a few*

Though you made several captures of the bride with her family back at the bride's home earlier in the day, now is the time to get the groom in the mix and take some shots of the couple with the bride's parents.

75. Newlyweds with Bride's Family – *shoot a few*

You've got the gist of this arrangement already from shooting the same shot with the groom's family. If you did any special posing with the groom's side, you might want to mirror that here.

76. Newlyweds with the Bride's Siblings – *1 pose*

Review my notes on this same shot with the groom's siblings. The bride and groom may likely have different numbers of siblings, so these shots need not mirror each other in the same way that some of the other corresponding shots might. And as with the shot with the groom's siblings, if you are running short on time, this is not a must-have image.

77. Newlyweds with Bride's Grandparents – *at least 1 pose each*

You might consider taking photos of the couple with each set of grandparents separately. The grandparents on either side of the groom's family will likely appreciate a portrait of themselves with the couple, and because each set of grandparents are in separate pictures you might get portrait print sales out of this image too.

78. Bride's Family Miscellany

If there are any shots that you didn't get earlier in the day at the bride's home, now is the time to grab them. Review your repertoire and check for any major holes.

79. The Bride's and Groom's Grandparents – *at least 1 pose each*

If you have the time, and the subjects are not frail, photograph the newlyweds' grandparents alone and/ or as couples. If successful, these shots can become heirlooms, lovingly displayed on the dressers and mantles of many family members' homes.

80. Extended Family – *shoot a few*

Some families are very close-knit. When this is the case, an extended family picture is in order. This picture includes aunts, uncles, and cousins, and you will need to shoot at least one of the bride's extended family and one of the groom's.

There are a few ways to handle these photographs. If the families are truly huge, you can break them down into two separate pictures—one of the newlywed's mother's family, and one of his/her father's. Note that this creates four separate family pictures—two of the bride's relatives and two of the groom's. Another option (to avoid having to organize such a mob) would be to suggest breaking down the family by generations. You could photograph the couple with their parents and all the aunts and uncles, then do one with all the cousins. I've actually organized 100 people in a family grouping on the catering hall steps! If you're faced with shooting a 100-person family, the quality of the posing won't be an issue as long as the photograph is sharp and centered. Forget about light quality or composition; just make sure you can see everyone's face, and that no one is cut off.

I must point out that you can kill the ambiance of a reception by asking 100 of the guests to get up and go outside for a picture. So, to remain on good terms with the banquet management (remember you'll be seeing them sometime soon at another reception), I ask the manager when he or she would like me to organize this kind of photo. Because banquet managers are interested both in serving a delicious, hot meal and having the party run smoothly, they will usually suggest that these photographs be done either during the salad course (it's a cold dish, so it won't be ruined if it has to sit for a few minutes) or after the cake ceremony (when they're finished serving food). If the banquet manager has any preferences, I follow them to the letter because, who knows, I could be back there next week!

The Reception

Instead of carefully directing the scene at a reception, it is better that you react to it. After shooting subjects in essentially controlled environments for several hours, it may be difficult to switch gears and become just an observer, but that's the way you'll get the best photojournalistic-type images. Good wedding photography is difficult, challenging, and fun because the assignments call for you to have talent in many diverse areas of photography, from formal posing one minute to photojournalistic images the next. While successful formal portraits depend on a photographer's control of the scene, great photojournalistic images require a photographer's quick reaction to the scene. Both are important, and both are quite different.

Just as you should have done prior to shooting the processional at the ceremony, you should begin shooting the reception with a fresh memory card. Unless you have an extremely high-capacity card on-hand, get a fresh card in the camera and ready to go. You don't want to miss a great candid moment due to having to switch cards in the middle of the party.

As for lighting, some of the best photographer's often set up radio-controlled slave units to eliminate the dark backgrounds created when using a single flash on-camera—a problem common in banquet hall flash pictures. My primary goal in doing this is to make photographs that are "demonstrably different" than those taken by guests with point-and-shoots cameras. If all the guests end up with photographs that primarily feature "blackgrounds" and my photographs show off the room's décor and ambiance, chances are good my photographs will look more professional... which is a very good thing!

Personally, I use 1,000-watt/second AC strobes. (My choice is Dyna-Lite, but any brand that doesn't draw a lot of amperage will work.) When I place my lights, I imagine where I'll be shooting from and position one or two units around the room to "open up" the backgrounds in my images. I put my lights up on 10-foot (3-meter) poles. If the ceiling is white, I aim the strobe heads upward at a 45° angle. If the

ceiling is dark or colored, I feather the lights slightly toward the ceiling so the subjects close to the strobe are softly lit without being tinted by the color of the ceiling.

Before the bridal party makes their entrance, I make a point to find out as much as I can about the entrance event and the first dance. I seek out the banquet manager, or whoever is running the party, and find out important details to plan my shooting. My first interest is from which entrance the bride and groom will walk into the room. Knowing that helps me figure out where to place my room lights.

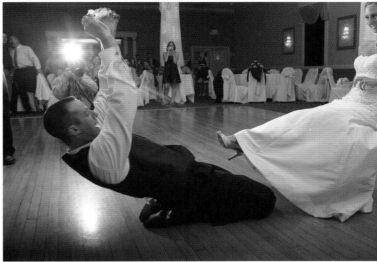

© Michael Brook

The Devil's in the Details

Have you ever thought about just what makes each wedding unique? While the bride and groom are, of course, unique from all other people, I have found that the easiest way to capture that uniqueness in a photograph is to record the details the couple surrounds themselves with on their wedding day: their rings, flowers, ceremony site, invitations, clothing, shoes, place cards, table settings, centerpieces, cake topper, favors, decorations, lighting effects, and almost every other detail. These are all expressions of their uniqueness, and they add to the mélange that makes that wedding theirs.

In my opinion, all these details deserve to be photographed. Montage wedding albums are particularly popular these days, featuring multiple double-page spreads filled with a collection of these kinds of detail shots. Not all of these images qualify as a "bread-and-butter" photograph, but they are relatively easy to capture and can flesh out an album nicely. Talented wedding suppliers have already creatively arranged the subjects of these photos and they are usually stationary, making it easy to choose the angle and position from which to photograph them. The only difficulty you face is getting your shots squared away before the guests rearrange or block them.

So, before you take a break to grab a bite to eat or a glass of ice water, take a moment to look around you and photograph some of these carefully crafted details. And don't forget that a grand view of the scene can also reveal the unique details of the

© Freed Photography

day. Try to get a picture of the entire dining room, especially if the décor is magnificent. If you get a great room shot, make sure that the venue (and the caterer, if they are different) gets a copy of the picture. You will have made a friend and ally in the business, and that can lead to more opportunities for you in the future.

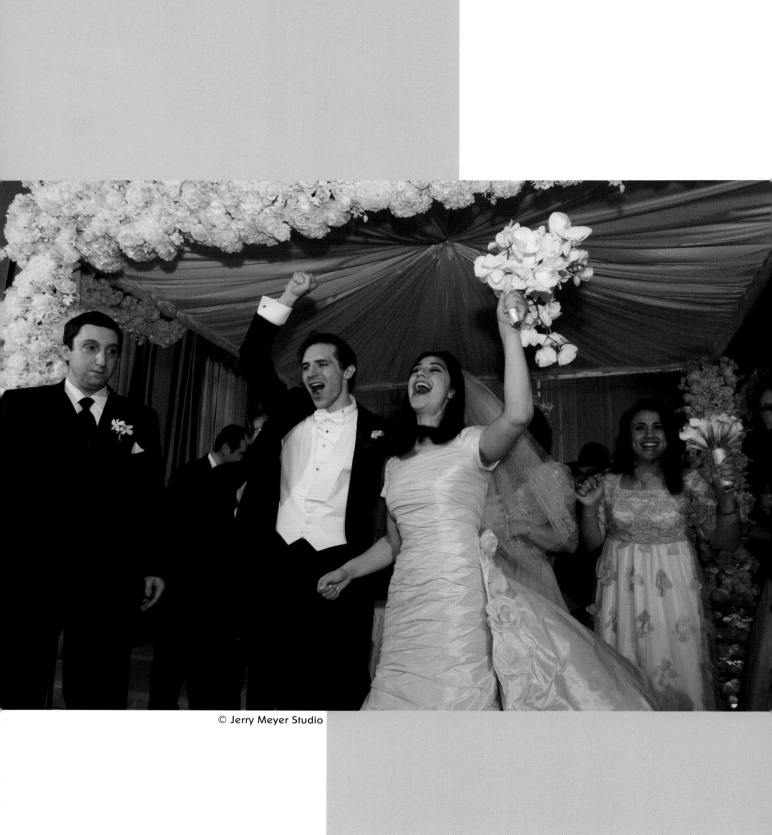

© Jerry Meyer Studio

The Grand Entrance

As when photographing the procession, my quick reaction to candid situations at the reception depends on estimating subject distances and presetting my camera's focusing scale (see page 71). For the bridal party's grand entrance, you might want to pre-focus on a specific spot and shoot the couples as they cross that line. One of my favorite pre-focus points is the edge of the dance floor because the line of demarcation between the carpet and the wood is an easy focusing target.

81. Siblings Entering – *at least 1 shot*

Although it isn't important to photograph every couple in the bridal party as they enter the room, sibling couples are worth a shot. As for the entrance of the best man and the maid of honor, the truth is that this picture rarely sells. If they are husband and wife, you should have gotten a formal portrait of them earlier... but at this stage in the game, I'm usually so adrenalized waiting for the bride and groom to enter that I shoot a photograph of them anyway.

82. Flower Girl and Ring Bearer Entering – *shoot a few*

When the flower girl and ring bearer make their entrance, their parents beam and people clasp their hands in joy. I have even seen the children's mothers run in front of them using a favorite stuffed animal as the proverbial carrot on a stick. All this fanfare should not go unrewarded, so I shoot a picture. If the flower girl or ring bearer is a niece or nephew of the bride and groom, the picture will probably make it into someone's album.

83. The Bride and Groom Entering – *shoot a few*

Some banquet managers arrange the bridal party into an archway through which the couple passes (check with the banquet manager beforehand). You may someday even have the opportunity to shoot a full dress military wedding, in which the bride and groom pass under drawn sabers! If you move quickly, you can get both a "straight" shot and a picture of the bride and groom coming through the arch, if there is one. The straight shot is good insurance because, when an archway is formed, the couple sometimes lowers their heads as they pass through it, and you end up with photos of the tops of their heads instead of their faces. No matter how good a salesperson you are, that's a tough sell.

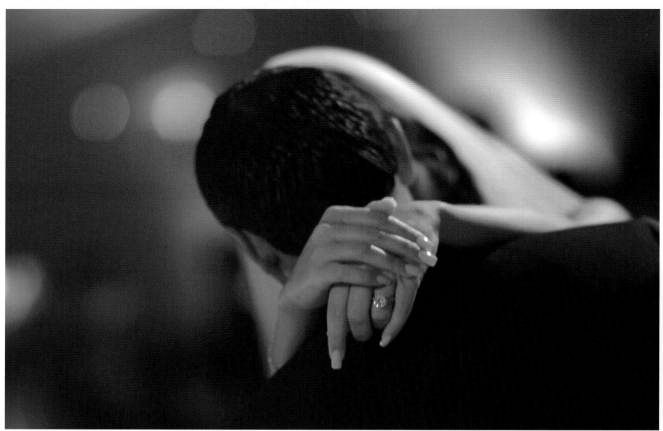

© Freed Photography

The First Dance

Back in the day when I was shooting 10-exposure rolls of 120 film, I often used two or three magazines on the first dance alone. In the here and now, you should be aware that having your DSLR set for continuous shooting will tend to burn through card capacity—and battery power—quickly, so you might consider having a spare memory card and camera battery in your pocket... just in case. Honestly, though, I never shoot in continuous mode because my flash units don't recycle fast enough to keep up with my camera when I do.

84. The Newlyweds First Dance – *shoot a bunch*

For the couple's first dance, you will want to get several full-lengths and possibly a close-up or two. Three shot possibilities to consider are: 1) the bride and groom looking at the camera (politely ask them beforehand to please look at the camera once, for a second, whenever they want to—and smile while asking!); 2) them looking at each other; 3) the couple sharing a kiss.

Instead of stopping the couple to take photographs, as some photographers do, I prefer to move with them. I have taught myself to move in a circle around the bride and groom, following their rotation as they dance. By moving yourself in an arc, you can maintain a consistently measurable distance from the couple, which is especially important if you prefer to use manual flash. You can change your framing by zooming your lens, but remaining at a consistent distance from the subjects ensures that your flash exposure doesn't change. Sometimes, as I'm rotating, I come across a particularly good background (i.e., the parents looking on) and I stop there for a while as the couple continues dancing.

© Sara Wilmot

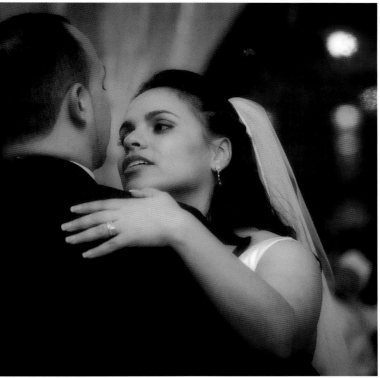

© Michael Brook

Recently, in my area, I've been to a few weddings where the bride and groom had worked with a choreographer to have a more formal first dance with bows, breaks, and twirls! Because they told me about it beforehand, I was ready with my 17-55mm lens instead of my longer telephoto zoom so I could get some full-length images of the action.

85. Bridal Party Couples – *at least 1 shot each*

After the bride and groom have danced alone for a few minutes, the rest of the bridal party is invited to join in. With large bridal parties, I have to work quickly to capture all the couples because, within a few moments, the parents will be joining in. This is one reason I usually switch from full-lengths to close-ups, which don't require as much back-pedaling to frame. Another reason I opt for close-ups is because, in full-lengths, the couple doesn't fill the frame from side to side, which usually means that other couples who aren't the subject of that photo make their way into the shot.

© Sara Wilmot Photography

Even in this difficult circumstance, I try to capture each picture professionally. I approach each couple and gently get their attention. When they turn to me I say, "Get close together and smile." As I say this, I'm already starting to backpedal out to a good shooting distance. The whole thing—contact, instructions, and taking the picture—takes just a few seconds.

86. Parents – shoot a few

While taking pictures of the two sets of parents seems straightforward enough, keep your eye on each of the couples because sometimes they switch partners. The parents might switch off with each other, or they might even invite a grandparent out onto the dance floor. And of course, the bride's dad may tap the groom and step in for a dance. All are worth a picture.

87. Grandparents – shoot a few

In this case, the picture is truly worth a thousand words. If the grandparents are out on the dance floor, get a picture of them! Of any of the guests at the reception dancing, pictures of grandparents on the dance floor are among the most likely to make it into the wedding album.

The Toast

Almost every wedding album I have ever seen includes a picture of the bride and groom toasting. In the days of film, some wedding labs used to have a stock shot of a brandy snifter glass into which they superimposed an image of the bridal couple toasting. I had thought the photo of the couple in the glass was absolutely and hopelessly outdated, but a few weeks ago, I was going over a set of proofs with a bride and her mom and I almost fell off my chair when they both requested a photo of the bridal couple in a glass toasting each other! I promptly went out, found a blue brandy snifter glass, set up a photo, put the snifter shot and the toasting shot together in Photoshop, and stuffed the extra $100 in my pocket. Maybe there is some truth in the adage that everything is old until it becomes new again. That said,, my more straightforward rendition of the toast shot is always a big seller for the album.

88. Best Man Toasting – at least one shot

The best man may be called up to the bandstand to offer his toast to the couple, who are seated at the head table. If that is the situation, a photograph of him toasting is in order. Be aware that the maid of honor often follows with a toast of her own, so be ready to take another photo in case that happens.

89. Bride, Groom, and Best Man and Toasting Glasses – at least one shot

If the best man stands next to the couple while proposing his toast, try to include the couple and the best man toasting. That way you've got a better chance of making a sale.

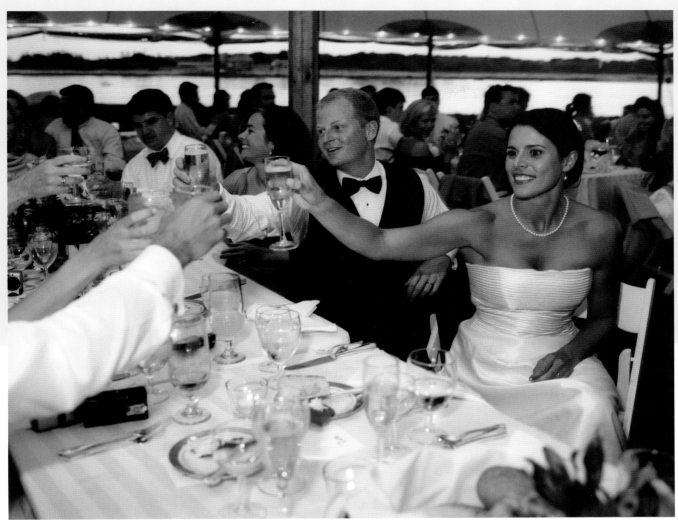

© Megan Jones

HINT: After you take the photo of the best man or maid of honor toasting, turn around and shoot the reactions of the bridal couple, the wedding party, and the other guests! You'll get images of people getting teary eyed, people laughing, and couples snuggling together

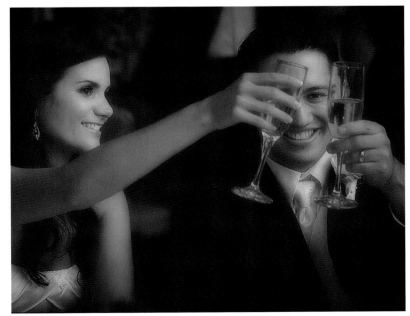

© Michael Brook

90. Bride and Groom Toasting – at least one pose

Once the toast has been completed, the guests seat themselves, and the dinner commences. My last duty before leaving the couple alone for a while is to take a picture of the two of them toasting, especially if the picture of the best man's toast did not include them. I ask them to move closer together and to hold their glasses with their outside hands. Their outside hands come together in the middle, clinking their glasses, and I have my shot. For this rendition of the toast shot, they can look either at each other or at the camera—both look great.

Sometimes the couple tries to intertwine their hands as they drink the champagne. Although it sounds like a great idea (and I always shoot a picture if they try it), it never looks as good as the straight shot. The interlocking arms look very confusing in print, and one of them always seems to be on the verge of taking an elbow in the eye or nose.

Table Pictures

If you ask many photographers what they hate most about wedding photography, chances are they'll say, "The table pictures." Someone is always missing ("Please come back later," "Martha is in the lady's room," "Chuck is in the parking lot," etc., etc.), someone doesn't want to get up and move around to the back of the table ("Don't even think about asking me to stand up. I'm exhausted."), or someone doesn't want to stop eating ("Come back after the coffee is served... or better yet, tomorrow!").

Many times, even after most guests have cooperated, other guests can still be a nuisance; someone at the table thinks it's funny to cover another person's head with a napkin, make their fingers into rabbit ears, or grab someone else inappropriately. After a few years, this type of behavior gets very old, but there are some ways to ease the burden. I make a point of first looking at the table's guests to note if anyone is physically disabled or if there are any elderly people sitting there. Next, I arrange my picture so that they can remain seated. That way, if someone gripes about having to get up, I say that I'm arranging it so that the elderly person or the one with a disability doesn't need to be bothered to move. And before asking anyone to move, I tell them that the bride and groom asked for a picture of the guests at this table, and if I do it now I won't have to bother them later. Then, I personally ask each couple whom I want to have stand to please step around to the other side of the table. I usually ask the man and say, "Excuse me sir, but could you and your lady please step around to that side of the table for a picture?" Invariably, some guy retorts, "That's no lady, that's my wife!" I respond by smiling and saying, "You wouldn't marry anyone but a lady." At that point, the wife usually steps in and takes her husband to the back of the table for the picture. The whole scenario is repeated so often I can do it in my sleep, but every guest thinks he (and it's almost always a guy) is being totally funny, unique, and innovative by creating a hassle.

Another potential fly in the ointment has to do with the many courses of food that have to be served and removed. It is very difficult for waiters and waitresses to serve hot food and clear tables while guests are being photographed. Etiquette demands that I not disturb their work. To add to the difficulty, at the end of each course, the table is covered with dirty plates, and food scraps don't make for an appetizing picture.

Because of all this, my studio rule is that I will do any table photographs requested, but they must be used in one of the three albums, over and above the contracted number of pictures. At this point, I've done it so many times that I actually enjoy the quick-witted repartee that goes into making good table pictures. I use it to keep myself sharp. That said, I don't want to waste my time playing the table-picture game with all the guests if my customer isn't interested enough in the pictures to put them in the album.

When shooting the table pictures, you will either be dealing with a small, low-lying centerpiece or a large, tall centerpiece. The illustrations on the left show camera and lighting position for a low-centerpiece table shot, and those on the right show the same for a tall-centerpiece shot. You can have an assistant light the low-centerpiece shot from either side, but you will have to make sure that the light is on the same side of the floral display as the camera for a tall-centerpiece shot. Otherwise, the centerpiece will cast a shadow over the guest's faces.

91. The Tables for Each Set of Parents – *1 pose each*

Whether the couple wants table pictures or not, I always get a picture of the two parents' tables. There are two ways to shoot these photos, and the style I choose depends on the table's centerpiece. If it is low and the table has 10 – 12 guests, I ask six guests to remain seated and ask the remaining guests to stand behind them. I always try to let the parents and grandparents remain seated, and I take a head-on shot.

On the flip side, if there is a large, high centerpiece in the middle of the table, I let four guests remain seated and stand the other six or eight people behind them. While my assistant stands to the far side of the flowers and aims his or her light at the people at the rear of the table, my camera's flash unit illuminates those guests in the front. You'll need a wide-angle lens to gain greater depth of field because the subjects are at various distances from the camera. Instead of shooting this shot head-on, I shoot it from the side so that the floral display is on one side of my composition and the people are on the other.

The Dance Floor

Many couples say that they like candid pictures of people dancing, but I have found that most customers choose only a few when it comes time to make selections for the album. The main limitation with totally "undirected" dancing pictures is a lack of focus. I'm not talking about correct camera focus; that part is easy. I'm talking about the lack of distinct subject matter. Typical photographs of people dancing show half of the subjects with their backs to the camera. Shoot 50 of these typical dance photographs and only a scant few will make the grade as album selections. That said, of the dance floor photos, there are certain types that are consistently chosen, and they should be your prime focus.

92. Two-Up Dancing Photos – *1 pose each*

These include photos of moms and their sons, dads and their daughters, the flower girl and ring bearer, and moms and dads with their parents. Get what you can, and make a polite effort to get them to look over at the camera.

93. Three- and Four-Up Groups Dancing – *1 pose each*

Getting this type of picture requires a bit of extra effort. I dance up to the people and say, "Keep dancing, but look at me!" Sometimes I pantomime putting their arms around each other or getting closer.

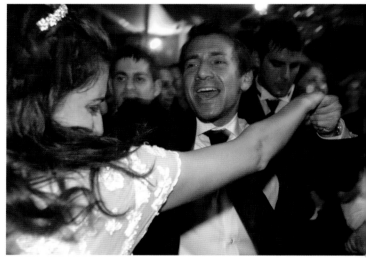

© Three Star Photography

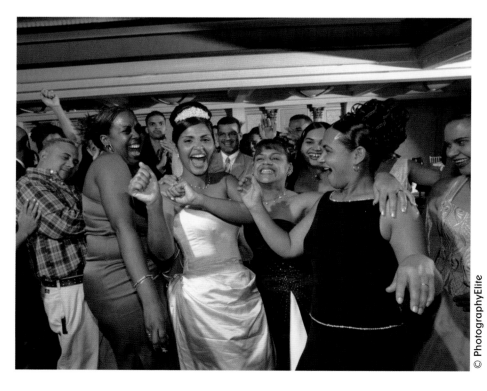

© PhotographyElite

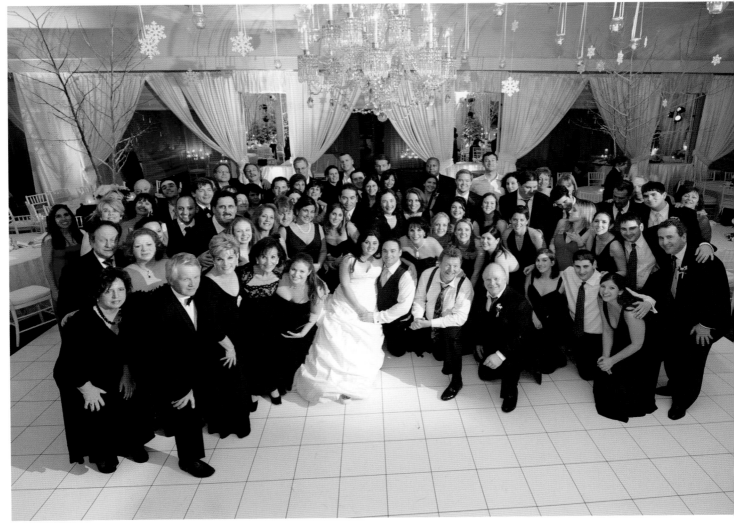

© Freed Photography

94. Large Groups of the Couple's Friends – *shoot a few*

This shot is best if the bride or groom is included in the jumble of bodies. I have actually seen friends of the bridal couple throw themselves across the dance floor, sliding in on their backs to be included in the picture!

95. Candid Close-Ups of the Bride and Groom – *shoot a few*

These should be totally candid, up-close-and-personal shots. The idea of working from a stepladder and using a short telephoto lens shouldn't be overlooked. By shooting from a high vantage point, you can eliminate some occurrences of the back of someone's head in the foreground.

96. Bride and Dad Dancing – *shoot a few*

Whether the band makes this into a ceremonial rite or not, this is a picture to get. Watch and be ready for a quick kiss or hug between the two. If the band or DJ gets into the act, ask them to have the groom join in with the bride's mom. It'll make a great two-page spread.

97. Groom and Mom Dancing – *shoot a few*

This picture is the companion piece to the previous shot, and it, too, is a keeper. Once again, be ready for a possible kiss or hug. You might also have a chance to get a shot of the groom with the bride's mom and the bride with the groom's dad. Take what you can get!

Romantic Interlude

I usually ask the bride and groom if we can do a few romantic photos after they've finished the main course. These take only about five minutes, and I try to get them in before the cake-cutting and bouquet- and garter-tossing ceremonies. It is important to fit them in now because, right after cutting the cake, guests start to leave the party, and amid all the good-byes it is often impossible to get any alone time with the bride and groom. Early in the evening, while the guests are eating, I take a walk around the reception hall with my light meter in hand. When the time to take these pictures comes about, I have very specific ideas about where and what I'm going to shoot. I try to get some romantic images, and at the same time I try to include some of the ambiance of the reception hall. Even in a VFW or Elks lodge, you can usually come up with some creative backgrounds or lighting effects.

© Freed Photography

98. Double Exposures – *2 poses*

One of the easiest—and most popular—pictures to do is an in-camera double exposure of the bride and groom. The trick is to find a dark background. If you can't find one on-site, get an assistant to hold a black posing drape behind the subjects for each of the two exposures. (Refer back to the double exposure of the bride, detailed on pages 64 and 74.) If you block out part of the scene with a small piece of matt board, be sure to view the scene at your lens' taking aperture (use the depth-of-field preview button) so you can see how much of the frame your mask is really blocking out.

Many times, I make an exposure of the bride and groom in an upper corner of the frame, with both subjects looking at the opposite, lower corner. I then take the couple outside and put them in the doorway of the reception hall and take a second image of the bride and groom caressing in the doorway, placing it in the lower part of the frame where I had them looking in the first photo.

99. Candlelight Photos – *1-2 poses*

If there's a candelabra, it's worth a few shots. I like to take out my tripod for images like this because it lets me use longer shutter speeds instead of blasting away with a flash unit that can kill the effect of the ambient light.

100. Album Closing Shot – *at least 1 pose*

Select a nice scenic element from inside or outside the venue and incorporate the bride and groom into the scene. Don't limit yourself to a scenic shot, though. Sometimes a great dip and a kiss after the cake cutting can be just as effective.

101. Gag Shots – *1-2 poses*

Have members of the bridal party strewn over the couple's car. Try having the couple run through an arch of sparklers. You can set up these shots or just look to capture fun events that the bride and groom have set up themselves.

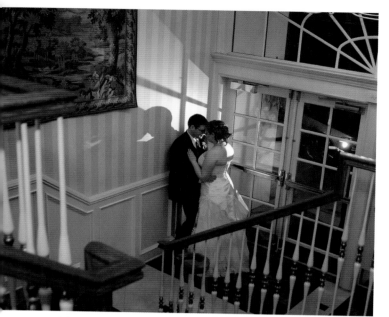

A kiss, a longish lens, a large aperture, and a flash behind the bride and groom to create a semi-silhouette can create a magic moment.

102. Available-Light Night Scenes – *1–4 poses*

Pick a secluded part of the venue (or even the lobby, if it's empty) and shoot a few variations. You might even find a landmark building outside the venue that's worth including. These are just a few of the ideas you can explore.

Cutting the Cake

The cake-cutting ceremony can be a major focal point of the evening or just a small event that takes place on the side of the ballroom. Some couples do away with the feeding and kissing parts and just cut the cake. There's a chance that the whole set of photos may be chosen for the album (cutting, feeding, kissing), but many couples just include the cake-cutting picture, which is why I always take a few of this shot. If you are able to double-light this picture, put the assistant's light off to the side and behind the cake so that it illuminates the couple and provides a rim light on the cake without burning up (over-lighting) the cake's decorations.

103. Couple's Hands over Cake, Showing Rings – *1 pose*

If you didn't get a ring shot during the formals, you can grab a quick picture of their left hands clasped together in front of the headpiece on the cake.

104. Cutting the Cake – *shoot a few*

As I mentioned, this is the one cake shot that consistently makes it into the album, so shoot a few. Take some with the bride and groom looking at the camera and some with them looking at the cake.

105. Bride and Groom Feeding Each Other – *1–2 shots*

This isn't always the most flattering shot, but it is an endearing one, so take the shot and let bride and groom decide later if it's album-worthy.

106. Couple Kissing with Cake in Composition – *1–2 shots*

Even if the couple doesn't use the cake-cutting sequence earlier in their album, this picture makes a great album closer.

107. Bouquet and Garter Toss – *shoot a few*

Whether you advocate these rituals or not, they are usually popular additions to the evening's festivities. If the couple is into the whole ritual, at least one (if not more) of the pictures will be in the album. Sometimes, the bridal couple doesn't go for the entire set of pictures, electing instead to just do the bouquet toss. Whatever the case, I try to get at least two lights working for this type of situation. While the flash on my camera lights the bride, I make sure that either my assistant's light (or my room lights) shine on the potential catchers. Very often, the band director or DJ runs this part of the show, and there is usually a countdown, which makes timing the shot a bit easier.

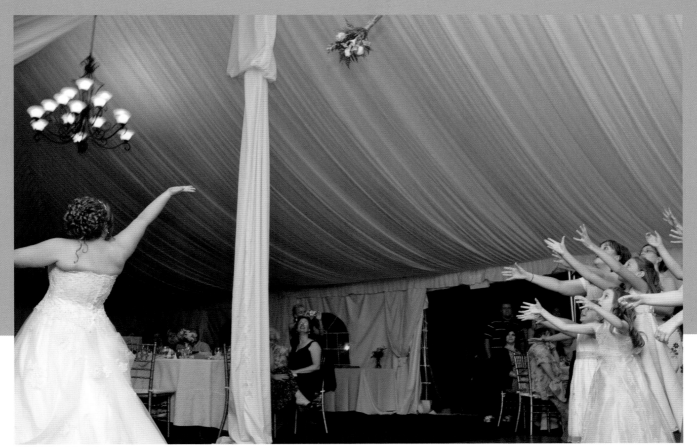

© Michael Brook

Make It Your Own

Everything you've just read is meant to augment your own photographic style. None of the suggestions I've presented are the only way to approach the assignment. Take what you need and add it to your own set of ideas, or use it as a foundation to establish your repertoire.

For two years, my number one assistant was with me at every wedding I shot. He took a six-month vacation from the business and, when he returned, we went out on an assignment together. After working through a set of formals, he turned to me and noted that my entire repertoire had changed. Well, that's the way it's supposed to be! A repertoire is a fluid thing. It changes as you mature and grow. It keeps you fresh and makes the job fun.

Here is a general idea of where the tosser, catchers, photographer, and lights are positioned during the bouquet or garter toss. Notice that the photographer is on the opposite side of the bride's throwing arm. If he were on the other side, there would be a good chance that the image would result in the bride's arm blocking her face. If you have the time, try to determine whether your subject is a righty or a lefty before you set up your shot.

Framing and Posing

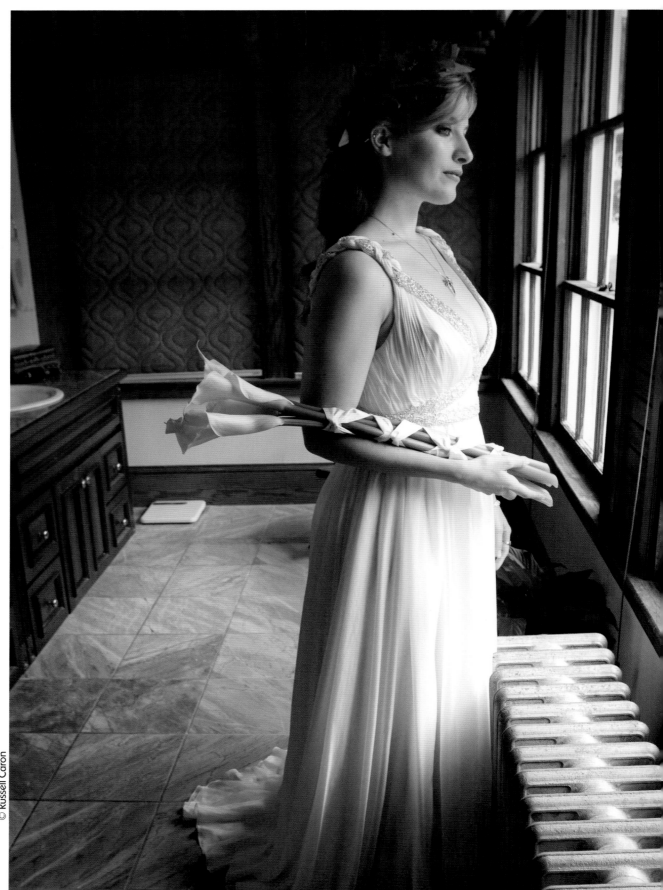

There I am, shooting a party at a major New York hotel. There are 800 guests, 80 tables, and at each table, there is a bouquet of 100 roses. Four photography crews have been hired to handle the assignment. As a member of one of the first two crews, I have been shooting since just after noon. The third and fourth crews were scheduled to start at 8:00 P.M., immediately following the ceremony. At 7:45 P.M., I go over to my studio manager and say, "I've established a beachhead and secured my perimeter; bring in the reinforcements."

Over the years, I've watched some of my view-camera-toting, nature-specialist friends agonize over whether an image should be vertical or horizontal, and whether they should crop out or leave in a certain branch, twig, or leaf. Wedding photographers don't have the luxury of these agonies. In the wedding-photography world, everything happens too quickly for agonizing.

I've also seen fashion photographers shoot frame after frame as a professional model dances joyously in front of their lens, with hairdressers and makeup artists ready to jump in for touchups at any break in the action. They might pump out 1000 images just to get the one picture they want. Wedding photographers don't have the indulgence of wasting time or working in a controlled studio environment to make their subjects radiant. It's simply impossible to shoot 300 photographs in order to capture that one single keeper. As a pro wedding photographer, you must do what you can to help your subjects look great in front of the camera while always considering the limitations of time and the fact that the photographs are secondary to the event.

So, to be good (and successful) at wedding photography, you must get to the heart of the matter quickly, and that is best achieved by having some preconceived notions in mind about how you want the final photographs to look. Framing and posing are governed by rules that eliminate wasted time while you're searching for that elusive "perfect" image. These rules speed up the process of capturing the "bread-and-butter" pictures, therefore creating time for you to shoot those extra, out-of-the-ordinary pictures that may produce additional sales. Without setting anything in stone, let's explore some simple framing and posing axioms that will add a professional touch to your pictures, let you take more photographs in less time, and make your subjects look better. Just remember, every rule needs to be broken occasionally.

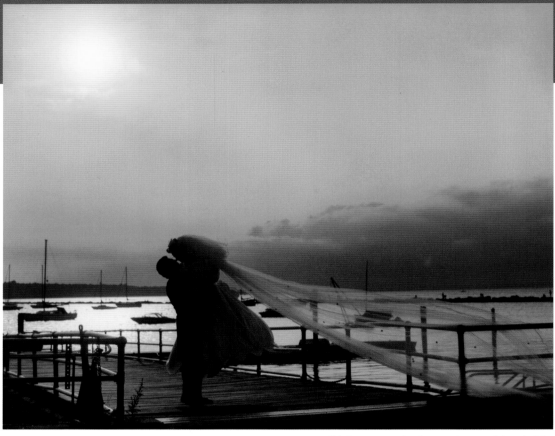

This is an example of an environmental portrait. In it, the subjects are as important as the scene they are in. © Franklin Square Photographers

Framing

There are basically three framing types for posed, formal wedding photos: full-length, bust-length, and close-up. At one time, a bust-length picture was considered a close-up, but with the emergence of the SLR (and its parallax-free viewing) and the growing popularity of telephoto lenses for wedding work, photographers have been able to get in closer and explore the subtleties of the face. This led to the bust-length image changing in status from being a close-up to a mid-range shot.

Full-Length Photographs: As a general rule, if you have five or more subjects standing in a line and they are heavyset, the image is horizontal. If they are thin, five subjects might be squeezed into a vertical. If you can pose multiple subjects at different heights (such as a mom sitting, dad standing, and their three kids sprinkled around), your subjects can often be rearranged into tiers, thus fitting into a vertical composition.

Horizontal or Vertical?

Individuals are generally vertical subjects. Large groups of people standing in line side-by-side are generally horizontal subjects. Hold those thoughts while we look in more detail at some basic rules of composition.

Full-Length Image Orientation
1. Images with one, two, three, and four people are usually vertical compositions.
2. Images with five people can go either way.
3. Images with six or more people are usually horizontal compositions.

You can sometimes place two subjects into a horizontal frame if you want the grandness of the scene rather than the people to be the primary element of the photograph. Note, however, that choosing to make the human subjects a small part of a grand scene changes this type of photograph from a "bread and butter" portrait into what is known as an environmental portrait. Environmental portraits often make great choices for large wall prints, which are very profitable.

If your group of six or more subjects is a mixture of kids and adults, you can sometimes arrange them into a vertical frame by placing the kids in front of the adults. Doing so also gives you the advantage of taking a more flattering portrait of any adults who might be on the heavier side. Taking thoughtful steps to portray your subjects in the most flattering ways pays off in greater customer satisfaction and, usually, more lucrative print sales.

The Dreaded Ankle Chop

One thing that often stands out in the casual snapshots taken by friends and family is that the shooter can't decide on whether to shoot a full-length or a bust-length photo so they try for something in between. I often refer to this type of photo as "the dreaded ankle chop." This is something that a pro should almost always avoid. To that end, think about what type of photograph you are going to take before you shoot it, and don't get stuck with a dreaded ankle-chop photograph.

That said, in some rare cases, the dreaded ankle chop may work for a particular composition. And of course, if you are shooting photojournalistic-style, a great expression always trumps whether or not the image includes an ankle chop or not. When you only have a second to compose the shot (but not enough to pose the subjects) in time to capture a fleeting moment, don't even give a thought to whether or not you shot an ankle chop or not. Shoot the picture instead! You can always crop the image to a more flattering composition during post-processing.

The "Dreaded Ankle Chop" is almost always something to avoid.

Here's an example that works. As always, rules are ripe for breaking!

Traditional posing rules include not cutting off the top of a subject's head, but for close-up portraits, all bets are off.
© Freed Photography

Close-Up Photographs: For tight close-up portraits, all bets are off in regards to vertical or horizontal framing. Part of this is because traditional framing rules don't really exist for this category of images. For example, while you certainly wouldn't want to chop off your subject at the hairline in a traditional portrait, it might be perfectly acceptable (or even desirable) to do so for added impact in a tight close-up. What once was a definite vertical composition can now fit neatly into a horizontal one. You might even want to fit two faces, tightly framed, running diagonally across a horizontal frame. Don't look at this lack of rules with fear; consider it a time when you are free to shoot more creatively. Obviously, because the faces take up so much space in this type of composition, I find extreme close-ups are usually limited to one or two subjects.

Bust-Length Photographs: Again, depending on the subjects' builds, the composition could be framed as a horizontal or a vertical. Sometimes, a vertical frame will crop out the shoulders of the subjects at either end, while a horizontal frame may leave too much empty space to either side. Often, by arranging the subjects so that they are at different heights, you can easily fit them into a vertical.

Bust-Length Image Orientation

1. Images with one or two people are usually vertical compositions.

2. Images with three people in them can go either way.

3. Images with four or more people are usually horizontal compositions.

© Three Star Photography

Breaking the Rules

The guidelines I just outlined are helpful in making snap decisions. However, it is important to remember that nothing in photography is cast in stone, and every rule can be broken if the spirit of the picture or the subject demands it, but that doesn't mean the framed print of the betrothed standing side-by-side, hanging over the mantle, should be a horizontal. While breaking the rules is allowed (and even appreciated), be mindful of the fact that there are certain classic shots your clients will want that shouldn't become experiments.

This photo of my mom and dad was taken in the mid 1940s at a photographer's studio. I love this photo because my parents are no longer around. Many brides also cherish family wedding portraits, and I can't count how many times I've been asked to copy a pose of the bride's parents' wedding photo. A wedding is filled with as many traditional moments as spontaneous ones, and your clients may have a request like this in mind even if it is off your radar.

Posing

Regardless of what a couple tells you about not wanting any posed wedding pictures, invariably, they will ask you to shoot posed photos some time during their wedding day. And, no matter how much prior discussion to the contrary you've had with the bride and groom, when it comes time for them to make their print selections, they always choose formal portraits of themselves, their parents, and their families. There might be 20 or 30 non-posed moments that they also select, but almost always, just as many posed pictures make the cut. I say this based on my long experience of shooting weddings (over 4,000 of 'em!) for a very long time and helping to create many, many wedding albums. Sure, the bride and groom really like the photojournalistic-style images and the catch-as-catch-can moments they have asked for, but a formal portrait of the bride and her mother makes it into the album at least as often as any of those individual shots. With this in mind, your directions for posing must go beyond, "Stand over there and smile."

Once you've figured out how to choose your framing, the next step is to arrange the people within the frame. That's posing—and it's an art, not a science. Posing can sometimes strike terror into the hearts of the people being photographed, but this can be avoided if the photographer uses a style that is comfortable for the subjects, converting a potentially stressful moment into an enjoyable game.

All too often, photographers who are oriented toward photojournalistic-style shooting treat posing like the plague. They consider it dishonest, manipulative, and intrusive. But, if you look at the photographs hanging in museums and displayed in magazines and books, you'll discover that the majority of them are posed. If you study the portrait work of Arnold Newman and the illustrative work of Annie Leibovitz, you'll soon realize that all of their photographs are posed! In fact, if you can achieve only a quarter of the success of these two luminaries, I'd say you've got it made. So, my response to photographers who won't "lower themselves" to pose a photograph is... phooey!

However, I also believe that there are times when relinquishing control will get the best picture. In other words, sometimes a photojournalistic approach really is the best one. As I have mentioned before, the key is being flexible and versatile with your approach to shooting rather than being tied to one specific way of doing things.

Over the course of a wedding day, there is more than enough time for both posed and photojournalistic photographs, and your coverage should include a great number of pictures that you take as a casual observer. For these shots, don't direct; just observe and react. A photojournalistic situation is just that.

Although I am trying to create an accurate record of the wedding day, my photographs are not intended to be a hot news item for a supermarket tabloid. No. A wedding is a celebration of love that I personally will not tarnish. The bride and groom are my clients, and there is no reason for me to expose their flaws to the world. To the contrary, I strive to make them look as attractive as possible on their important day. If I move a light or suggest to my subject a slight turn of the body in order to present him or her in a more flattering way, I am just doing my job. If my clients want to live a fantasy day, I'll do my best to help them create one.

Poses produce effects ranging from subtle to overbearing. Turn the body slightly and the subject appears slimmer in the resulting photograph. Extend the subject's hand gracefully, and instead of it looking like a lobster claw, it beckons the viewer with a sense of intimacy, as though revealing a secret. During my many years of professional commercial photography, I never shot an advertising photograph that wasn't rigidly controlled, contrived, planned, and posed. And, in my opinion, wedding photographs are not a far cry from advertising photographs. You want to sell the bride and groom to the viewer at their the most coiffed and manicured best. What I am trying to create is the most beautiful photographs of the couple that I am capable of creating on this once-in-a-lifetime

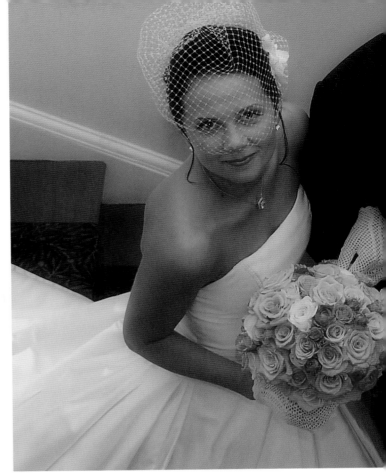

© Michael Brook

special day. In most cases, they have invested a lot of time, money, and energy to make everything about this day beautiful, and I want to support them in conveying that in the images I take of their event.

The very best posing doesn't look like your subject is posed at all. In fact, the more natural and more invisible the posing is, the better the picture will be. This is true not only of wedding photography, but almost all other professional photography as well. Posing is an art form that is at its best when it doesn't scream that it has been done. So, pause for a moment to understand, enjoy, and appreciate this invisible art form before we continue!

A Quick Posing Guide

Posing starts with the body position of your subjects. With all the layers of material that make a bridal gown, however, and all the accessories that go with a tuxedo, it is sometimes hard to see exactly how the subjects' bodies are situated. Therefore, instead of trying to explain with mere words how the subject's body is positioned under all the vestments of the wedding day, I will show you the basics of posing unencumbered by the clothing of the event. To do this, I got some help from the students and teachers at Great Expectations, a Staten Island dance school.

Although I've also included standard bridal photographs in this section, those that are worth extra study are the photos of the dancers in leotards. In each of the illustrative photographs, you can see how the body is arranged to look flattering. As a counterpoint, I've also included a non-posed "stand-over-there" image of various groupings so you

can visualize the difference. The time it takes to clean up a pose (tucking someone's belly behind someone else's elbow, showing a shirt cuff at the end of a tuxedo sleeve, strategically placing a hand, or flaring an elbow) takes mere moments and is well worth the effort.

The decision about how much posing to use with any given assignment is a matter of choice. Your clients will have some idea in mind of whether they prefer more photojournalistic shots or more posed photographs, and you will cater your job to suit their wishes, keeping in mind that at least a few posed shots are almost always in order. The best photographers can make posing into a gentle game, ensuring that even their most carefully posed work does not appear overly so in the final image, nor does it feel intrusive to the subjects.

Tricks of the Trade

There are three fundamental rules that always help your subjects look their best when they pose: the 45° angle, the pointed toe, and elbows away. These rules are especially helpful for posing your bridal shots, which I explain in full detail on pages 126 – 127. In addition, there are several more tricks that can help you make the most of your portrait sessions. These posing suggestions are generally simple and are designed to make your subjects look as attractive as possible.

Posed photographs run the gamut from images in which the photographer controls the subject's every finger position to images in which the photographer's input amounts to, "Stand over there." The only real requirement for success, in my opinion, is that the photo should look natural. That's the real issue. Posing is the art of placing people in natural-looking, flattering positions.

I have found that the majority of the photographs my customers purchase are those that have been directed by me in some way. Go shoot 100 totally photojournalistic photographs and the bride and groom will buy about 10… or 20, if you're lucky. "Mom's face is turned away," "My veil is in his face," "You can't see Aunt Martha," and the list goes on. Now shoot 100 posed pictures and, if you're good, the couple may well purchase 60 of them. That is a huge difference in the return on your time and effort!

Now, on to the posing tips. All the suggestions I make here should be used judiciously. Remember, overdoing a good thing can result in disaster, so your application of these ideas should be carefully measured.

Stand Up Straight: This may seem obvious, but something as simple as standing up straight can do wonders for your subject. Although the groom can benefit from this too, it is especially pertinent for the bride because she's probably never worn a headpiece and veil for a whole day before. All too often, brides look as if they are nervously balancing a bowl of fruit on top of their heads! Keep assuring the bride that her headpiece won't fall off… and if does, there will be plenty of willing hands to help her fix it.

No = slumped

Yes = standing straight

Banish Those Double Chins: In an effort to hide a double chin, many people tilt theirs head slightly backward. This actually has negative effects. The chin becomes more prominent, the insides of the nostrils are more visible, and the eyes (the most expressive facial feature) look smaller. One way of banishing double chins is found way down at your subject's waist. If they lean slightly forward at the waist and then tilt their head slightly backward, the end result will leave their face in its normal position. The slight forward tilt at the waist cancels out the backward tilt of the head and results in the face being parallel to the camera's film plane (without the adverse prominent chin, nostril interiors, or small eyes). Importantly, the skin under their chin is pulled tighter, which helps eliminate the extra chins. Shooting from a slightly higher angle can also be equally effective.

 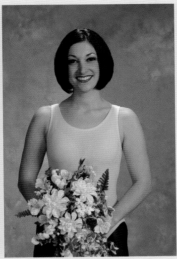

No = raised shoulders Yes = shoulders relaxed

No = backward tilt Yes = leaned forward at waist

Relax the Shoulders: When people get nervous, they have a tendency to tighten and raise their shoulders. This makes shoulders look narrower, necks look shorter, and that air of tension translates into the photo. While it is true that some brides and grooms are tighter than a drum, there are things you can mention to help relax them without drawing attention to the situation. An example would be to ask your subject to relax their shoulders so they fall naturally, being careful to watch that they don't go from tight shoulders to slumped ones!

What About Eyeglasses?: Photo-gray lenses are a big no-no! They darken when outdoors, and even when indoors, they look darker than regular lenses. Non-glare lenses are available at reasonable cost, and you could mention these at a pre-wedding meeting. Also suggest they get their frames adjusted before the wedding. The surface of the eyeglass lenses should tilt slightly downward so the flashback from the camera's flash will reflect harmlessly toward the ground. This trick can also be accomplished by having the subject lower their chin slightly.

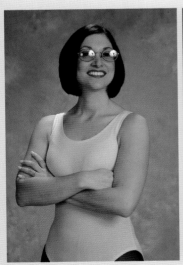 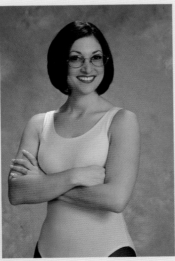

No = chin up, flash reflected in glasses Yes = chin lowered, no reflection

No = chin slightly up

Yes = slightly lowered chin

Accentuate the Eyes: When your subject lowers their chin a fraction of an inch, it accentuates their eyes—the most expressive facial feature. This movement causes the eyes to tilt closer to the recording plane of the sensor in your DSLR. Their eyes are closer to the plane than the chin and mouth, making them appear larger. Just a tiny dose is all you need, so use this move cautiously.

Relax That Forehead: In an effort to accentuate their eyes, people will sometimes try to open them as wide as possible. Consequently, subjects also raise their eyebrows, which in turn wrinkles their foreheads—an undesirable look. When this happens, I tell my subject to relax his or her forehead. Although your subject might have to concentrate for a moment, once they are aware of what you are saying, they can usually figure out a way to un-furrow their brow.

No = eyes wide, wrinkled forehead

Yes = eyes and forehead relaxed

No = raised bouquet

Lower the Bouquet: Many times, a bride will automatically hold her bouquet of flowers directly in front of her, making it appear as though she were hiding behind it. The bodice of her wedding gown is beautiful, and often intricately detailed, so she shouldn't hide it behind her flowers. As an added advantage, holding the flowers a bit lower places her forearms at a 45° angle, which will make her body look longer and leaner while covering the belly area that most people don't want to advertise. No matter what type of bouquet a bride has—whether it's a small, round snowball or a long-stemmed extravaganza—your best bet is to tell her to lower the bouquet down away from her face and chest and more towards the hip and stomach area.

Yes = lowered bouquet

Posing Tips for the Bride

The star of the day demands extra attention, not only because she's the bride, but also because a bridal gown and bouquet offer so many aspects to show off. Here's the scoop: While the groom may be wearing anything from a rented tuxedo to his Sunday best, the bridal gown is a one-day-only outfit. After the wedding, it will be lovingly cleaned, wrapped, and stored. It might even become the first of the new family's heirlooms. If you shoot pictures that offer variety, chances are good that you can sell a half-dozen (or more) pictures of the bride, her gown, and her bouquet. Single pictures of the groom always sell fewer. That's just the reality of it. And as for shooting with variety, a truly varied set of shots for the client to select from starts with a range of full-lengths, bust-lengths, and close-ups, but continues to include background and lighting changes.

When shooting full-length poses of the bride, there are three basics that you should keep in mind: the 45° angle, the pointed tow, and elbows away. These three composition rules are so effective that many a good close-up can be taken just by moving in on a properly posed full-length. Simply reframe, refocus, and shoot.

1. The 45° Angle: The bride's body (and almost everyone else's too) should be at a 45° angle to the camera. This narrows the subject's shoulders, and narrower looks thinner to the camera, which most brides will appreciate.

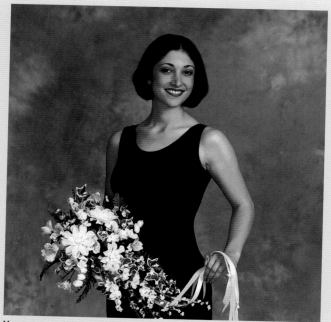

You can see the same effect illustrated here in this full-length head-on shot of the model. The pose looks stiff and unnatural, and the flowers seem to fade into her body shape.

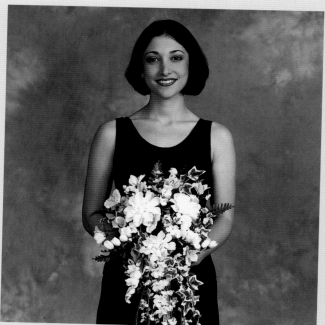

Posing the bride at a 45° angle creates a much more pleasing and more natural-looking composition.

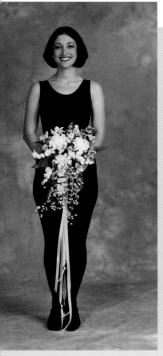

Photographing the bride head-on can make it look like she is growing out of her flowers.

Having the bride point her toe makes for a much more flattering pose.

Having the elbows in close to the sides will tend to make your subject look as wide as her elbows.

2. The Pointed Toe: Have the bride push her forward-most foot slightly outwards and point it towards the camera. The toe-pointing routine forces the subject (unknowingly) to put her weight on her back foot, which causes her hips to shift, resulting in a flattering pose. The goal here is to get one hip to be slightly more pronounced than the other. A little goes a long way with this technique.

3. Elbows Away: Instruct the bride to move her elbows slightly away from her sides. If her elbows appear to touch her sides in the resulting photograph, the viewer's eye will perceive the subject to be as wide as her elbows. On the other hand, if there is a small space visible between the bride's elbows and her sides, this will show off her waistline, which usually improves how a bride looks.

The elbow move is a tricky one because, if exaggerated, it looks as if the subject is doing the chicken dance. In addition, subjects sometimes lift their shoulders when moving their elbows. Both of these problems can detract from the image and should be gently corrected. Usually, when these pitfalls arise, I smile and say, "Don't let it look like you're doing the chicken dance," or "Relax your shoulders."

Putting some space between the arms and the sides of the body can have a pleasant slimming effect.

Don't Forget the Groom!

A guy in a tuxedo is just a guy in a tuxedo, and that is what the groom is. In reality, there is less to work with in shooting a portrait of the groom when compared to the bride, who has a gown, a veil, and bouquet. Still, he is the other star of the wedding.

As with the bride, the groom should hold his shoulders at a 45° angle to the camera when posing for full-length portraits. The feet, however, are a different story altogether. Usually, separating them slightly and splaying one foot outward a bit will do the trick. The simple fact is, a woman's gown, usually with a wide base, lends itself to a pleasing composition, while men's attire often translates, photographically, into making them look as if they are about to topple over, especially if they have broad shoulders.

The elbow game for the groom is a bigger challenge. Arms naturally fall straight unless you have something to hang the hand on that is slightly higher than its normal position. God bless pockets! By having your subject place a hand in his pants pocket, his arm will bend naturally at the elbow. There are some caveats, however. If the groom puts his hand in a pants pocket and is wearing a jacket, be aware of how the hem of the jacket looks with the hand snaking under it. On vested suits, it is often helpful to have the subject open his jacket and push the jacket back out of the way before he puts his hand in his pocket. This also shows off the vest.

A stance with both hands in both pockets and jacket sides pushed back out of the way creates a relaxed look that translates well into the final image, especially if the subject is leaning with his back against something. If the man is not wearing a vest or cummerbund, just make sure his shirt is tucked in and smooth at the belt line. Some guys look great when they hook a thumb in their belts. This, too, can get the elbow/body separation you are looking for. As an alternative, if your subject has a great physique, you might try having him remove his jacket and drape it over his arm or flip it over his shoulder, à la Frank Sinatra.

The groom's shoulder width (which can make him appear top-heavy in full-length portraits if you're not careful) is less of a problem in bust-length portraits. However, it still does come up as a visual hurdle from time to time. My favorite work around for bust-length poses is to lean the man's torso into the picture. Have the groom lean an elbow on whatever may be handy—the back of a high-backed chair, a fence post, the hood of a limo, or a camera case on a posing ladder covered with a drape. It depends on how tall he is and what is available.

A more flattering pose can also be achieved with male subjects by using the 45°-angle and elbows-away rules. With men, however, I often ask them to point the rear toe away rather than the front toe to create a more masculine, squared-off look.

Leaning the groom into a pose tilts his body slightly, eliminating the stiff appearance that often results from a "stand-over-there-and-smile" pose. Get creative in finding things for him to lean on. In this instance with the model, I had him lean on a camera case placed on a step of my posing ladder, but you could just as easily find a more natural prop for the groom to lean on, such as a staircase banner or a garden wall.

Posing Hands

One of the most difficult things to photograph is the hand. Many fine photographers struggle with how to pose hands and where to place them in their wedding photographs. Sometimes, the best solution is to crop the hands out of the picture altogether! But, there are times when hands are simply part of the picture. They can help tie two subjects together, they can be used to frame and support a face, and in a ring shot, they are a crucial part of the scene.

If you pose a hand so that either the palm or the back is parallel to the sensor plane, you will find that the hand appears unnaturally large. You could place the hand so that its edge is toward the camera (the little-finger edge, not the thumb) so that the hand appears to be much more delicate. A slight backward bend at the wrist and slightly curled fingers will produce an "S" curve, which is also pleasing to the eye.

One definite no-no to watch for is a hand peeking over another subject's shoulder. In the resulting picture, those fingers will appear to be four pink, foreign dots on the subject's shoulder—quite distracting. If you want to include a subject's hands in your photos, catch them from the side. Another pitfall to watch out for is interlocking fingers. This will often make the subjects' hands look like some sort of weird ten-fingered mutant.

Use a Mirror as a Learning Tool: One of my mentors was able to pose a subject's hands in the most creative ways. When I asked where he got his ideas, he told me he used to practice in front of a mirror, using himself as the subject. I have found a mirror to be a perfect teaching aid to help with good posing. A full-length mirror is best, but even a

No

Yes

small bathroom mirror can help. Find a suitable mirror, put aside any fear of looking ridiculous, and alternate posing yourself as you would both the bride and the groom. Wear a suit jacket to try out groom poses and hold some sort of prop to represent the bouquet for the bridal poses. Analyze what you are doing to see how it affects the pose. Tilt your head, turn your body, and try to imagine how and where another person would fit into the composition. This technique may sound silly, but it can be extremely valuable for adding variety to your repertoire. On a similar note, look critically at magazine images to analyze how the models are posed. Those pages can add to the variety of poses you use, which can make for larger, more profitable wedding albums.

The Bride and Groom Together

Once you accept the concept that the subject's shoulders should be at a 45° angle to the camera, it becomes obvious there are really only four ways that two bodies can fit together: front to front, his front to her back, her front to his back, or back to back. Just as there are thousands of photographers, there are thousands of variations on posing the bridal couple. But, when it comes to formal posing, all the variations fall into one of these four categories.

These arrangements apply to bust-length shots and to full-length poses with both parties standing. In fact they apply to any arrangement with two subjects in it. Therefore, these poses work for more than just the bride and groom. They are relevant any time you have to photograph two people together. Study some of the variations detailed here, then

In this pose, the bride's back is to the groom's front. The groom's left hand on the bride's left arm creates a feeling of connection between them.

This pose is not as common as the other three illustrated here, but it can make for a unique addition to the album. It is most suitable for two siblings or the groom and his best man.

In this pose, the bride and groom face each other with their rear shoulders touching. By having the groom put his right hand in his pocket, you can create a pleasing symmetry with the the bride's left arm.

Here, I had the groom sit on a posing ladder with the bride over his left shoulder so her left hand can be placed to show off her ring. This pose can work for the bride and groom or the bride and her father.

think up some of your own. You can do a lot by changing the heights of the two subjects. Both of them can stand, one can sit while the other stands, or both can be seated. Mix, match, and be creative. Find a mirror and a friend and work out some variations that you like.

Here, the man is turned at a 45° angle away from the camera so that his head is in profile, framing the woman's face.

Compare this shot to the image at left. In this version, the woman's back is to the camera.

Here is another way to shoot the man in profile while framing the woman's face. The closeness of the subjects in this pose can make for a very romantic wedding portrait.

This is considered a front-to-front pose even thought both subjects are essentially facing the camera. The woman is placed over the man's left shoulder so that she can show off her ring.

Posing Three People

After you've mastered the two-up, the next group is, you guessed it, the three-up. The bride and her parents—or the groom with his—makes three. For a quick pose of three subjects, it's hard to beat what I refer to as "the lineup." Although a lineup looks easy, make sure to use the posing tips we have already examined. These will make your photograph look more professional. Instead of the "stand-over-there-and-smile" non-pose, remember the basic rules for posing; first and foremost turn one of your subject's bodies so that the shoulders are at a 45° angle to the camera. If you start with the bride in the middle of her parents, and turn her toward her right (referred to as "subject right" or "camera left"), then Dad can fit in behind her (at camera right) and Mom can face her on the opposite side (camera left). Since this pose usually works best as a horizontal, you might consider having Mom place her right hand on the bride's right forearm and Dad putting his left hand on the bride's left arm. The "hands-on" approach I'm suggesting creates a horizontal holding line that stops the viewer's eyes from falling off the bottom of the picture.

If one of the three subjects is a little person, such as a flower girl, ring bearer, or younger sibling, you can arrange the little one in front of the tallest person and make a vertical composition. If you follow this route, make sure the two heads do not line up exactly one above the other. If you aren't careful, it will look like the tall subject is growing out of the short one—not a pleasing image! You could also arrange three faces in a vertical composition by posing the subjects so that their faces all fall along a diagonal line. In the image at the top of the opposite page, I sat the mom in the lowest portion of my composition (the middle step of my posing ladder) and arranged the young girl and the bride from there in order of their size. Notice, too, that the mom's shoulders are at a 45° angle, but her back is towards the camera, and she is facing her daughters. By placing her and the bride so they both face in, they contain the viewer's eyes by surrounding the middle subject.

No

Yes

Compare the "stand-over-there-and-smile" shot (top) with the posed composition (bottom). Notice that in the posed shot, one of the three subjects is turned slightly toward the other two. Having all the subjects facing inward toward the center of the image keeps the viewer's focus.

Once you start doing these variations, you might find that you run out of depth of field. As the posed subjects get deeper and you get closer, it becomes apparent that you can't get everyone in focus because all the faces are on different planes. The obvious remedy is to choose a smaller f/stop (which will increase your depth of field) and focus on a point that is one-third into the maximum depth of the subjects. However, there is only so much this fix can accomplish.

The other remedy to always be aware of is to create a pose that looks deep, but isn't. Since you're posing the subjects anyway, you might as well position them so that your technical limitations are minimized. In the variation to the right, notice that the tall subject's rear shoulder is behind the bride's rear shoulder. This creates a little pocket for the short subject to fit into. In the pose illustrated at the top of this page, the rear-most subject is leaning in over the middle subject. This lessens the perceived depth of the image, making the subjects appear closer together.

Try a three-up vertical composition if you have subjects of three different heights. Or, you can create a similar effect by seating one of them in front of the other two.

Posing Tools

One easy way to get variety in the heights of your subjects is to have some of them sit. For this reason, I carry six chairs and two couches of different sizes with me everywhere I go. Not really! Of course I don't lug chairs and couches around with me, but I do carry a posing ladder. I also use carefully chosen hard cases for my lights instead of today's more popular, soft-sided equipment cases. Each of my three cases, when stood on end, is six inches (15.24 cm) taller than the next. Inside each case I carry a posing drape that can cover the case, converting it into a seat or perch for a subject to sit or lean on. I also carry a fourth posing drape to cover my stepladder when it's used for posing.

These posing aids all perform double duty. The posing drapes can become a background for a close-up when I'm in a VFW hall with painted cinder block walls. The cases are needed anyway to protect my lights as they are lugged around from assignment to assignment, and the posing ladder can serve two purposes. Not only can it help me to pose my subjects in an ideal composition, but it can also give me a high vantage point when I shoot over crowds or want to photograph an overall view of the dance floor.

Even though I try to avoid using lineups, sometimes the size of the group warrants them. To make the best of a lineup, try to use the subjects' different heights to your advantage.

Posing Large Groups

One of the hardest things to is to make a large group look interesting. If you don't have any posing tools, you are pretty much stuck with a lineup. In general, I will go to great lengths to avoid shooting subjects in a straight line. If there are short people as well as tall people in the group, you can pose a lineup in which you use the various subjects' heights to make the composition more pleasing. In the stand-up grouping pictured above, for example, notice that the subjects are placed so that the lines connecting their faces all create diagonals that lead to the bride. Also note that the subjects are arranged so that no face is directly above another.

In the next picture (at the top of the opposite page), pretend that we're in a park and I have my posing ladder with me. Two subjects—in this case, the groom and the ring bearer—are seated on the steps of my posing ladder. To create other heights, I sat two of the girls on the grass. Some may criticize this pose because the flowers seem to be growing out of the little boy's head, but from sad experience, I've found that you're lucky if you can get most little kids to sit still, look at you, and smile for a picture. If he (or she) is still and smiling, I shoot the picture. To heck with the flowers!

Adding a ladder to your arsenal of posing tools opens up new possibilities. Ladders that are best for use with wedding portraits will have a top step that is around 30 inches (76.2 cm) high.

I often add empty equipment cases to my posing ladder as additional props for large group shots. That way, I can create many different levels on which to place my subjects.

For the lower of the two group shots above, I used my posing ladder and two empty camera cases to create multiple tiers. In a real photo shoot situation, posing drapes and gowns would be covering all the posing tools, but I left them revealed here so that you could see how all the lines connecting the subjects are diagonal, and the grouping looks like a pyramid instead of a lineup.

Creating Your Own Style

Posing is an art form. The photographers I consider to be great have taken years to refine their styles. Many photographers who are new to the business have trouble changing a pose once they get their subjects(s) into it. They think that, by changing it, they are making an admission that their posing was incorrect, and instead of fixing it to make it appear more natural, they just shoot the picture as-is. This drives me nuts!

Before I shoot a posed photograph, I stop for a moment and look critically at how my subjects are situated. If they don't look natural, or they appear too staged, uncomfortable, or just plain hokey, I walk right up to them and say: "This doesn't look right. Let's change it." Don't be afraid to make mistakes. And never, ever be afraid to change something for the better!

Your goal is to achieve natural and relaxed poses—poses that don't look stiff and contrived—and that is not an easy task. I find that beginners tend to plod along on one plateau for a while, and then, overnight, the quality of their posing ability takes a quantum leap. Making that leap requires looking at and critically evaluating your posed pictures. Once you can identify stiff, unnatural poses in your photos, you'll be able to notice stiff, unnatural poses when you are setting up the shot. All that's needed then is the courage to change a pose before you push the shutter button. Once you achieve that, you'll make your first quantum leap.

Other Special Family Occasions

Bill and I were sitting on a park bench, waiting for a photography association meeting to start. Whiling away the time, he pulled out a stack of about 150 proofs from a family portrait session for an anniversary he had shot, asking me for my opinion of the pictures. As I thumbed through the photographs, I found two different poses of the group with about 75 photographs of each pose. The group included a mom and dad, three married children, and about a dozen small fries. Two different poses of the group were taken for one 16 x 20-inch (A2) final print. There wasn't a single photograph of each married child's family alone! Not a single photograph of each married child with his or her spouse! Not one picture of the grandparents with their grandkids! Not even a single photograph of the anniversary couple alone! Bill had done a two-hour shoot, photographing eight adults in their finest outfits and 12 kids, scrubbed and neat, and he had come back with two (just TWO!) saleable images from which the customer was only going to choose one. Looking at the stack of proofs and mentally calculating the costs of the equipment, processing, and labor for the shoot versus the fee he was charging, I pointed out that he made little or no profit on the job. Bill thought for a moment, then brightened and said: "That's okay. I might lose a few pennies on each job, but I'll make it up on volume!"

Weddings are two-family affairs, but there are also a number of photo-worthy single-family celebrations. The list of such celebrations is nearly endless, including occasions like Bar and Bat Mitzvahs, sweet-sixteen parties, Quinceañeras (a 15-year-old girl's coming of age party, celebrated by some Latin American cultures), anniversaries, baptisms, retirements, and family reunions. While many photographers turn up their noses at such parties, these types of assignments can be a great source of profit, and they may lead to future wedding bookings. Looking at these jobs with a cold, calculating eye reveals the chance to become a family's exclusive photographer. These occasions also usually result in multiple orders from single pictures. So, before you decide to dismiss these kinds of jobs, consider the profit that can be generated by the fact that everyone at the event wants a keepsake picture.

One way to view these special events is to think of them as a wedding assignment with only one family. Another way to look at them is as a glorified family portrait session. For many photographers, as illustrated in the opening to this chapter, a family portrait session results in the sale of one print. Even though it's often a huge print, you would do well to consider stretching a family portrait session so that you end up selling many different portraits, or even an album. Further, it is easy to imagine your client saying, "Hey, I liked the photographer who shot my son's Bar Mitzvah. We should call him for the wedding." Obviously, you should be interested in this kind of work! And remember, you will increase your profit dramatically if you take the family portrait session one step further to create an album (and therefore receive an order for 36, 50, or more prints).

Anniversaries

As you do with weddings, you should develop a repertoire for these types of jobs. Let's examine a possible list of photos for an anniversary party.

1. The Star(s) of the Show — *minimum of 3 poses*

Whether it's an anniversary couple, Dad's 50th birthday, or a teenage girl turning sweet 16, your main subject is worth several portraits. Consider bust- and full-length renditions. If your subject is an older woman, use some sort of diffusion filter over your lens (see pages 167 – 168 for details). Furthermore, if you're shooting a couple, be sure to do individual portraits of each separately. While some may question this tactic, I have seen individual portraits of a mother and a father hanging side by side on a wall in some homes.

2. The Couple's Children — *1-2 poses*

When shooting a family event, no matter what the occasion, make sure to include portraits of each child in the family. In some cases, such as at a 50th anniversary party, the couple's children will be adults with families of their own. In this instance, I may shoot a portrait of the child and their spouse in addition to the child, spouse, and their children, but I'll rarely photograph the child alone unless it is in conjunction with his or her other siblings. In addition to a few pictures of each of these second-generation families, shoot a few of each family with the grandparents—the anniversary couple. Also, get a picture of each son or daughter and their spouse with the anniversary couple. Work your way through these various family groups and you'll have a basketful of different photos for the family to choose from.

3. Extra Credit: The Star(s) with Each Family Member — *1-2 poses*

If you're shooting an anniversary, consider doing a picture of each of the couple's sons or daughters with them (minus the spouses and grandchildren). Also, consider doing a picture of the child with his or her spouse and the anniversary couple. I can tell you from personal experience that I would give a lot for a picture of me as a young adult with my mom and dad! Additionally, you might try to get mom with all her daughters and dad with all his sons, then vice versa—mom with the boys and dad with the girls.

4. The Whole Family or Group — *1 pose, multiple shots*

After you've finished with all the satellite families, next is a photo of the anniversary couple and their children. After that shot, you can add in all the spouses and grandchildren. While this picture of the whole family is important, you aren't finished until you get a final few pictures of the group of grandchildren—first with just the kids, then with the guests of honor.

5. Don't Forget the VIPs — *1-2 poses*

While anniversary parties almost always revolve around family, remember that there are also friends of the honorees at these events. These include not only best friends, neighbors, and coworkers, but also brothers and sisters of the couple. You'll never know about these special folks if you don't ask, but pictures of these groups may result in multiple sales.

6. Decorations and Symbols — *shoot a few*

Finally, keep an eye out for special decorations or favors. There are almost always personalized decorations at these type of parties. I've seen events where every guest gets a baseball cap with "50" embroidered on it, or refrigerator magnets

with the anniversary couple's wedding photo on them, even a 30 x 40-inch (B1) print from the anniversary couple's wedding album displayed on an easel. Each of these is worth a photo, and it's even better if you can capture the honored couple while wearing their caps, or next to the easel. Furthermore, regardless of the type of party, there's always a cake that is worth a picture. That, of course, is in addition to photos of the couple blowing out the candles and cutting the cake.

If an anniversary couple has four married children, and those married children have a total of a dozen kids, the repertoire I've just sketched will give you approximately 30 different saleable photos. From an expense perspective, if you are using paper proofs (as opposed to electronic proofs, such as a CD), your costs approach 25 – 30 cents per photo. They may even be more like 50 – 60 cents per photo if you take your shooting, downloading, and image-backup time into account. So, if you shoot four or five images of each of the 30 portraits outlined above, your investment is $60 – $80, counting labor.

On the other hand, if you only shoot several different poses of the full, extended family together—let's say about 50 pictures—your expenses would be closer to $15 (not counting labor), but your sales will likely max out at around five prints, or one per family group. The crux of the issue is this: While the single photograph of the whole family is essential, it is the other combinations of smaller groups that greatly improve your chances for extra sales and, hence, greater profitability.

Protecting Extra Sales

It should be pointed out that if you intend to sell your customers an album and/or extra prints, and you want to show the proofs electronically rather than making paper prints, you should take the following steps to protect your sales investment before you hand over a CD of images to your client. First, you should make a folder containing duplicates of all the images you want to show them. Next, reduce the image size for all the duplicates to 4 x 6 inches (A6) and change the resolution to 72 ppi. This will stop your customers from making large, photographic-quality prints from the proof images on the CD. If, on the other hand, your agreement with seethe customer was always simply to shoot the wedding and hand over the disc of images, this suggestion obviously does not apply.

As an aside, today's customers often demand a high resolution CD or DVD of all the images you take at their event. One way around this dilemma (i.e., to satisfy your client without killing the album order) is to include the high-resolution images as part of your sales package but stipulate in your contract that they will be delivered to the client with the completed album. I find I can sell almost anything if I can give my client a sound reason for why I'm doing something in a certain way. In this instance, I point out that I will be digitally adjusting the images they select for the album and portrait prints, and I want to be able to deliver those images to them together with all the other images I will take, so I have to wait for their album order before I can deliver all the images at one time. In my ten years shooting digitally, I have never had a problem doing this. Every client has been satisfied with the reasoning behind my method. Not only do they get all the images, but they also get retouched and adjusted ones. And, on the plus side of the ledger, I haven't killed an order by doing this!

Bar Mitzvahs, Sweet-Sixteens, and Quinceañeras

Creating a repertoire for what to shoot at a Bar Mitzvah is difficult because there are several groups within the Jewish religion that observe Jewish laws and traditions differently. As a professional photographer, I have learned that is helpful to understand, prior to the event, which set of practices your subjects follow. This will affect which traditions or laws are most significant to them, and you do not want to overlook taking these important shots.

Simplistically stated, the most observant Jewish people (those who follow the teachings in the Torah literally) are called Orthodox Jews. Others, who are less strict in their observance of the Torah, are called Conservative Jews. A third group, called Reform Jews, is even less strict in their observance of Jewish law and custom. There are also smaller sects, but these three groups encompass the vast majority of Jewish people for whom a photographer will be contracted to shoot a Bar or Bat Mitzvah.

A Bar Mitzvah is when a 13-year old Jewish boy is called forward to read from the Torah, commemorating his becoming a full-fledged part of the congregation. The Torah is read from on Mondays, Thursdays, and Saturdays (the Sabbath), so the religious part of the ceremony can be held on any of these days. However, the party that celebrates the event may not necessarily be held on the same day the Torah reading takes place. This means that you might find yourself shooting the religious part of the ceremony on a Monday or Thursday morning and covering the party the following Saturday or Sunday. Most temples (though not all) prohibit shooting pictures on a Saturday because it's the Sabbath; Jewish tradition states that work (such as photography) is not allowed on that day.

A Bat Mitzvah is a Bar Mitzvah for young ladies and happens when they are 12-years old—one year younger than their male counterparts. In the Orthodox Jewish community, a Bat Mitzvah girl does not read from the Torah, though she often will in both Conservative and Reform Jewish ceremonies. If the Bat Mitzvah girl is called to read from the Torah, all the photos listed here should be the basis for the pictures you want to capture. However, if the girl is not called to read from the Torah, then the party can be likened to a sweet-sixteen type of affair.

For a sweet-sixteen or Quinceañera party, family photos and general pictures of the occasion (including the décor) should be your prime targets. To develop a repertoire of your own for these types of festivities, review, prune, and combine the shots outlined in the anniversaries repertoire (pages 138 – 139) with those outlined in this section to generate a working list of what to photograph.

The affluence and religious customs in your geographic area will determine whether or not family parties and religious passages will become a part of your photographic workload but, because they represent lucrative assignments, these occasions should not be overlooked as a source of both income and an opportunity to network for future wedding assignments. I've shot hundreds of these parties over the past 35 years, and the following are my observations about the most important photographs you will want to shoot. For simplicity's sake, I will list the repertoire for a Bar Mitzvah, but know that it can be applied to a Bat Mitzvah, or excerpted from and combined with my anniversaries repertoire to cater to a sweet-sixteen party.

Religious and Formal Family Portraits

A number of temples will not allow photographs during the ceremony because it often takes place on a Saturday, the Jewish Sabbath. However, many rabbis will pose with the Bar Mitzvah boy reading from the Torah on an alternate day. If this is the plan, you can also photograph the boy alone at that time as he looks at the Torah in contemplation. Shoot pictures with him looking at the camera and looking out towards the congregation. And don't forget to consider the additional Torah portrait combinations outlined here, since you're already there and all set up.

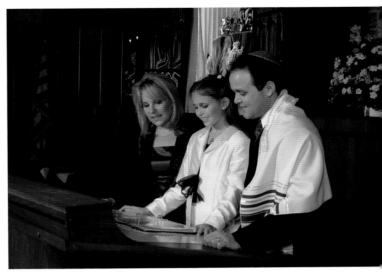

© Salzman & Ashley Photography

1. Bar Mitzvah Boy Alone — *minimum of 3 full-length poses, 3 close-up poses*

Take formal and casual shots, both full-lengths and close-ups. Add a few photos of the boy with his talis (prayer shawl) and prayer book. Maybe even shoot some double exposures and silhouettes.

NOTE: For suggestions 2 – 5, you might consider doing each of these with the secondary subjects in the background and slightly out-of-focus—a technique known as selective focus. Then, do another pose where all the subjects are in sharp focus. The last thing you want is to have your creative, selective-focus image derided by an onlooker saying it looks "blurry" without having a more traditional sharp image to present as a backup.

2. Parents Look On as Boy Reads from Torah — *2 poses*

As I suggested in the note at lower left, I like to start by shooting with the boy in the foreground and his parents slightly behind him (further away from the camera) and slightly out-of-focus. I then set up a second shot with all the subjects in focus.

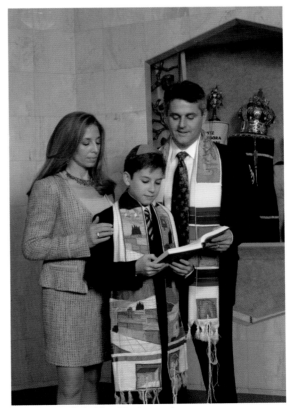

© Salzman & Ashley Photography

3. Grandparents Looking On — *2 poses*

Again, I set up a selective-focus image with the grandparents slightly behind the Bar Mitzvah boy and the boy in foreground of the shot, being sure to include an all-sharp rendition of these subjects as well. Don't forget that, because of the star's young age, there is the possibility that all four grandparents will be present, so you may need to shoot both sets of grandparents with the Bar Mitzvah boy or Bat Mitzvah girl.

4. Father Looking On — *2 poses*

In addition to this staple shot, add the boy's grandfather (his father's father), if possible, for a three-generation picture.

5. Mother Looking On — *2 poses*

As with the add-on shot to the star with his father looking on, you may elect to do a three-generation shot with the star's mother and maternal grandmother, if she is living. This additional pose is a particularly good one to consider for a Bat Mitzvah girl.

6. Youngest Sibling Looking On — *1 pose*

Stand the young sibling up on a case, if necessary, to bring the two children closer together in height. This is a picture that always sells.

7. Next in Line for Bar Mitzvah Looking On — *1 pose*

If this is a different sibling than the one in the previous item, this is another very saleable portrait.

8. Rabbi Looking On — *1 pose*

This is a classic shot, and you are on the rabbi's turf, so let him or her do whatever he or she wants to do! That said, you might suggest that the two subjects point to the same portion of text as the boy reads from the Torah.

9. Extra Credit: Boy's Torah Passage — *1 pose*

Have the rabbi show you exactly where the boy's portion of the Torah starts. Then get on your stepladder and shoot it over the kid's shoulder. Try to include the boy's hands and the yad (a pointer that is used to hold his place in the text so the reader doesn't touch the scroll).

10. Extra Credit: The Invitation — *1 pose*

Prop a copy of the invitation over the scroll, using the yad as a prop. This is an excellent opening shot for an event album. Additionally, you might consider setting up a second shot later with the invitation resting on the cake.

In order to maximize picture sales, you simply must have visual variety! When shooting at the temple or synagogue, be sure to take some shots with your subjects looking at the camera and some in which they are looking at each other. You should also plan to shoot some formal portraits of the family in their formal attire while you are there. If weather permits, shooting outside with the exterior of the temple as the background can be nice. For these portraits, I recommend the following:

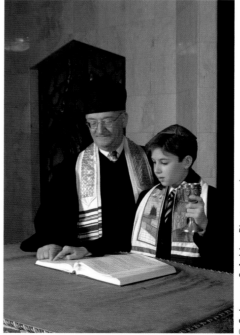

© Salzman & Ashley Photography

11. Bar Mitzvah Boy Alone — *at least 3 full-lengths, 3 close-ups*

Oddly enough, even though the clothing is still formal, I try to make these portraits more relaxed than the formal portraits I shoot of the family with the Torah. Group hugs, kissing, and funny faces are all acceptable and can be a nice contrast to the more formal images captured inside the temple.

13. Bar Mitzvah Boy with Dad — *at least 2 poses*

Don't be afraid to go for big smiles and interaction between your subjects in these out-of-the-temple portraits. Again, to maximize your sales, you will want these images to look like anything but a repeat of the poses you took inside.

12. Bar Mitzvah Boy with Mom — *at least 2 poses*

As outlined above, keep these photos fun and relaxed even though they are technically formal portraits. You want these to be different enough from the more religiously focused formal portraits taken with the Torah and inside the temple.

14. Bar Mitzvah Boy with Both Parents — *at least 2 poses*

For tips on taking formal portraits of three or more people, refer to my suggestions on pages 132 – 135.

15. Parents Alone — *at least 1 full-length, 1 close-up*

Keep in mind that, though the Bar Mitzvah boy or Bat Mitzvah girl is the star of the show, this is also an opportunity for the other family members to have a formal portrait done, and can definitely result in multiple print sales beyond just those selected for an album.

16. Each Sibling Alone — *1 pose for boys, 2 for girls*

Take portraits of each of the boy's brothers and sisters individually. For the girls, be sure to take a close-up of each, then add a full-length portrait of each girl to show off her dress.

17. Bar Mitzvah Boy with Each Sibling — *1 pose each*

You may or may not have the time to do these portraits. If you do, you may likely see the profit from a few extra prints. If time is tight, however, go straight to the next photo suggestion.

18. Bar Mitzvah Boy with All Siblings— *1-2 poses*

As outlined in the last chapter, as the group of subjects grows in number, you'll need more images of the group to ensure that you get at least one great one. After you know you've gotten your shot, you might suggest that they all squish together, then shoot a few more of their laughing faces. These kidding-around shots can really work!

19. Extra Credit: Mom with the Girls, Dad with the Boys — *1 pose each*

Though I list these shots as extra credit, you should know that they are especially important with Orthodox Jewish families. At Orthodox parties, the men and women often eat and dance separately, so the further representation of that in the portraiture you do for them only makes sense.

20. Extra Credit: Mom with Boys, Dad with Girls — *1 pose each*

These portraits are truly extra credit. If you're faced with time constraints (and you'll always be faced with time constraints!), they can easily be pruned from the list. But, if you do have a few minutes to spare, extra credit is always nice to get.

21. Parents with All the Kids— *1-2 poses*

You might consider a full-length lineup (because it's fast and easy), but also try for a bust-length portrait of the group, which might look better as a large wall portrait.

22. Grandparents with the Parents and Kids — *1 pose*

My suggestion is to include both sets of grandparents in one photo, but you might also consider taking a shot of the parents and kids with each set of grandparents if you have the time.

23. Grandparents with Bar Mitzvah Boy — *1-3 poses*

For this set of portraits, you will want to be sure to shoot each separate set of grandparents with the boy, as well as all the grandparents together with the boy. In a case where only one grandparent on a particular side of the family is living, photograph the boy with that grandparent alone.

24. Each Set of Grandparents Alone — *1-2 poses*

These portraits may or may not make it into the album, but you may still get some print sales out of them.

25. Grandparents with the Boy's Mom and Dad — *1-4 poses*

I tend to both shoot a portrait of the star's parents with each set of grandparents and try to get a picture of the boy's mom alone with her parents and the dad alone with his parents. As I mentioned earlier, I, myself, have often wished I had a photo of me with my mom and dad, so I include this add-on for sentimental reasons. As with all my suggestions, decide for yourself if you think it would be a good addition to your personal repertoire.

26. Aunts' and Uncles' Families — *2 poses*

Remember to catch each of the Bar Mitzvah boy's aunts and uncles with just their own immediate family members. Then, of course, get a shot of each family with the star of the show.

27. Extended Family — *1 pose for each side of the family*

For these large family groupings, be sure to include all the grandparents, aunts, uncles, and cousins if you possibly can. Be aware that, as the number of subjects grows, you must take more images of the group to insure a good one. (Check out my detailed instructions for this type of shot on pages 134– 135.)

28. Extra Credit: Each Parent with Their Family — *1 pose each*

As a bonus shot, get each parent of the Bar Mitzvah boy to pose with their parents and all their siblings. This shot does not include the spouses or children of the parents' siblings.

The Cocktail Hour

During a Bar Mitzvah, there will usually be a cocktail hour followed by dinner and dancing, and you will want to be sure to capture all the activities and special features that are important to your clients. I have seen wheeled hot dog stands (complete with umbrella!) and even sushi bars at these events, and both of them make great subjects or background items for portraits. You might shoot a picture of the boy and his mom in front of an ice sculpture, and you could shoot the boy at the hot dog stand with his friends.

Earlier in this book, I mentioned becoming an insider—a trusted confidant—of the bride (see page 40). I often use the time during the cocktail hour to befriend the Bar Mitzvah boy. I take the boy aside and tell him, as far as I'm concerned, this is his party and I'm here to make it more exciting for him. For example, one shot I list in my repertoire for this section is the Bar Mitzvah boy with his female friends (see page 147). I tell him if he wants to have a photo with the girls at the party but is embarrassed to say so, I can be the one to suggest it and make it happen. I tell him no one will be the wiser if I take the brunt of any embarrassment that's generated because it will be me (instead of him) making the suggestion. Some young men actually blush or look at their shoes when I suggest this, but others get serious, look me in the eye, and say, "Okay!" I can tell you that, if the boy likes the idea, that kid and I are now friends, and we start working like a team instead of as strangers.

All of the cocktail-hour photographs mentioned here must happen quickly because there is a hundred-dollar-a-minute party going on all around you. Stopping the festivities to grab a photo should happen as quickly and unobtrusively as possible. While some of the following ideas may sound old and cliché, that doesn't mean that they aren't worth your consideration. They are clichés for a reason, after all! So, without further ado, here is the repertoire that I have put together for this part of the Bar Mitzvah celebration. In addition to these suggestions, you should also be sure to take a few spins through the crowd and pick up shots of friends and family members greeting each other and mingling.

1. Bar Mitzvah Boy and Dad Toast — *1 pose*

This photo can be more photojournalistic in style, where you take the photo as the action naturally unfolds, or you can opt to have the boy and his dad pause to look at the camera.

2. Bar Mitzvah Boy Serving Something to Mom — *1 pose*

This is one where you might need to suggest the idea to get the shot. Even so, you don't necessarily have to have your subjects turn to face the camera for the photo. Certain shots, even posed ones, will look more natural if the subjects are either looking at each other or appearing to be absorbed in the task at hand.

3. Dad Giving Boy a Cigar — *1 pose*

This one will either happen naturally or it won't. In some families, this is a tradition. In non-smoking families... not so much.

4. Bar Mitzvah Boy Sitting in Driver's Seat of Family Car — *1 pose*

While some photographers might cringe at such a contrived picture, my suggestion for them would be to put themselves in the shoes of their subjects. At a Bar Mitzvah—or Bat Mitzvah, sweet-sixteen, or Quinceañera celebration—the next marked event on the horizon for the honoree is getting his or her driver's license. And, generally speaking, boys are more car-aware than girls, so if Dad has a 'vette, a Porsche, a hot rod, or even a muddy open-cab Jeep and you get a photo of the Bar Mitzvah boy in or leaning on that car, I can promise you he will treasure that photograph.

5. Bar Mitzvah Boy with Male Friends — *1-2 poses*

One suggestion for this shot is also my suggestion for a great album-closing shot. See page 151 for my notes on shooting the boys in a 3-2-1 pyramid with the star on top. And I will note again here, be absolutely sure that you have liability insurance—just in case!

6. Bar Mitzvah Boy with Female Friends — *1-2 poses*

This can be kissy, cutesy, or whatever you feel is appropriate. I have placed the Bar Mitzvah boy behind a sushi bar, had him borrow the sushi chef's cap, and had his female friends hold out plates as he serves them. Don't be afraid to get creative.

7. Bar Mitzvah Boy with All His Friends — *1-2 poses*

Get some pictures of the kids crowded around the hot dog cart, the sushi bar, or some other fun site at the cocktail hour. And, as ever, the bigger the crowd in the photo, the more shots you will have to take to make sure that you get one great one.

8. Extra Credit: Entertainers — *1 pose each*

Sometimes there might be a magician roaming through the crowd doing magic tricks, or an artist doing caricatures of the guests. Both of these are prime targets for photos. Again, any aspect of the evening that cost the clients money to provide is probably worth at least one photograph.

The Dinner and Reception

Other than certain situations where I ask for a quick pose, I tend to cover receptions in a purely photojournalistic style, with no interaction between me and my subjects other than the fact that I'm standing there with a camera in my hand. This is for the best because, once the dinner starts, the caterer (or DJ or band leader) takes the lead and I just follow along. Please note that, for suggestions 1 - 4 in this part of the repertoire, I have not included a specific number of poses. It is just too difficult to suggest a certain number of poses when shooting in a truly photojournalistic style. I can tell you, though, that if one of my principle subjects moves during the shot, I essentially start snapping pictures until I'm sure I've captured a good one. This is definitely a time where a quick review of the image on the LCD monitor comes in very handy.

1. Room and Decoration Pictures

Before the guests enter the dining room, you should try to get pictures of the room itself and any decorations. Shoot the room (an overall view), the cake, and any special decorative touches that you see. All you need is a few shots of each thing, and the whole group of shots shouldn't take more than a few minutes.

These pictures serve two purposes. For one, they make great segue images in the album to fit between the cocktail hour and the reception photos. Secondly, and oddly enough, the principles at a party often don't get to see what the room decorations look like because they are too busy with their guests to admire the décor. So, you have captured the finery in all its glory before the guests arrive, preserving that memory.

2. The Grand Entrance

Depending upon the size of the star's immediate family, the grand entrance can happen a few different ways. If the family is small (say, two parents and two kids), they might all make a grand entrance together. If it's a large family, though, a DJ might amp up the crowd by having the honoree's siblings enter first, followed by the parents, and ending with the honoree himself (or herself).

Occasionally, the family will even have hired performers to participate in the grand entrance, such as a dance troupe. In such a case, some of the dancers will often escort the honoree into the room. I have even seen the star ride in on a male dancer's shoulders!

3. Bar Mitzvah Boy and Other Key Family Members Dancing

Next up is the Hora dance. The Hora is a type of circle dance that originated in the Balkans and has become a national dance in Israel. In some ways, it can be likened to the Tarantella at an Italian wedding, or the one-handed conga line that winds its way around the tables at a traditional Greek wedding. Regardless, at a Jewish Bar (or Bat) Mitzvah, or a Jewish wedding, it is a dance where everyone participates and the honorees dance with their family members in the center of the circle as the guests swirl around them.

Everyone in attendance dances, and all the family members are featured one-by-one in the circle's center, making this a prime picture-taking opportunity. One tried-and-true way that I have found to get a great angle on the action is to have a stepladder with me so I can shoot over the guests at the circle's edge. Although you may want to get individual photos of each family member, with and without the Bar Mitzvah star, things don't always go exactly as you might want. So, for suggestions 3 – 4 in this part of the repertoire, my only true piece of advice is to get what you can and roll with the punches.

4. Bar Mitzvah Boy (or Anyone!) Lifted up in Chair

At Jewish celebrations, it is traditional to lift people up in a chair. These photos always go over well with the client if you are able to capture them. At Orthodox affairs, there will be two circles of dancers: one of men and one of women. The circles may merge, they might stay separate, and they even merge and separate again. One shooter on a stepladder will be very, very busy.

5. The Blessing — *1-2 poses*

After the grand entrance and the Hora dance, it is time to start the meal. Most Jewish meals begin with a blessing over the bread that's eaten with the meal. Often, this blessing is recited by a grandparent (it's an honor). The caterer, headwaiter, band leader, or DJ (i.e., whoever is guiding the events at this stage of the game) will usually get the Bar Mitzvah star to stand near the person who is reciting the blessing, but if not, you've got to be quick on your feet to get the star over there before the blessing begins. The blessing is spoken, then the grandparent cuts the bread, sprinkles salt on a slice, takes a bite, and hands a piece to his grandson (or granddaughter) who also takes a bite. It's simple, really; just take pictures of what happens.

6. The Guests at Each Table — *2-3 poses*

Table photographs are usually done in one of two ways, and the choice you make will depend upon whether the centerpiece is low or high. I have included detailed notes on how I go about this on page 107.

7. Candle Lighting — *2-5 shots per candle*

Not every Bar Mitzvah will have a candle lighting ceremony, but if your assignment does, be sure to take a picture of the cake alone before the lighting starts. For the candle lighting, the boy and his close relatives (and sometimes friends) will each light a candle on the cake. I suggest taking a shot candidly, then stepping in and asking your subjects to look at you for another shot. Once the candles are lit, you may also get a chance to take some great pictures of the boy by candlelight, though this requires acting quickly so as not to disrupt the flow of events. To be honest, you'll need a second camera mounted on a tripod and a second shooter or competent assistant to pull it off seamlessly.

8. Blowing Out Candles — *shoot a bunch*

Take many more shots of this scene than you did of any single person lighting a candle. Sometimes, the star of the show is the only one who blows out the candles, but sometimes the entire immediate family joins in! Whichever way it happens, your job is to be ready and shoot it. Furthermore, right after the candles are blown out, the family starts hugging and kissing, so stay ready to cover what happens next, too.

9. Social Dancing — *at least 1 full-length, 1 bust-length*

The after-dinner dance set is often social dancing instead of a circle dance. If this is the case, you should try to pick up a portrait combination of a full-length and a bust-length shot for all the most important partygoers (i.e., the star with and without his parents, the parents alone, grandparents, siblings, aunts and uncles, cousins, etc.). Please check out the correlating section on pages 108 – 109 in my wedding repertoire to see how I handle this.

Photo Composites

Sometimes clients ask if I can merge two photos together. Since the advent of digital imaging, this is a relatively easy post-production task, and it can be a real profit center for you. In this example, the Bar Mitzvah boy's grandfather had passed away and the boy's parents asked if I could add a photo of him to the photo of his grandmother lighting the candle. Currently, I charge $25 per element in the photo composite. In this case, there were tow elements, so I charged $50. If you are competent in Photoshop, you should consider offering this profitable service to your clients!

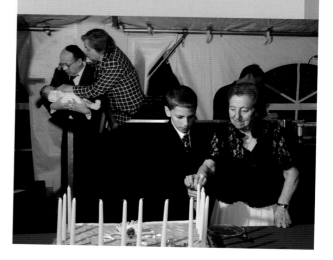

10. Extra Credit: Assorted Kids Activities

Keep your eyes open for additional pictures, as well. Assorted kids' activities, dance floor games, and the DJ giving out gag gifts can also make great shots. Importantly, always remember who is in the family as you take your shots. Pictures of the Bar Mitzvah boy and his close relatives will sell, while one of a non-related kid will rarely (if ever) become more than a proof.

An Irresistible Closing Shot

You will still need some type of picture to close the album you are going to create for the family. It doesn't matter when you create this image, but you should create a few options for the family to choose from. Here are a few the ideas that might work, though you should certainly not feel limited by these suggestions.

1. Bar Mitzvah Boy Waving from Doorway — *1-2 poses*

Stand outside the reception venue and have the honoree inside the venue, holding the door partway open while he (or she) peaks around it and waves goodbye to you.

2. Bar Mitzvah Boy in Mid Leap — *2-3 leaps*

This can be a fun shot. Just be cautious that you don't recommend a leap off of something that is too high off the ground... and have liability insurance!

3. Pyramid of Boy and Friends — *shoot a few*

Take a few shots of the pyramid itself, then a few after it collapses. You will want to make absolutely sure that you stage this shot on carpeting and that you have paid your insurance premiums. Place the Bar Mitzvah boy at the top of a three-two-one, stack of kneeling kids and BE CAREFUL!

4. Boy Sleeping on Catering Hall Sofa — *1 pose*

You might luck out and get a naturally occurring chance to nab this shot, but you can always have the honoree act out. If this shot opportunity arises, don't be afraid to get creative and take a few shots of the scene. An image like this can add variety and a unique touch to your shot selection.

5. Group Shot of the Kids at the Party — *2-4 poses*

Indoors, you can use a stairway for this type of picture, with the kids sprinkled around on the steps—some seated (the tall ones), some standing (the short ones). If it's a tent party at a private home, there might be a swing set or a jungle gym that could also make a great background for these types of pictures. (See the group photo of the kids on page 147.)

"House Call" Portrait Sessions

If you're unable to take photographs at the temple the day of the service, you might want to offer to photograph the family in their temple clothes on a different day. In these instances, you can also shoot casual portraits while at the family's home, and then go to the temple and shoot the Torah-related images I detailed on pages 141 – 142.

This should give you the chance to create a number of additional saleable images. You can also mix in some photojournalistic-style images. Photographers in my area charge $400 to $750 for this type of "house call" portrait session. With the several outfit changes and the different locations and photo styles involved, you will end up with an assortment of pictures that will really expand sales potential.

Choosing and Using Equipment

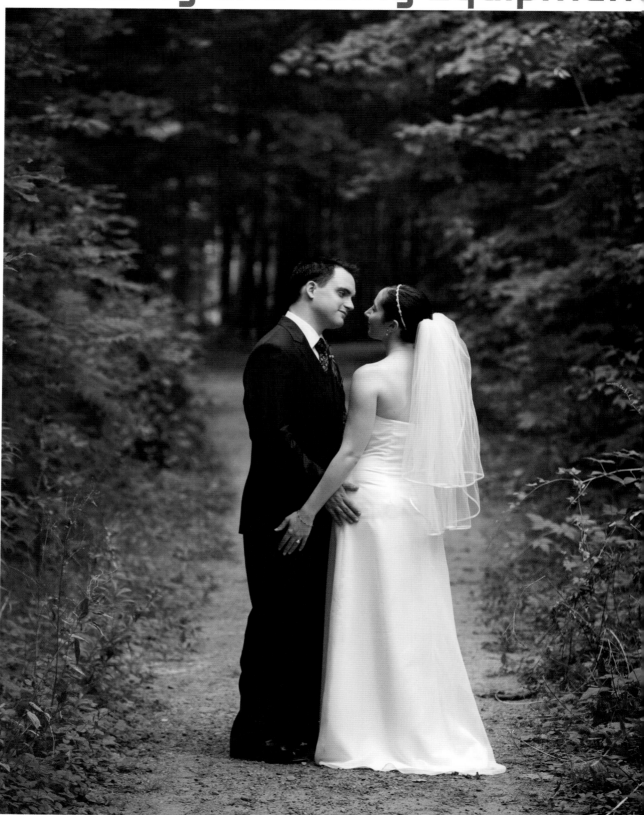

© Chantal Gauvreau

My first wedding camera was an old baby Linhof Technika—a small-sized folding technical camera that, while similar in design to the venerable Speed Graphic (or the smaller Anniversary Graphic), had smoother controls due to its German machining. The day I finally scraped together enough money to get it, I brought the camera to my mentor's studio to show it off. Joe's response was, "Get insurance." I told him it would take awhile to save the money for that, shifting the conversation to my real purpose: Could I bring my camera to the job we were shooting next weekend? His answer was yes, and I left the studio walking on clouds.

The following Sunday, I set up my camera and flash, put it aside, and started to assist Joe. Two hours later, he told me to organize one of the last large family pictures. When I was finished, he told me to go shoot some photos of the buffet table while he finished the family groups. I was overjoyed to finally be able to do some shooting! I ran to where I had left my camera and… it wasn't there!

I ran back to Joe who was posing the last group. "Joe, my camera is gone," I blurted. Without skipping a beat he replied, "Not now. I've got to finish this family group." I searched and searched and still couldn't find my camera. My heart was fluttering; I felt dizzy. I had put all my money into that Linhof, and now it was gone. For two hours I was a miserable lump of human flesh.

Finally, when my misery became unbearable, Joe took pity on me and produced my Linhof. He had hidden it in his camera case. I was livid! Absolutely crazed! Joe just looked at me deadpan and said, "Get insurance." As I cooled down and thought about what had happened, I realized Joe had taught me an important lesson that day. On Monday morning, I called an insurance agent.

What Works for You?

Even without the digital versus film debate, writing about equipment choices for shooting weddings can be a nightmare. Every photographer has favorite brands and battles rage about which camera or flash system is king of the chapel hill. Every time a famous photographer endorses a specific brand, other photographers rush out to buy it. This is true for products across many fields—from cola to cars—and it is what drives the endorsement game. Many of your customers are also influenced by the same photo industry advertising, and it may add to your credibility to use a well-known brand that has a sterling reputation.

Regardless of which brand you think seems best, I agree with you as long as you add in the caveat that it's best "for you." The reality is that there is no earth-shattering difference in which specific brand of camera you decide to use. It just isn't true that brand X takes ugly pictures while brand Y takes beautiful ones. The biggest factor involved in making great pictures is the skill and the creative vision of the photographer.

I am willing to admit that there may be a specific feature or lens on one camera versus another that makes creating a certain type of photograph easier to accomplish, but the vast majority of DSLRs with a resolution of 10 megapixels or more will do the trick for any wedding assignment you want to cover. In my opinion, the images you make with whatever camera you use are really the bottom line and are more important than which camera you use to make them. So, if anyone ever tells you that you can't possibly make beautiful images unless you use the brand of camera they use, you can grin to yourself knowing that they are feeding you a bunch of baloney!

Living in Interesting Times

It is extremely important to realize that digital technology is improving almost daily. Rapid changes are occurring not only with camera design and overall system functionality, but also with imaging sensors, computers, software, and storage media. When the "digital revolution" started, a digital back on a roll-film camera was one of the first ways many pros got into the digital the scene. Then, in relatively short order, digital SLRs came into being, modeled after traditional 35mm SLRs. The market for these cameras is still expanding at an exponential rate thanks to ever-improving sensor and processing technology and ever-decreasing price points.

Lately, digital medium-format cameras like the Mamiya ZD and the Hasselblad H1D (both possessing up to 56 megapixels) along with the newer Leica SL and Pentax 645 have joined the fray. These cameras, with larger-than-full-frame (i.e., larger than a 35mm film frame) sensors, feature higher resolution and physically bigger pixels. Bigger pixels mean less noise in addition to their high resolution. So, it looks like the death of medium format has been greatly exaggerated (to paraphrase Mark Twain).

Likewise, the Fuji S5 with its two differently sized pixels at each photosite on the sensor is an advancement that may help prevent blown highlights and blocked shadow detail. Meanwhile, Canon, Nikon, and Sony continue to produce improved, higher-resolution cameras that, along with the latest round of ultra-fast zoom lenses, may finally cement the 35mm-based DSLR as the camera of choice for wedding work.

There is an old Chinese toast that doesn't wish for health and wealth, but instead hopes that the person being toasted "lives in interesting times." The switch from film to digital imaging has set the photo world on fire and, without a doubt, we are living in interesting times!

© Russell Caron

Selecting a Camera

Many photographers consider the camera to be the most important of their hardware choices (though I personally think that lighting equipment is of equal or greater importance). By far, the most popular camera design for today's wedding photography professional is the DSLR (digital single lens reflex). Mirrorless cameras are beginning to break through into the market, which may eventually tip the scales against these popular reflex mirror cameras, but currently, DSLRs are the standby choice for pros.

The choice of which sensor to invest in is a critical step in determining which camera will work best for you. Given equal pixel count, a larger sensor will have larger pixels, and this is a definite advantage. Larger pixels create a cleaner signal, and a cleaner signal means less noise. This, in turn allows for image capture at higher ISOs.

There are two metrics by which to measure pixel size. One way to compare one pixel's size to another is via a metric called MP/cm^2 (megapixels per square centimeter). On DPReview.com under the Specifications pull down menu, you can find a comprehensive list of var

ious cameras' MP/cm^2 measurements. You'll see that the smallest cameras form each manufacturer might have 50 MP/cm^2 while the biggest DSLR sensors might have 1.4 MP/cm^2. The lower the number before the MP/cm^2 metric, the better the camera's image quality.

The other metric that can be used to measure the size of a camera's individual pixels can be found on www.dxomark.com by looking under their Camera Sensor/Compare Sensors menu. This website offers the size of each pixel measured in microns—the symbol μm--which stands for 1 millionth of a meter. In this case, the bigger the μm number, the better the camera's image quality. For example, when comparing the Nikon D300 and the Nikon D3, which are both 12-MP cameras, the D300 has pixels that are 5.42 μm while the Nikon D3 has 8.4 μm-sized pixels. Therefor, the D3's sensor can produce a higher image quality. Almost always, given any two cameras with an equal total MP pixel count, the *lower* the MP/cm^2 number is or the *higher* the μm number is, the better the camera's image quality will be.

© Michael Brook

Digital Camera Choices

While the coming years will undoubtedly see the introduction of new, less-expensive medium format digital cameras and backs, today, most of the digital cameras used by professional wedding photographers are DSLRs that have been modeled after 35mm SLRs. For 35mm shooters, this offers the advantage of being able to use lenses they already own. However, one thing to be aware of is that many DSLR sensors are physically smaller than a 35mm film frame, which changes the view through a given lens placed on that camera as compared to what you would see with a 35mm SLR (or a full-frame DSLR). DSLRs with smaller-than-full-frame sensors make lenses perform as if they had longer focal lengths than they actually do. To quantify this change in view, multiply the focal length of the lens by the magnification factor associated with the particular sensor. For example, if your camera sensor has a magnification factor of 1.5x, the field-of-view coverage for a 50mm (normal) lens will be equivalent to that of a 75mm lens on a 35mm camera.

While telephoto focal lengths get a boost in magnification power, more importantly (for wedding work), so do wide-angle lenses. In other words, wide-angle lenses don't offer their maximum width unless you are shooting with a full-frame (35mm-film-strip-sized) sensor. For example, the same 1.5x sensor that effectively turns a 50mm lens into a 75mm lens also makes a 20mm lens perform as though it were if a 30mm lens, with a narrower field of view.

It is important to consider this when shopping for a digital camera, especially if you are looking for one that will gel with your existing lenses. Without a full-frame sensor, your favorite portrait lens will suddenly offer a very different view of the bride. And, perhaps more importantly, the wide-angle lens that you used for group shots will no longer include the four cousins at either edge of the photo. This narrowing field of view is even more of an issue when you go to crop the standard 3:2-proportioned image to a 4:5 proportion to make 8 x 10-inch (A4) prints for the wedding albums. So, think long and hard about whether going the full-frame route makes the most sense for you, though I will warn you that the ticket price on full-frame DSLRs is somewhat more daunting than that of their smaller-sensored cousins.

Personally, I find small-sensor cameras perfectly suitable for wedding photography. They have the added advantage of being able to use smaller, lighter, and less-expensive lenses than full-frame DSLRs need in order to achieve the same focal lengths. Plus, lenses generally perform best at the center of their imaging circle, and when using a small-sensor camera with any lens made for use with a full-frame camera, you end up using only the center (and best) part of the lens' circular projected pattern.

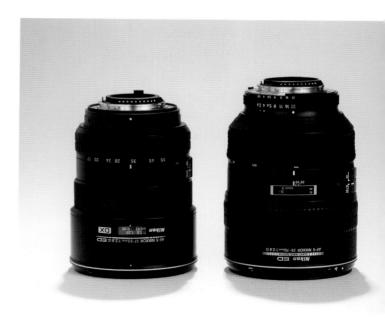

Here is a 17-55mm lens compared to a 28-70mm lens. While both lenses feature fixed aperture of f 2.8, the 28-70mm is both bigger and heavier than the 17-55mm. Additionally, the 17-55mm has a greater range when I consider the 1.5x magnification factor that I am working with (bringing the effective range up to about 25-82mm).

©Russell Caron

An Eye on Features

Some of the bells and whistles that today's cameras offer are quite advantageous to wedding photographers, while others may be more sensationalistic than they are useful. For example, while a camera manufacturer will crow that their particular model can sync with their flash at 1/300 or 1/8000 of a second, they neglect to mention that this can only be accomplished by using the flash unit in a stroboscopic mode that greatly limits its power and does little to freeze action at the lower end of the shutter speed range. Excuse me, but I need to shoot at f/8, not f/2.8, and I have to get to that aperture in one flash pop so my other flash units (including my assistant's light on a pole and the room lights I use) work in sync with my camera.

Interestingly, although all of the photographers I hang with—including myself—make use of autofocus features, we mostly set exposure manually because auto exposure systems are too easily tricked by white bridal gowns, black tuxedos, and cavernous, dark wedding venues. Neither I, nor my customers, find it acceptable to blow out the detail in a lace overlay on a $10,000 wedding dress, and that can

happen all too easily when using automatic exposure and flash. Furthermore, dialing in exposure compensation and remembering to dial it out again for the next image takes more time than setting the f/stop manually.

Lastly, while it is important to get a DSLR with the highest resolution you can afford, keep in mind that any latest and greatest lens you can bayonet onto a top-of-the-line camera model can also be mounted on a lower-priced model within the product line. Because of this, while your main camera should be the best you can afford, your backup equipment can be further down in the same system in terms of features and price point. That said, I have to admit that I personally hate using two different camera models; I prefer that my cameras are identical so I can pick up either without worrying about which button is which while trying to stay on top of the action. So, for me, this means that when I buy a new camera I buy two instead of one. Although this is pricey, I find the benefits of being able to use my two cameras together seamlessly are worth it.

Making the Most of Your Megapixels

Photographers often rush to sell their 10-megapixel camera when a 12-megapixel model becomes available but, in terms of resolution, there is hardly any difference between the two. Camera manufacturers are very interested in having you upgrade to the next generation of their latest and greatest, so each advance of one or two megapixels is touted as if it's the ultimate improvement. That said, I will admit that there is a certain amount of logic in the argument to purchase as many megapixels as possible. The more resolution you have to work with, the larger the prints you can offer to your clients, and the more wiggle room you have for image adjustments and cropping during post-processing. You (and your clients) might be satisfied with the resolving power of a 6-megapixel camera if you don't need prints larger than about 8 x 10 inches (A4), but bear in mind that if the original image file has only just enough resolution to produce an 8 x 10-inch print, there is very little cropping that can be done before you run out of pixels. If megapixel restrictions are a reality with your current equipment, you will really need to concentrate on getting the framing right in-camera.

Sharpness

While it can be proven mathematically that a medium format camera can still beat a full-frame DSLR camera when it comes to paper-print sharpness, proving this argument is not the purpose of this book. Therefore, in accepting that the DLSR is the standard for today's wedding photographers, the question then becomes, what can you do to get the highest possible image quality out of your DSLR? Here are a few ideas worth exploring in your search for fabulous image quality.

Tips for Sharper Images

• Whether you use zooms or fixed-focal-length lenses, invest in the highest-quality lenses you can. The zooms in this class usually have a constant aperture and the single-focal-length lenses usually have a larger aperture than the fixed aperture zooms.

• Always use a lens hood! The fastest way to kill image quality is lens flare, so do everything you can to avoid having a light source skim across the front of your lens. (See pages 166 – 167 for more about lens hoods.)

• When you want maximum image quality, try to select an aperture value that is three to four stops smaller than the lens' maximum aperture.

• Learn how to hold your camera steady during handheld shots. When possible, tuck your elbows into the sides of your body to create a more stable platform for your camera and press the camera against your face as you release the shutter button.

• Press the shutter release button down slowly instead of jabbing at it.

• Take a breath and release half of it before gently pressing the shutter release button, concentrating on keeping you body relaxed and still.

• Test yourself to find out just how slow a shutter speed you can handhold successfully. Remember that longer, heavier lenses require shorter shutter speeds than shorter, lighter lenses to insure sharpness.

• Use a tripod whenever it is practical in long exposure situations.

• Use a higher ISO (within reason) and invest the resulting extra sensitivity in shortening your shutter speed.

• Use the highest resolution (and the lowest compression rate for JPEG files) that your camera has to offer. That way, you have the most possible pixels to crop from if necessary when you go to make your final image presentation.

RAW vs. JPEG

Some photographers try to speed up their postproduction downloading and back-up processes by shooting only in the JPEG format. However, I have found that the exposure accuracy required to shoot quality JPEGs is equivalent to shooting with transparency film, which is fine for a commercial or portrait assignment where there's time for careful light-reading and exposure refinement. However, for wedding photographers used to the forgiving nature of color print film, it is difficult to get the same results with the JPEG format in the fast-paced world of the wedding photography unless your exposure technique is very good to excellent.

Shooting JPEGs too often results in blown highlights on the bridal gown or lack of detail in the groom's tuxedo, and you are stuck with these poor captures unless you have a RAW file handy so you can adjust your exposure. This only gets worse when photographers try to substitute automated flash exposures for solid photographic flash technique. One friend of mine who works regularly with JPEG has told me that his digital shooting style is shoot, shoot, shoot, delete, delete, delete, then shoot, shoot, shoot, ad nauseum.

Shooting RAW files (which contain all of the original capture's unprocessed data) gives you the ability to make exposure and white balance corrections in postproduction. That said, they do take up more space on memory cards and hard drives than JPEGs do. Some cameras offer the option of recording both JPEG and RAW files simultaneously. This is handy, as you can use the JPEG for proofing and only process the RAW files for the pictures the customer orders as prints. This results in a huge saving of computer processing time.

In truth, I use the RAW+JPEG recording option for every image I shoot. And, because I work very hard at nailing my exposure and color balance on every image I take, my goal is to never have to open a RAW file at all. This way of working demands very good shooting technique, but it works for me. And when I do foul up (and I do), I always have a RAW file on hand to save the day!

© Sara Wilmot

The Issue of Cost

Digital camera manufacturers and digital photographers alike are outspoken about how shooting digitally eliminates film costs. This is true, of course, but focusing on that benefit without considering the new costs that come into play with digital shooting amounts to one-sided thinking. The current business model for digital camera manufacturers (and retail stores) requires that these companies constantly clear out old models to make way for the new. This means that this year's "MVP" camera may well find itself steeply discounted two years from now. Just as with old computers, rather than becoming an investment that will appreciate in value, digital camera models that are more than a year or two old depreciate rapidly towards being worth not much more than a fancy paperweight. The resale value of these few-year-old digital cameras is next to nothing because ever-advancing technology has stripped them of their usefulness.

Camera manufacturers do everything in their power to push old products into obsolescence. They want you to buy a new camera every few years. And don't forget that digital photography includes so much more than just the camera and lenses to make the system work. Laptops, desktops, memory, hard drive upgrades and replacements, software, CD and DVD burners, and backup storage devices are all part of the costs that must be considered. Check out pages 20 and 253 for more about what you need to consider when calculating the cost of your digital wedding photography business.

Understanding Color Temperature

Before I start this section, I would like to share two emails I received from a student I taught at a wedding photography workshop at the Maine Media Workshops. Shortly after the workshop, I received this note:

Yesterday I shot my first wedding since taking your wedding workshop. I shot the ENTIRE event setting the color temperature myself! I can't thank you enough for teaching us that in class. I am beyond thrilled with the results! It's already obvious to me how much less color correcting I'll be doing in Camera RAW. Thank you, thank you, thank you!

About a month later, I got this second email:

I have to sing your praises again! Color temperature has changed my life! I know I already mentioned this a month ago, but I have been shooting all of my children's sessions by dialing in the color temperature, and I did another full wedding doing the same. Honestly, my post-production time has been cut to at least 1/3 or 1/4 of what it was before. Thank, thank you, thank you!"

My favorite method of setting the white balance on my camera is to manually set the Kelvin temperature. It is the only repeatable white balance option that doesn't require me to reset a custom color balance each time I change lighting conditions, and it can be adjusted easily in small increments to suit my taste. For those who don't know what Kelvin temperature is, let's start with a quick definition.

All light is not the same! Household tungsten light bulbs put out a yellowish light compared to sunlight, and the light in open shade is bluish compared to sunlight. A scientific and more exact way of comparing and quantifying the color of light is by using the Kelvin scale, which measures color temperature in degrees. The lower the Kelvin temperature, the warmer (yellower) the light is. The higher the Kelvin temperature, the cooler (bluer) the

Kelvin Temperatures to Know

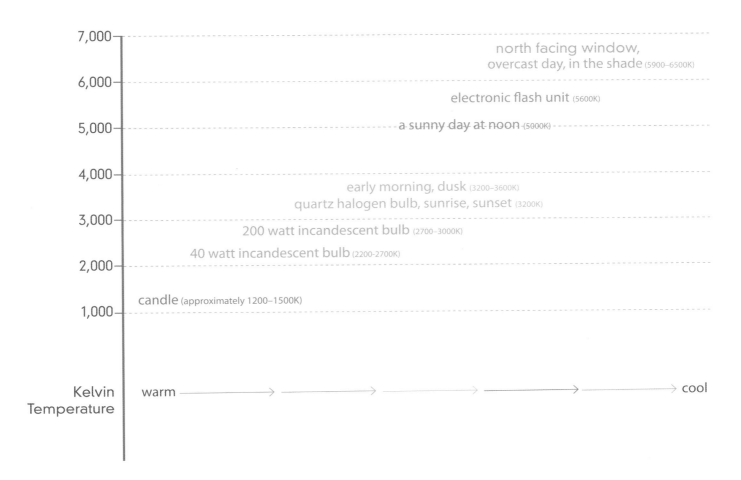

light is. Here are a few specific Kelvin temperatures to help you picture the concept. Direct sunlight (defined as sunlight on a clear day between 10:00 A.M. and 2:00 P.M. in the northern hemisphere) is about 5000 degrees Kelvin (5000K). Quartz halogen bulbs (common video lights) are 3200K, electronic flash is usually about 5600K, and open shade or full cloud cover (no distinct shadows) is usually somewhere between 5900K and 6500K.

Nearly all DSLRs give you the option to select from a group of preset white balance settings, such as Electronic Flash, Daylight, Cloudy, and Incandescent (or similarly named items), which you can choose from depending on the light in which you are photographing. But, it is important to note that these presets are not exact and are biased by the camera manufacturer's tastes. Thankfully, more and more current DSLRs are including the ability to go beyond these presets so you can set the white balance to a specific Kelvin temperature. Part of

my reason for choosing manual Kelvin temperature white balance selection over all the other options is that I'm against giving creative control to my camera in almost any situation where my personal input can offer better or more consistent results. Furthermore, there are really only a few Kelvin temperature settings to remember for wedding photography with electronic flash, window light, or quartz halogen lighting. What follows is a listing of color temperatures in degrees Kelvin for various light sources. However, it is important to note that you might not agree with my suggested settings if your visual aesthetic is different from mine, so do some testing on your own.

Color Temperature Basics

For those who may just be starting out on their journey to understanding the intricacies of color temperature, here is a quick primer. First off, the artificial light produced by low-wattage tungsten bulbs is warmer (more yellow/red/orange) than daylight (which rings in at between 5000K and 6500K). To account for this, set your camera's white balance to a lower Kelvin temperature of about 2000 - 2400K for a more color-correct rendition of a scene that is mostly lit by tungsten lighting, as many indoor scenes are, especially at weddings. If you want the warmer tones of the tungsten-lit scene to come across in your images, try adding 200 – 600K to that original 2000 - 2400K suggestion and observe the effects to see what works for your tastes.

Many folks these days are replacing tungsten bulbs with fluorescent bulbs in their homes to be more energy efficient and "greener," which may affect portraits that you take at the bride's home before the ceremony. Coincidentally, greener is how your subjects will look if you don't color correct for this type of lighting! Fluorescent lighting acts very different from tungsten lighting, and if the lighting is a mix of tungsten and fluorescent, you could have a real challenge on your hands. Manually setting Kelvin temperature is not ideal for such cases. Typically, fluorescent lighting cannot be adjusted for simply by plugging in a Kelvin temperature equivalent (except for the warm, white type of fluorescent bulbs, which have the same color balance as tungsten lights). Fluorescent light has a discontinuous spectrum with a spike in the green component, and it is missing most (if not all) of the red part of the spectrum. For this reason, working under fluorescent lighting is literally the only time I use one of my camera's preset white balances, and even then the results often have a green tinge to them because there are so many different kinds of fluorescent bulbs. So, when I'm forced into working under fluorescent lighting, my first choice is to try to overpower it with electronic flash or, if I want to

Custom vs. Manual White Balance

Some photographers feel that setting a custom white balance by shooting a grey or white card instead of using manual Kelvin temperature is a better solution for the best color rendition, but I disagree. During the film-to-digital transition, my photographer friends and I set custom white balances all the time. The problem with doing this was remembering to reset the custom balance every time we changed locations during a shoot. The more times you change your location, the more variety your coverage has, which makes for better, more interesting images. But, if you try doing this while setting a custom white balance for each location change, you will make yourself crazy! Forget to do it once or twice and you're in trouble. On the other hand, by knowing and using the few Kelvin settings you need, you will achieve your end results with more efficiency and consistency.

make use of the tungsten light fixtures that exist in the location I'm working, I turn off the fluorescent lights and use a flash with an orange filter on it (the Lee 204—see page 213 for a photo of this). When I do this last trick, I manually plug in a 3200K white balance to my camera (remembering to change my white balance back to 5600K when I switch back to unfiltered flash).

Be sure to examine your results closely if you are shooting in any type of tricky lighting situation. Sadly, because of the discontinuous spectrum issue, trying to fix this problem by using a RAW file sometimes presents you with another problem called crossover. Crossover occurs when you correct for the fluorescent lighting in your image-processing program and doing so creates problems with the other light sources illuminating the photograph. Again, this is why my first choice when working under fluorescent light is to over power it with an electronic flash unit, and my second choice is to turn it off altogether, if possible.

As a general rule, any time you get a color rendition that is too blue (or not warm enough), increase the Kelvin temperature by anywhere from 200 – 600K and check your results to see if you've hit the mark. If the picture looks too yellow (or too warm), decrease the Kelvin temperature by 200 – 600K. Lastly, when photographing people, almost any slight color balance shift is acceptable as long as it's towards the warm (yellow) side, while a shift to blue or green makes your subject look like a corpse!

The Ups and Downs of Autofocus

One of the first things I do when I start using a new DSLR is decide which of the various automated features I want to use and which I want to turn off. Part of my reason for doing this is the fact that, as I have mentioned, I generally do not want my camera making important decisions for me. In creating these various automated functions, camera designers assume that you are mostly shooting average subjects. However, the reality is that wedding photographers face off against subjects that are in no way average! Masses of white (brides) and masses of black (grooms and their ushers) in cavernous ballrooms (as opposed to average living rooms) drive auto exposure systems absolutely nuts! Regardless, one automatic feature that I do use constantly is autofocus, but even then I find it disconcerting to let the camera choose which items within my frame it should focus on rather than me doing the choosing.

Almost all of the wedding photographers I know, including me, tend to pick a central (or slightly off center) autofocus point and lock the autofocus system onto that focus point. I frame my picture with my main subject on that focus point, partially depress the shutter button to lock focus on that subject, and then I reframe the photograph to suit whatever framing I want for the final picture. This allows me to use the faster and more accurate cross-phase focus sensors instead of the single-phase sensors. This is very important. Autofocus sensors read the contrast of the area that they are measuring, with the highest contrast result being the point of sharpest focus. Single-access autofocus sensors read only vertical or horizontal areas of dark and light—not both. Cross-access sensors, on the other hand, read both vertical and horizontal dark and light areas, so they are more able to focus quickly on a much larger variety of subjects. Most DSLRs have the majority of their cross-access

sensors arranged in the center of the frame, so if you choose an autofocus sensor and your camera hunts for focus lock, try picking another, more centrally located sensor and you might be pleasantly surprised at the improvement it makes to your camera's autofocus ability.

One of the most frustrating things when working with a camera's central autofocus sensor happens when you are shooting two people horizontally. The central sensor sees through the space between your subjects and locks focus onto something in the background, ruining the photograph. My method of pre-selecting an autofocus point to lock onto is a great way to avoid this problem altogether. Choose a focusing sensor one off from the central one in your viewfinder along the horizontal axis and lock focus to that point. As an added benefit, when shooting vertically, you can end up with a sensor point that is closer to your subject's face than the center focus point.

Once you've decided what camera will work best for you, your next decision is what focal length lenses to choose. For most wedding work, you'll need access to three main focal-length groups: wide angles (16-17mm for small sensors; 20-24mm for full-frame), normal range (24-35mm for small sensors; 35-60mm for full-frame), and short-telephoto range (50-100mm for small sensors; 80-200mm for full-frame). You can achieve access to these with a set of fixed-focal-length lenses or with zoom lenses. Fixed focal lengths are often faster (have a larger maximum f/stop) and are sometimes sharper, but they are less convenient and much less versatile than fixed-aperture zooms.

Some photographers believe in stuffing their camera bags with every lens available for their camera. They end up toting so much weight that, after a hot weekend in June shooting four weddings, they can barely stand up straight! For me, it is more important to be light and mobile than to have every lens available. When I work alone (which is not too

© Russell Caron

often anymore), I use two zooms for the majority of my work: a Nikon 17-55mm f/2.8 and a Nikon 24-85mm f/2.8-4 for portraits. When I work with an assistant, I pay him to carry more of my lens choices! My full wedding case includes the following in addition to the two I mentioned above: a 16-85mm, a 24-70mm, and a Sigma 50-150mm. Part of my choice of lens selection is due to the fact that I shoot with a smaller-than-full-frame sensor. This means that my 50-150mm Sigma lens acts like a 75-225mm, and it weighs 20 ounces (about 567 grams) less than the 70-200mm Nikkor I would need if I used a full-frame camera. Additionally, the Sigma is much less intimidating to my subjects and costs about half of what the latest 70-200mm Nikkor lens costs. For me, these advantages makes the Sigma a great deal! Considering my Sigma is lighter, costs two-thirds less, and is less intimidating, I consider it a great deal. The weight savings alone becomes especially germane when I'm shooting two weddings in one day.

New photographers often want the widest or longest lens available. They don't understand that most photographs are shot at normal focal lengths. In my DSLR system, I have lenses ranging from 14mm to 300mm, but if I had to choose only two, they would be my 17-55mm and my 24-85mm zooms. Why not the 50-150mm instead of the 24-85mm, you ask? Because in an emergency, the 24-85 could pinch-hit for my 17-55mm zoom lens, and I feel that having a backup lens is more important than having the added range the 50-150mm would give me. Over the years, I've realized that, while I can take a single "show-stopper" with an ultra-wide or ultra-long lens, 99% of my photographs can be taken with these two "money lenses"—the 17-55mm and the 24-85mm. Since I have the choice to carry more than just my top two, when the money is on the line, I want to be sure to have a wide-angle, a normal, and a short telephoto on hand.

Here is a visual comparison between the Sigma 50-150mm and an older Nikon 80-200mm. If you shoot with a small sensor camera, you can achieve the versatility of a larger lens without toting around the weight of one.

Regardless of my first choice being zoom lenses, single-focal-length lenses are often sharper, faster, lighter, and less expensive. This being the case, for lawn weddings, tent parties, and customers who prefer a photojournalistic style, I often add a 20mm f/2.8), a 24mm f/2.8, or a 35mm f/2 lens plus a 50mm f/1.4 and an 85mm f/1.8 to my case. The larger maximum apertures let me throw backgrounds more out-of-focus to add to the photojournalistic look.

The real lesson here is that you will get the greatest amount of use from lenses that closely border a normal focal length. A 28mm or 105mm lens will see a lot more action than a 15mm or 300mm. Realize what your priorities are for the job you're going to shoot and pack accordingly.

Fixed vs. Variable Aperture

Lens weight, speed, and sharpness are of vital importance to a wedding photographer. Although zoom lenses are very convenient, they require you to make certain sacrifices. Zoom lenses are usually heavier, slower (having a smaller maximum aperture), and less sharp than their fixed-focal-length cousins. In addition, a zoom with a variable aperture can create nightmares for photographers working with manual flash.

There are two different types of zooms to consider: variable aperture and fixed aperture. Variable aperture means that the effective aperture changes as you change the focal length. For example, you might have an 18-70mm f/3.5-5.6 that starts at 18mm as f/3.5 and becomes an f/5.6 lens when zoomed to 70mm. It is very difficult to use manual flash with this type of lens. If you're willing to commit to TTL auto flash, Nikon has a 24-85mm f/2.8-4 zoom lens that offers excellent optical performance and a macro mode that I find very useful. They also have a fixed aperture 24-70mm f/2.8 lens that is possibly the best zoom lens I have ever owned. I have both of these lenses in my system, which is important for me, as one backs up the other. Canon and Sony have similar lenses in their lineups. Whether you opt for fixed or variable aperture, zooms enable you to create an outstanding one or two lens wedding system.

A Cost Consideration for Non-Full-Framers

Interestingly, many non-full-frame DSLR shooters have found that less-expensive, fixed-aperture zooms by Sigma and Tokina offer equal performance to camera manufacturers' lenses at what is sometimes half the price! (This may be true of other independent lens brands also, but I can only speak to witnessing this truth with these two brands.) Here's the inside track on this phenomenon. Almost all of today's lenses are very sharp and offer great performance in the center of their circular pattern. Conversely, edge performance is not as easy to achieve. Now, take into account that photographers shooting with less than full-frame-sized sensors are already dealing with a comparatively zoomed-in view, using only the central portion of the lens' pattern. Thus, even if the edge performance of an inexpensive lens is somewhat lacking, the smaller-sensor DSLRs will never see it!

Lens Hoods

Number one on the list of important lens accessories has got to be a lens hood. In fact, the more edgy you get with your lighting (hair lighting, off camera lighting, room lighting, etc.), the more important a lens hood becomes. Lens hoods offer protection from stray light rays that can cause flare. Plus, they can also protect the front element of the lens from oily fingertips or absorb some of the impact if you drop your lens (which almost inevitably will happen at some point). Whenever possible, I prefer to use bayonet-mounted, rigid lens hoods instead of screw-in or bellows-style compendium hoods. Although compendium lens hoods have their place (such as when shooting portraits using a hair light or working outdoors in soft backlight), the rigid ones are smaller and, if they bayonet into place, they can be removed quickly so you can easily add a filter.

There is another interesting point worth mentioning when discussing lens hoods. Here's the scoop: The hood I'm using on my 50mm f/1.4 is from an ancient 105mm f/2.5 Nikkor. Although this combination is "vignette-ville" on a full-frame DSLR,

Since lens flare is a prime cause of poor image quality, I'm always exploring ways to combat it, and using a longer lens hood on lenses for my small-sensor camera is a great way to do that. There are two 50mm f/1.4 lenses pictured here, and the one on the left has a lens hood from a 105mm lens on it, while the one on the right is wearing a hood designed for a 50mm lens. My smaller-than-full-frame sensor uses only the central part of the lens' imaging area, so the longer hood on the lens on the left doesn't cause vignetting like it would on a full-frame DSLR.

it doesn't cause any vignetting with my Nikon D300 because the smaller sensor only sees the center of the lens' circle of coverage. Likewise, my 24mm f/2.8 Nikkor is sporting the lens hood from an old 85mm f/1.8 Nikkor without a trace of vignetting. So, if you're shooting with a camera sensor that is smaller than full-frame, investigate hoods designed for longer lenses. You might be pleasantly surprised at how much extra protection you can get from lens flare without dealing with vignetting woes.

Diffusion Filters

Today's lenses are very sharp—sometimes too sharp! They can record with great clarity every pore and blemish that is part of the complexion of all normal people. Quite often, this level of detail is not what I have in mind. For this reason, my camera case contains three different types of diffusion filters, and each has a specific purpose. While a touch of diffusion can mask the harshness of time on an older person's face, a large area of diffusion can take a mundane picture and elevate it to a romantic, pictorial event that can become the centerpiece of the newlyweds' living room.

For just a touch of diffusion there are a few ways to go. Of the methods I use, one just cuts sharpness while the other both cuts sharpness and makes the highlights in the scene glow with a halo effect. To simply cut sharpness, as I might want to do in a portrait of an older woman, I use a piece of very fine black netting (called tulle) and stretch it over my lens. I hold it in place by attaching my lens hood over the material. This eventually tears and shreds the fine netting, but the material costs less than a nickel per 5 x 5-inch (12.7 cm x 12.7-cm) square; I cut these squares out from a bigger piece of the fabric, using just enough to comfortably cover my lens. So, at that cheap price, when it shreds, it shreds. I just throw it away and cut another piece. If this seems like too much trouble, you could use a Tiffen Softnet Black filter. The only trick to using the net or the Softnet filter is remembering to open the lens up a half stop more than you would without the filter in place. Depending on how coarse it is, the black tulle prevents about 1/3 to 2/3 of a stop of light from reaching the sensor, as does the Softnet filter.

The second type of diffusion filter I use has small, lens-like elements on the filter's surface. They scatter light and selectively defocus details while maintaining an overall appearance of sharpness. These filters are available in varying degrees of diffusion. Tiffen's Soft/FX and Warm Soft/FX filters are both available in five densities.

Zeiss makes its own version, called the Softar, available in three densities. Of the three Zeiss filters, the Softar I is my first choice (although I also carry the Softar II, but most times find it softens the image too much). When used in sunlight, a Softar I creates highlights with an angelic glow. Diffusion filters of this type are expensive, but their sophisticated design maintains image clarity while creating soft, luminous highlights—perfect for wedding photographs.

The last type of soft-focus filter I use is another homemade variety. Commercial photographers often use Vaseline streaked, smeared, and/or dabbed on a UV filter or sheet of glass. This creates a soft-focus filter that is soft only where they want it to be and sharp in other areas of the composition. Although the idea is a great one, while shooting a wedding there is no time to clean the filter and reapply the Vaseline for each shot. My solution is to buy old, scratched, ratty skylight filters from the junk boxes at photo shops and swirl on clear nail polish in various patterns. My favorites have a dime-sized clear area slightly off-center, and when I put it on my lens, I orient the clear spot so that the part of my composition that I want to be sharp is aligned with the clear area of the filter.

These makeshift filters, along with my handy tulle filter and manufacturer-made soft-focus filters, do the trick for me. But, there are dozens of other soft-focus devices that I have seen photographers use over the years. From translucent plastic cups riddled with holes to very expensive Imagon soft-focus lenses, each photographer has his or her favorites. Over the years, I've tried many softening devices, from crumpled cellophane with holes burned in it to simply breathing on my lens in cool weather. Although I have listed the ones I'm currently using, if you ask me to list my favorites next year, they would probably be different. Consider trying my ideas then get creative and think up some of your own.

NOTE: It is also easy to add diffusion effects in post-production, but I prefer to create the effect in-camera if I can. Not only are the hands-on organic effects very cool-looking, but creating them in-camera helps me to limit my image-processing time.

Tripods

If some wicked witch were to cast a spell over me that would allow me to carry only one accessory other than my camera and flash (she's not totally wicked—she let me start with my camera and flash!), I would be hard-pressed to choose between my tripod and my light meter. I calculate my flash exposure in my head, so if I were using a DSLR with a built-in, continuous light meter, my choice would be easier. But even if my camera didn't have a meter... I'd say, give me my tripod! While tripods create a professional presence, more importantly, they make a new range of shutter speeds available, which in turn makes more apertures available, which gives you more tools to work with.

Taking pictures of people quickly with a tripod-mounted camera requires a specific set of criteria. The choice of features one needs should be made with speed foremost in mind. Consider the following:

1. Although leg bracings (rods, either adjustable or fixed, that attach between the tripod's center column and its legs) make for a sturdy tripod, they are not conducive to fast tripod-shooting technique.

2. A tripod's capability for being extended or collapsed quickly is important. Tripods with quick-release leg locks can be operated much faster than those without them.

3. Ballheads or speed-grip tripod heads are much faster than pan/tilt heads for taking people pictures (which is what wedding photography is all about).

4. A geared center column not only slows you down, but also makes you carry unnecessary weight. Tripods with a sliding, friction-locking center column are lighter and faster.

5. Weight and sturdiness also must be factored into your choice. Strong used to mean heavy, but with the advent of carbon-fiber tripods, that's no longer always the case.

6. Spike-tipped tripod feet might be great for shooting in the muck and mire, but you'll regret it if your tripod scratches up a caterer's parquet floor. Avoid spiked feet.

7. Your height plays a role. Many of your shots will top out at eye level. For this kind of shooting, it doesn't make sense to carry a 10-foot (3-meter) tripod if the highest camera position you'll be shooting at is your own eye level.

A Handy Tripod Tip

There is a way to avoid having to constantly change your tripod's leg length. This method only requires slight adjustments to be made to assure that the sensor plane is parallel to the subject plane (which enables an accurate rendition of the subject). To accomplish this, I open the tripod's legs to a length that allows me to shoot a close-up portrait at eye level with the center column fully extended. Then, I use it to shoot a full-length portrait with the center column at its lowest point. Considering that my center column is only 24 inches (about 61 cm) long, to get to an eyelevel photograph at full center-column extension means I'm often a little high when I drop the column for a full-length shot (coming up at about the base of the subject's sternum instead of the subject's belly button), but I'm still willing to give up that slightly more perfect full-length camera position in exchange for the speed of operation gains involved.

The favorite 'pod among my peers used to be the Cullmann Titan. Now, they're pretty hard to find, but are worth picking up if you come across a used one. This German tripod's claim to fame is a two-section leg that is both released and locked in position by a lever at the top of each leg near the tripod yoke (where the three legs meet). This makes for lightning-fast leg operation. On the negative side, the two-section leg means the Cullmann doesn't collapse compactly, but this is not a big concern in wedding work. The tripod is also heavy and requires a special Allen wrench to keep the tripod screw tight.

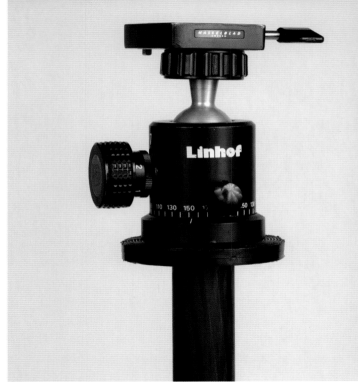

A few of us also swear by our Gitzo tripods (imported by Manfrotto Distribution). The first one I bought over 30 years ago still works well. Gitzo's legs use threaded collars to tighten their leg extensions (unlike the faster-operating locking levers on some other brands), but one plus is that their latest tripods are made from carbon fiber, which is lighter and stronger than aluminum. However, the 40% reduction in weight and the increase in strength offered by carbon fiber also means they are quite expensive. Other contenders for the tripod throne include models manufactured by Manfrotto, Adorama, Induro, and Slik.

In nearly 40 years shooting weddings, this is only the second Linhof ball head I have purchased. The first one never broke, but over the years, all the paint chipped off, blackening my sweaty hands after handling it, and making them useless to me for straightening the bride's white train.

No matter which tripod you decide upon, the head is another choice you've got to make. Serious shooters mix and match different brands to suit their needs. As already mentioned, pan/tilt heads are slow compared to ballheads when used for people pictures. The Bogen 3265 Grip Action Ballhead has a spring-loaded release lever. By squeezing the head and the release lever together, the camera can be positioned as you like; by releasing your hand pressure, the head is locked. Very nifty! My current choice, though, is a Linhof ballhead that is more compact, almost as quick, and basically indestructible.

Whatever head you decide upon, look into a quick-release camera coupling between the tripod head and your camera. The same type of coupling should be on your flash bracket so you can switch the camera back and forth quickly between bracket and tripod. Some candidmen add another quick-release coupling plate beneath their flash bracket so they can quickly mount it onto the tripod. Once again, speed is of the essence, and anything you can do to make the flash bracket-to-tripod switch happen quickly is advantageous.

Here are two versions of Hasselblad's Quick Couplers flanking a Hasselblad Quick Coupler Plate. I actually prefer the older version of their quick coupler (on the right) because it is more compact.

Light Meters

Even if you use an automatic flash and a TTL (through-the-lens) metered DSLR camera, a separate, handheld light meter that can read electronic flash in the incident mode is a worthwhile accessory. And if you decide to shoot with multiple manual flash units for your portraits and dance floor photographs, it is almost a necessity! With brides dressed in masses of white and grooms and ushers dressed in masses of black, the light meter you choose should be able to measure incident light. Reflected light meters (which are also the type in your DSLR) are calibrated to transform anything they are pointed at into middle gray. Therefore, brides (masses of white) are underexposed and recorded as middle gray, while the groom and his ushers (masses of black) are overexposed and recorded as middle gray. Although you will be able to record detail in the bridal gown and tuxedos this way, you will wreak havoc on the rendition of skin tones; brides look perpetually sunburned and grooms always look pasty (thanks to the camera adjusting to the bright white and deep black clothing, respectively).

On the other hand, incident light meters read the light before it is reflected off the subject. Therefore, the reading isn't affected by the color of your subject. In addition to making sure a meter can read incident light, make sure it can handle flash readings. Currently, Sekonic light meters are the favorite choice among my circle of peers. While there are a few other brands of perfectly good incident-light-reading flash meters available, if you use PocketWizard radio slaves, there are Sekonic meters that have built-in radio slave transmitters that make it a breeze to take flash readings. Truth be told, I carry a Minolta and a Sekonic meter because I prefer the handling of the Minolta meter (and it has a more contrasty LCD readout) and use it for available light readings. But, I use the Sekonic (with it's built-in PocketWizard radio slave transmitter) for my flash readings because it's so convenient when used with my PocketWizard radio slave system.

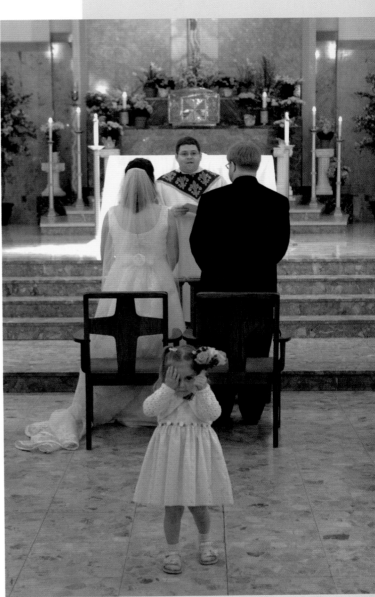

© Russell Caron

Even if you know your guide numbers like the back of your hand and can read available light very accurately by eye, a flash/ambient incident light meter can be used to check a manual flash unit's output or your exposure guesstimate of a sunlit scene. I carry my two nearly identical meters with me and check one against the other (and both against a known, manual flash) at the beginning of each assignment. For me, peace of mind is worth carrying two flash meters! Additionally, I have a third flash meter at my studio that never goes on the road. This meter, which lives a life of ease in its foam-lined box, is used as the standard against which I test all my other meters.

Hoodman Loupe

This relatively new addition to my kit was added because I was having trouble seeing my camera's LCD panel when I was working outdoors. In warm weather months, when I'm shooting outdoors on almost every wedding, this loupe has become my constant companion. Although I have a few other excellent loupes from my view camera studio days, the Hoodman Loupe's primary unique difference is that its skirt is made of rubber so it can't scratch the LCD screen. It also seals out extraneous light completely. Over the last two years, I have let various students borrow it for class assignments and everyone who has borrowed ended up buying one themselves. It's a good product and I recommend it highly.

The latest addition to my kit, the Hoodman Loupe has an adjustable diopter lens built into the eyepiece so you can tailor it to your eyesight, and it comes with a neck strap.

Backdrops

By carrying a backdrop along, I can shoot formal portraits on location by setting up a small studio wherever I am. It's great not to worry about ratty, reflective, wood paneling in a VFW hall, and not have to shudder when you see the painted cinder block walls of its basement meeting room. So, I tuck a 10 x 20-foot (3 x 6-meter) muslin backdrop into the trunk of my car. It is stuffed into Tenba pole bag, which contains another, smaller bag that has all the clips needed to set it up, along with the two stands and three-piece PhoTek crossbar used to support the muslin.

Backdrop-Packing Tip

Many novice photographers who buy a backdrop notice that it comes to them neatly folded, and they dutifully continue to fold it up every time they pack it away. After a while, though, the creases in the backdrop show up as a checkerboard pattern in their pictures. A better alternative is to stuff the muslin into its bag willy-nilly. This way, you end up with a random pattern that, when thrown out of focus, doesn't distract from the subject.

Posing Drapes

One accessory that rides in every equipment case of mine is a posing drape—a piece of nice material that can be used for a variety of things. I carry black ones that are about 45 inches (114.3 cm) square, but gray, white, and other colors can also be used. (I carry a white one in my "just-in-case" case.) The cut ends are folded under and sewn with a simple line of stitching. The stitching keeps the material from fraying and makes the drape look neater and more professional.

What do I use a posing drape for? My black drape can be used as a quickie background for a headshot. I either tape it or safety-pin it to a wall or curtain but, in a pinch, I've even had an assistant or casual bystander hold it behind the subject. Additionally, I often use a hard camera case as a posing prop, and I can hide it by throwing a drape over it. My black drapes can also do double duty as a scrim (or flag) to block light from hitting some part of the subject or background that I want to stay in shadow. Finally, I've even rolled one up and used it for a pillow when I needed a nap!

Tool Kit and Emergency Kit

Two things that might save your day are a tool kit and an emergency kit. What you include in yours is very personal and should be tailored to meet your needs and your equipment system. My tool kit includes the normal complement of jeweler's screwdrivers, a Leatherman Wave tool, two Allen wrenches (that fit my Hasselblad quick-release plates and the Allen-type locking screw on my Dyna-Lite variator knobs), and an open-ended metric wrench (that fits the leg bolts on my Gitzo tripod yoke). These tools fit my system; the tools you select for your tool kit should fit yours.

My emergency kit includes adhesive bandages (the flexible fabric kind the doctor gives you), acetaminophen, antihistamine (sometimes pollinating roses give me sneezing fits!), safety pins, bobby pins, pearl-topped hat pins (for carefully pinning down a train on a windy day), and rubber bands, all stored in a plastic 35mm slide box that I've covered with gaffer tape to keep it from cracking. While these small things may seem insignificant, if the groom pops a suspender button and his pants keep falling down, my safety pins can save the day. Once again, the stuff I include (although it is chosen with the eyes of experience) should only be a jumping-off point for your kit. You might not need the antihistamine, and you may want to double up on the headache medicine!

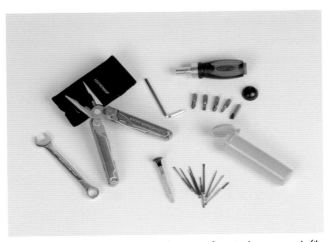

This in my repair kit. Importantly, while some of my tools are generic (the jeweler's screw drivers and the Leatherman Wave), others are carried for use with my specific equipment. Your choice of tools should fit the equipment you use.

Ladder

I've saved this for last because it is one of my most important accessories. In the trunk of my car, beneath all my cases, is a 30-inch (76.2-cm) stepladder. The more photographs I take, the more I use my stepladder. If I want a high view to shoot over the crowd, my stepladder is ready to lend a boost. If I need a place to seat a subject to make a more interesting pose, I use my ladder. If I need to get an equipment case off the ground for easy access, my stepladder is with me. In fact, once all my equipment is tucked away in the catering hall or church, the equipment that stays with my assistant and me includes the camera, our two lights, my camera case, and the ladder. My ladder is one of my best friends on a job.

My ladder of choice is the Little Jumbo made by Wing Enterprises. More like a portable staircase than a ladder, the Little Jumbo is very sturdy and heavy but, for me, it is the way to go. I use all three of its steps for posing people, and it can change a lineup photograph into a grouping portrait in the blink of an eye. One modification I've made to my Little Jumbo has to do with the spacer plate that is riveted between the legs on the non-step side. I've found the rivets loosen over time, and the thing becomes rickety. To combat this, a local welding shop welded my spacer plate in place for $20, which was worth the expense. The current version of the Little Jumbo has a safety handrail type of bar that folds for compact storage, but this makes the ladder even heavier and more cumbersome to use. Quite literally, every photographer I know who has bought the handrail version of the Little Jumbo has removed the handrail and had the handrail brackets ground off. While I understand Wing Enterprises' (and probably OSHA's) reasons for adding the handrail, in my opinion, it drastically limits the ladder's usefulness. Because of liability issues, I will not tell you to remove the safety handrail that comes attached to the current version of the Little Jumbo, but I will say that I've seen many photographers who have done so to theirs.

What I Use

Everyone always wants to know exactly what equipment I bring along to a wedding! Which cameras? Which lenses? Which lights? I even get asked about which light stands I use! However, I am often concerned that a photographer who is just starting out might be intimidated by a straight list of what's packed in the trunk of my car. That being the case, I must point out four things about the following list: 1) I didn't walk into my camera store and buy everything I carry on a single day; 2) I don't use everything I carry on every assignment; 3) when I first started out, I didn't carry everything that I carry now; 4) you don't necessarily need all the equipment I use right now, but you eventually will if you want to compete with big-city wedding photographers shooting high-end assignments. And now, without further ado, here is a list of what I bring along to every wedding, even though some of the cases filled with equipment often stay safely tucked into the trunk of my car and never make it into the catering hall.

© Sara Wilmot

Camera Case Contents

2 Nikon D300 DSLRs

2 Hasselblad Quick-Release plates

Nikkor 17-55 f/2.8 AFS zoom & hood

Nikkor 24-70 f/2.8 AFS zoom & hood

Nikkor 24-85 mm f/2.8-4

Nikkor 16-85 AFS/VR lens & hood

Sigma 50-150 f/2.8 V.II & hood

Nikkor 50mm f/1.4 AF-D & hood

Nikon 85 mm f/1.8 AF-D & hood

2 Nikon SB800 flash units

64 total gigabytes of CF cards - Sandisk Extreme IV (ten 4GB, three 8GB)

Sekonic L-358 meter

Minolta FlashMeter IV

3 Pocket Wizard radio slaves

Hoodman LCD Loupe

Assorted tools, tape

12 PC Cords

Spare batteries (2 Nikon, 12 flash, 2 meter)

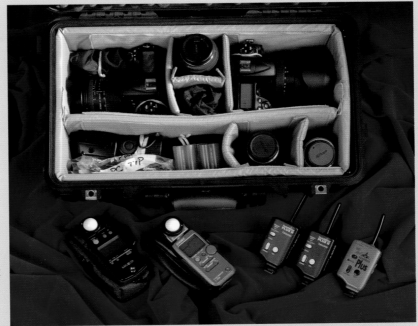

This is my camera case: an airline carry-on legal Pelican 1510 equipped with wheels. I strongly believe in the old axiom "a place for everything and everything in its place." By always packing my cases exactly the same way, I know where everything is. Furthermore, when I pack everything away at the end of an assignment, it only takes a quick glace to see if there is any item I forgot.

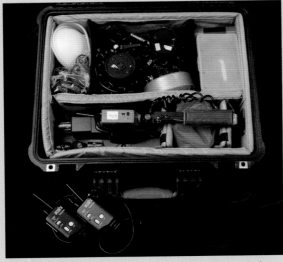

This case holds four of the six battery-powered flash units I carry. My two Nikon OEM flash units ride along in my camera case for when I want to work in a minimalist style.

Portable Flash Case

2 Lumedyne 065X battery packs, heads, regular batteries

2 Sunpak 120j Pro Flashes

2 Lumedyne Cycler battery packs

Customized Flash bracket

3 Lumedyne wide angle reflectors

Gary Fong dome

Ultimate Light Box

2 PocketWizard radio slaves

Flash to light stand adapters

4 battery pack shoulder straps

Spare cables, slaves, StroboSocks

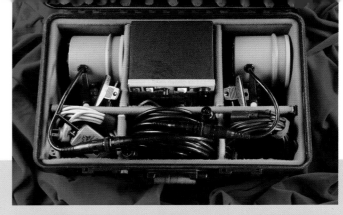

AC Flash Units

3 custom cases

3 DynaLite M1000x flash generators

4 Dynalite 2000ws fan-cooled flash heads

4 head extension cables

2 Dynalite grid holders

5 Dynalite grids (10°, 20°(X2), 30°, 40°)
6 25-foot (7.6-meter) HD extension cords
Spare parts, posing drapes, miscellaneous
accessories

Light Stands, Light Modifiers

Tenba light pole bag

3 Manfrotto aluminum 11-foot (3.4-meter)
stands, black

1 Manfrotto Convertible Boom/Stand 420 – Black

1 7-foot (2.1-meter) Cheetah C8 light stand

1 short background light stand

5 Photek umbrellas – 4 54-inch (137.16-cm) (one is a
shoot through); 1 60-inch (152.4-cm)

1 84-inch (213.36-cm) Photek Sunbuster umbrella

1 48-inch (121.92-cm) translucent diffuser

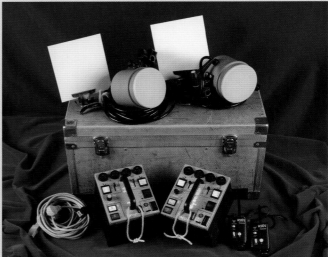

My AC-powered flash units are broken down into three cases. One case holds one generator and two flash heads, one case holds two generators and two flash heads, and one case holds spare parts, accessories, and extra extension cords. Importantly, each of the first two cases features a concept called "stand alone packing" which means that any accessories needed to make the equipment in that case work are included in that case. Doing this lets me cart in only what I need to shoot that particular assignment.

Miscellaneous

Little Jumbo 3-step ladder with the safety bar removed

1 Gitzo tripod

1 Linhof ball head

2 Hasselblad Quick Couplers (one on my custom flash bracket and one on my tripod)

A second Tenba light pole bag with a 10 X 20-foot (3 x 6-meter) muslin, 2 light stands, one 12-foot (3.7-meter) 3-piece cross bar, and a ditty bag of spring clips

1 heavy-duty luggage cart

© Russell Caron

Working with Flash

© Chantal Gauvreau

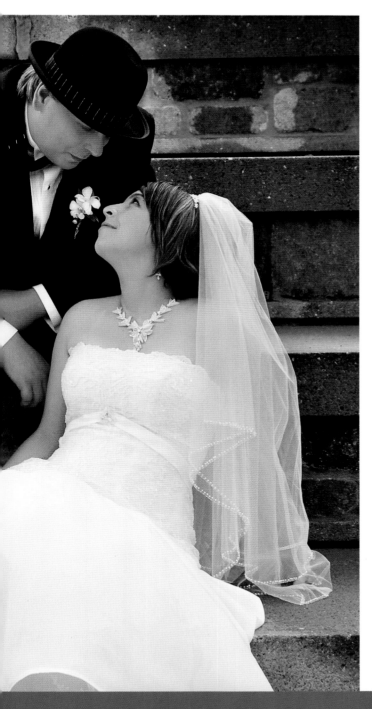

It's a large wedding with two photo crews. The studio manager watches as my assistant and I unload four cases of lighting equipment from the trunk of my car in the hotel parking lot. I pile the cases onto my wheeled cart and the manager asks, "How come Bill (the second photographer) only carries three cases of lighting equipment?" I shrug my shoulders and my assistant starts wheeling the groaning cart across the lot and into the venue. Backgrounds are chosen and each crew starts to set up for a portrait session. Ten minutes into setup, Bill's assistant comes over to me and asks: "Can Bill borrow a 25-foot extension cord?" (25 feet is about 7.6 meters.) With a look at the studio manager, I smile and say, "Sure, take the spare out of my silver case." Five minutes after that, Bill's assistant comes over again and says, "Bill wants to know if he can buy a spare modeling lamp from you." I smile again and say, "Sure, it's fifteen bucks and there are two extra in my silver case." The assistant forks over the cash and hurries off with the precious bulb. I turn to the studio manager, smiling one more time, and say, "I just figured out why Bill doesn't need a fourth lighting case... he's got me!"

The Essential Electronic Flash

No matter how you look at it, wedding photographers depend on electronic flash. While anyone can extol the virtues of natural (or available) light, the simple truth is that shooting only by natural light is very limiting because nature isn't always cooperative. It pays to remember that the wedding warrior works under noonday sun, in dim churches, and even dimmer catering halls. Just as important is the fact that while the ceremony might take place in the afternoon, at an outdoor location, and under a beautiful sky, the party will extend into the dark of night. While a hobbyist can wait to capture just a single great photograph when the available light is perfect, a pro—driven by profit and having to take a picture at whatever time it happens—can't afford that luxury. Another point you should consider is the fact that many meeting and catering halls are nothing more than huge, windowless barns that often use dark colored décor to hide their flaws (and ceilings!). And, while some photographers might want to use all the lens speed that he or she has paid for to take pictures, I am usually much more comfortable with a smaller f/stop, which can increase depth of field and lens performance in addition to helping to cover focusing errors. If you add together a high-end flash unit's fast recycle time, its action-stopping ability, and the fact that weddings are often covered in "available dark" situations, you will probably agree that a good flash can be (no, is!) a wedding photographer's best friend.

Although some young photographers think of their shoe-mounted flash unit as an afterthought, more seasoned wedding pros consider it to be one of their most important tools. That's the reason why I've devoted this whole chapter to shooting with flash! Before I give specific recommendations about the brands that have withstood the test of time, there are some general features that you should look for. Let's examine portable, battery-powered flash units first, because they are the corner stone of your flash equipment.

Since the moment photographers started using electronic flash units, there have been discussions, arguments, and debates about how to take pictures using electronic flash. I find most of it funny, because there are literally dozens of ways to use a flash to make successful photographs and all can work effectively. So, because there is never one way to take a picture, why shouldn't we jump into the fun (or the fray) in this book? Now, here are some rules of the road:

• What I will explain is how I, myself, use flash units. Other photographers have their own way of doing things.

• On some things, I agree with them; on other things, I don't. This is not a matter of one of us being right and one being wrong; it is a matter of style and taste.

• My suggestion is that you read through this chapter and incorporate the ideas into your flash photography in ways that make sense to you and fit your style.

For those of you more interested in what than why, I've decided to start out with a short bit about which camera-mounted flash equipment my friends, associates, and I use. For those of you only interested in the equipment aspect, the following few paragraphs might be considered the short answer. However, I think you should be more interested in the long answer of why we use this equipment because it will give you information to make more-informed decisions of your own.

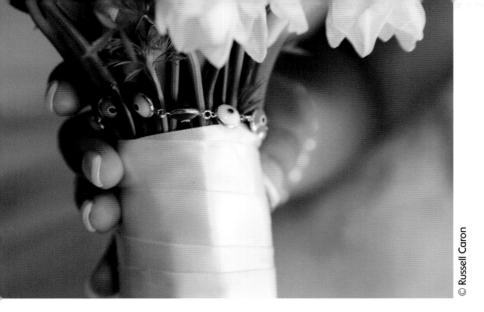

Using Light Modifiers

Every professional photographer I know has at least two of their camera manufacturer's higher-end flash units in their kit. Interestingly though, every pro I know also uses some form of light modifier on the front end of their OEM flash unit and an external battery pack to get more flashes at a shorter recycle time from their flash units.

I find the topic of light modifiers very interesting—so interesting, in fact, that I want to spend a paragraph or two talking about it. OEM, by the way, stands for original equipment manufacturer. If you have a Canon flash for your Canon camera instead of a Metz flash, for example, your flash is OEM. There are two ways you can get a smaller-sized flash unit to be as powerful as a larger-sized flash unit, and both ways have to do with the flash unit's reflector design. If you surround the unit's flash tube with mirrored surfaces (as opposed to spun aluminum, for example) you can actually amplify the amount of light the flash unit puts out. Secondly, if you tightly restrict the pattern of light that's projected by the flash to exactly fit the coverage of the lens you are using you can actually amplify the amount of light the flash unit puts out. I often call these kinds of reflectors "hot" reflectors, and sadly, in their quest for power output, manufacturers often substitute quantity of output for quality of output. I can understand that major flash manufacturers desire to make their flash units as small and powerful as they possibly can,

but in doing so, they have created a gigantic cottage industry for shoe-mounted flash light modifiers. In fact, the number of companies in this cottage industry and the fact that both Canon and Nikon offer flash diffuser caps for their top-of-the-line flash units can be considered as proof of this.

Because I'm very interested in light quality and I almost never like the look of camera-mounted flash. I'm a sucker for every option or accessory that can improve it. I make custom fill flaps and have bought and tried most of the available diffusers that have come out. In my opinion, it turns out that the larger an accessory dome-type diffuser is, the better the light quality is. This is really no surprise, but I find the size of the diffuser must be tempered with a high dose of practicality—both from an in-use point of view and from an ease-of-packing-it-into-my-case point of view. My current favorite is the newest Gary Fong Dome, primarily due to its ease of attachment to my flash and portability; it can collapse to a smaller size when not in use. However, when I work in rooms with white ceilings that allow me to use bounce flash with good results, I most often choose a custom-made fill flap in conjunction with the bounce flash because it is an even more compact and less cumbersome solution.

Part of my reason for always using light modifiers on OEM flashes has to do with the pattern of light the flash projects when I'm not using a modifier. It's not the central part of the flash pattern that I'm interested in so much as the edge of it, the place where the pattern transitions from "light" to "no light." Remember earlier, I said that a manufacturer could increase a flash unit's output by making its pattern closely match the field of view of the lens in use? While it's all well and good for a manufacturer to look for ways to increase a flash unit's output, this particular practice can create unflattering lighting in certain situations. For example, if you were to put your flash's head one click down from the full bounce position, you might find that the top part of your subject is hit by some direct flash (from the edge of the flash's pattern) in addition to the light from bouncing the flash. In some instances, the direct flash from the edge of your flash unit's pattern can create a line of light right across your subject's face! Forgive the poor pun, but this is not a pretty picture at all!

Auxiliary Power

Another accessory that every pro wedding shooter I know uses is an auxiliary battery pack. Available in both standard and high voltage versions, both types of external packs are often rechargeable, increase the number of flashes you get from a charge (as compared to flashes powered only by AAs), and in the high-voltage versions, they can drastically decrease your recycle times. Aside from OEM battery packs, others are available from Lumedyne and Quantum. Cables from the high voltage pack to the OEM flash unit are also available from Quantum as well as OEM manufacturers. While most OEM flash units recycle very quickly when used in auto modes with large lens apertures and high ISOs, many hardcore pros (myself among them) often prefer manual flash mode, smaller apertures (for extended depth of field) and lower ISOs for better image quality. Without a doubt, high-end, OEM, battery-powered, shoe-mounted, flash units (especially those fitted with suitable light modifiers and a high voltage battery pack) can become the foundation for a professional-grade flash system totally sufficient for the wedding photography world.

© Sara Wilmot

Using Flash Units

Although I have two OEM flash units in my camera case, I really don't use them when I'm working in situations where flash is my only light source. What I do use them for is augmentation of available light. In fact, one of my two units has a Lee 204 filter taped to its reflector to convert the 5600 degree Kelvin temperature of the flash to 3200 degrees Kelvin so it matches both videographers' lighting equipment and ambient room lighting. When flash is my only light source, I use a swing bracket fitted with a now discontinued Sunpak 120J Pro flash unit. (See pages 197–198 for more on swing brackets.)

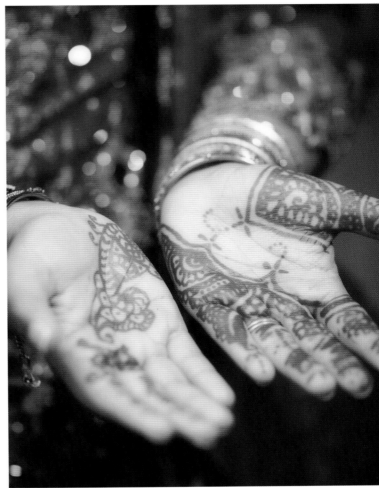

© Michael Brook

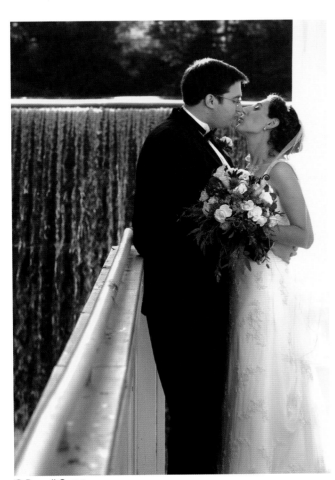

© Russell Caron

Getting Organized

After you have been shooting weddings for a while, you will probably have accumulated a boatload of flash units and flash accessories. Throughout this chapter, I keep harping on the importance of having backups (or multiple backups) for all your equipment, but I can't help but tell you one more time how dumb you'll feel if you find yourself at a wedding without a critical piece of equipment. More importantly, you run the risk of ruining a bride's wedding pictures and finding yourself with a tarnished reputation. Both are things you should avoid at all costs! Here are some ideas for developing an organizational plan to keep track of all the equipment and stuff you'll be carrying.

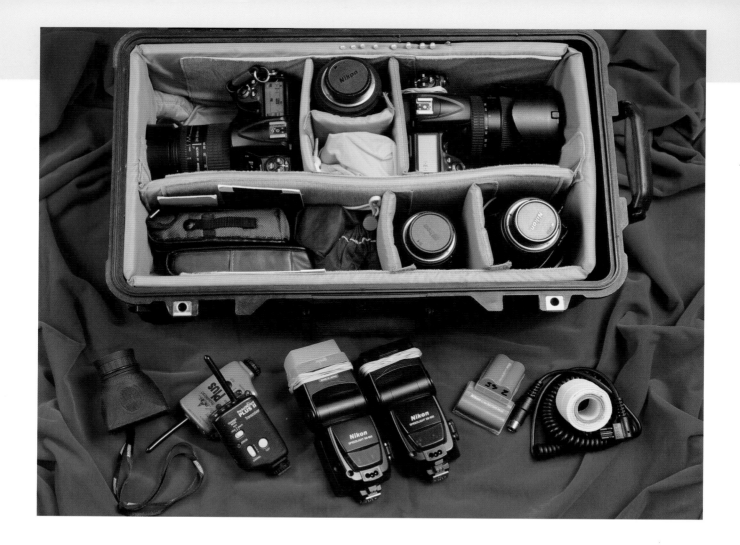

Develop a Packing Plan

Shortly after starting to shoot weddings, you'll realize that you don't need to bring every lens you own to every wedding you shoot. But, after finding out which items you absolutely must have with you on every assignment (including backups), why not get into the habit of always packing your camera bag the exact same way each time? Some photographers I know just stuff their bags and cases with equipment in a willy-nilly way, but I find that this non-system has huge disadvantages. Where did you put that spare camera battery? Did you leave your battery charger plugged into the catering hall wall? Where's that spare sync cord or radio slave you just know you packed? Every one of my bags and cases is packed exactly the same way each time I pack it. This means that before I close it up (either before I leave my house to go to the wedding or as I pack up to leave the wedding) I can glance at the open case and see if anything is missing.

Numbering and Dating Systems

On every assignment, I carry two Nikon flash units, two Lumedyne flash packs along with two Lumedyne flash heads, and three Dynalite 1000 packs along with four Dynalite flash heads. Every flash unit, every flash pack, and every flash head is numbered. If the unit is black, I put a small square of grey (or white) gaffer tape on it with the item's number written on the tape with a Sharpie pen; and if the item is a lighter color, I just use the Sharpie to write its number right on the item. That way, when something breaks (and something is always breaking!), I don't have to go nuts trying to figure out which of the five packs (or the six heads) has to be sent in for repair. On assignment, when a pack or a head stops working, I just note the pack's (or the head's) number in my trusty little brain and pull out a spare. Doing this saves time and sanity!

Another numbering idea is to number your camera batteries. Currently, I carry two batteries for each of my cameras and when I pack up at the end of the wedding I change the batteries in each of my two cameras. That way, when I get home and it's time to charge my batteries, I only have to charge the spent ones. To take this a step further, all my CF cards are numbered, too. I use my initials followed by a number, then a dash, then the card's capacity (written in another color ink). I use my cards in consecutive, numbered order because, that way, when I download them, I can do so in the order in which I used them. Since I shoot about 100,000 images per year, doing this really helps me to stay organized.

Here are a few more specific tips about the way I use and organize my memory cards:

• I've settled on 4 GB cards so each card fits onto a DVD with no hassles.

• I no longer bother to carry cards smaller than 2 GB.

For Nikon shooters, Nikon DSLRs allow you to change the file prefix from the predetermined "DCS" to letters of your own choosing. I use SS1 and SS2 for my two different camera bodies. That way, if there are any imaging issues, I can easily trace the image file back to the specific camera that is the culprit.

Staying Powered

I carry about 12 – 16 lithium AA batteries to power my OEM flash unit's internal circuitry and my Pocket Wizard radio slaves. Although lithium batteries cost approximately three times as much as alkalines, I find their longer life and lighter weight more than counters their higher cost. (Shop for them carefully, as I find there can be an over 100% price difference between the stores that stock them!)

When I buy them, I cut the display card they are packed in down to a smaller size so they are more compact to pack. And, before they are packed away, I flip the blister pack over and write the date (mo/yr) I bought them so that I use the older ones first. Lastly, everything that gets new batteries also gets a small square of gaffer tape on it with the date the battery was last changed. It helps to know the age of the batteries in a unit when I'm trying to troubleshoot a problem!

Ditty Bags

One way to organize your equipment cases is to place similar items into ditty bags. A ditty bag is a small pouch that closes with a drawstring. They can be found in camping goods stores and if you look for them, remember to get a thing called barrel locks (sold in blister packs of 2, 3, or 4) that can be used to ensure your ditty bags stay closed. Both the bags and the barrel locks are inexpensive and I usually buy the sizes I need in various colors so I can know what's in one just by looking at its color (and, as mentioned above, where it's packed in my case). Currently, there are three ditty bags in my camera case: one for my tool kit, one for my Lithium batteries, and one for my CF cards. There are also two in my flash case: one for Nikon flash accessories and one for Lumedyne flash accessories.

In a way, getting organized can help you be more creative. Once you get your system up and running, you won't have to waste your brainpower on mundane junk and be more free to concentrate on the images you're making. All of these ideas can help you. They can make your life in the wedding arena easier. Use them, don't use them, the choice is yours!

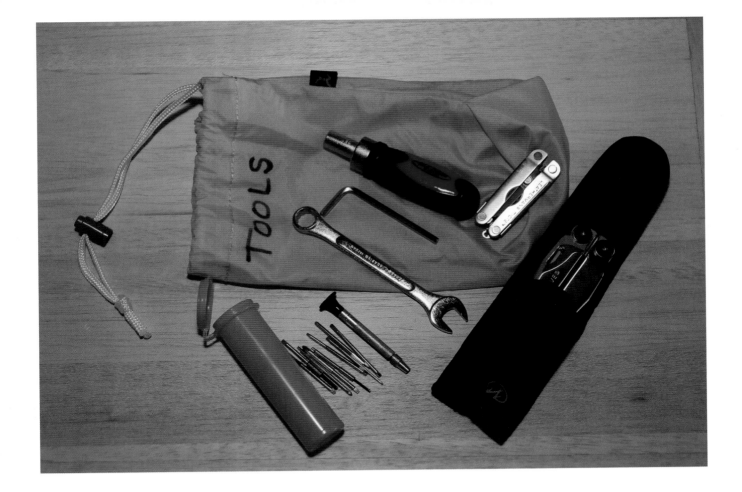

Flash Units

There are a few reasons I prefer the Sunpak 120J Pro flash unit instead of one of my OEM units, and you might be interested in what they are. My reasons can be divided into two categories: the quality of the light and the speed of operation. Keeping in mind that I prefer manual control of my flash as opposed to automatic operation, here is a more detailed breakdown of my reasoning.

Light Quality: My Sunpak has a 5-inch (12.7-cm), round reflector that is much larger than the reflectors on OEM units. Larger light sources offer more pleasing light than smaller sources.

The edge of my reflector's pattern is very soft and the transition from light to no light happens over a greater distance. This means I don't have to worry about exact alignment between my flash and camera lens axis.

The Sunpak has bare bulb capability that creates beautiful light in small, light-colored rooms. Think of a bride's dressing room and you'll get the idea.

Speed of Operation: The Sunpak offers a 5-f/stop range on a simple, sliding, mechanical switch with five detents, while my now discontinued OEM units require three pushes of a button to change the flash unit's output by one f/stop. While this may not seem like a disadvantage, if I want to lower my OEM flash unit's output by three f/stops for a dramatic rendition of a picture, I have to push the button nine times and then push the same button another nine times after I'm finished to reset it! Phooey! In truth, the latest high-end flash units now use a rotary dial to change output, but it took Nikon (though not Canon) years to make this improvement to their flash unit's operation!

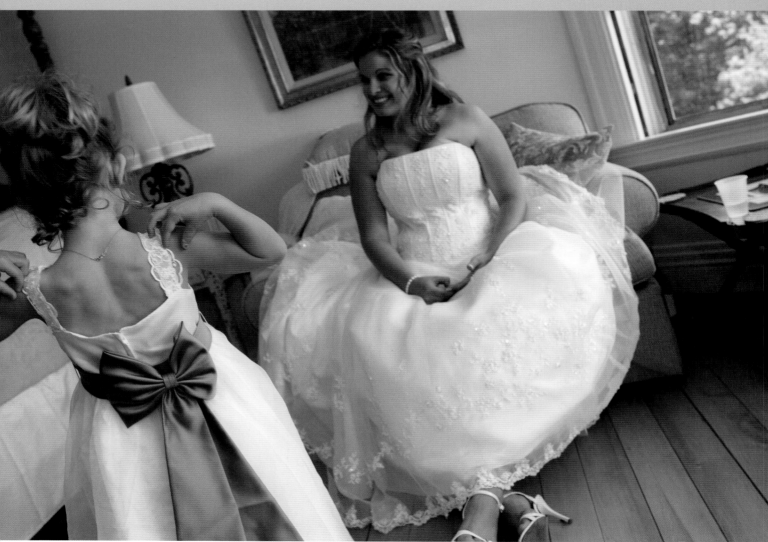

© Russell Caron

Because I use it in manual mode, the flash exposure doesn't change from picture to picture, so I can do less chimping (digital photographer lingo for reviewing images on the LCD monitor) from picture to picture to make sure I've got the shot.

The flash unit has a 1/4"-20 threaded hole on its bottom that I find both stronger and more secure than any hot shoe connection I have ever seen.

Because my camera light is rarely my main light, it is rarely used at full power (usually it is set to 1/4, 1/8, or 1/16 power), so its recycle times are fast enough to keep up with taking multiple images in fast breaking situations at apertures about 3 stops down from wide open (f/8 or so).

Flash Brackets

While a flash unit mounted securely in a hot shoe creates reasonable on-camera lighting when you shoot horizontally, when you switch to a vertical format, which places the flash unit's reflector next to the lens instead of directly above it, the light quality becomes just horrendous. The easiest way around this is to use some form of swing-flash bracket. Whether store bought, modified, or even custom-made, for many wedding pros, it can become an expression of individuality. While there are some excellent ready-made brackets on the market, many serious players customize a store-bought item to better suit their needs. Since each photographer's bracket is different (even if only slightly so), it pays to look at one of these weird beasties to get a better idea of what each shooter considers important.

I use a modified StroboFrame bracket for my rig and its modifications suit my purposes. These include the addition of a Hasselblad quick-release coupler with an extra screw passing through the bracket and then threaded into the coupler's bottom to prevent it from rotating on the bracket. Each of my current DSLRs is fitted with a matching Hasselblad coupler plate. I also added a StroboFrame shoe to hold my Pocket Wizard radio slave but, because it is metal, I had to grind away a bit of it so it wouldn't foul the contact on the bottom of the radio slave. And, I've added a wooden handgrip because Stroboframe's rubber ones wear out.

My next modification involved removing the large, knurled camera-mounting screw on the bottom of the bracket and countersinking the hole so a flathead 1/4"-20 screw could be used to mount a quick-release camera coupling. That way, the bottom of my bracket is flat, so I can rest the camera on any flat surface.

While there are many readymade flash brackets on the market, don't feel intimidated if you want to file a notch or add a threaded hole in one if it makes it better suited to your shooting style. Remember that your bracket is a personal thing, and if it's comfortable for you (you'll be holding it a lot) and does what you want it to, then it's right.

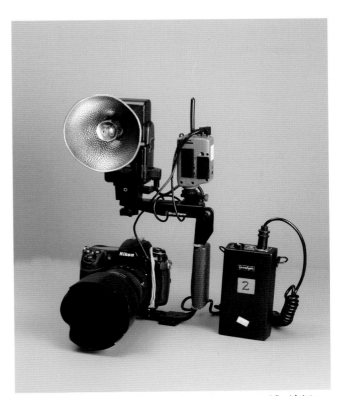

This is my current rig (when I'm not using a shoe-mounted flash). It is big and bulky, but it balances well and I find it comfortable to hold. The rubber bands wrapped around the camera are used to keep the PC cord from pulling out of its socket.

Single-Light Setups

There are different debates going on (simultaneously) amongst wedding photographers over which kind of flash to use and how to use it:

• Should we use automatic flash or manual flash?

• Should we mount our flash in the camera's hot shoe or use a swing bracket instead? (See pages 197 – 198 for more on swing brackets.)

• If we use a single flash on camera, should we use one of the many light modifiers that are available?

• Or should we use bounce flash instead?

• If we use bounce flash, should we use a fill flap as a light modifier?

• And, if we use bounce flash and a fill flap, should we use the one often supplied with the flash or should we look at a custom-made option?

• How can we use both indoor and outdoor ambient light in harmony with our shoe-mounted flash?

As you can see, using just one flash creates a list of decisions we must make that is long, complicated, and even confusing. In fact, if I were to look at this whole list as a rank newcomer, I would throw my hands up in frustration and decide that a dedicated flash unit set to "auto everything" plugged into my camera's hot shoe was the ticket for me! Regardless of the creative limitations this choice might impose on me, the amount of decisions I would have to make if I went with another approach would make me shy away from every other possibility. But thankfully, one nice thing about having a list is that you can take it on one point at a time so, instead of being overwhelmed by the list as a whole, let's approach it from that direction by starting with number one.

Automatic vs. Manual Flash

Whether to use a flash in its manual or automatic mode is a tempest in a teapot, but let's start by facing this issue head on. Many photographers consider manual flash difficult to use, especially when they are concerned that most wedding couples express interest in seeing creative photos of themselves. However, when it is time to order prints and enlargements, most couples are just as interested in pictures that I call "bread-and-butter" images. These are the classic pictures of the bride and her mom, the bride with her dad, the groom with his parents, family shots, the wedding party, sibling photos, along with all the standard scenes that happen during the richness of a wedding day, from the ceremony to the garter toss. Regardless of how many photos of themselves the couple wants, they always choose some traditional pictures, so these bread-and-butter images become very lucrative types of photos.

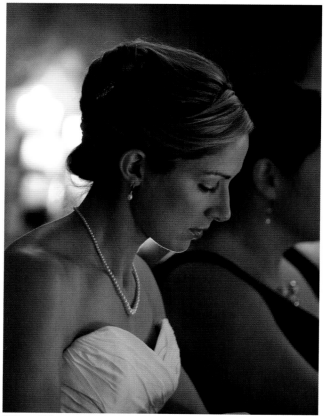

© Russell Caron

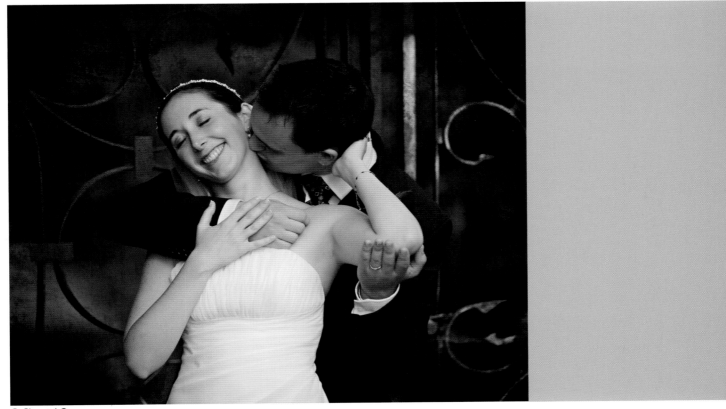

© Chantal Gauvreau

Here's where it gets easier—most bread-and-butter photographs are shot from three separate distances: 15, 10, and 5 feet (about 4.6, 3, and 1.5 meters, respectively). Naturally, you don't stop your shooting to measure these distances, but with practice, you can get quite accurate in estimating how far you are from your subjects. A 15-foot (4.6-meter) picture will cover full-length shots with a normal lens or group shots with a wide-angle. The 10-foot (3-meter) picture can cover bust shots of singles, two-ups, and three-ups with a telephoto, bust shots of groups of four to six with a normal lens, or full-lengths with a wide-angle. Finally, the 5-foot (1.5-meter) distance can cover tight head shots (singles or two-ups) using a portrait telephoto, three- and four-ups with a normal, and intimate photojournalism-style images with a wide-angle lens when you are in the middle of the action. These three distances convert to three different f/stops with a manual flash unit, and even if you add in a fourth f/stop for bounce-lighting effects, you can see that there really aren't that many possibilities you need to remember. Furthermore, using the

zoom lenses most photographers choose today, the framing of any image from any of these three distances can be modified easily just by turning a ring on your zoom lens. This means that if manual flash is your choice, you'll find within a short time you'll be able to figure out exposure by feel. Soon you'll be able to forget about calculating f/stop, because with a little experience, you'll become a precise, walking, talking, human flash meter.

However, until you can become a human light meter, you'll still have to figure out which f/stop to use. That's not as scary as it sounds. Remember, you are usually shooting from one of three approximate distances: 15 feet (4.6 meters), 10 feet (3 meters), or 5 feet (1.5 meters). The f/stop you choose for proper exposure with a manual flash is based on the light's distance from the subject. By dividing the flash unit's distance from the subject into the guide number (which is different for every ISO setting), you get the proper f/stop for correct exposure (at that distance and with that ISO). This is not difficult, so follow along as I illustrate.

If you have a flash unit with a guide number of 80 when working in feet (or 24 when working in meters) for ISO 100, and you are 10 feet (3 meters) from your subject, the f/stop for proper exposure is f/8. To get this, I divided 80 (the guide number) by 10 (the distance), and the result is the correct f/stop. (In metrics, for this example, I would divide 24 by 3.) This works for metric guide numbers, too, as long as you divide meters by meters. So, in our example above, if you are shooting from 15 feet (4.6 meters), the correct aperture is f/5.6 (80 divided by 15 is 5.33—close enough for practical purposes), and when shooting from 5 feet (1.5 meters), you use f/16 (80 divided by 5 is 16).

© Michael Brook

Shooting by the Numbers: Almost 40 years ago I got my first good camera: a beautiful Canon FT-QL. Inside the viewfinder there was a moving needle and a little circle. To set proper exposure (not flash exposure, mind you, this was for ambient light exposure), I would adjust either the aperture or shutter speed dials so that the little needle was centered in the little circle. I had no idea which aperture or shutter speed I had chosen, but that needle sure was centered in that circle! Thus centered, I proclaimed to the world that I was a professional photographer!

Thankfully for my creative growth, my mentor at the time demanded that I remove the battery that powered the needle and get a separate handheld light meter. This made me use my brain and think about what I was doing instead of limiting my understanding of exposure to centering the needle in the circle.

For some, selecting from a menu will be good enough. But if you look at thousands of pictures, hardly any of the ones that stop your gaze and make you wonder how the photographer got that shot were created from menu selections. They came about from mental effort, practice, reviewing, and improving on mistakes. This is hard work. Some of you will read these words and actually use manual flash as opposed to automatic flash. To those people, I can promise a more fulfilling career; not an easier one, but one that makes you feel better about yourself at the end of the long day!

Regardless of whether you decide on manual or automatic flash exposure, the important point is to exploit to the fullest whatever lights you happen to be using. I prefer manual, but if automatic flash is your cup of tea, more power to you. The real issue is not which hardware you use, but how you use it. What you should be interested in is a thing called "light quality."

Whenever I run a workshop on wedding photography at the Maine Media Workshops, my students are always amazed at how fast I can do the mental calculations for coming up with a correct f/stop for any given distance, power setting on the flash, and ISO. The truth is by understanding how f/stops, power settings on the flash, and ISO settings are interrelated I don't have to make any calculations at all! In fact, if you're given the correct f/stop to use at a distance of 10 feet (3 meters) for a specific flash power setting and ISO, you can mentally extrapolate the correct f/stop to use for any other given flash power setting, distance, and ISO. Here's how it works:

Full-Power Guide Number at ISO 100	80/24 (feet/meters)	110/36	160/52
5 feet (1.5 meters)	f/16	f/22	f/32
7.5 feet (2.3 meters)	f/11	f/16	f/22
10 feet (3 meters)	f/8	f/11	f/16
15 feet (4.6 meters)	f/5.6	f/8	f/11
20 feet (6.1 meters)	f/4	f/5.6	f/8
30 feet (9.1 meters)	f/2.8	f/4	f/5.6

Not only do these f/stop numbers work for the flash at its full power setting, but if your flash is has a full power guide number of 160, it has a 1/2-power guide number of 110 and a 1/4-power guide number of 80. This is not an approximation—it's a fact! Furthermore, if your flash has a full-power guide number of 80 for ISO 100, for example, it will have a full-power guide number of 110 for ISO 200 and a full-power guide number of 160 for ISO 400. Once again, this is not an approximation, but a fact.

The whole point of this exercise is to prove two things: First, that just knowing the guide number of a flash at a specific power setting and ISO can give you all the information you need to make pictures with that flash unit at various distances, power settings, and ISOs; second, that by changing the flash unit's power settings and / or your DSLR's ISO, you can end up using almost any f-stop you want to for a specific picture. Lastly, because this method of flash exposure is not based upon your subject's reflectivity (but mathematics instead) it is always accurate—not sometimes... always!

There is one small fly in the ointment. Small white rooms push your guide number up slightly because light from the flash bounces off the walls and ceiling, kicks back onto the subject, and adds to the exposure. On the flip side, big dark rooms, such as banquet halls and cathedrals, suck up some of your light and take away from the exposure. To compensate for this, I open up 1/2 stop from the calculation for cavernous dark rooms and close down 1/2 stop from the calculation in tiny white ones.

The term to describe this is called "Kentucky Windage." During the early years of our country's history, the best sharpshooters were from Kentucky and used long rifles. Their accuracy depended on taking the wind direction and velocity into account as they took aim. Kentucky Windage was the compensation factor the sharpshooters threw into their mental calculations to adjust for the wind's effect. Pro photographers do the same thing with regards to room size and color.

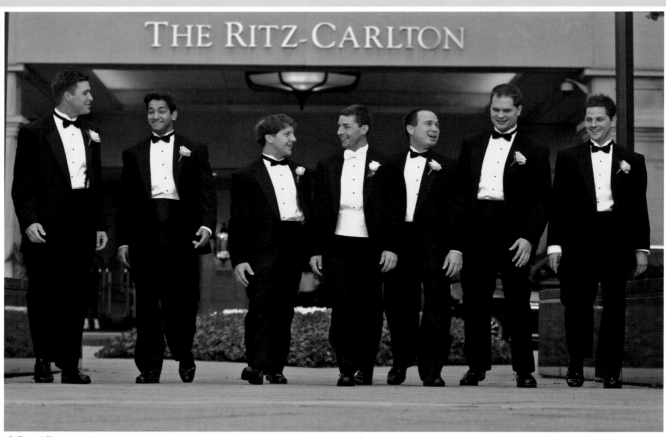

© Freed Photography

Some readers might be concerned about my choice of ISO 100 for my examples when the majority of weddings photographed today are shot at different ISO settings. Well, for the uninitiated, ISOs work just like f/stops (and, although irrelevant in this discussion, shutter speeds do, too). Everything works in multiples of two; ISO 200 is one f/stop faster than ISO 100 and ISO 400 is two stops faster than ISO 100. The term "faster" refers to the increase in how the camera's imaging sensor responds to light; the faster the ISO, the less light is needed for proper exposure.

Having taken a tremendous amount of pictures using manual flash, I find this method unerringly accurate, fast, and simple to use. But some photographers may argue that auto flash units are faster still. I counter that the auto flash unit's "brain" is frequently tricked by a huge white wedding gown, or a sea of black tuxedos or, worse still, a huge white wedding gown in front of a dark background. And, sometimes, the flash unit's auto system must contend with a fairly small, light subject in the middle of a huge dark room (such as a banquet hall). These situations, which are common in the wedding world, can addle the brain chip in all auto flash units. Those of you in the automatic flash camp might be asking why auto flash units are so easily confused. Read on.

For auto flash to work, the flash unit and/or camera must have a way of measuring how much light is reflecting back from the subject to set the correct exposure. To do this, because the meter measuring the flash's light has no idea what your subject is, camera and flash designers make the assumption that your subject is a middle-grey. While it is true that if you merge all the colors and tones of a so-called average scene, the result is a middle-grey, wedding scenes are in no way normal. So, if a bride in a huge white gown makes up the majority of your scene, the auto flash still assumes the scene is a middle-grey and underexposes the white dress until it is rendered as such. The result is that the bride's face is also underexposed, causing her complexion to appear sunburned.

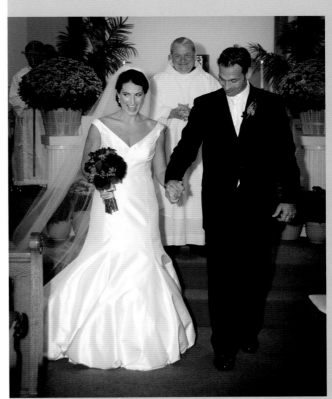

© Sara Wilmot

The opposite is true for the groom with his ushers in their tuxedos. Even though the guys are dressed in a sea of black, the auto flash still assumes the scene is a middle-grey and overexposes the men in black until the suits are rendered middle gray. The result is that the groom's face, as well as the faces of his ushers, is also overexposed, leaving them looking pale and pasty. The situation only gets worse if you find yourself in a typical large banquet or catering hall with your subjects dancing 25 feet (7.6 meters) or more from the nearest (possibly dark-colored) wall. In that instance, the auto flash will take the rear wall into consideration and your intended subjects will end up overexposed. Most of these problems can be fixed in post-production (primarily so if you are shooting in RAW), but that just adds to your post-production time.

On the other hand, using manual flash eliminates all of these problems, and is a more consistent way to expose your photos, because it is based on the distance from the flash to the subject. Therefore, it is unaffected by things like the color of the bride's dress, the groom's and usher's tuxedos, and the subject's distance from the background. Though using manual flash requires more experience and technical virtuosity from the photographer, it is not an advantage that should be overlooked! While ease of use is a prime consideration for a hobbyist, it's a poor criterion for a professional photographer making choices about lighting!

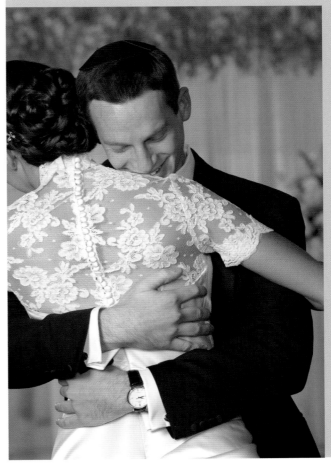

© Jerry Meyer Studio

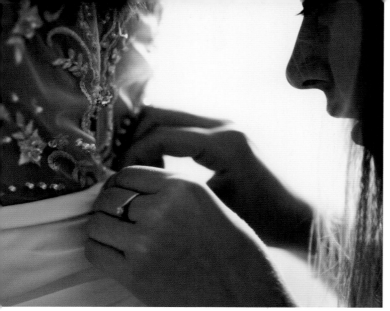

© Michael Brook

One way for a candidman to greatly increase the speed at which he can shoot with manual flash is the use of pre-visualization. Many photographers think of pre-visualization as the tool for landscape or view camera photographers, but as a fast-working wedding pro, I rely on it all the time. After watching me work, many assistants have commented that I can work as quickly with a manual flash as a novice with an auto flash. This is possible because I pre-visualize my pictures.

Here's how it works: I decide to shoot a bust-length candid picture of two people on the dance floor. I choose my wide-angle zoom lens. Before I approach them I set my f/stop for a 5-foot (1.5-meter) flash picture. After I've done my camera fiddling, I walk up to my subjects and ask them to look my way and smile. I then backpedal to 5 feet (1.5 meters) away, raise my camera in front of my face, and push the shutter button. On the flip side, if I want a truly photojournalistic image I walk to where I'm 5 feet (1.5 meters) from the subject and just shoot my pictures from that distance without first walking up to my subjects and asking them to look my way. No wildly computing an f/stop for me! That's already been done because I've pre-visualized my picture. In fact, the whole thing takes less time to do than to read about. As an aside, don't think that working at 5 (1.5 meters), 10 (3 meters), and 15 feet (4.6 meters) limits your ability to frame your photographs as you want to. Using today's excellent zoom lenses, you can frame almost any photograph from any of the three distances mentioned as a wide, normal, or tight picture.

The last point about automatic flash will probably be considered controversial, but I feel a responsibility to honestly provide this information. Many TTL automatic flash systems use a single or series of pre-flashes in determining exposure. This technology is a huge, deleterious blow to creativity! While this idea flies in the face of what many camera manufacturers would have you believe, remember that they have a monetary interest in pre-flash systems. Having an exposure system based on pre-flash technology makes it difficult to incorporate flash units from other manufacturers into your flash lighting system, just as the pre-flash technology also makes it difficult to use multiple flash units simultaneously. There you are, locked into the flash products manufactured by the camera company.

If a camera company sells you their own brand of flash unit, they have a lucrative sideline to their camera business. Importantly, the profits generated by that sideline mean the company's concept of creativity is colored by the extra dollars the flash unit division adds to the corporate coffers. More importantly, this system has inherent problems. If, for example, you set up slave-equipped, manual, high-powered flash units to light up the background in a cavernous wedding hall, an exposure system based on pre-flash will cause those lights to trigger during the exposure measurement part of the process. Since they will be recycling when the actual flash exposure is made, they won't be ready when you need them to flash.

There is also a huge difference between selectivity and creativity. Suppose a manufacturer designs a pre-flash system that offers ten different ways to control and modify flash exposure using a camera they also manufactured. They might try to say they are giving you the ability to produce a great number of creative lighting options because their flash units and cameras are working in unison. In truth, the manufacturer has not offered creativity; instead, they have offered selectivity. Your choices are limited to selecting from the menu they have provided. A truly creative system would allow you not just ten different ways to light a picture, but encourage nearly limitless options, letting you choose to experiment with any lighting ideas you've dreamed up in your own little brain.

Hot-Shoe-Mounted
Flash vs. Swing Bracket

When using direct flash, the best place you can position your flash unit is directly over your camera's lens. Doing so causes the shadows created by the subject's head to fall behind the head, making them less conspicuous. While a hot-shoe mounted flash is perfectly positioned when you use the camera for a horizontal composition, when you switch the camera to a vertical composition, the flash is no longer over the camera's lens, but to the side of it instead. In addition to making the shadow of the subject's head (created by the side positioned flash) much more prominent, the lighting on the subject's face also suffers. The flash positioned beside the lens causes light to get under the subject's brow and eye sockets, plus it creates a shadow on the side of the subject's nose instead of under it. Both of these traits, caused by the position of the shoe-mounted flash when the camera is in the vertical composition position, look unnatural and even more artificial. See the two photos at right for an example of this.

As a caveat, there is a way to always keep the flash directly over the lens without resorting to a swing bracket. You can always (only!) shoot horizontal images. What? Give up vertical images altogether? Not really. But, as DSLR resolution increases, once you get close to 3000 pixels on the short dimension of the format, you can easily crop a high-resolution 8 x 10-inch (A4) 300 ppi vertical image from the center of your camera's full horizontal image. The advantage to doing this was brought home to me on aisle shots. If you shoot your aisle shots as verticals, you often don't see any

These two images were taken during a wedding photography workshop I run every summer at the Maine Media Workshops. While everyone who sees these two images immediately recognizes the shadows on the wall behind the subjects' heads in the top photo as being distracting, a more careful examination of the lighting on the bottom-photo subjects' faces shows that it, too, is unnatural and just plain awful!

of the guests looking on and also end up cropping out a lot of floors and ceilings in post-production. If you shoot your aisle shots as horizontals, you include all the onlookers (who are often important relatives and friends) and have the ability to crop them out in post-production if you (or your client) prefer not to see them. In this instance, shooting horizontals can give you the best of both worlds but requires two things: 1. That your camera has at least or close to 3000 pixels on its short dimension and; 2. That you understand you are increasing your post-production processing time. Personally, even though I now shoot my aisle shots as horizontals, I still want to have my camera on a swing bracket so I have a better-lit vertical composition as a ready alternative.

Since the best place for the flash is over the lens (whether you are shooting with the camera oriented vertically or horizontally), many wedding pros use a thing called a swing bracket that allows them to change the orientation of the camera and maintain the flash's position above the lens. Until recently, these brackets were big and bulky, but there is now an alternative. StroboFrame (a flash bracket manufacturer) offers a bracket called the ProDigiFF that folds down to a relatively flat package that you can store in an average camera bag pouch, so if compact is your thing but you still want to try a flash bracket, check out the three photos below.

Light Modifiers

Most, if not all, of today's OEM flash units have a smallish, mirrored reflector instead of a larger, aluminum one with a more diffusing surface (that I prefer). While the mirrored reflectors increase a flash unit's output, that same reflector surface combined with its smallish size makes for a harsh light output. I call them "hot" reflectors. The fact that both Canon and Nikon offer a diffuser cap is proof that their designers know the reflectors are

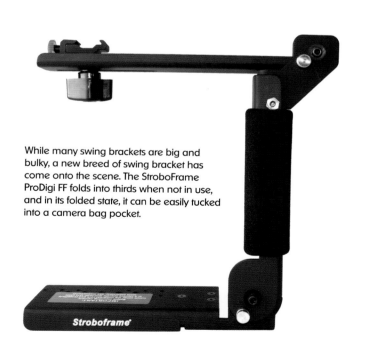

While many swing brackets are big and bulky, a new breed of swing bracket has come onto the scene. The StroboFrame ProDigi FF folds into thirds when not in use, and in its folded state, it can be easily tucked into a camera bag pocket.

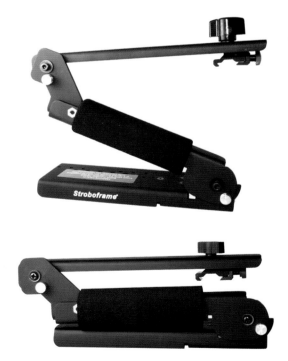

hot and offer the caps to soften their reflectors' performance. Furthermore, an entire cottage industry has grown around creating various diffusers for most (if not all) of the OEM flash units. That being the case, let's look at them in detail.

I must admit that I am a sucker for every flash diffuser that enters the market. This is partially because I use the Sunpak 120J (with its 5-inch—12.7-cm—reflector) on a camera mounted on my swing bracket and an OEM flash unit mounted in the hot shoe of my second camera. Since I shoot with both cameras at different times during the assignment, I can easily compare the results from the two. As expected, the camera equipped with the flash using the larger, 5-inch (12.7-cm), round reflector gives me softer, more flattering lighting than my camera equipped with my OEM flash unit. Just comparing the differing results led me to look for ways to soften the light quality of my OEM flash units.

The problem facing photographers looking for a light modifier for their OEM flash units seems to boil down to a choice between light quality and compact size. The smaller they are, the less perfect they are at softening the light, but the more convenient they are to use and pack away. The larger they are, the better they are at softening the light, and the more bulky they are. The following are four different OEM flash modifiers that I have used or currently use.

The small Stofen cap was the first diffuser on the market and they are similar in size to the units that currently come with OEM flash units. Of particular interest to wedding photographers is a gold colored Stofen cap that changes the flash from 5600 degrees Kelvin to 3200 degrees Kelvin so the flash balances with either tungsten or quartz halogen video lights and incandescent lighting. When using the Stofen gold cap, you set your DSLR's white balance to 3200 degrees Kelvin and then all the light sources in your frame are balanced one to the other. Of all the aftermarket light modifiers for OEM flash units, the Stofens are the smallest and least expensive.

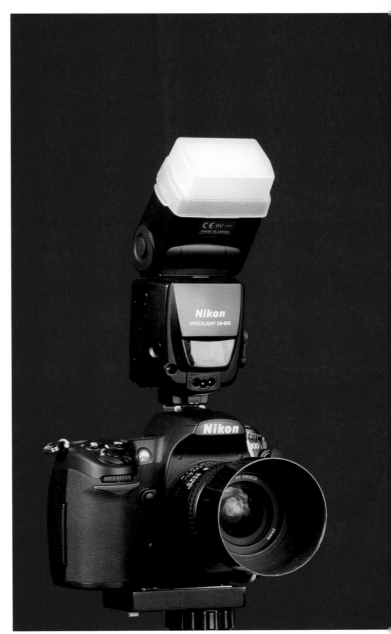

Nikon's diffuser cap

The Fong Dome (called that by photographers who use it, though the official name is the Lightsphere Collapsible) was designed by wedding photographer Gary Fong. It has gone through many iterations, with each design revision offering improvements over the previous one. The original version didn't grip the OEM flash very well and could easily be knocked off when working in a crowd. You can't be taking pictures and crawling around on a dance floor looking for your Fong Dome at the same time! The second version added a Velcro strap that secured the dome to the flash head and made the whole attachment method much more reliable when working in a crowd. Still, the first two versions were relatively bulky and hard to pack in your case at the end of the day. The current version is made from a more sticky material (so there's no need for the Velcro securing strap) but its real advantage is the fact that it's collapsible. Although pricey, the current sticky, collapsible version is the one I currently like and use regularly.

The Harbor Design Light Box is the largest and most bulky of the light modifiers I use. Its primary advantage is a secondary diffuser that fits over the flash head and to which the bigger light box clips onto. More expensive than the Fong Dome, the Harbor Design unit gets the closest of all the units I've mentioned to being a studio-quality light. Because it's so large and bulky (but hollow), before

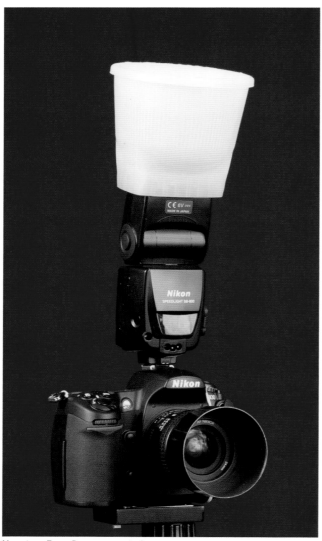

Here is a Fong Dome mounted on-camera.

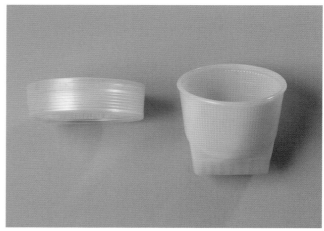

These two photos show how the latest collapsible Fong Dome compares to the original Fong Dome. In both pictures the newest Fong Dome is on the left. It should be noted that the original Fong Dome has discolored in the 5 or 6 years since I bought it and I no longer use it all.

I pack it away in my battery-powered lighting case, I fill it with the little doodads that usually just rattle around in the case. In truth, while I occasionally use it in portrait situations, I don't use it during the trench warfare that a dance floor can become, because it's too easily bumped off.

Do-It-Yourself Light Modifiers: For you frugal photographers out there, it is possible to construct your own makeshift light modifier. I have a friend who owns a Japanese restaurant. Two years ago, he invited my girlfriend and me to an after hours holiday party at his restaurant. After eating some very good food, I decided to take some photos of the festivities. Wanting to work light and fast, I put a Fong Dome on my camera and started to take some photographs. One of the sushi chefs saw my Fong Dome, disappeared into the back of the restaurant and returned with a medium sized, frosted plastic soup container and told me it looked just like the light modifier I had purchased. I had to agree and went back to taking pictures, enjoying the party, and eating the great food! The following year I was invited to the bash once again. This time one of the staff members brought his own DSLR and riding on top of his accessory flash was the soup container I had been shown at the previous year's party!

The following morning, I rummaged under my kitchen sink and found a stack of my very own medium-sized soup containers that I had saved to store leftovers in. I held my flash head against the outside bottom of the container and marked where the corners of the flash head fell. Being very careful not to cut myself, I cut lines through the container's bottom connecting the 4 dots with a sharp #11 blade in an X-ACTO knife. I made sure that I cut the rectangular hole slightly smaller than my flash head so it was a tight fit. I pushed my flash head through the resulting hole and used a Stofen dome on the front end of my flash unit (which was now inside my soup container) to hold the container in place. I popped the cap on the soup container and made some test shots. The results were promising but I thought I could make them better. After taking my container off the flash, I sanded the inside of

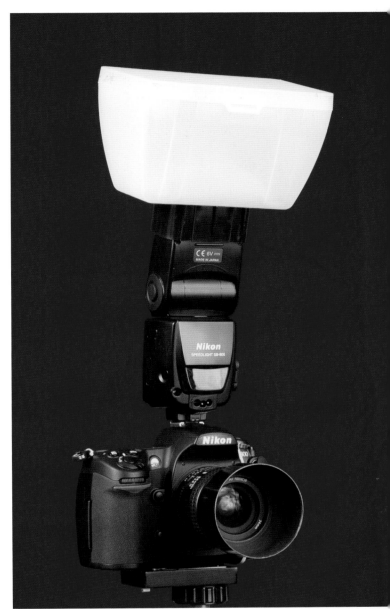

Harbor Design Ultimate Light Box

the container's front and stuck a patch of white gaffer tape on the container's back. Thinking about this more, the next time I do it I might try some aluminum foil with the dull side facing the flash's beam. Finally, I added some more white gaffer tape to the edges of the rectangular hole in the bottom of my container to cover up my sloppy cutting job. I used a mannequin head placed close to a wall as my test setup to see the effect my Soup Dome had on the shadows created by my on-camera flash, and my results were better still. In a tight economy, getting

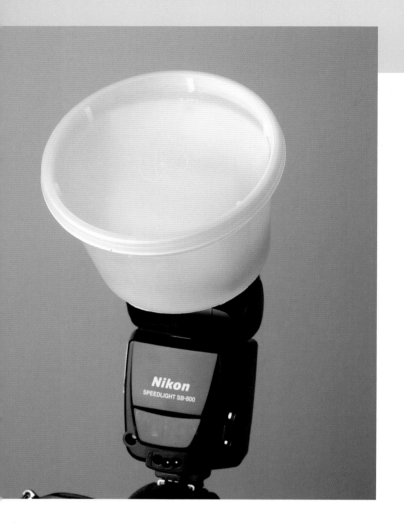

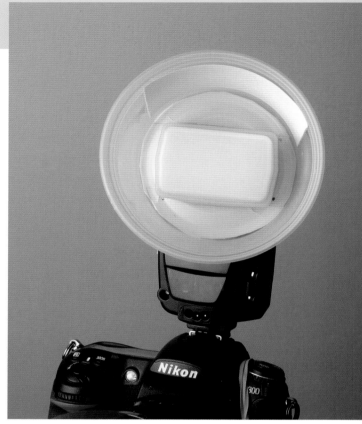

Here are two photos of my Soup Dome. I have only used mine with the dome's cap on it but in the second photo I removed the cap so you can see the Stofen cap and the white tape I added inside my experiment.

When to Use Bounce Flash

free soup when you buy your light modifier seems like a good deal to me. So, with apologies to dome makers everywhere, and although my results are not an exact copy of those achieved using my Fong Dome, I can only paraphrase Tina Turner in the Mad Max movie series and say, "Welcome to Soup Dome!"

Three of the four light modifiers I just covered (the Fong Dome, Harbor Design's Light Box, and the Chinese soup container) can also be used in a ceiling bounce mode (as opposed to a direct flash mode) without their front covers. And this brings us to my next method of modifying (and softening) the light from an OEM flash unit: bounce flash.

Always remember to keep your eyes open for bounce-lighting situations. Any time you are in a room with white ceilings, bells and whistles should go off in your head shouting, "Bounce, you fool... BOUNCE!" In fact, it is so ingrained in me that the first things I look at when I enter a room are the ceiling's color and height. The color is very important because a blue ceiling will give you blue pictures if you use ceiling-bounced flash. From personal experience, I have found that most white ceilings (from bright white to eggshell) will give pleasing results, but bouncing a light off any other color is a definite no-no. I know, I know—you can fix it in post ... but why would you want to waste that time?

Here are comparison photos taken with my Soup Dome (left) and with direct flash (right). Not only are the shadows behind the mannequin's head softened by the Soup Dome, but the light hitting her face is softer, too.

The ceiling's height is also very important. Many years ago, one of my mentors gave me a formula that gives a ballpark calculation for setting exposure when using ceiling-bounced flash. Estimate the distance from the flash to the ceiling and add that to the distance from the ceiling back down to the subject. The sum is the distance the light will travel. Take into account the diagonal slant from the ceiling to your subject. If you are in a room with a 10-foot (3-meter) ceiling and are 6 feet (1.8 meters) from the subject, and the height of both the camera and subject is 5 feet (1.5 meters), the light will travel about 12 feet (3.7 meters)—5 feet straight up and then about 7 feet, diagonally, back down to the subject (or 1.5 meters up and about 2.1 meters back). Since bounced light from a flash travels up and then down in order to reach the subject, it covers a longer distance. Therefore more flash output (or a bigger f/stop) is required to bounce light off high ceilings than is necessary when working in rooms with low ceilings.

Using the distance calculation described above, I base my exposure upon the total distance covered. But, because the ceiling doesn't reflect 100% of the light hitting it (only a front-surface mirror could do that), I open up about 1/2 an f/stop for a clean white ceiling and about 1 f/stop for an eggshell colored one. And because bounce lighting is so soft and full (low contrast), you will find that you can overexpose a bit in a bounce-light situation without much image degradation. Personally, I find bounce lighting has a more casual feel than direct flash, and I find it better suited for home portraits or afternoon affairs than formal evening galas.

There is an additional consideration that is important to remember when determining whether or not to use ceiling-bounced flash: The ceiling now becomes the light source. This can be a problem. Not only will the light take on the ceiling's colorcast (as mentioned previously), but the direction of the light hitting your subject will be from above. This creates shadows in your subject's eye sockets and under their nose and chin. Read on for a way to get around this.

Fill Flaps

To minimize the shadows in the eye sockets and under your subject's chin when using bounce flash, many shooters often use an accessory called a fill flap to push some light into these shadow areas. A small, white plastic, cardboard, or paper card secured with tape, Velcro, or a rubber band to the back of the flash head will redirect some of the upward-traveling light forward to help fill in the unflattering shadows. I've seen one photographer use a white plastic spoon as a fill flap to add tiny catch lights to his subject's eyes, while some photographers use 8 x 10-inch (20.32 x 25.4-cm) fill flaps for an extremely open effect. I even know one shooter who uses a piece of cardboard covered with aluminum foil—dull side towards the subject—for a more specular (mirror-like) result. While all of these effects are acceptable, my own preference is to use a flap a bit smaller than the size of a 4 x 6-inch (10.16 x 15.24-cm) file card, although the ones I use are made of white matte board. As with most things photographic, the size, shape, and reflectivity of the fill flap are a matter of personal taste, so experiment to find your own favorite combination.

Many years ago, a few of us wedding photographers were sitting around a bar (after a long weekend of weddings) arguing about just how big a fill flap we should use. The main revelation of our discussion was that using bounce flash with a fill flap really broke the light into two components. One component was the light that bounced off the ceiling and was directed back down towards the subject, and the other component was the light that bounced off the fill flap and was directed back towards the subject.

Once we sobered up, we figured out that the important point about the two components was how they compared to each other! From experience we knew that we all, when working with two separate flash units, generally preferred that one flash (the main light) was about 1.5 to 3 f/stops more powerful than our other flash (the fill light). The

brightest bulb amongst us declared that the two components—our one-flash, bounce-plus-fill-flap setup—could be treated the same as our two-flash, main-plus-fill setup. A collective decision was made to figure out just how strong different-sized fill flaps were. What follows is the method we used to test a whole lot of different sized fill flaps.

Realizing we were interested in how the two components compared to each other, we set up the flash unit in a bounce light position, but without a fill flap, and took a few meter readings from about 10 feet (3 meters) away and from 7.5 feet (2.3 meters) away. The room we were working had about a 10-foot-high (3-meter-high) white ceiling. The flash meter reading was about f/8 for the 7.5-foot (2.3-meter) shot and about f/5.6 for the 10-foot (3-meter) shot. Now that we had this information, we had to devise a way to measure the intensity of light bouncing off various-sized fill flaps. This is what we did.

We took a large, open-topped cardboard box and painted the inside of it black. Next, we turned it upside down (so the open side was facing down) and suspended it between two light stands. The box was held in place with simple hardware store spring clamps. The open bottom of the box was approximately 6 to 7 feet (1.8 to 2.1 meters) off the floor. Next, on a third light stand, we placed a battery-powered flash unit set in the bounce light position (meaning the reflector was pointing upwards) under the box so all of the bounce light's power was directed up into the black box. We left about 18 inches (45.72 cm) between the top of the battery-powered flash's reflector and the bottom (which was now the open top) of the box. A quick test with a flash meter set about 10 feet (3 meters) away from our test setup showed that all of the bounce flash component was directed into and trapped by the box. Finally, we taped different sized fill flaps behind the flash head and took meter readings of each different sized fill flap as we

flashed the flash. Because our black box captured and contained the bounce light component of our bounce-plus-fill-flap setup, our meter readings were only of the fill flap component of the flash unit's output.

The smallest fill flap we measured was 2.5 x 3 inches (approximately 6 x 7.5 cm) and found it had created a meter reading of f/2.8 for the 7.5-foot (2.3-meter) shot and f/2 for the 10-foot (3-meter) shot. While this size of fill flap was at the extreme edge of our desired difference between the two flash components (about 3 f/stops) we also found that by moving the fill flap slightly forward into the flash's beam by using a fingertip pressing on its back we could increase its output by one f/stop. In that case the difference between the bounce flash and the fill flap would be two f/stops, and that, to my taste, seemed perfect.

Next, we tried a fill flap that was approximately 3.5 inches (about 9 cm) square. This increased the fill flap's output by about 1 f/stop. To this day, I use two fill flaps sized to these dimensions when I'm shooting bounce flash. I use the smaller one in rooms with high ceilings and the larger one in rooms with more normal ceiling heights. I make this choice (when shooting manual flash) because I have to open up my lens a stop of two more for proper bounce light exposure in rooms with a high ceiling and the bigger fill flap would create too strong a fill-flap component in that situation.

One of the photographers participating in this experiment then asked if we could switch the two components around and make the fill flap the primary light component so we made an even bigger fill flap and tried that one out. The new, larger fill flap was 5.5 x 3.5 inches (approximately 14 x 9 cm) and it (unlike the smallest one) was arranged horizontally.

Although I don't agree with making the fill flap the primary of two lighting components, on a hunch, I later experimented with the large-sized fill flap for a specific purpose. Sometimes, in a dressing room, the ceiling is painted a color other than white. In fact, I've seen them painted gold, red, and even a dark green. If I put on my largest fill flap and tilt my flash head forward one or two clicks, the big fill flap acts almost like the box with the black inside in the experiment we did. This means the bounce component of the flash is almost entirely blocked by the fill flap and for all practical purposes, the flap itself becomes the only light source.

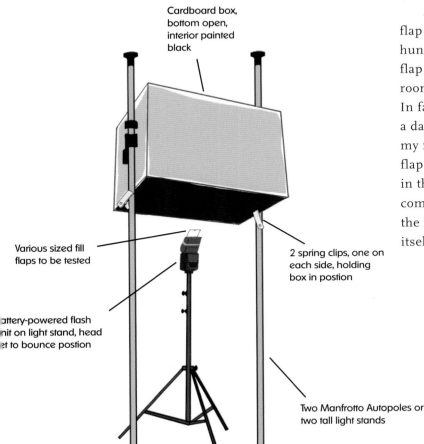

Cardboard box, bottom open, interior painted black

Various sized fill flaps to be tested

2 spring clips, one on each side, holding box in postion

Battery-powered flash unit on light stand, head set to bounce postion

Two Manfrotto Autopoles or two tall light stands

It didn't matter whether our fill flap was vertical or horizontal. We thought it would matter, but it didn't seem to.

The last thing I learned from this experiment with my friends was that, just as there are two components of the flash when using a flash with a fill flap, there are two components that must be considered whenever you are choosing (or making) almost any piece of photo equipment. One has to do with convenience, portability, and practicality; and the other has to do with how well the piece of equipment performs. Sadly, the convenience, portability, and practicality side of the equation is often at odds with the performance of the item. As an example of this, one just has to examine the fill flap built into the Nikon SB-800 flash unit. The

built-in fill flap's design lets it slip into a slot on the flash head for storage, but for it to fit into the slot, its size is limited to 1.5 x 1.75 inches (4 x 4.5 cm). While this makes it eminently convenient, portable, and practical, its performance suffers in some instances because it is so small. But note that one of the reasons my smallest custom fill flap is only 2.5 inches (6.35 cm) wide is because that size doesn't exceed the width of my SB-800 flash unit, so I can store this size of fill flap under a rubber band wrapped around my flash head and still have it fit neatly into a camera bag pouch. Obviously, this is not as elegant a solution as Nikon's built-in fill flap but to me, its larger size more than makes up for the inelegance of the rubber band holding it in place!

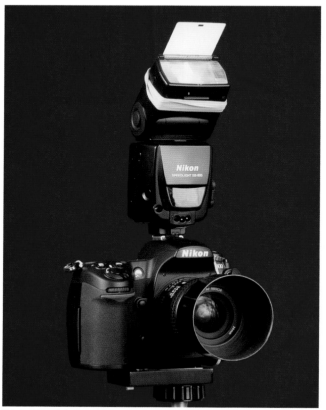

This is Nikon's built in fill flap.

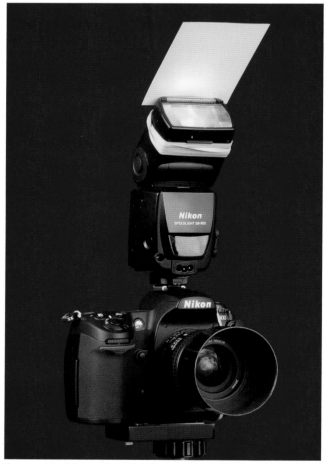

Compare the Nikon unit at left with my mid-sized fill flap, shown here.

Lastly, although many photographers think of bounce lighting in relationship to ceilings, a crafty photographer can also exploit white walls for bouncing light from a flash off of. But, when using wall bounce, because the light's direction is no longer from above, but from the side instead, I don't use a fill flap in wall bounce situations. Wall bounce can often create pleasing effects that emulate window light. Like ceiling bounce, manual exposure calculation for wall bounce is based on the distance from the light to the wall plus the distance from the wall to the subject. From this calculation, I again open up about 1/2 stop for white walls and about 1 stop for tan ones. Also, as with ceiling bounce, the color of the wall (the bouncing surface) is important.

© Jerry Meyer Studio

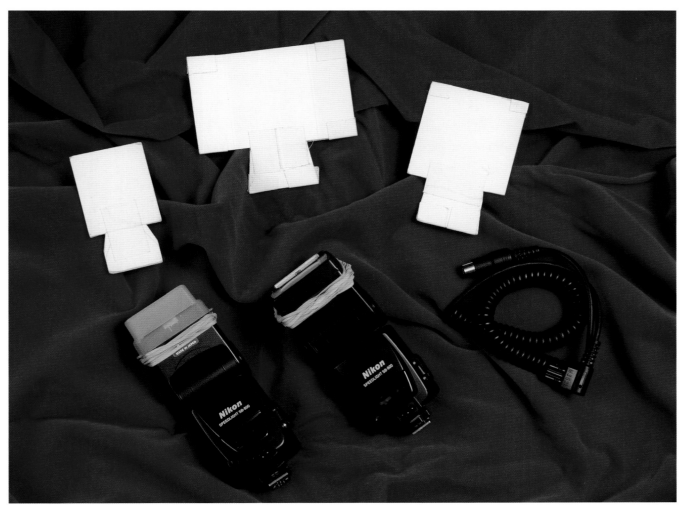

Here are my three fill flaps, with a high-voltage cable that runs between the flash unit and my external battery pack.

Harmonizing Flash with Ambient Light

Many photographers already know that midday light is awful. A big, beautiful noonday sun beating down on subjects from directly overhead creates inky black shadows under our subjects' noses and chins and makes their eyes recede into dark sockets under the shadows of their brows. Very often, such beautiful days (though they are what every couple hopes for) don't lend themselves to making beautiful portraits at midday. But whether faced with soft light or glaring light, the wedding photographer must prevail! Every couple wants outdoor pictures, whether the light is cooperative or not. Against all odds, with only a flash unit in their DSLR's hot shoe, a wedding photographer can still create beautiful pictures. Even though photographers new to the wedding game are often afraid to try flash outdoors, it is a tool that can save the day.

To a novice, mixing sunlight and flash is voodoo, but there really is no magic involved. You are just mixing two ingredients, and there are recipes you can follow. By understanding how the ingredients work, you can control how much of each ingredient to use in your recipe. Ingredient number one is ambient light (you can substitute the word daylight, sunlight, skylight, available light, or moonlight here), which is a continuous light source. You can control the ambient light's exposure on your image by changing either the aperture or the shutter speed.

The second ingredient is the burst from your flash, which is an instantaneous light source. You can control flash exposure by changing the flash's distance from the subject, its power output, or the lens aperture. Flash exposure, for the most part, is unaffected by your choice of shutter speed (as long as the shutter speed allows flash synchronization). This means that by changing the shutter speed you can affect the ambient light portion of the recipe without affecting the flash. And, by adjusting the flash unit's output or changing its distance from the subject, you can affect the flash part of the

recipe without changing the ambient light exposure settings. You can also choose a comparable set of f/stops and shutter speeds (for example 1/250 at f/5.6 and 1/125 at f/8) and the change in f/stop between the two will affect your flash exposure without affecting the ambient light exposure. This is where camera designs that offer high-speed flash sync really come into their own.

With flash and ambient daylight as your light sources, you must decide if you want one light to be dominant, and if so, which one. Or do you want the two sources to have equal value? Once you've made that choice, getting the two light sources to complement each other is the name of the game. The best way to understand this is by walking through a hypothetical scenario for each possibility.

In the first scenario, consider ambient light the main source and flash the fill light. We are outside at noon and we're looking at a beautiful bride with black shadows under her brow, nose, and chin. We are in the middle of a field. If there was a nearby tree with leaves, I might suggest we work in its shade. But this scenario includes harsh sun and no shade, so we must make do. An incident meter reading of the ambient light falling on the subject calls for an exposure of 1/125 second at between f/11 and f/16. Set the camera to these settings. The next step is deciding how much light you need to fill in the shadows caused by noonday sun.

From hard-earned experience, that I openly share here, I've found that I can usually eliminate excessive shadows on the face with a fill-light exposure that is about 1-1/2 to 2 stops less intense than the main light. That means the flash has to be far enough away and have enough power to create an exposure of f/8 for the subject. (Why f/8 you ask? Because it creates an exposure that's 1-1/2 stops less than the ambient exposure of 1/125 second at between f/11 and f/16.)

© Russell Caron

I know the intensity of light from my manual flash unit is f/8 when the unit is set to half power and is 10 feet (3 meters) from the subject. Perfect. So, using a long sync cord, or a radio slave, I can position the flash 10 feet (3 meters) from my subject, and voilà—I have a fill light 1-1/2 stops under the sunlit ambient exposure. Of course, you could dial the flash unit's power up or down, as well. There is always more than one way to skin a cat.

Although this scenario may seem easy, maybe the ambient light intensity is something different, like 1/125 second at f/5.6. What should we do then? Well, remember that flash exposure is unaffected by a change of shutter speed as long the shutter and flash are synchronized. Then, remember that 1/125 at f/5.6 is equivalent to 1/60 second at f/8, which is equivalent to 1/30 second at f/11. We could shoot at 1/30 at f/11.

I know that my manual flash at half power puts out f/8 at 10 feet (3 meters). I also know that when a flash unit is 15 feet (4.6 meters) from the subject, the situation calls for f/5.6 (see the guide number chart on page 193). So, if I want an f/stop of either f/8 or f/5.6 (which would be 1 or 2 stops below my ambient f/stop of f/11), once again, I can put an off-camera flash unit (on a radio slave again) 10 feet (3 meters) from the subject and either choose 1/2 or 1/4 power, depending on whether I want my flash exposure to be f/8 or f/5.6. Now, the fill light will be 2 or 3 stops below the ambient light exposure.

Next, let's look at a scenario in which we want the light from the flash to overpower the ambient light falling on the subject. This might be desirable when the subject is in shade but the background is a sunlit sky. If we expose for the light falling on the subject's face, which is in the shade, the sky in all its azure glory will be overexposed to a very bland looking white. In this example, an incident reading of the subject might call for an exposure of 1/30 second at f/5.6, while a reflected reading of the sky might call for an exposure of 1/125 second at f/11. What do we do?

Because we want the sky to register deep blue, set the camera to 1/125 second at f/16. Then move the flash unit so that it is about 5 feet (1.5 meters)

from the subject. Remember from our discussion about guide numbers (see page 193) that flash exposure from 5 feet (1.5 meters) calls for an exposure of f/16. Therefore, we are ready to shoot the portrait.

This picture will produce a properly exposed bride in front of a deep blue sky. You might want to take a second photograph without the flash, with the camera set to 1/30 second at f/5.6 (meter for an incident light exposure of the subject in the shade). The two pictures will appear wildly different, and you might get two sales from these two frames. The one (with flash) will be richly colored, while the other (ambient light only) will appear high key and airy.

Even under conditions that many photographers consider perfect, such as an overcast or cloudy bright sky, you can to use a tiny puff of light to brighten the subject's eye sockets. For these situations, I carry a white handkerchief that I drape over my flash head and hold it in place with a rubber band. The white cotton cloth cuts the flash output by about 1 stop. I use this technique when the ambient light intensity is low so that light from the flash is not unnaturally harsh.

As mentioned in this book's introduction, there is always more than one way to do anything photographic, and with that thought in mind, you can also accomplish all of the feats mentioned immediately above by using your shoe-mounted flash set to a TTL (through the lens) auto mode. Every DSLR I have seen or used has the ability to set the flash unit's output relative to the ambient available light. That being the case, you can try setting your shoe-mounted flash to an auto mode minus 1.5, 1.7, or 2.0 stops and see if you like the results you get. Personally, I have not gotten consistent results using this method, so I prefer to work in a manual flash mode. Furthermore, if you want use a hot-shoe-mounted flash in manual mode instead of an off-camera flash, you can use the distance information outlined above and use a zoom lens to control your framing when working at the specific distances cited.

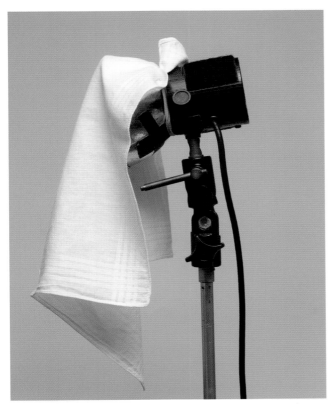

This is how I use a handkerchief as a diffuser. Check out the resulting soft light on my subject.

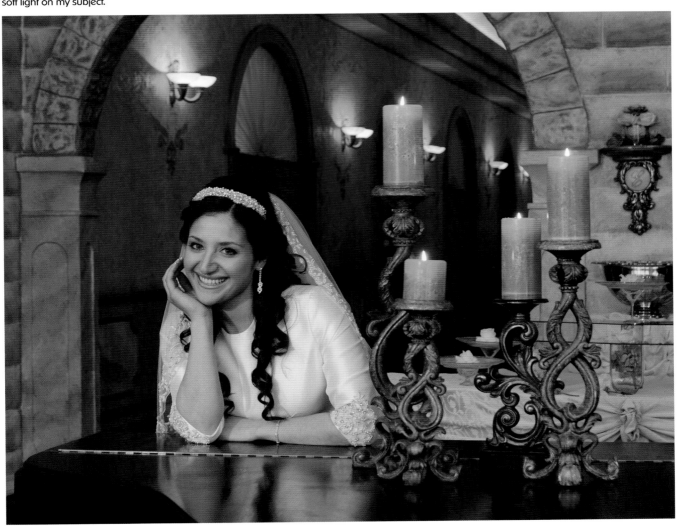

Here are two images of grandmothers congratulating the bride after the ceremony. For the photo on the left, I used an unfiltered flash and set my white balance to about 5600K for the flash. Notice the orange cast on the subject (created by the video lights) and the orange cast to the ambient room lights. For the photo on the right, I put a Lee 204 filter over my flash (changing it's output from 5600K to 3200K) and set my camera's white balance to 3200K to match. By doing this, the orange cast caused by the video lights and the room's ambient lights matched my flash units output, and the result was a more accurate color rendition. © Three Star Photography

But, the mixing of flash and ambient light is not limited to use only out of doors. Many shooters, in reception halls with great crystal chandeliers and wall sconces, shoot their dance-floor images at 1/30 second (instead of 1/60 or 1/125) to pick up some of the "flavor" of the room. Just remember not to do this when working under strong video lights or the images will have a yellow cast, and hold your camera steadily so you don't run the risk of blurry images caused by camera motion. One way around the yellow cast caused by video (and other indoor tungsten) lights is to put a salmon (orange) colored gel over the flash head, set a 3000K – 3200K white balance on your DSLR and start to shoot with your hot-shoe-mounted flash.

The OEM flash unit I use comes with both salmon and green filters to change the flash's output so that it coincides with either tungsten (helpful at weddings) or florescent (not so helpful at weddings) light sources. However, after some testing, I prefer to make my own flash filters cut from a Lee Filter's 204. I bought a relatively large sheet of Lee 204 (available from Adorama, B&H, and the SetShop), which changes the flash's 5600 degrees Kelvin output to 3200 degrees Kelvin so it closely matches the light put out by video lights. Considering the size of the sheet versus the size of my OEM flash unit's reflector, it should last me forever! In truth, one of my two OEM flash units has my snippet of Lee 204 gel permanently taped over its reflector because I use this technique so often. In fact, my results have a very different look than my regular flash shots that I take with a bracket-mounted camera; and by shooting both types of pictures, I get more saleable possibilities.

I have realized that using a gel-covered flash in conjunction with room lighting and video lights is a two-lighting-component situation—one component being the flash and the other component being the ambient and video lighting. This being the case, here's how I handle the situation: I set my camera's ISO to 800 – 2000, depending upon how bright the ambient light is—for bright room and video lights, I use ISO 800; and for dim room and video lights I set the ISO much higher. I set my camera's white balance to 3200K (or as close to 3200K as my camera has) and set my camera's exposure mode to my favorite mode, "M" (manual). Next, I put my orange-gelled flash (equipped with an OEM or white Stofen cap and one of my three custom fill flaps) into my hot shoe and set the flash unit to TTL. I choose a guesstimate exposure on my DSLR (usually somewhere about 1/30 or 1/60 at f/4 or f/5.6) for the ambient room and video lighting and make a test exposure.

Now, here's where it gets interesting: If the ambient room and video lighting looks too dark or too light, I adjust my shutter speed by either lengthening or shortening it respectively. Doing this doesn't affect the flash component of the exposure because, as long as you are at a shutter speed that syncs with the flash, flash exposure is only dependent on the f/stop you choose. If, on the other hand, my flash component seems too dark or too light, I could use a slightly larger or smaller f/stop as needed. However, if I change my f/stop, I have to change my shutter speed, too, so that my ambient light exposure remains constant. So, if my flash seems too light or too dark, I change the flash compensation feature on my camera instead. Once I'm dialed in, I can shoot away. By using manual exposure for the ambient light (room lights and video lights), I lock it in; and then by adjusting my flash using the TTL mode and flash compensation, I keep the effects created by the ambient light, plus everything balances correctly.

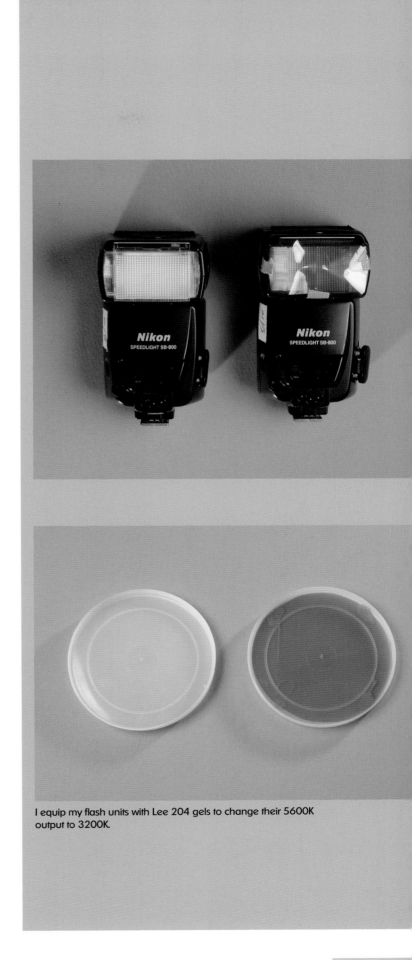

I equip my flash units with Lee 204 gels to change their 5600K output to 3200K.

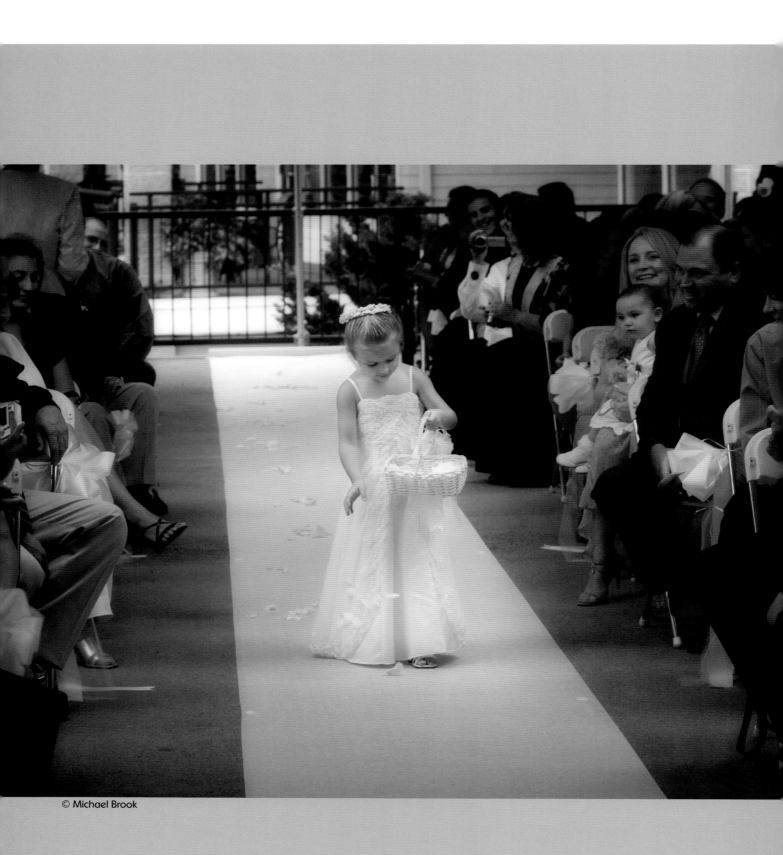

© Michael Brook

Two-Light Setups

After you've mastered how to use a single light, the next step in portable flash work is called "double lighting." In addition to the camera-mounted flash unit, the photographer uses a second slave-triggered flash on a pole. To get the most out of a portable second light, you need an assistant to hold and aim it so let's start there.

Get a Good Assistant

A good assistant is one of the most valuable tools in a wedding photographer's arsenal. Many photographers feel that they can work most effectively alone, but when it comes to weddings, I disagree. A photographer and a good assistant become a team. It has been said that the best assistant is a second photographer because they know what the first photographer is trying to accomplish and, therefore, they can act to achieve that goal.

Some might feel that they are quicker when working alone; and others, who have been reared in a photojournalistic tradition, feel that an assistant makes them too conspicuous. Let's get real here for a second. Imagine you are standing at the foot of the aisle with 300 guests sitting in the pews. All of you are waiting for the bride to enter the church. The 300 pair of eyes aren't all turned to the back of the church. Most guests are looking towards the altar. And guess what's right there, blocking their view? You!

Wedding photographers, by the very nature of their jobs, are conspicuous. Everyone's eyes are always riveted on the bride and groom, watching their every move, and you are always right in the middle of the action. If you expect to be the fly on the wall you won't be getting many great photographs. In fact, most brides and grooms expect you to be right there next to them. So much for being inconspicuous.

Finding a good assistant is not easy, but there are some likely places to look. Trade schools and your local high school or college photography department should be obvious choices. Some schools offer job-finding assistance to young people and it might pay to look into them. If you live in a big city with multiple room catering halls, sometimes your next assistant is working for the photographer at the other reception! Keep your ears open for members of the wedding party who are interested in photography also. Lastly, you might look for a young person in your neighborhood that's interested in photography or just wants to earn a few extra bucks.

A good assistant is to be treasured. I've heard some older candidmen calling their assistant a light pole with legs. I pity these photographers because they aren't exploiting their assistant's potential. Their egos get in the way when they feel that only they can push the button. After a short time, an assistant can be helping to organize the families and even touching up a pose. A good assistant can even shoot

another view from the choir loft of the church while you are working on the lower level. Actually, there are many other times when a good assistant can switch hats and become a second photographer to give you a second, sometimes more unique, view of the party.

To get this kind of productivity from an assistant requires that the photographer (you) can communicate what you want and say it in a way that is understandable. I try never to criticize an assistant in front of a customer, but many times, on the way home from an assignment my assistant and I discuss how things can be improved. If you listen carefully, you might get ideas to improve your own work as well, but more importantly, this makes an assistant feel like a teammate, and therefore willing to work harder. It pays to remember that as you become more successful, your number-one assistant can become a first photographer in his / her own right and cover a second assignment for you.

Be polite to your assistant and, in general, treat them like you would like to be treated yourself. Ask how they are doing and listen when they speak. I make it a point to throw my first assistant a few extra bucks after a heavy June season and around Christmas time, and I always give them a share of any tips I get. It should not be surprising that you can get extreme loyalty and effort out of a worker if you treat them well. My goal is trying to establish a team because a good team usually means better pictures and a smoother assignment.

© Russell Caron

© Russell Caron

Remote Flash Triggers

To make your second (or remote) light fire in synchronization with your camera's main light, you need a piece of equipment called a remote trigger or flash slave. Originally, there were three categories of remote triggers, classified by their actuation method:

1. Light (from a flash unit)
2. Infrared pulse
3. Radio slave

Light-actuated slaves, though inexpensive and very robust, are often triggered by any flash from any of the guests' digital cameras. This will eat up your batteries, and worse still is the fact that the unit is often recycling (due to being fired by a guest's camera) when you need it to flash for you! Light-actuated slaves are much better for working alone in a studio environment. They just don't cut it in a wedding situation.

Next, we come to infrared-pulse (IR) slave units. While IR slaves are dedicated to you alone, many wedding venues are huge rooms that just suck up the IR signal, making these units less than ideal in practice. When it really comes down to it, although all three types of slave units still exist and are used in a variety of other circumstances, the only truly viable way to remotely fire a second flash unit in the wedding photograph business is to use a radio slave.

A radio slave is a closed, dedicated system, and that means guests won't be able to inadvertently fire your flash every time they take a flash photo with their camera. Most radio systems also offer a number of different channels to choose from, which makes it possible for two photographers to set up their lights and work independently of one another at the same wedding or at two different weddings in adjoining rooms. The vast amount of small digital cameras that guests bring to weddings makes a radio system a basic necessity if you want to synchronize multiple flash units. This being the case, let's turn our focus to radio slaves.

Radio Remote Flash Triggers: Radio remote triggers use the same basic technology as electric garage door openers. The transmitter sends out a radio signal. The dedicated receiver picks up the signal and fires the remote flash unit that is attached to it. They are preferable to light-actuated flash slaves for weddings because they don't react to the flashes of all the point-and-shoot digital cameras that guests bring with them. However, they aren't perfect either. Most require two cords connected to the transmitter (which is mounted on the camera): a sync cord from the camera to the transmitter, and a second cord from the transmitter to the on-camera flash. Some radio slave transmitters come equipped with a foot that allows them to be mounted directly to a camera's hot shoe. This eliminates the need for a sync cord between the transmitter and the camera. A third sync cord is also needed between the receiver box and the second light (or third, or fourth light – see below).

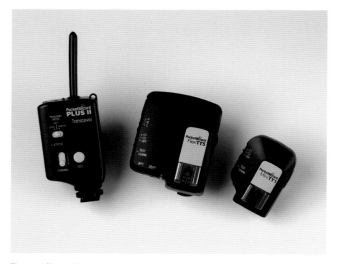

Three different Pocket Wizard models are shown here. On the left is Plus II 4-channel transceiver (a receiver and a transmitter in one) that I use. In the center and on the right are Pocket Wizard's newest models, the Flex TT5 receiver and the Mini TT1 transmitter. The Flex TT5 features a folding antenna, and all of these units work with Canon and Nikon TTL flash units.

To further complicate things, radio remote triggers require batteries in both the transmitter and receiver. The transmitter box draws power only when you fire the camera, so its power supply seems to last forever. The receiver, on the other hand, must always be in a state of readiness to receive the transmitter's signal. Because its circuitry is always up and running, it eats batteries for breakfast, lunch, and dinner! Older radio slave's circuitry required expensive and heavy 9-Volt batteries to operate. Some used one 9V battery in the transmitter and two 9V batteries in the receiver. More recent and present designs usually only require one or two double AA batteries. While the newest radio remote triggers have cut back on their power-hungry ways with improved circuitry, they still require frequent battery replacement.

To counter this, many photographers report good luck using rechargeable batteries to power their radio slaves, but I have had problems charging them and having them hold a charge. On the other hand, I have had good luck using lithium batteries instead of alkaline batteries. They are more expensive than the alkalines, but are lighter and last much longer. If you use AA batteries to power your radio slave system, it is worth considering a switch to lithium cells.

Currently, the Pocket Wizard radio slave system has become almost ubiquitous in my geographic area, and there are some good reasons for the popularity of these units. They are available in four-channel (the Plus II), 32-channel (the MultiMax), and the newest 32-channel TTL (the FlexTT5 and miniTT1) models. As an aside, and while some may disagree, I feel that 32 channels is huge overkill for wedding photography—four channels are more than enough for our wedding situations and venues.

Earlier Pocket Wizard designs required different transmitters and receivers, but later, the design was switched over to a transceiver design where each unit could work as either a transmitter or a receiver. It is also worth noting that in order to use a flash meter with a radio slave, photographers used to rubber-band a radio slave transmitter to their flash

meter. Currently, there are Sekonic meters that have the ability to accept a Pocket Wizard transmitter module that plugs into an inside compartment on the meter which eliminates the transmitter rubber-banded to the meter. This feature makes the Sekonic meters with the module socket and the Pocket Wizard radio slave system work together more seamlessly with the added advantage of creating a less bulky piece of equipment.

Another big plus is that a few of today's AC powered light units (Dynalite, Norman, Photogenic, and Profoto at last count) can be bought pre-equipped with Pocket Wizard radio slave receivers already built into them so you can have the beginnings of a radio slave system when you buy your lights. Finally, Pocket Wizard has just introduced their new Flex system that, in addition to having a smaller transmitter and receiver, works in harmony with the auto-flash capabilities of both Canon and Nikon DSLRs and their auto flash systems.

Current radios use a digital signal instead of an analog one, and this is full of advantages. My first radio slaves were analog and required eight AA batteries in the receiver, which had an 18-inch (45.72 cm) telescoping antenna. My next set of radios (still analog) required two 9-volt batteries in the receiver (also with an easily breakable telescoping antennae), plus a 9-volt battery in the transmitter. My current digital radio slaves require only two AA batteries, and the transmitter and receiver are combined into a single unit that can play either role. Furthermore, digital radios have much shorter antennas than older units did.

My original radios had a limited range and the frequency would wander when the batteries started to become exhausted. This is no longer true with digital radios. Advances in circuit design have also enabled digital radio slaves to be smaller than older analog radio slaves. And, they are finally compatible with TTL flash control. As more and more photographers see the advantages of radio slaves, the market for them has expanded and new manufacturers want to enter this lucrative arena. While it is true that some older analog radio slaves are still being used, the advantages of digital

radio slaves are very apparent. All that said, while I currently use and trust radio slave triggers, it should be noted that my gear cases include multiple replacement sync cords, multiple spare batteries, and multiple backup light-actuated slaves for use if and when my radio system fails.

© Sara Wilmot

Using the Second Light

Now that you have an assistant and a radio slave system, it's time to look at what you can accomplish by using two lights. The type of remote trigger you use is not the real issue. What you can do with a second light and how you use it are much more important than simple hardware preferences. That's what makes your photographs look totally different from the guests' point-and-shoot pictures, and that's what can increase your potential picture sales.

In my opinion, there are four different ways a wedding photographer can use a second light on a pole. (Actually, there is a fifth, but it is really a combination of two of the first four.) I'll go on to discuss each possibility one by one.

1. You can use a second light as the main light to illuminate the primary subject you are shooting.

2. You can use a second light as a hair light to separate the primary subject(s) from the background.

3. You can use a second light to light up the background, which won't improve the lighting quality on your primary subject(s), but will eliminate the light-in-a-tunnel, dark-background look.

4. With help from a good assistant, you can use a second light to provide a hair light and light up the background at the same time.

5. You can use a second light to create a special effect for a highly salable picture.

Second Light as Main Light: One neat technique stems from a second light's potential to make the subject appear three-dimensional. The remote light should be placed closer to the subject than the one mounted on the camera, and at an angle 45 – 60° to the lens axis and 4 – 8 feet (1.2 – 2.4 meters) above the subject. In this approach, the second light (on the light pole that's held by your assistant) becomes

the main one, and the flash on the camera becomes the fill light and therefore the weaker of the two. This diminishes the feeling that your subject was lit with a coal miner's helmet light.

I have heard some photographers claim that when they are double lighting, they make the camera light the main one and the second, pole-mounted light the fill. Without meaning any disrespect to my colleagues, I think they are wrong! If you think about this practice, you will realize it is impossible. If the camera light is the main light in the traditional miner's-helmet style (coming directly from the camera lens axis), what shadows does it create? The answer is none! There are no shadows to fill in!

A much more interesting question is, how strong should the second (main) light be in comparison to the camera-mounted fill light? Although I might answer the question by saying it depends (actually, it does), many photographers would like a simple rule that governs most situations. I have found that if the main light is one or two f/stops more powerful than the fill light, the resulting pictures feature shadows that are "open." The idea isn't to make all the pictures overly dramatic by creating inky black shadows, but instead to create well-lit, three-dimensional-looking images.

Here's the trick: If you are working with two flash units of equal power, and the fill light is mounted on the camera, then the main light should be located somewhere between two-thirds and one-half the distance from the subject as compared to the camera-mounted fill. If you do the guide number math (see page 192), you will find that the two-thirds / one-half rule equals about a 1-stop and a 2-stop difference in exposure between the two flash units, respectively. If I'm taking my photograph 10 feet (3 meters) from the subject, then the main light should be about 5 – 7.5 feet (1.5 – 2.3 meters) from the subject. If I'm 15 feet (4.6 meters) from the subject, the main light is 1 stop "hotter" if it is 10 feet (3 meters) away from the subject. If I'm 15 feet (4.6 meters) from the subject, the main light is 2 stops "hotter" if it is 7.5 feet (about 2.3 meters) away from the subject.

Here's the difference between a single-light on-camera photograph and a double-light one. In the single-light photo (bottom), don't let the illuminated background fool you; if it wasn't bright white, it would have appeared much darker in the photograph. More importantly, note how the subject appears more three-dimensional in the double-light picture (top).
© Three Star Photography

Second Light as Hair Light: How does one expose for this type of two-light setup? Some might think that you should expose for the main light and let the shadows fall where they may, and in fact, that is exactly what I do! With your assistant's help you can place a second light above your subject(s) so that the beam skims the tops of their head(s). This separates the subject from the background. It may not seem important, but in the murkiness of a dim catering hall with dark-haired people wearing dark suits, the edges of your subject can sometimes disappear as they merge with the unlit background. However, there are a few notes of caution worth considering. If the light above the subject hits the face, it will illuminate the top of the nose, which I can say from sad experience is very unattractive. Also, if your subject has thinning hair (or is just plain bald) and you accentuate that feature for the whole world to see, you could have a very unhappy customer. Worse still, often the cue ball you've exposed is the Dad who's paying your bill, and that is definitely not a pleasant situation to be in!

You can place a more powerful light at the edge of the room to light your subject's hair. Even though the primary subjects are only lit by a single, on-camera flash, the picture doesn't have the typical "coal-miner's-helmet-light" look because the room light adds life to the image

Second Light for Background: Many photographers work alone, and although I'm not often in that situation (anymore), when I was, I put my second light on a light stand equipped with wheels. To stabilize the rig, I hung the flash unit's battery pack from a lower section of the light stand so that it is less apt to tip over. Working with two lights in this fashion isn't easy, and because of that, it requires a different plan of attack. I do not use my second light as a main light or as a hair light on my primary subject. Instead, I place it so that it illuminates the area behind my subject. This is called lighting the background, and although my prime subject is bathed in miner's helmet light once again, now it's acceptable because the background isn't unbearably dark. I have watched couples add pictures to their album at the proof return just because they could see Uncle Louie in the background of a photograph, lit by my background light.

Background Light / Hair Light Combination:
With the help of a top-notch assistant, your second light can be positioned so it can skim the top of your primary subject's head and illuminate the background. In reality, this is easier to tell you about than to accomplish! It's difficult because it requires the person aiming the light to visualize the width of the beam the flash is projecting without actually seeing it. That's because the beam of light the flash projects is instantaneous and not even visible until the moment of exposure. So, while it's nice to theorize about this technique, it's basically a hit or miss type of thing. Thankfully, even if your assistant aims the light in the wrong place and doesn't illuminate the hair of your subjects, it still ends up lighting the background!

Special Effects with Two Lights: Using a second light to create a special effect offers almost unlimited possibilities. If a subject has a winning profile, simply putting the second light on the floor behind him or her aimed at a wall can create a silhouette. If you decide to go this route, you must block most of the light from the camera-mounted flash so that the front of the subject remains dark (unlit). This can be achieved by bouncing the on-camera light or by blocking most of its reflector with your hand. If you are using a radio slave, there is usually a provision for shutting off the light mounted on the camera. If that's your plan of attack however, you MUST remember to turn the camera-mounted light back on after you've made your magic. You Must! You MUST! YOU MUST!

A second flash can also be used to rim-light a kiss. Instead of aiming the second flash unit at the wall behind the subject (as you would for a silhouette), you can turn it around towards your subjects for a beautiful, glowing effect. Trying this is often a hit-or-miss proposition, but sometimes even the mistakes are outstanding.

Your imagination is the only limit to the different ways you can use a second light for a special photograph—a sure-seller. Many photographers I know put their cameras on a tripod and make time exposures (with a second light fired into the background when doing this indoors). Remember to use the orange-filtered flash mentioned in the single-light section (see pages 212 – 213) if you try this. It will help to ensure that the light from your flash matches the room's lighting fixtures, which are most often tungsten. And don't forget to change the white balance on your DSLR to 3200K when using this flash filter—and to change it back to 5600K after you're done! You might try placing your second light up a stairway and aim it down at the bride and groom's faces as they climb "the ladder of success" (a little hokey, to be sure, but pretty nonetheless). I knew a photographer who always carried a small piece of reddish-orange gel with him. Whenever he saw an unlit fireplace, into the fireplace went his gelled second light. Brides and grooms appeared to gaze longingly at the roaring fire, when actually they were only looking at a 50 watt-per-second pop!

Setups with Three or More Lights

While a flash on your camera is the easiest and most compact way to insure properly exposed photographs when shooting moving subjects in dark rooms (like at a wedding), it is also true that the quality of such lighting leaves much to be desired. The blast from a camera-mounted flash does nothing to make your subject look three-dimensional and it often results in photographs with dark backgrounds (because light intensity falls off rapidly over distance).

A third (or fourth) flash unit lighting the background can open up new possibilities. These lights are generally called room lights, or picks, and most often they are radio-slaved, high-powered, AC strobes on 10-foot (3-meter) stands, aimed to bounce off of or just skim the ceiling. They aren't aimed at the crowd on the dance floor, but instead they flood the background jumble with light. If the room is large enough to require room lights, I try to place them inconspicuously along the sides of a room. Near an electrical outlet and away from waiter and guest traffic is a perfect location.

If you decide to set up a room light, you have to be aware of where it is placed, and you must position yourself in such a way that the room light doesn't appear in your picture or flash into your lens. Although, in truth, sometimes including the room light in your picture can add to the scene. Most importantly, you and the room light must be positioned so that the room light is illuminating the background of the picture you are taking. When I explain this to green assistants (or photographers not used to exploiting room lights), I employ the analogy of "setting a pick" in a basketball game. The pick (the room light) remains stationary, and the play develops around its position.

Many times at huge, multiple-photographer, hotel-ballroom, weddings (which I often do), another, second photography crew is responsible for setting up the room lights. If this is the case, after taking bride and groom portraits in another location, you may find yourself dashing into the ballroom (or ceremony room) with just a few seconds to orient yourself and discover where the room lights are positioned and aimed. When I'm faced with this situation just moments before the action starts, as I enter the room I'll pop the room lights with my radio-slave trigger just to see where they are. Once I see them, I choose my position. This may seem far-fetched if you are used to smallish weddings with 50 to 100 guests. However if you are photographing in the grand ballroom of the New York Hilton (which is the size of a pro football field, has 40-foot (12.2-meter) ceilings, and a wrap-around balcony) and there are 700 guests milling about, finding the room lights is no easy task.

It may seem like a big to-do, but properly using room lights will always give you an advantage, separating your photographs from those of the huddled masses using point-and-shoot digital cameras and their pop-up flashes. When I first started to shoot photographs, I worked as an assistant to a busy New York pro. I once told him that I shot only by available light. He told me that if I had an 800 watt-second strobe in the trunk of my car, then it would also be "available." The truth is that I shot by available light then because I didn't own or know how to use flash equipment. Shooting weddings required that I learn flash lighting techniques. Now I don't take out all my lights on every assignment, but when the need arises, at least I know what to do with them—and they're "available!"

© Three Star Photography

This photograph is lit by my on-camera flash, a flash unit on a pole held by an assistant, and two other AC-powered flash units illuminating the background. The end result is a photograph that looks totally different from the images the guests get with their little point-and-shoot cameras.
© Photography Elite, Inc.

Special Effects with a Third Light

A third light, like the second, can be used to create interesting effects. If used as a carefully placed room light, a third light can make a small church look like a cathedral. And you can use it not only to open up backgrounds at the reception, but to open them up for formal portraits as well. This often frees you from having to work against a wall or a drape. If you use a third light as a room light, you can set up a portrait location in the middle of a fairly large room without fear that a dark background will detract from your images. Another advantage to using a third light is that the background lit by it will be quite far away from your subject and will be slightly out of focus. That's another way to make your subject "pop" off the page.

But if an artificial background (such as a muslin) is required for more formal portraiture, a third light opens up all sorts of possibilities. Whenever my background comes out of its bag, my third light really starts to shine. I place the stand behind the background, with the flash head peeking over the top. When I put a 20-degree honeycomb grid over the head, it becomes a studio-type hair light.

One thing that usually sets studio portraiture apart from typical wedding portraits is the use of a hair light. With a background and a flash equipped with a 20-degree grid, I can make my location portraiture look more like studio work. Many shooters set the hair light's output so it is 1/2 stop more powerful than the foreground lights. But, I've found that a perfect exposure for hair light is matter of taste and also depends on the subject's hair color. With black-haired subjects, the hair light can be 1 stop stronger than the foreground exposure, for subjects with dark brown hair, I set my hair light 1/2 stop stronger than my main light exposure, and with blond or white haired subjects, I make the hair light either equal to or 1/2 stop less powerful than my foreground exposure. If you are going to use a hair light, here are a few suggestions:

1. Put a small piece of tape on the floor where your subject must stand in order to be bathed in the hair light. That way, you'll know that the subject is the proper distance from the hair light, ensuring proper exposure.

2. Hair lights are notorious for causing lens flare. If you use a hair light, investigate purchasing either a deeper or a compendium lens hood for your portrait lens (see page 166). Short hoods will not do the job!

3. If your subject has thinning hair or is bald, turn the hair light off. This is a feature most folks don't want you to accentuate.

© Michael Brook

Sometimes in rooms with a low ceiling, I will give up on the idea of using a hair light since I can't place the light as high as I would like without increasing the possibility of lens flare. It's better not to have a hair light than to have lens flare. In that case, I carry a special short light stand and put my third light (complete with 20° grid) behind my subject, aimed at my muslin backdrop or the wall behind the subject. Although not as effective as a hair light, a light placed low and aimed at the background makes a subject appear to glow!

When I first started to shoot wedding photographs I carried just two battery-powered flash units. Today, counting backup equipment, I carry five or six battery-powered flash units and three or four AC-powered studio strobes. Considering this, I have also added an assistant to my list of essentials. If you think this is the antithesis of reportage-style wedding coverage, I agree. But I have seen what *National Geographic* and *LIFE* photographers included in their kits in order to be prepared for anything. In the world of wedding photography, the real players (i.e., the busiest, highest-paid photographers) are always willing to go the extra step and if that means carrying an extra light or two, then so be it.

Stabilization Techniques

An easy way to stabilize a fully extended light stand with a heavy flash head on top of it is to hang a weight from the base of the stand. Since the flash head is often attached to a battery or power pack by a cable anyway, you can use either type of pack as your weight. Some photographers I know use wire cable to make a loop to hang the pack from on the stand; others use large key rings to achieve the same purpose; while others use all sorts of bullet-proof metal hardware designed for mountain climbing! But, in reality, you're not hanging a person (dangling over an abyss) from your light stand, but a relatively light 2- to 10-pound (.9 – 4.5-kilogram) weight from it, so a 1 foot (30.48 cm) piece of nylon rope can do the same bullet-proof job.

Hanging your power pack from your light stand has another, often overlooked, advantage. In addition to stabilizing your stand, it also raises the power pack off the floor so you can change settings without having to stoop down to get to the pack's switches. If you decide the nylon rope loop trick is for you, read the next section on knots before you make your loop.

All of these stabilization tricks require that you prepare the nylon rope and use the right knot to get the job done, so here are three things to do to insure that your knots and rope don't loosen or fray (more than your nerves).

Use a match to melt the ends of your nylon rope so it won't fray. Be very careful not to touch the melted end until it cools completely because melted nylon is VERY hot!

When tying two ends of a rope together, use a square knot because it won't slip and send your power pack crashing to the floor. A square knot is a double knot created when you place the left piece of rope over the right piece of rope for the first knot and reverse the process for the second knot (right over left). It can also be tied by starting off with the right side going over the left side followed by the left side going over the right for the second knot. Although this sounds confusing it is really a very simple kind of knot—right over left, left over right—look at the diagram below to see what a loosened square knot looks like.

The Square Knot

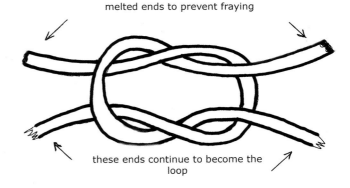

This is a sketch of a loosened square knot. It's a type of knot worth knowing about if you decide to do some rope tricks. See the text above for instructions on how to tie one.

Hanging battery packs from a light stand can be a stabilizing influence and has the added benefit of eliminating stooping to change the pack's settings.

It has been said that pro photographers often wear belts and suspenders at the same time because their hard earned experience has proven that if something can break, it will, and most times this happens at the most inopportune moment. Knowing this to be true, as added insurance against a square knot loosening, I drip a few droplets of Crazy Glue™ on my square knots to secure them forever. Two caveats are worth noting:

• Work in a well-ventilated area. Crazy Glue™ gives off caustic fumes you want to avoid inhaling.

• Don't touch the glued knot until the Crazy Glue™ is completely dry because wet Crazy Glue™ sticks to skin instantaneously.

Another situation in which a background light is worth its weight in gold is during the bouquet and garter toss. I use it to illuminate the crowd diving for the bouquet or garter that is frozen in mid-air by my on-camera flash. This is almost always a winner. Although you might not be a fan these rituals yourself, your job is to create photographs that sell, not to make value judgments about a client's tastes. These photos almost always find their way into a wedding album.

© Russell Caron

A Parting Potpourri of Lighting Tips

Using flash (or even continuous light sources) creatively is not always an easy thing to do. It requires you to think about what you are trying to accomplish and then figure out just how to use your lights to accomplish your goals. It also requires that you have the equipment and are willing to pay for and carry that equipment. On the positive side, unlike DSLR cameras, lighting equipment is basically timeless and, because light is light, a 30-year-old piece of lighting equipment can often work just as well as a piece of lighting equipment you bought yesterday. What follows are a few tips that might well help you along your journey to mastering creative lighting.

AC-Powered Flash Units

There are two types of AC-powered flash units: one has a pack that plugs into a wall outlet and a separate flash head that plugs into the pack. The second type, often called mono-lights, combines the guts of the pack into the flash head. I strongly prefer using the separate pack and flash head setup. For starts, the pack (which is heavier than the head) can be hung from the light stand to stabilize it. Secondly, when using a mono-light on a tall pole, you have to lower the stand to change the flash output since the controls are all on the flash head. With the pack and head combination setup, the switches are on the pack and always within reach.

Avoiding Red Eye

Red eye is caused by light shining into the eye through its iris, bouncing off the retina, passing through the eye's iris (again) and back into the lens. The red-eye effect is caused by blood vessels in the iris being lit by the flash's light as it passes

through the iris after bouncing off the retina, on its trip back to the camera's lens. This means red eye is a reflection problem, and the old rule "the angle of incidence equals the angle of reflection" applies here. Therefore, one good way to eliminate red eye is to increase the distance between the flash and the lens. This is easily accomplished by using a swing bracket because the bracket adds distance between your flash and lens center. Do some testing on your own with a blue-eyed friend (the worst red-eye offender) to determine just how far apart the flash and lens need to be for your setup to eliminate red eye.

Toting Light Stands

Some might say that a stand is a stand is a stand, and to a certain extent they are right, but even when it comes to light stands, thinking of your equipment as a system has advantages. No matter what kind or how many light stands you carry with you (it depends on your lighting choices), make sure that all of them have the same diameter on the mounting stud. It is too frustrating to try to remember that one light stand requires a bushing to mount a specific light and another doesn't. You'll probably misplace the darn bushing anyway, and then you'll be sticking stuff together with gaffer tape, which works in a pinch, but it's a pain. The mounting studs on all my light stands are 5/8-inch (1.59 cm) diameter, and all my flash equipment and their adapters fit this size mount. Just make sure all your lighting equipment works with all your stands and you'll be okay.

I carry four 10-foot (3-meter) Manfrotto stands (one of them has a boom feature incorporated into it), one 7-foot (2-meter) Cheetah C8 stand, a tiny PIC stand (for a back light), and four soft white Photek umbrellas—three 48-inchers (122-cm) and one 60-inch (152-cm) version. All of these fit into a soft Tenba light stand case that is slung over one of our shoulders when we walk into the catering hall. When I work "light" (with only two battery-powered lights),

I pull the Cheetah stand and one umbrella out of the case and leave the rest of the system in my car's trunk.

Cheetah Stands: I don't know about where you live and work, but one of the hottest accessories in my neck of the woods (NYC) was the RedWing automatic light stand. Sadly, the distributor stopped importing them a few years ago and soon after (when the stock of them sold out) they were nowhere to be found.

Their main advantage was the fact that they could be opened or closed with only one hand. Lift the main pole of the stand and the three outrigger legs automatically folded inwards. Place the base of the stand on the floor and the three outrigger legs automatically extended. The whole operation was amazingly simple and fast. The totally unique design let a photographer, who was working alone and holding his or her camera in one hand; move a second light on a stand around easily and quickly.

There were two versions of the Redwing stand: a lightweight, 7-foot (2-meter) model and a taller (but much heavier) model. In honesty, I bought two of the taller, heavier ones but returned them soon after purchase because they were just too heavy. However, I also bought two of the lightweight ones and they immediately became part of my kit until finally (after years of hard use) one, then the other, finally broke. I used good parts from the two broken stands to cobble up one working unit, and although it still soldiers on, it is now on its last legs (pun intended).

Last week, in the middle of four consecutive wedding assignments, I got a call from an old friend telling me that a Redwing-type light stand had been resurrected under the name Cheetah Stand (CheetahStand.com). I went to their site and immediately ordered two of their model C8s (the lighter-weight model). I can't tell you how happy I am with my new purchases! If you're looking for a Redwing-type replacement (or just a fast light stand that you can use with only one hand), this is it.

I drilled two holes through the top section of my Cheetah light stand and screwed on a hand-cut and drilled, small aluminum plate covered in Velcro to hold my radio slave. I use aircraft-style locking nuts threaded onto the countersunk flathead screws so the plate never loosens.

Using Booms

A lot of professional photographers, and other imaging and sound professionals, know all about booms. Primarily, they use booms to defy gravity and float a light over a subject's head with no visible means of support in the picture's frame. This, in turn, allows them to create a beam of light hitting the subject from above and behind that can make their subject look angelic while keeping the top of the subject's head from merging with the background.

I often tell green assistants that the goal of my lighting technique is to make my subject come alive, as though my lighting has a force all its own and, through its proper placement and intensity, can transfer that life energy to the subject. Because of how a boom can position a light, I tend to even think of it as a light modifier! Further, because

of a boom's importance to me, of the four 10-foot (3-meter) light stands I pack in my pole bag, one is a boom/light stand combination made by Manfrotto, called the Convertible Boom/Stand 420. But, defying gravity is no easy feat and there are a few safety precautions you should take when setting up a boom to be used as a hair light just in case gravity decides it doesn't want to be defied.

Always place one of the boom stand's three legs directly under the boom arm's extension. This will keep it from tipping over due to uneven weight distribution.

The longer the boom extension is, the more important it is to always use a counterweight hung from the tail end of the boom. As an aside, attached to almost all my camera bag straps are lightweight, aluminum carabineer clips that I use to hang my counterweights from. The clip goes through a hole that's drilled in the tail end of the boom and the counterweight is hung from the clip. These clips are available in most hardware stores and are both lightweight and inexpensive.

No matter what, don't exceed the weight limits of the boom you are using!

Sometimes a second weight hung from the stand's base will help stabilize the whole thing (boom and stand) to keep it from toppling over!

Even if you follow rule 4 directly, as an insurance policy, always try to position the boom's fulcrum so that the boom itself (with your light at one end and the counterweight at the other) balances at the fulcrum right over the light stand that is supporting it.

While rules 1 and 2 are imperative to follow, you might get away with not using rules 3, 4, and 5 if you are using a very light-weight flash unit such as a battery-powered, shoe-mount flash (think Nikon SB-700, Nikon SB-900, Canon 430EX, or Canon 580EX). While throughout this book, I have consistently stated that all rules are meant to be broken, here is a word to the wise in this particular instance: Don't break these rules!

For these two images, I placed a wedding invitation on a piece of layered, wrinkled, pink cloth and sprinkled the area with artificial white rose petals. The image at left is lit by a single flash unit projecting through a shoot-through umbrella, while the right-hand image has a second flash unit added and positioned so that the light's beam skims the subject's surface. While the difference is obvious, I think it is a good example of how light can give life to a subject.

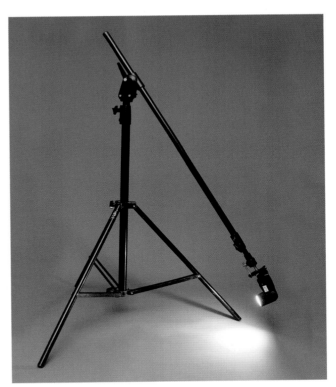

In most cases, photographers think of using a boom as a tool for positioning a hair light over their subject, but you can also use a boom to position a light so that the light's beam skims the floor. Used this way, a boom can allow you to position a light lower than any regular light stand can. Think outside of the box and use your equipment in different and creative ways!

With all of the above out of the way, let's spend a moment on another way to use a boom creatively. Manufacturers will often tell you how you should use a piece of equipment they produce but often, in my opinion, you are better off taking the manufacturer's recommendations with a grain of salt and instead try to think outside of the box they draw for you. To this end, one way to get a textured surface to really pop is to have a light skimming across its surface. But, if that textured surface is lying on the floor, getting a light positioned low enough to skim its surface is no easy task. Enter the boom that I carry with me: Instead of using it to position a hair light (as it was originally intended to do), I use it to position a light so it skims across the floor.

Relating and Selling

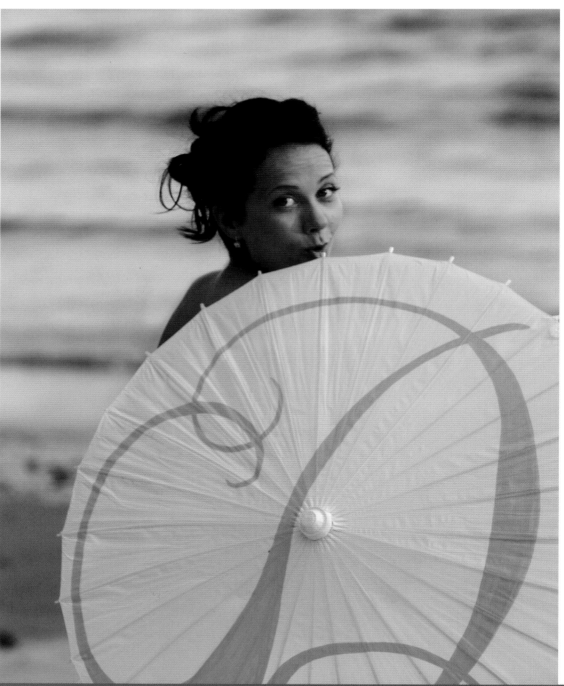

© Michael Brook

After many years working weddings and parties on a big city hotel circuit, I realized that one way to tell I was at a high-class party was the fact that the groom, the ushers, and the male family members and guests were all wearing different tuxedos. Even though the gentlemen all wore black, some tuxes were single-breasted; some were double-breasted; some had peaked collars; some had shawl collars; some had a single back vent, while others had side vents. It didn't take me long to realize that these weren't rental suits; these guys actually had tuxedos in their closets!

By the time I had been a wedding photographer for a few years, I would often joke (because it was true) that my closet contained four tuxedos, one black suit, and three pairs of jeans. Of course, I never wore the jeans to a wedding. I prefer to disappear into the crowd of guests, so my wardrobe goal was--and still is--not to stand out, nor to become the center of attention.

When he was running for president, Senator Robert Dole was the guest of honor at a thousand-dollar-a-plate fund-raising dinner hosted by a New York City corporation in the Grand Ballroom of the Plaza Hotel. The photographers who were "officially" covering the event were hired by two competing factions from within the sponsoring corporation: the advertising department and the public relations department. The ad guys contracted a noted wedding studio, and they hired me.

When I arrived at the hotel, the foyer was filled with photographers shooting the arriving guests, but once the party started, only two photographers were allowed inside the dining area for the "grip-and-grin" photos: the one representing the ad guys (me), and the other representing the P.R. guys. My assistant and I were dressed in tuxedos, the same as every male guest. The P.R. group's photographer was wearing jeans and a corduroy sport coat. He stood out like a sore thumb! Fifteen minutes into the affair, the head of the P.R. group came over to me and asked if my photos would be available to him. He'd noticed that the other photographer and I were basically duplicating shots because there was really only one subject to photograph—Senator Dole—and thus, there was no need for two photographers. Wanting to make the assignment as profitable as possible for the studio I was working for. my answer was, "Of course." Then he went over to "his" photographer—the guy in the jeans and corduroy jacket—and sent him home! Since the P.R. guy hadn't seen either of our photos, I've always felt I was kept on that assignment because I blended in with the crowd and the other photographer didn't.

© Russell Caron

Relating to Your Customers

When it comes to weddings, everyone involved strives to look their absolute best, especially the bride. Professional hair styling and makeup applications are the rule rather than the exception, and much thought is put into the choice of attire—not just for the bride, groom, and wedding party, but for the members of the immediate family, as well. Every aspect of the day, from the invitations to the dessert table, is planned and re-planned with an eye toward perfection. With everything and everyone looking nearly flawless, delivering great photos of these "perfect" subjects suddenly seems more doable.

So, why concern yourself with the interpersonal relationship side of the equation? Without rewriting Dale Carnegie's book *How to Win Friends and Influence People* (which is valuable reading for all who want to shoot any kind of people pictures), there are some aspects of interpersonal communication that I have noticed can really make or break things with a client. Knowing which of your actions to cultivate and which to avoid are the keys to running a successful wedding photography business, whether as a candidman or a studio owner.

Positive Energy Is Contagious

I once shot a wedding the day of a huge snowstorm. Around 50 of their confirmed guests didn't make it to the wedding due to the weather, and the rest of them, plus the band and the photographer (me), trudged through the blizzard to get there. I made sure to get a few pictures of the couple in the snow, pointing out that it made their wedding unique, and in 20 years it would be a great memory. I also pointed out that the guests who did make it had to love them dearly to come, and that they were lucky to be surrounded by such supportive friends and family. It was a great party and the band played "Let It Snow! Let It Snow! Let It Snow!" more than once that afternoon.

Every situation has both negative and positive components. At almost every wedding something will happen that will challenge you—and everyone else—to respond with positivity. Don't ever let a minor quirk of nature or human behavior get you or your subjects down. Instead of saying, "This ruins everything!" try saying, "Boy, this will be very funny... next week. But right now, let's make beautiful pictures!" You are acknowledging that whatever happened is a drag, but you are also pointing out that the joy of the day overshadows the snafu.

Six Secrets for Relating Well with Your Clients

Here are some concrete things you can do to make yourself a pleasure to work with. Remember, if every wedding you shoot can generate three recommendations without these prospective customers even seeing your photographs, you will soon be a very busy photographer, so these ideas are well worth the effort.

Cultivate a Positive Attitude: There is a reason that the edict "Do unto others as you would have them do unto you" has remained a philosophical cornerstone for many. Practicing the Golden Rule is one thing that helps you become a great people-person. If you can apply this principle to your business, you'll be on the right track.

In this business, a negative attitude is totally counterproductive. Without being saccharine, you can make it part of your style to always see the bright side and be positive. Of course, underlying this is the assumption that you like people. If you don't like people, you should question your career choice!

Make it your goal to accentuate the positive and eliminate the negative, not only in wedding photography, but in everything you do. While this might sound simplistic, it really does work; you can apply an optimistic outlook to almost all aspects of life. Winners (in both life and wedding photography) see the roses, not the thorns. This doesn't mean you are oblivious to the thorns; it just means that you are focused on the roses.

Know When (and How) to Exert Control: During my early days as a wedding shooter, the first photographer I assisted told me repeatedly that great wedding photography was a matter of control. I would say, "Yeah, yeah. I understand," but I really didn't. Later, when I moved into commercial photography (though I continued to shoot weddings), I learned that most advertising pictures are rigidly controlled. A photographer in the studio, sweating over a still life, must examine everything in the frame. Even if something in the frame is not central to the composition, the photographer must examine it and make a conscious decision about how they want it to appear in the final image.

This extreme type of control is not always possible at a wedding. Most novices, when first trying to exercise control over their subjects, can be rather heavy-handed. They raise their hand and demand that the world stop for them. If you can get past that rigidity, you'll realize that, while you might think you want total control, what you're really after is a controlled situation in which the subjects are free to express themselves.

Let me draw an analogy. Imagine a bird, softly enclosed in a hand. At the right moment the hand relaxes its grip, and the bird is free to fly. But the softly enclosed hand was so comfortable that, after the bird does its soaring, it chooses to return to the hand. In the same manner, you want to gain control of your subjects in a way that is comfortable to them. You want to release this control, allowing their natural expressions to be recorded, and then regain control of the situation once again. While all this sounds very Zen-like (and it is), it does make for successful pictures and happy subjects.

Memorize the Important Players: Before every wedding, I make it a point to find out from the bride and groom (or their parents) who the important players are. I like to know how many siblings the bride and groom have. I also ask about grandparents, godparents, aunts, uncles, and cousins. In fact, I want to know about anyone who is important to the couple or their parents—a best friend, a boss, anyone. Once I have this information, I make it a point to use it as I work. If the mother of the bride mentions that she is particularly close to one of her brothers, I'll go up to her sometime during the party and say, "Is now a good time to get a picture of you with your brother?" Mom beams. After all, I listened to her. I paid attention to the details and remembered them and, chances are, when her next child gets married, she'll remember me!

Remember Names: One thing you can do to make your customers feel at ease is to remember their names. If you say to the bride, "Bride, take a step to your left," she is not going to feel very special. If the parents (whom I always initially call Mom and Dad, or Mrs. Smith and Mr. Smith) tell me to call them by their first names, I always express my thanks. I make it a point to remember people's names; I consider it a sign of respect.

Whenever I do a portrait, the first thing I say is, "What is your name?" From that moment on, any direction I give is always personalized: "Mary, snuggle up to John." I even try to remember names of siblings and bridal party members.

Rein in Troublemakers: Every now and then there is one member of the bridal party who is a troublemaker (and it is almost always a guy). This person is never interested in being photographed or doing what the bride and groom want. Usually his goal is to get to the bar at the reception as quickly as possible. If left unchallenged, he tries to become a ringleader, intent on reducing the day to a drunken, bleary-eyed non-memory. Controlling such a person is difficult, but it is easier if you know his name. I make it a point to direct some of my comments to him while shooting pictures that he's in. Very often I'll say, "Let's do a picture of all the ushers. I promise to make it quick, Lou!" You have to be cautious with this tactic, though. I want to isolate him from the crowd, but I don't want to antagonize him, so everything I say is done with a smile, and I never attack him personally. As a last resort, if there is a person I just can't seem to control no matter how hard I try, I do the pictures that include him first then let him go drink his beer in the limo while I finish the other portraits.

Avoid Saying No: Ideally, the word "no" should be eliminated from a wedding photographer's vocabulary the day he or she shoots the wedding. On that day, this is the last word any bride wants to hear. "No" is a powerful word, and it puts an end to almost any further communication the moment it is uttered.

Even if the couple (or a parent) asks you to do something impossible at an inopportune moment, you still shouldn't use that word. You might say, "That's a great idea; I'll fit it in later," or "Absolutely, I'll remember to get that," or anything else that will keep the lines of communication open. Even though your clients have hired you for your expertise, they are still the ones paying the bill, and almost any request of theirs deserves to be honored. Besides, if a bridal couple makes a specific request, it is almost always destined to become a sale (they want it!). Even if you think an idea is ridiculous, the cost of time and material to try it once is well worth the goodwill it maintains between you and your clients.

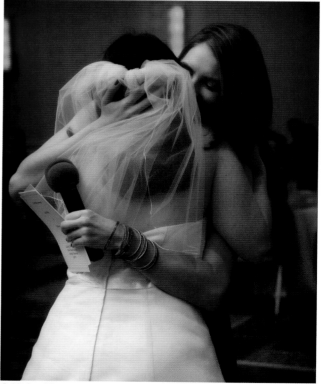

© Michael Brook

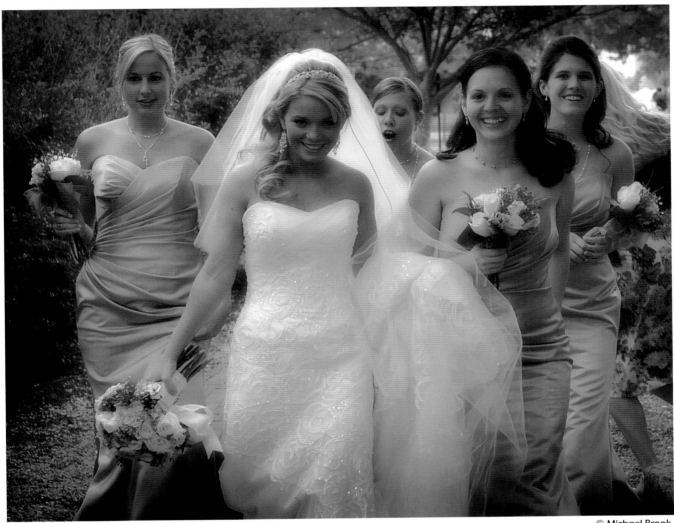

Selling

Selling the job is really a two-pronged effort, and is another place where your interpersonal skills are put to the test. First you have to sell your potential customer on the work you do so they will agree to contract you for the assignment and make an initial order. Then, when the proofs are returned, you have to sell your customer on purchasing extra pictures. The second sale will never happen if you're not successful at the first, but without that second sale, the wedding photography business is not very profitable. Therefore, each of these two parts holds weight.

Securing the Assignment

Success at the selling game is not easy, but there are some rules that can help you. If you have a natural "gift for gab" (which is almost a requirement for being a successful wedding photographer), the battle is almost won, but let me offer you some other ideas to improve your percentages. Obviously, you should be dressed neatly and have clean, well-organized samples to show, but also consider the following.

Sit at the Kitchen Table: When you visit a prospective customer, try to describe your services and display your work at the kitchen table. Although

this may seem like an odd suggestion, I have found that most important family decisions are made at the kitchen table. While the living room is reserved for more formal meetings, people let their hair down in the kitchen, and it is easier for the customer to treat you as a friend (instead of an adversary) there.

The table also allows you to sit opposite the customer and look them straight in the eye as you make your pitch. However, be careful not to allow the table to become a barrier between you. I circumvent this by always bringing two sample books with me, and while one side of the table looks at one book, I invite a family member to my side so we can view the second book together. My invitation is usually made to the mother of the bride because I try not to break up the bride and groom and, quite frankly, I've found that most fathers are more interested in the bottom line (cost) than the quality of my work. Besides, if Mom likes you and your work, she will often cajole Dad into spending a little more than he planned.

Determine Who Is Buying: Generally, there are two possibilities as to who will be paying your bill for photographing a wedding. Either set of parents could be laying out the money, or the newlywed couple might be buying their own photographs. While it doesn't really matter who is paying the tab, there is a difference in how each of the prospective customers sees the resulting transaction.

For a moment, put yourself in the position of the father or mother of the bride. Your child is getting married. She is dressed and quaffed to the nines, and you love her. Parents don't really see the bride (or groom) in the harsh light of reality; they see their toddler's first steps, school graduations, happy family dinners and holidays, sports team victories, and a slew of other fond memories. They also see the beginning of the end of their parental responsibilities, a feeling of freedom on the horizon,

and a continuation of their bloodline. These are easy people to please! In fact, other than your bill, you are giving these people nothing less than the best memories of their lives. Now, step back into your shoes as the photographer. If you present pictures that are sharp and centered, chances are good that the parents are going to love them; after all they already love the subject. These people are an easy sell.

As for the couple, brides can be a much more difficult sell—and it is almost always the bride you will be selling to. Grooms tend to go with their brides when it comes to aesthetic choices, of which your photography has become one. Often, brides may go overboard looking for the photographer who can give her the most bang for her buck. Another point to consider is that her pockets may not be as deep as her parents', and any suggestions you can make to ease the financial burden will be appreciated. You might suggest that she ask her parents to pay for their own albums, or offer to start her out with a minimum package so that she sees you're interested in saving her money. If you come across as someone she can trust, she may be willing to follow your lead.

When selling to a bride, mentioning that you are creating an heirloom that will have great value in the years to come sometimes helps, but often it isn't enough. What does work, in my experience, is the idea that you are producing a very personal thing for her and that the two of you are working as a team with that goal in mind. The bride has to feel that you are extremely interested in her unique needs and that you will work tirelessly toward meeting them.

Finally, never overlook mentioning any weddings you've shot for her friends or other family members. In this case, peer pressure can be used to your advantage. Overall, I feel that brides are more difficult to sell to than parents, but it is certainly still possible!

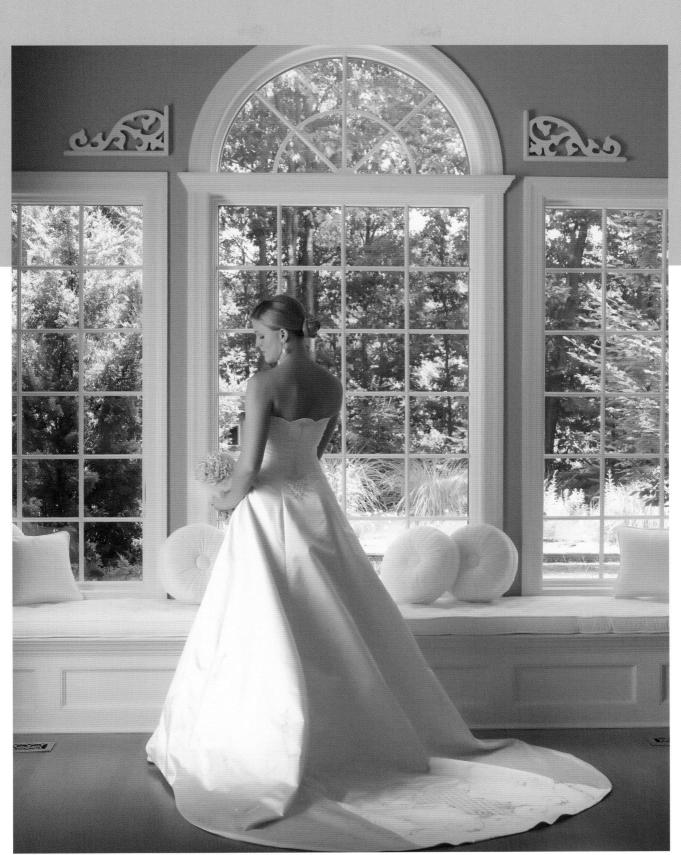

© Botticelli Studios

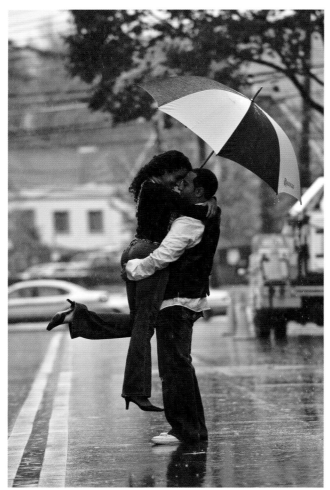

© Freed Photography

Listen Carefully: The customer will tell you what they are looking for. They say things like, "I don't want a pushy photographer," or "Family pictures mean everything to me," or "I don't want to miss the cocktail hour." Remember those words and, some time later in your pitch, throw them back to the customer. As you describe what will happen at what time on the wedding day, you might say, "I would like the immediate family to come to the park with us for the family pictures so I don't have to act like a pushy photographer at the reception," or "Tell me who is in the immediate family so I'm sure not to miss anyone," or "Let's plan on doing the family pictures after the main course so we won't have to spend valuable time doing them during the cocktail hour." Although this might seem insincere, in reality, you are simply acknowledging that you

are listening to them and are willing to meet their needs. All wedding coverage should be tailored to the customer, and you're just saying, "If you want it that way, that is how it will be!"

Take Notes: When my potential customers outline what they want, I make a minor show of writing it down. I want them to see me doing it, and I question them about what I've written down so they can make sure I've got it right. I tell them that I'm going to attach the information sheet to their contract so I'll be sure I won't forget. This has two benefits. One, my information sheet assures the customers that I'm catering to their individuality and that I care about their desires; two, by saying I'll keep it with their contract, I've broached the subject of there being a contract. Once they start giving me specific information, we are both beginning to work on the assumption that I am their photographer, and this assumption will make closing the deal easier.

Don't Get Technical: Belaboring the technical side of your photographs when showing your samples is a sure way to turn off your customers. Don't dwell on how you got the shots. Other than another photographer (or an avid amateur), no one is really interested in what f/stop you used to take a picture. Ask your potential clients about the day, the gown, the flowers, the church, the park, the reception—anything they can relate to—and only mention technical considerations in passing.

Ask for the Assignment: It is amazing to me how many photographers never tell their prospective customers that they want the job! You have to ask them to give you the assignment. People hardly ever say, "I'm sold!" So, at some time near the end of your pitch you have to say something like, "Look, you seem happy with me and my work. Can we wrap this up now? I would love to be your photographer!" Now comes the tricky part. They'll probably say that they have to check with other photographers, or maybe even refuse you outright. Do not get

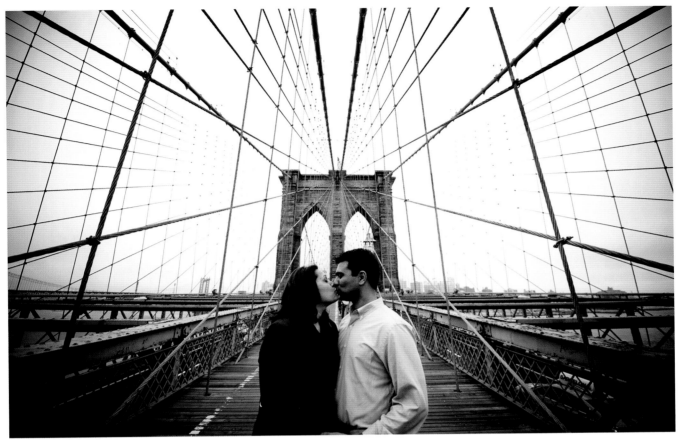

© Freed Photography

discouraged. Many great salespeople will tell you that the real sell doesn't start until your prospective customer says no!

Offer Incentives: If the customer turns you down, you may be able to snatch victory from the jaws of defeat by offering an incentive. Look your customer right in the eye and say, "I really want to shoot your wedding. If you're happy with my work, what would it take to close the deal right now?" Sometimes, lo and behold, the customer will say, "Well, XYZ studio offered us two extra portrait prints and 100 photo thank-you cards in their package, and because we're on a tight budget, that may become important to our decision." If you know what it takes to get the job, then you can decide if the incentive is worth offering based on what kind of profit you would make on the paid portion of the job. In other words, if this prospective customer is talking about purchasing three albums and a video (which have a high profit

© Jerry Meyer

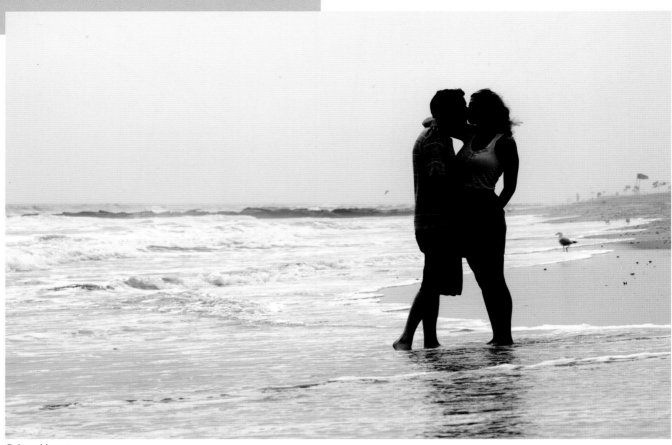

© Jerry Meyer

margin), two portrait prints and 100 thank-you cards are a cheap price to pay for their signed contract. If they're considering a minimal package (without much profit), you might say you're willing to split the difference and offer the portrait prints but not the thank-you cards. Splitting the difference might work even for the more expensive sale, too, because customers aren't always truthful about what they were offered by your competition.

Offering an engagement portrait session can be a great way to entice your customers into closing the deal. However, it is only a good incentive if the couple knows what the portrait is worth. To that end, I will often make a point to mention earlier on in our discussion that I can do an engagement portrait session for an additional $250. I list and describe the related services they will receive for that price, knowing full well that I might offer it up for

free as a deal closer. Doing an engagement portrait session can also be good for you because it gives you a chance to work with the bride and groom before the day of the wedding to get a sense of how natural they are in front of the camera and how they relate to each other. I suggest that you practice on friends and seek out beautiful outdoor settings in your area before offering this incentive to your customers.

Whatever happens, be aware that the last photographer a prospective customer sees is usually the one he or she signs with, so you want to do everything in your power to close the deal when you are there. Just be aware that, if you give away too much, your generosity may come back to haunt you. Other client recommendations that come from this job might ask for the same deal.

A Few Incentivizing Dos and Don'ts

1. Avoid offering your incentive portrait session as a "test session" before the client contracts you to shoot their wedding pictures. The incentive is that this specialty extra session is theirs for free if—and only if—they sign the contract with you. Otherwise, you are giving away a portrait session for nothing in return!

2. Don't give away an engagement portrait session if you have already offered another incentive, such as matching another photographer's price, offering free photo thank-you cards, or taking a percentage off your price because the clients are your friends. You don't want to risk the assignment becoming unprofitable.

3. Consider offering a menu-type list of incentives from which your customer can choose. Maybe even let them choose, say, two of the five you list. Some people will appreciate having options. That said, I have found that incentives seem to be most effective when they are offered up one at a time. If you can close the deal by offering one small incentive, then why start out offering two? You will need to carefully plan out which incentives can stand alone and which can be offered as a pair, all depending on the tangible savings you can show to the client and, of course, the costs on your end.

4. If you do an engagement portrait session, keep your tone and style light-hearted. In other words, make the session fun! Invest careful effort in pre-production with the couple and discuss wardrobe, makeup, hair styling, even the location and time of the shoot because, unlike the wedding day, you can have some control over these things.

5. The last thing you want is for the bride and groom to consider your test session a reason to cancel the contract they have already signed. If for some reason they are so unhappy with your results that they want to cancel, call up any pre-production elements you established that they may have balked at and explain how everything will be different and more perfect on their wedding day.

© Russell Caron

© Michael Brook

Get a Retainer: No matter what you think, until you have a retainer in hand to reserve the date, you haven't completed the sale. You can be absolutely sure the customer is yours, but without a deposit, it just isn't so. Some customers will tell you that their word is their bond, and no deposit is necessary once you have their handshake on the deal. Forget it! Even a first-year law student will tell you that without an exchange of something of value, your contract, even though it is signed by the customer, is nothing but a piece of paper. If the customer decides to renege on their commitment to you and hire another photographer, it won't be worth the time, energy, and expense of taking them to court to force them to pay for the job they agreed to. Besides, you'll lose anyway. The judge will point out that you never produced a single wedding picture for these people, and throw it out of court. (See page 260 for more details about securing a retainer.)

Building Your Order

Unlike the first sell, the proof return has a different set of sales goals. During the first sales opportunity, you may have offered incentives to secure the job. When the proofs are returned, however, your object is to maximize your profit. An analogy might be a builder who throws in the kitchen sink to get a signed contract but then charges the customer for the plumbing and hardware required to make the sink functional.

The proof return is the time where you enjoy the fruits of your labors. I usually begin by letting the customers show me their choices of what to include in the album before I make any suggestions. Once they've shown me, I arrange their selections in a loose, chronological order and then start to look for holes. It's amazing but true that, often, couples leave out entire sections of their wedding day from their picture selections. These obvious gaps are some of the easiest sales to make. For instance, the bride might select a picture of her dad walking her down the aisle, and her next choice is a picture of the newlyweds getting into the limousine. All we have to do is look at the two images and usually we both just laugh out loud. Sliding in a few photos of the ceremony is an easy sell!

On my next go-through, I pick out all the single images for which I shot a matching second image. Sometimes, the bride forgets to include a picture of the groom's parents alongside the picture of her parents, for example—another easy sell. Look back through the repertoire section (pages 48 – 113) for other image sets I suggested, such as the bride dancing with her father as a match for the groom dancing with his mom, or the selective focus shots of the bride and her parents mated with the same shot of the groom with his parents. Any album order can be built up nicely with these image pairs.

Finally, check to see if a portrait with one sibling was selected but not another. It is an easy step to have most couples include photos of the other siblings once they've included one. Again, review my wedding repertoire and note every place I claimed something was a sure-seller. If the bridal couple hasn't included one or more of these top sellers, be sure to suggest including them in the album.

Lastly, take a final spin through the unselected proofs and pull out any images that you feel look great and ask the couple if they might be interested in those. You might point out that while the food has been eaten, the band has gone home, and the flowers are wilted, your pictures remain as the only permanent memory of the great day, and your product is the only one they are purchasing that will become more valuable as the years pass. While you are at it, remember to suggest purchasing a picture of the bridal party for each party member. If the proof return happens at an opportune time of the year, the idea of pictures as holiday gifts for family members is another idea worth mentioning. Some photographers also offer framing services for gift prints, and that is another way to maximize profits.

Plan Your Presentation

As in the entire wedding photography game, presentation is important. Because big prints are very profitable, some studios work with a digital projector and project huge images into blank frames so the customer can get an idea of how the photograph will look on the wall at home. Obviously, if you go this route, framing can be a very lucrative sideline worth investigating. One way to insure success at this is to make sure to take at least a few images to fill that big frame. As you shoot pictures on the wedding day, keep your eyes open for any grand scenes into which you can incorporate the bride and groom.

© Russell Caron

Get a Deposit

The last part of the proof return requires you to total the remaining bill and get at least half of it as a deposit. You should not start to produce the wedding albums without this final deposit. Some couples will rush to give you the print order and then disappear for a year as the finished albums languish on your shelf. Don't let this happen to you! All production costs should be paid with the customer's money. You are their photographer, not their banker.

Consider Finding a Sales Partner

Selling is so important that it can make or break a wedding studio's success. Oddly enough, many excellent photographers are terrible salespeople. If you find that selling is not your cup of tea, you can still be a studio owner. Photographers who are not great salespeople can actively look for an exceptional salesperson to handle that side of the business for them. If you find that person, consider forming a working relationship with him or her. Many novice photographers first build a wedding studio business to 100 weddings per year (about $200,000 to $500,000 gross) and find a salesperson at that point. That then allows the business to grow to more than 300 weddings a year (up to about $1,500,000 gross).

Finding Work and Generating Leads

Getting your very first "real" assignment will be the most difficult because you will have limited samples to show, and without samples, it is hard to demonstrate the quality of your work to a stranger. Therefore, for most new wedding photographers, the first few assignments will probably come from family and friends. On these assignments, it is imperative to do your best because these photos will become the basis of the samples you need to establish and expand your business.

Remember that every bridal party is brimming

© Russell Caron

with potential customers. When I suggested in the wedding repertoire that you include pictures of unmarried couples in the bridal party, I had an ulterior motive. These portraits can lead to future assignments! If you do a good, conscientious job and are a pleasure to work with, each wedding can produce more leads for future business.

However, growth by word of mouth is a very slow process. While these assignments and the leads they generate can slowly build your reputation and your client base, there are additional things you can do to help accelerate the growth of your business. The following are some other good ways to generate new work.

Become Active in the Community

In all likelihood, local religious and spiritual leaders are the first people in the community to know about upcoming weddings. Although you can't turn them into your sales force, you can meet with them and introduce yourself. You might consider offering your photographic services (for free, of course) at a church function. You could also participate in community bazaars or even donate your services (providing a family portrait, for example) as a prize in a raffle.

Befriend Local Caterers

Caterers are the big fish in the wedding business pond. All the other suppliers, including photographers, are the pilot fish that swim around these behemoths. Caterers are always in need of photographs that show off their talents. Not only do they need pictures of their food presentations, but they also need pictures of their facilities to show prospective clients. Some upscale caterers create beautiful individual dishes—or even ice or fruit sculptures—that are each worth a picture. While at a reception, shoot some pictures of these unique items, then make some prints, dress neatly, bring your business cards, and pay a visit to the caterer. It pays to remember that there are many ways to form symbiotic relationships within the industry, and these relationships can help ensure success for all concerned.

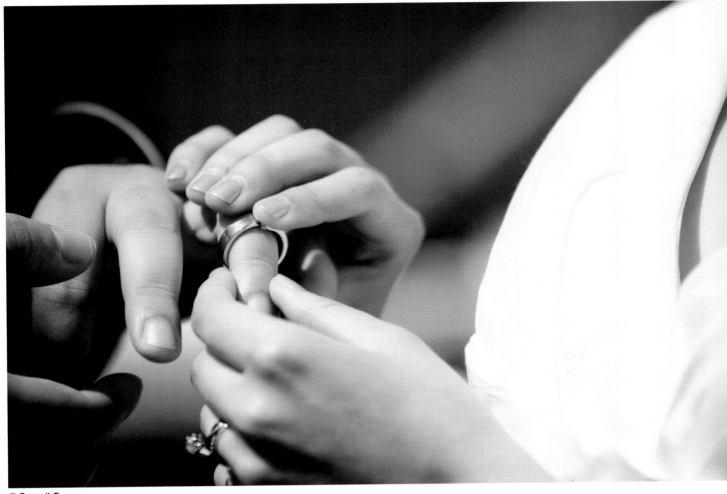

© Russell Caron

Befriend Other Wedding Suppliers

Florists, dressmakers, bands, makeup artists, hair stylists, and limousine companies also need pictures to advertise and develop their businesses. Providing these people with free samples of your work—which shows off their work—is always a good idea. Very often, these businesses don't have sample pictures of their work. If you make a point of seeking them out and giving them a nice-sized print that shows off their artistry, you've made a friend who can recommend other customers to you. Without being heavy-handed, explain that you are also on the lookout for new wedding clients and that you would appreciate any leads. Offer to shoot pictures for them from time to time and ask if they could pass around your business cards when appropriate.

As I said earlier, success in the wedding photography business requires relating and selling skills that are at least equal to your photographic skills. Some even think (and I tend to agree) that relating and selling skills are more important than photographic technique. Most photographers like to take pictures, but it's the relating and selling that can guarantee your success.

Pricing and Packages

It was after midnight and I had just finished shooting a wedding at the Rockleigh Country Club. It was a beautiful place. To enter, guests had to walk over a covered bridge spanning a small stream. Spotlights dramatically lit the main building, and spigots threw arcs of water from each side of the stream that landed on the opposing banks. The water jets on the opposing banks formed an archway of water that the guests marveled at as they crossed the bridge to join the party. After loading my car, I leaned against its hood, undid my tie, smoked a cigarette, and marveled at the scene in front of me. My quiet moment over, I ground out my cigarette and pulled out of the driveway, which was flanked by ornate wrought-iron gates.

I was tired, but the cool October breeze felt good. I got on the highway and found myself driving a little too quickly when I saw flashing lights in my rearview mirror. Cursing to myself, I pulled over as my mind raced to prepare a story. After all, it was well after midnight so I couldn't use the "I was late for a wedding" excuse. The trooper pointed his flashlight in my face and asked, where did I think I was going? I said, "I'm sorry, officer. I know I was driving a little over the limit. I'm a wedding photographer and it's been a very long 12-hour day." He smiled and said: "That's okay. Do you know who I am? You shot my sister's wedding two Saturdays ago, and you did a great job!" I smiled with relief and replied, "Thanks for mentioning it. You're welcome!" He placed two fingers against the big brim of his hat and told me to drive carefully and take care. I guess it always pays to shoot the best job you know how to shoot.

© Chantal Gauvreau

© Botticelli Studios

The goal of any business is to make a profit. Profit is quantified by the difference in price between what the product cost you and what you are able to sell that product for. And don't forget, in the case of the wedding photographer, there is much more that goes into the cost of creating a final image for sale than just the time needed to take the photographs. From camera, lighting, and posing equipment, to computer hardware and software, printing, proofing, and binding costs, office rent and supply expenses, car expenses, business insurance, medical insurance, retirement planning, and, of course, your valuable time, wedding photography is not just an enjoyable pastime; it is a business endeavor.

Some newcomers to the game think their expenses are limited to the cost of their camera equipment, computer, storage hard drives, memory cards, making prints, and binding albums. This kind of thinking will doom you to failure... or at least to a life of eating gruel. Since gruel is not too tasty, it pays to take the time needed to define your expenses in order to maximize your profit.

Time Is Money

Before we review the concrete costs of producing photographs for weddings, it is important to realize that one of the key items you are selling is your time. How much should you charge for your time? There are several factors that should come into consideration as you make this decision. For starters, how much time do you actually have, and how much money do you want to make? Everyone always answers that they want to make "a LOT of money!" Obviously. But for a more specific answer, you first must figure out some other things. How many hours can you dedicate to work at wedding photography per week? How many in a year? Before you answer, consider these facts:

• Booking, shooting, selling, and producing a set of wedding photographs takes almost four times longer than the six to twelve hours you spend shooting during the typical wedding day.

• About the same amount of this "non-shooting" time is required whether you spend two hours or six hours shooting an assignment.

• You can't shoot wedding photographs 40 hours per week, 50 weeks a year.

Completing an Average Assignment

Let's look at each of the points outlined on the previous page in more detail. To start with, how long does it actually take to complete an average assignment? Here are the tasks involved in actually delivering a set of wedding photographs, with the approximate timing of each task noted. Please note that the times listed here are just estimates. Certain things may take less time than you expect; other things may take much more time that you expect.

As you can see, the starting-point estimate for the time needed to produce an entire assignment is more than quadruple the time it takes to just shoot the pictures. I have heard some photographers claim that they can book an assignment in 15 minutes. This is certainly possible, but hardly common. Others use an FTP (file transfer protocol) site to send their files in for printing, claiming it only takes 15 minutes to upload the images. This, too, is certainly possible, but I have found that the length of time files take to upload depends greatly upon the computer from which you are uploading. In other words, you would be safer to budget out a longer period of time and be pleasantly surprised if it takes less than you thought. Otherwise, you could be sitting in front of a computer for hours waiting for your files to upload and cursing the mention of an FTP shortcut!

Every photographer has his or her own system and own special set of circumstances. Make up your own time sheet and see what you come up with. You might also consider the time it takes to buy, test, repair, and organize equipment, clean tuxedos (not to mention buying them), choose samples of your work, make those samples into prints, and do your paperwork.

Task	Time
Book the job (sell your services)	3 hours
Preparing for the shoot (day of the event)	1 hour
Travel to the shoot (for weddings within a 50-mile—or 80.5 kilometer—radius)	1 hour
Setup time	30 minutes
Shooting time	6 hours
Breakdown time	30 minutes
Travel back from the shoot	1 hour
Download, backup, and store images; deliver (or FTP) files to lab for proofing	3 hours
Check proofs, cull rejects*	1 hour
Review proofs with customer (sell your products)	3 hours
Prepare selected files for printing	1 hour
Deliver files to print lab; pick up from the lab	1 hour
Check prints	1 hour
Organize and number prints	1 hour
Deliver or send prints to the bindery; pick up bound albums**	1 hour
Deliver albums and prints to customer	2 hours
Estimated Total Time	29 hours

*Some photographers do this before they send out files for proofing. I usually skip this step because I want my clients to see every picture I've taken. Sometimes, a client likes a picture I would have culled.

** Most high-end binderies take 4 – 8 weeks to produce an album.

© Botticelli Studios

Figuring out what to charge and how to collect your money are among the most difficult and most important parts of the wedding photography game. Putting aside the collection aspect for a moment, let's start by looking at the smallest unit of your product—the print. An 8 x 10-inch (A4) print can be purchased for between two and five dollars and easily resold for many times that amount, but I am of the opinion that there are other costs that should also be reflected in your print prices.

Processing and proofing time needs to be accounted for. Let's say you shoot 10 - 15 images of the bride and groom cutting the wedding cake (see page 112 for details). When the couple returns the proofs, you find that they've chosen only one cake-cutting picture, and no amount of your cajoling or salesmanship will make them include an additional rendition in the album. In this instance, the actual cost of the one print that sold needs to reflect the cost of the print itself plus the cost for proofing the 10 - 15 total cake-cutting images—which almost doubles the cost of that one final print when you're talking about proofing the 14 other prints that didn't sell. An even more horrid example (from a profit standpoint) is when you shoot 60 portraits of the bride and she narrows her selection down to her two favorites—one full-length and one close-up.

In summary, the total cost of the prints you do sell needs to reflect the time and money spent on all the rejected proofs as well as the time it takes to massage that one chosen image to perfection in an image-processing program. But, it doesn't end there. You are also entitled (and essentially required) to make a profit if you want to call what you are doing a business.

My advice is to include the cost of proofing about 15 images in the price of one final, purchased print. In the digital age, I have found that the ratio between pictures taken and pictures actually selected for purchase is about 15:1. This difference was much smaller in the film days, but photographers are shooting more now (because many make the mistake of thinking that digital shooting is free—see

The Minimalist Option

In order to break into the market, some photographers offer minimal wedding coverage at minimal prices. This creates several problems. No matter how short the actual shooting time, the selling and production work remains about the same. When you contract for short assignments at low prices, you end up using a disproportional percentage of time on non-shooting responsibilities. This lowers your profit. Additionally, by offering the short, low-priced option to your customers, you run the risk of committing to a small, low-profit job on a day when you might otherwise have worked a big, lucrative assignment. Furthermore, if you offer the low-priced alternative, you leave the bigger assignments for your competitors, and in wedding photography, bigger is better—or at least more profitable.

page 20). While there are instances where one image will yield an order of six or more prints (such as a family group shot, or the entire bridal party), these images are few and far between.

If you are going to use paper proofing, I have found that a color-corrected proof costs between 19 and 35 cents. While some might consider the cost of one single proof negligible, you also must be aware that each extra image you proof adds to your downloading and backup time. It also takes up more room on your memory cards (meaning you'll need more cards), more space on your hard drives, and means more CDs and DVDs, as well. This, in itself, should be a sobering thought. Every time you push the shutter button, it costs you much more in time and hardware than the simplistic 19 to 35 cents for the color-corrected proof!

Size and Format Affect Price

While most photographers sell rectangular prints, from a profit standpoint, you might look into selling square prints. Most labs will make a 10 x 10-inch print (25.4 x 25.4 cm) for slightly more than an 8 x 10 (A4), but a photographer can sell that same print for 50% more than a traditional 8 x 10. While this may represent an increase of only $10 for a single print (my price goes up from $20 to $30), the extra profit can really add up when you consider that an album contains anywhere from 50 to 75 prints. If you add an extra charge for a book in 10 x 10 binding (as opposed to 8 x 10), the profit rises even more.

More Per-Print Costs

As a pro, you can't just hand your client a stack of loose prints. Presentation is part of the game and adds value to a seemingly simple piece of paper. The cost of a folder for each print can range from fifty cents for a simple cardboard folder up to almost two dollars for a heavy stock, lightly textured, feather-deckled edge, gold-embossed, cardboard Cadillac—which is my studio's choice. Add 10 to 25 more cents if you decide to have your studio name and phone number imprinted on each folder. Spend some time with an album catalog to decide in which type of folders you want to use to present prints to your clients in. (I use TAP folders from Albums Inc.: www.albumsinc.com).

Also, be sure to include any other print-finishing costs in your calculations. Examples might include lacquer spraying and texturing of your final prints. Special finishes can add a dollar or two to your final print cost. That brings your bottom line for an 8 x 10 (A4) print up over $7—a total that reflects only your materials and actual printing costs, not the cost of the equipment used to make the original file, nor your time, nor your profit.

Include Your Labor Costs

You must consider how much time it will take you to download and back up your files, work on them in an image-processing program, order prints, pick them up, review them, have the prints finished, organize and insert them into folders, and deliver them to your client. It doesn't matter whether you or a staff member performs these tasks, nor does it matter whether completing these steps just means delivering the file to an outside supplier. It still takes time, and as you now understand, time is money!

I met a young wedding photographer at my lab a few weeks ago. She was cursing the digital age and complaining that it took her dozens of hours to color correct all her files before submitting her images to the lab for proofing. Listening to her lament, two things immediately crossed my mind:

It is of the utmost importance to get your technical act together. Good photographic technique makes good business. If I have to spend 12 hours (or more!) cleaning up image issues that should have been dealt with in-camera at the time of shooting, I am losing 12 hours of time in which I could have shot (or booked) two more weddings!

Thanks to honing my shooting technique, I don't feel the need to correct any of my proofs before my client sees them. I have three reasons for this. In the first place I think it's a waste of time to perform minor corrections on 1,000+ image files when I know my client will only choose about 100 of them. Secondly, I want my final prints to look better than my proofs! If I correct all my proofs before the client sees them then, other than size, what's the difference between a proof and a finished print? Finally, I get pleasure from telling a client that is concerned about an image being too dark or too light or too yellow or too blue that my image-processing skills will eliminate any areas of concern. It makes my final prints more valuable than the proofs.

Don't Forget Car Mileage

I can't even count the number of times a beginning photographer has told me that sending CDs, DVDs, or prints to a customer costs only the price of the postage and the envelope. Obviously, it takes time to put the prints (or disks) into the envelope, insert protective cardboard into each envelope, and write out the address, but he or she never mentions the drive to the post office and back.

It's a sad but true fact that every time the odometer on your car clicks to the next mile, your car is one step closer to needing a repair, one step closer to being replaced, and worth a few pennies less when you try to sell it. Big companies understand this and calculate an expense of approximately fifty cents for every mile traveled by car (which fluctuates over time and from business to business according to gas prices and other factors). Why companies (and the government) can understand this and photographers can't is beyond me.

Test it out for yourself. Pick a busy week (or month, or even six months) and keep track of all the miles you put on your car while doing photographic legwork. Remember to include trips to the camera store, the lab, the post office, the bindery, prospective clients, other wedding suppliers, the cleaners to drop off and pick up your wedding outfit, and travelling to and from assignments. Add the miles up and multiply by .50. The resulting dollar amount will be what is needed to operate your car for the period of time you documented (a week, a month, etc.).

Furthermore, this estimation is for an average car. If you drive a big SUV in stop-and-go city traffic, the price per mile goes up rather quickly. In fact, you might want to keep receipts for everything car-related along with a business mileage log. Itemize your expenses because you'll probably spend more than the IRS-allotted mileage deduction if you're driving a vehicle that gets less than optimal gas mileage.

Tolls and parking fees are not included in the IRS mileage-pricing estimate but are also a legitimate deductible car expense. And lastly, consider how much your car insurance and your car depreciation actually cost you for every business mile driven. Living in the greater New York area, my car insurance runs me about $2000 per year, and my business mileage is about 75% of my total driving. So, my business expense purely for car

© Sara Wilmot

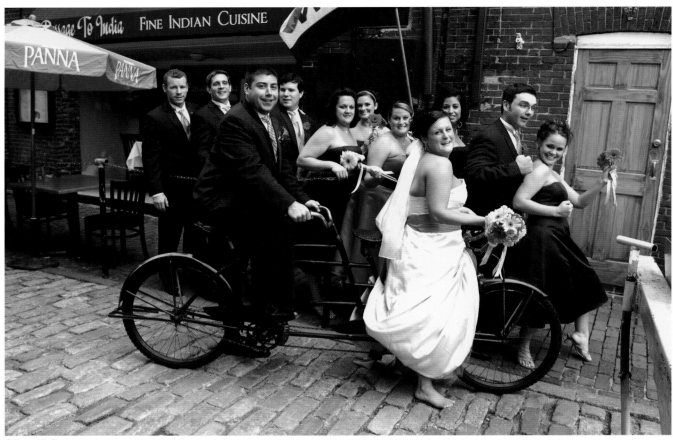

©Russell Caron

insurance is about $1500. Considering I put about 15,000 miles on my car each year for business related travel, this equates to ten cents of insurance costs for every business mile I drive. Obviously, if you live and work in a less densely populated area your insurance costs will be much less (but your mileage might be much higher) so you will have to spend time figuring this out for yourself. Regardless, I bet you'll be surprised at what your car actually costs to operate. Remember to include this figure in your expenses.

The Final Tally

With all these costs included, I can't see how any studio owner could charge less than $20 to $25 for an 8 x 10-inch print (A4). However, there are hundreds of studios that squeak by selling them for between $10 and $15. These studios either do a huge volume or operate at such a small profit that driving a cab would be more profitable. How much you charge is up to you, but to make an educated decision, you have to be aware of the costs I've outlined.

Setting a high price as a starting point for additional prints presents another advantage when you are selling your work. If your profit margin is strong enough, you can offer a slight discount if your customer is willing to guarantee a larger order at the time of booking. Here's the scenario: You explain your prices and packages to the customer, and when the customer asks how much additional 8 x 10s (A4s) are, you tell them $25 per print. The customer goes crazy and says she wouldn't pay $25 to see the Statue of Liberty swim back to the isle of

© Sara Wilmot

© Sara Wilmot

Manhattan! Don't get flustered. Instead say, "I can offer you a 20% discount on the price of extra prints if you will guarantee me a minimum order of 70 prints in the bridal album right now."

Once you agree to a set of terms, write it up in the contract. If you've built a good profit margin into your print price, you have room to negotiate. Some customers don't really care about the price, but they do care about getting some type of discount. With proper planning on your part, you can give those customers what they want and still make the profit you need to make a living.

Always Have a Contract

While some photographers consider a handshake as a way to seal a deal, I believe a written contract is a necessity. Any time you are selling services and products to a customer, it pays to have both parties' responsibilities written down and agreed upon. The contract you design should include much more than just a list of what the customer is going to receive and how much he or she is going to pay. Even if your contract is simple, here are some ideas on other things that should be included in it.

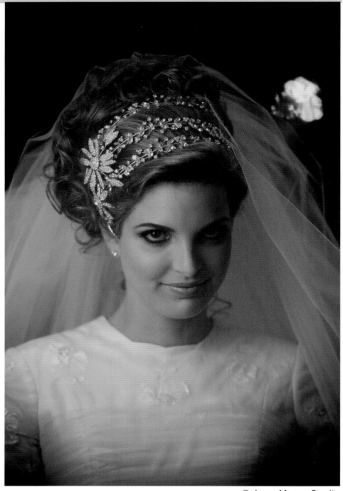

© Jerry Meyer Studio

Payment Schedule

Two (or five) thousand dollars is a lot of money to receive in one big sum. Your contract should break the total down into amounts that are manageable for the customer. You can start by requiring a retainer from your customer to reserve the date. This might be anywhere from 10% to 25% of the total amount due. Use the term "retainer" instead of "deposit," both in your contract and in your language to the customer. Deposits are refundable; retainers aren't! If the client gives you a retainer while you hold the date open for them, you and the client are exchanging something of value. Your contract should stipulate that, if the customer cancels, the reservation retainer is refundable only if you can get another assignment for that day.

The second payment after the retainer should be required on or just before the wedding day. That payment plus the reservation retainer should equal between 75% and 80% of the total bill. Then, half of the remaining balance (with any extras included) should be required when the customer returns the proofs. The final payment is due upon album delivery. All final payments should be by cash or certified check.

Be very careful about making exceptions to these rules. Once you have delivered the final album, you have no leverage left to insure payment. The last thing you want to do is chase after a customer who bounces a final payment check!

Shooting Hours and Charges for Overtime

Are you shooting pictures for two hours or twelve? Some customers expect you to be with them for the entire wedding day, regardless of when it starts and when it ends. Bands do not work that way. Caterers do not work that way. Why should you?

In my region, "standard coverage" (if there is such a thing) consists of six hours of photographic time. Additional half-hours are billed to the customer at rates from $35 to $100 per person (remember, you might have an assistant with you). When deciding upon an overtime rate, your charge must take into account not only the labor costs involved, but also the additional equipment usage and processing costs for the additional digital files.

© Michael Brook

The Limits of Your Liability

What happens if there is a power failure or a fire at your lab while they have your digital files? What if one of your memory cards goes bad? What if your laptop is stolen? What then?

There may be a time, through no fault of your own, that the pictures you take at a wedding don't come out. What do you owe the bridal couple in such a case? Your contract should cover this possibility (in the gentlest words possible), and your liability should be limited to the return of your customer's deposit(s). Note that I used the word "deposit." In this amount, I am not including the retainer you got at the contract signing, which had nothing to do with the outcome of the photography. That retainer was paid to you just for reserving a specific day of your time. However, in the event of a calamity (which, in honesty is less apt to happen in the digital age because you should always make and keep backups of your files), anything you can do to appease an angry customer is a worthwhile endeavor. If this type of catastrophe does occur, your contract needs to serve as a mechanism for detailing what you are going to do about it. If you're dumb enough to get falling-down drunk at a wedding you've contracted to cover, no disclaimer on your contract will save you from a lawsuit (and you'll deserve it), but if there is a problem that is beyond your control and you've acted in good faith, your contract should protect you.

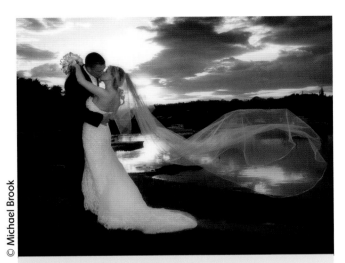

© Michael Brook

Twilight Bookings

Consider charging extra for "twilight bookings" during peak seasons—those that stretch from afternoon to early evening. Normally, you could fit in two weddings on a Saturday in June if one is a morning ceremony followed by a luncheon reception and the second is at 4:00 P.M. followed by a dinner. However, a 2:00 P.M. ceremony with a 6:00 P.M. reception will eat up your entire day. Every caterer (at least in my area) understands that they must maximize their profit given the limitations of their dining room facilities. Therefore, they charge a premium if one party ties up their facilities for the entire day. If you are a lone photographer, you, too, must maximize your profit during the busy seasons. Whether or not you decide to follow this suggestion is up to you, but to make informed choices (and more money), you should consider all of your options.

© Sara Wilmot

© Michael Brook

Who Owns the Copyrights?

This may be self-explanatory to you, but it should be covered in your contract. In the digital world, it is a simple process for a bride or groom to plop your photographs on the bed of a scanner and create copies for the entire family. Although this type of unauthorized use of your intellectual property (the pictures) is hard to police, your contract should state in plain terms that the images are yours. One photographer I knew pointed out to customers that the piece of paper on which the photograph was printed was worth only pennies. It was what he put on the paper that was of value! What you put on that piece of photographic paper is yours, and you are selling the bride and groom only the rights to look at and enjoy the images, not the right to make, distribute, or sell copies. Furthermore, even if you use the business model of giving the couple a DVD after you shoot the assignment, you should consider retaining the copyright to your images. What happens if you want to use the images for samples or other forms of self-promotion? If you give away the copyright to your images, you might no longer have the right to do that.

Extra Charges

Most often, disagreements over wedding photography occur because something wasn't discussed beforehand and, when you bring it up later, the customer is distraught because you never mentioned it during your sales pitch. Therefore, everything that might add to what the customer is paying should be listed in your contract, including your overtime rate and the charge for an additional set of proofs. No surprises, no arguments.

Navigating the Legal Side

All of the legalese in your contract might make selling your wedding photography more difficult. It would be easier to gloss over the fine points as you use words to paint a beautiful picture during your sales pitch. However, covering all these points up front can eliminate numerous problems later.

Consider getting legal help when writing your contract. Laws are different from state to state and, because your contract is a legal document that might someday be needed in court to settle a dispute, it is important to be sure that it can stand up to scrutiny. Most importantly, the contract you design should favor you! It should be fair to your customer, but your goal in making a contract is to protect yourself.

The Whole Package

Some full-service wedding studios offer package deals that typically include a bridal album, two parent albums, a large-sized portrait, and a dozen wallet-sized prints. Other studios (usually ones that are catering to an upscale clientele) believe in an à la carte policy that requires a minimum order (usually the bridal album) to reserve the date, and everything else costs extra, from parent albums to portraits. Still other studios (again, usually those with an upscale clientele) charge a creative fee for the shoot day and everything else (including the bridal album) is extra!

The type of pricing structure you choose will be based on the clientele and the competition in your area. You might want to work with a creative fee and an à la carte menu, but if all the local competition offers packages that include everything for one price, you might find it hard to attract customers. Besides, in terms of a small studio operation, selling packages means that on any given popular wedding day (i.e., a Saturday afternoon in June or September), you won't be committed to fulfilling a small order without knowing what extras may or may not be purchased, as you would in an à la carte arrangement; your package customer will have already agreed to purchase the bridal album, parent albums, portraits, and other products.

While basic photographic costs (i.e., camera equipment, production, and printing) remain about the same from one geographic area to another, everything else is much more expensive in large metropolitan areas (including your labor, due to the higher cost of living). Defining your prices based on the specific location you are working in is your job, but I can give you an idea of the expenses involved in producing two single-album wedding orders. Please note that the figures I include below are approximations and are based on six hours of coverage and working with one assistant. Additionally, my approximations include labor costs and are based on the fact that I work in the New York metropolitan area.

What the Client Gets

A basic starter package might include:

An 8 x 10-inch (A4) leather-bound wedding album with 50 pictures

An 11 x 14-inch (A3) portrait

12 wallet-sized pictures including up to two poses (12 of one pose or 6 each of two poses)

Typical Photographic and Labor Costs

1000 numbered proofs @ $0.25 each = $250

50 8 x 10-inch (A4) prints @ $7 each = $350

8 x 10-inch (A4) leather-bound wedding album = $300

Lacquer spray of album prints @ $1 per print = $50

Six hours of shooting @ $125 per hour = $750

Six hours of shooting assistant's time @ $25 per hour = $150

11 x 14-inch (A3) print = $12

12 wallet-sized photos @ $0.75 each = $9

Total = $1,871

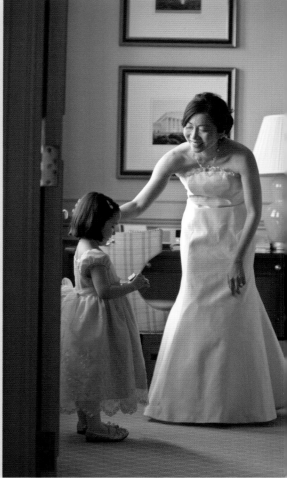

© Freed Photography

I'm certain that some readers are going to question the figures I outlined above. Some may feel that they can cover a wedding with 500 images instead of 1000, and that change alone reduces proofing expenses by $125. Others might offer a 24-print starter package instead of my 50-print minimum—a difference of $108. Still others might not lacquer spray their prints (a savings of $50), or they may provide a less expensive, plastic, slip-in binding. These photographers might be willing to work for $50 per hour and offer only three hours of coverage. Further they may be able to find an assistant that will help out for only $25 for the entire assignment.

© Sara Wilmot

Minimal Coverage
Photographic and Labor Costs

500 numbered proofs @ $0.25 = $125

24 8 x 10-inch (A4) prints @ $7 each = $ 168

8 x 10-inch (A4) plastic slip-in wedding album = $ 75

Three hours of shooting @ $50 per hour = $150

Flat fee for shooting assistant's time = $25

11 x 14-inch (A3) print = $12

12 wallet-sized photos @ $0.75 each = $9

Total = $564

All of these cost savers are valid. The customers and the competition in your region may demand these more thrifty choices, but I have found that I don't enjoy the end product of my labors as much when I start to cut corners. However, if your geographic area demands that you cater to customers on a smaller budget, so be it. But I find that it is much more fulfilling (and profitable) to offer the best quality I can produce, and I look for customers with the same desire. In addition, because the number of days on which you can shoot a wedding is limited, choosing to shoot low-budget weddings cuts into the time you have available for high-end assignments.

If you expect customers to hire you based solely on your rock-bottom prices, realize that, whatever you charge, some other photographer will be willing to do the same thing for less. If you get your price down to one measly buck, some other photographer will offer the same job for 99 cents. The real question is, do you even want the lowest-paying, least-profitable assignments? Setting aside my distaste for low-budget coverage, let's total up the minimalist approach costs just to see what the bottom-line expenses are.

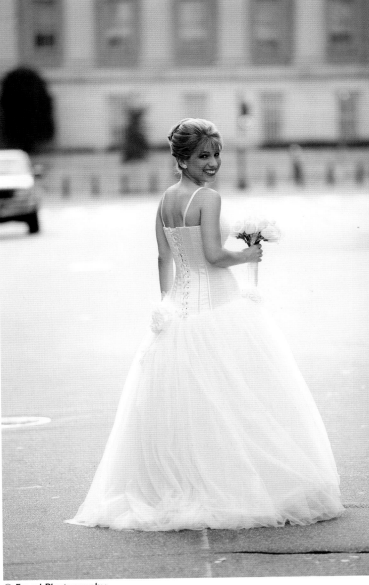

© Freed Photography

© Sara Wilmot

In retail situations, traditionally, gross profit is often defined as about a 100% markup; buy an item for $50 and sell it to the customer for about $100. Net profit (the profit after all the costs to sell the item are calculated in) is usually about 50% of the gross profit (i.e., $25 in our $100-item example). In the wedding photography business, however, trying to determine how much of a markup you should build into your pricing structure can be very difficult. I think that part of this is because historically (and sadly) photographers are just not good business people. Many photographers run into trouble trying to attach a specific value to their time. And, to exacerbate the problem, I have met many a photographer who is also awful at realistically judging how much time something takes to accomplish. It's a bad double-whammy!

Due to intense competition between local studios, many take a smaller-than-normal profit on their initial contract and a larger profit on the extra prints and other additional items sold after the event. With complete candor, I will share that I work on an approximate 80 – 100% markup of the total production costs on my starting contract, which drops to between a 65 – 75% markup when my clients hire me for a larger, more complete package. For prints and after-the-event extras, I work on a 300 – 500% markup over cost. That said, if I were just starting out in the business, I doubt I could successfully compete using my current pricing scale if price were the primary criteria for comparison. Because of my experience and reputation, my client base is established and my pricing works for me in my current business model. You will have to factor in your own level of markup in your playing field and weigh your pricing and services against those of your competition to come up with a pricing model that works best for you.

As you can see, there are many ways to cut a corner. But, no matter whether you choose to provide a low-budget option to your clientele or you prefer to stick to the more typical, more lucrative minimum order option, don't mistake the total costs listed here as the amount you should actually charge. These figures are your costs, having nothing to do with profit. You should never price either of these hypothetical assignments at their bottom-line cost. It wouldn't make any sense. Cost is not profit!

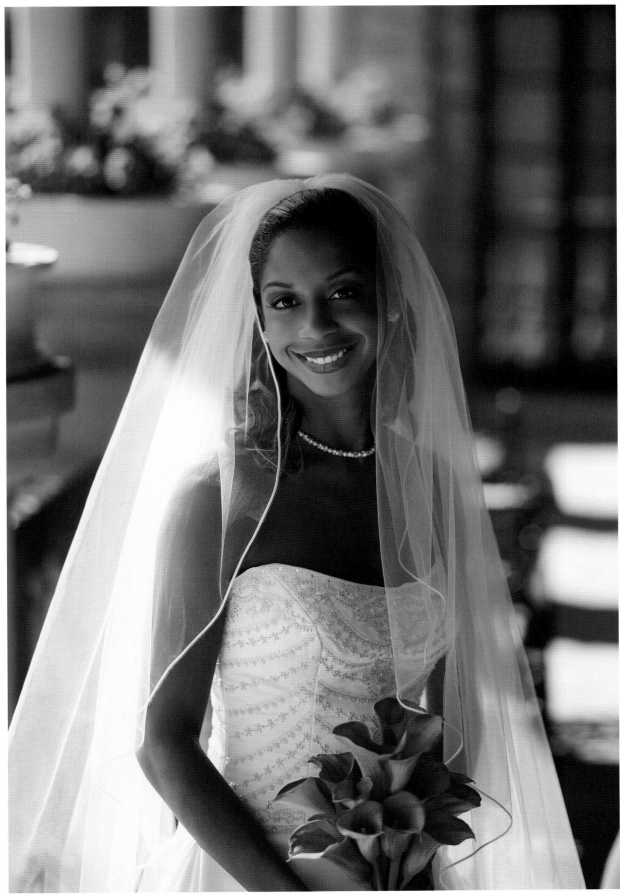

© Freed Photography

Index

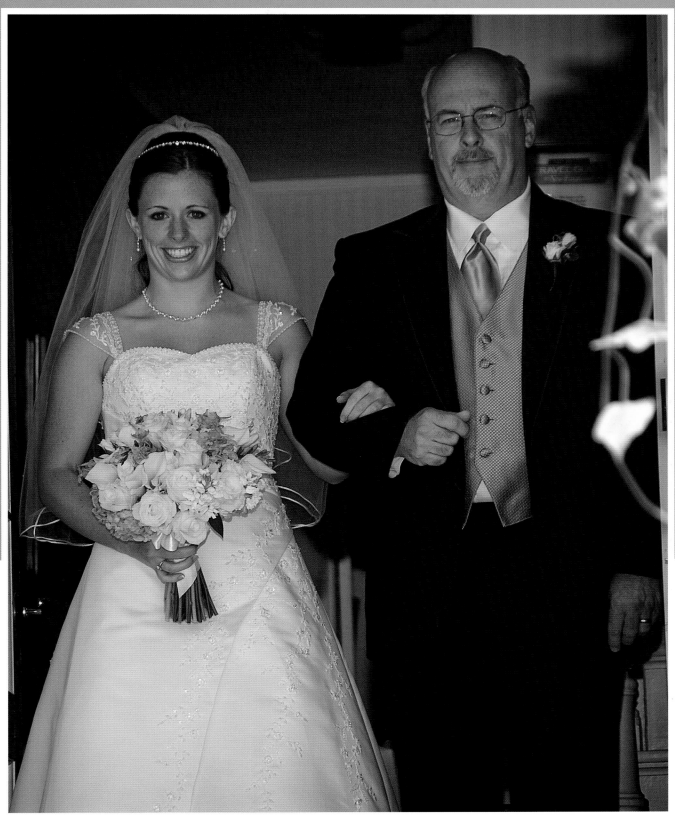

© Sara Wilmot

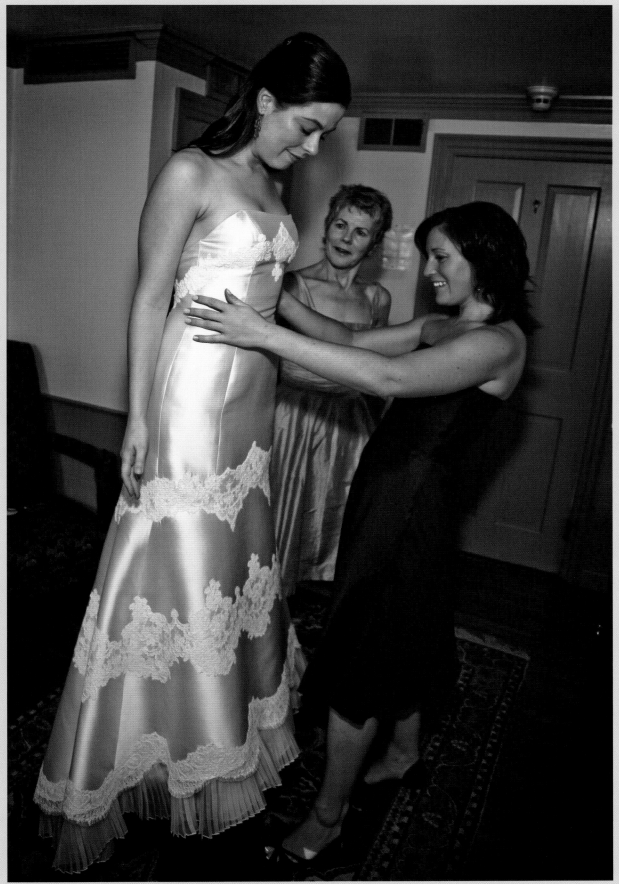

© Sara Wilmot